Adaptation Theory and Criticism

Adaptation Theory and Criticism

Postmodern Literature and Cinema in the USA

GORDON E. SLETHAUG

BLOOMSBURY

NEW YORK · LONDON · NEW DELHI · SYDNEY

Bloomsbury Academic

An imprint of Bloomsbury Publishing Inc

1385 Broadway	50 Bedford Square
New York	London
NY 10018	WC1B 3DP
USA	UK

www.bloomsbury.com

Bloomsbury is a registered trade mark of Bloomsbury Publishing Plc

First published 2014

© Gordon E. Slethaug 2014

Library of Congress Cataloging-in-Publication Data

A catalog record for this book is available from the Library of Congress.

ISBN: HB: 978-1-6235-6028-7
PB: 978-1-6235-6440-7
ePub: 978-1-6235-6201-4
ePDF: 978-1-6235-6058-4

Typeset by Integra Software Services Pvt. Ltd.
Printed and bound in the United States of America

Contents

Introduction

Since George Bluestone's 1957 *Novels into Film*, Robert Richardson's 1969 *Literature and Film*, and the 1973 introduction of *Literature/Film Quarterly* that provided an important space for discussion of individual adaptations, historicizing and theorizing film adaptation and refuting fidelity studies has been an ongoing endeavor, giving way to a plethora of examinations.[1] The development of adaptation theory, however, was off to an unexpectedly slow start.

Part of the reason adaptation theory did not succeed immediately after Bluestone and Richardson, as Timothy Corrigan suggests, is that during the 1970s and 1980s English studies and film studies moved in the direction of "medium-specific, neo-formalist studies and toward ideological studies," neither "particularly hospitable to adaptation studies" (2007, 40). If new criticism and cultural studies left little space for literature-film comparisons, they did leave room for analysis of particular texts, a tendency that has endured with some success. Indeed, Christine Geraghty recently has made a strong neo-formalist case for looking at "the particular ways in which adaptations make their own meanings" (2008, 4) through setting, landscape, and costumes.

Another part of the reason that the study of adaptation was not entirely liberated from earlier fidelity studies can be attributed to "logocentricism or a belief that words come first and that literature is better than film" (Cartmell, Corrigan, & Whelehan 2008, 1). Significant in this belief is the appeal to the originary written work and also to authorial intention, so far as it can be apprehended (Leitch 2007, 3).

In addition, because in English departments adaptations are often discussed and ranked with reference to such mainstream figures as Shakespeare,

[1] These include volumes by Geoffrey Wagner (1975), Dudley Andrew (1980, 1984), Linda Seger (1992), Millicent Marcus (1993), Timothy Corrigan (1999), Brian McFarlane (1996, 2007), James Naremore (2000), Robert B. Ray (2000), Robert Stam (2000), Kamilla Elliott (2003), Robert Stam and Alessandra Raengo (2005), Míreía Aragay (2005), Linda Cahir (2006), Linda Hutcheon (2006), Deborah Cartmell and Imelda Whelehan (2007), Thomas Leitch (2007, 2008), Christine Geraghty (2008), Rachel Carroll (2009a), Dennis Cutchins, Laurence Raw, and James Welsh (2010).

Austen, Thackeray, Dickens, Wharton, and Hemingway, the study of adaptation often remains firmly linked to the primacy of canonical texts and writers. In short, because film adaptation was seen as a foster child in literature and film departments, because the literary often stood above the cinematic, and because the written word of canonical literary figures was frequently the gold standard by which the cinematic was judged, adaptation theory was given short shrift for a time after Bluestone and Richardson.

Even with those restraints, adaptation studies began to be incorporated within academia in the 1970s[2] and critics increasingly argued against faithfulness of film to originating text. As Millicent Marcus notes,

> If the most avid proponents of faithfulness expect a literal-minded transcription of the novel in film, more advanced thinkers, like biblical allegorists, distinguish between the letter and the spirit of the original, and, in an enlightened recognition of the unique discursive requirements of the two media, ask only that the adaptation be faithful to the spirit of its precursor text. (1993, 16)

Robert Stam adds to this argument, asking what faithfulness really means:

> Should one be faithful to the physical descriptions of characters? Perhaps so, but what if the actor who happens to fit the description of Nabokov's Humbert also happens to be a mediocre actor? Or is one to be faithful to the author's intentions? But what might they be, and how are they to be inferred?… And to what authorial instance is one to be faithful? To the biographical author? To the textual implied author? To the narrator? Or is the adapter-filmmaker to be true to the style of a work? To its narrative point of view? Or to its artistic devices? (2000, 57–58)

Using a story and discourse distinction—that the story has a "code of narrativity" while discourse is contextually and culturally defined and bound, many argue that the author and adapter both keep the story in mind, but that in the public forum the linguistic and cultural context is especially

[2]In 1999, Timothy Corrigan remarked that adaptation history and theory still lacked recognition in either the fields of literature or film. Even a few years ago at the launch of the journal *Adaptation*, Corrigan along with Deborah Cartmell and Imelda Whelehan repeated this earlier criticism, saying that "the subject has been long neglected in literary and film studies" (2008, 1). More recently, however, academics like Thomas Leitch have perceived a stronger shift in favor of adaptation studies in university undergraduate English programs (2010, 1). Consequently, while some still feel that film suffers from its association with literature and that adaptation studies suffers generally from academic neglect, this is no longer a universal perception.

relevant to the film, thereby muting the story-film adaptation debate (Marcus 1993, 14).

Others have added to theory as well, seeing a broad spectrum of adaptations and inventing new categories of analysis. In 1975, Geoffrey Wagner distinguished between transposition, commentary, and analogy. In 1984, Dudley Andrew divided adaptation into "borrowing, intersection, and fidelity of transformation" (2000, 29); in 2003 Kamilla Elliot, arguing that film adaptation operates on the basis of "interart analogy," offered six approaches to adaptation, including psychic, international, ventriloquist, decomposing, genetic, and trumping; in 2006 Linda Cahir referred to literal, traditional, and radical translations (instead of adaptations); and in 2007 Thomas Leitch provided a ten-stage taxonomy of "hypertextual relations as they shade off to the intertextual" (2007, 93–126) that included celebration, adjustment, neoclassic imitation, revision, colonization, metacommentary or deconstruction, analogy, parody or pastiche, secondary-tertiary-and-quaternary imitation, and allusion.

All told, these categories are indicative not only of what Deborah Cartmell and Imelda Whelehan call the "will to taxonomize" (2007, 2), but especially the need to move away from the rigid faithfulness to see the new possibilities in adaptation. In other words, Platonic metaphysics was replaced not just by Aristotelian taxonomy but by a fluidity of approaches and relationships including "readings," "translations," "transmutations," "transformations," "intersemiotic transpositions" (Stam 2000, 62, 70), "narrative transmutability" (Ray 2000, 39), "transferability" (McFarlane 2007, 19–20), and "performativeness" (Naremore "Introduction" 2000, 7–8) that would open the field in a healthy way.

Of late, adaptation theory has incorporated tropes of linguistic and semiotic analysis, post-structural and postmodern enquiry, textual reproduction, and cultural criticism to indicate that adaptations have value, validity, and integrity not dependent upon the originals and able to say interesting and unique things about language and culture. Andrew, Stam, Hutcheon, Leitch, and Cartmell and Whelehan note that the adaptation process is much more far ranging than was previously admitted with originals and adaptations consisting, among other things, of comic books, video games, role-playing games, and board games. Moreover, these critics note that views of the dialogic play of textuality and "intertextuality," which Julia Kristeva, Roland Barthes, and Mikhail Bakhtin were among the first to theorize, have opened up a new discursive enquiry into adaptation theory (Ray 2000, 41).

This assessment of intertextuality in film now goes back several decades. Janet Staiger, referencing Barthes and Genette, finds that intertextuality is not simply

some relation between two texts, but rather a fundamental and unceasing spectatorial activity, the semiotic action of processing a filmic narrative by repeated referencing and referring to other texts. Intertextuality as understood from a poststructuralist perspective is a constant and irretrievable circulation of textuality, a returning to, a pointing toward, an aggressive attempt to seize other documents—the results of this procedure of referencing other texts are also complicitly and irrevocably circular and ideological. For although the activity of intertextuality is neutral and without cessation, none of the discourses invoked are neutral nor is the real ever fixed, halted, and cured but only referred to, compulsively and repetitiously. (1989, 399)

Updating this view, Hutcheon, drawing on views of Jacques Derrida, finds intertextual play a central part of the spirit and mechanics of adaptation which she subdivides into the process of adaptation, the product generated, and the process of reception. In this way, Hutcheon joins Staiger, Leitch, McFarlane, Ray, Andrew, Cartmell and Whelehan, and Brooker who see adaptations in terms of intertextuality, repudiate the "transcendent order" of the traditional original/copy paradigm, and affirm the "de-hierarchizing impulse, a desire to challenge the explicitly and implicitly negative cultural evaluation of things like postmodernism, parody, and now, adaptation, which are seen as secondary and inferior" (Hutcheon 2006, xii).

Stam puts forward a strong postmodern narrative, suggesting that in the theory of intertextual dialogism "every text forms an intersection of textual surfaces" (2000, 65). He particularly cites Gérard Genette's notion of transtextuality, that is, moving from and linking one text to another (including intertextuality, paratextuality, metatextuality, architextuality, and hypertextuality) as an important way to see adaptation (2000, 65). Genette's notion of "intertextuality" represents quotation, generic allusion, and reference; "paratextuality" is the relationship between the text itself and paratexts—"titles, prefaces, postfaces, epigraphs, dedications, illustrations, and even book jackets"; "metatextuality" is the "critical relation between one text and another, whether the commented text is explicitly cited or only silently evoked"; and "artchitextuality" links "generic taxonomies suggested or refused by the titles or subtitles of a text" (Stam 2005a, 26–31).

In discussing "the impact of the Posts," however, Stam notes that, aside from intertextuality in general and transtextuality in particular, "other aspects of poststructuralism have not yet been marshaled in the rethinking of the status and practice of adaption" (2005a, 8). The post-structuralists he alludes to are those that are often considered the fathers and mothers of postmodernity such as Roland Barthes, Jacques Derrida, and Julia Kristeva.

Many of their views are implicit in current criticism but perhaps not explicit, and it is the intention of this volume to draw on their theories along with others such as Mikhail Bakhtin, Jean-François Lyotard, Michael Foucault, and Jean Baudrillard who form the backbone of postmodern theory. Thomas Leitch has also remarked that "the challenge for recent work in adaptation...has been to wrestle with the un-dead spirits that continue to haunt it however often they are repudiated: the defining context of literature, the will to taxonomize and the quest for ostensibly analytical methods and categories that will justify individual evaluations" (2008, 65).

My position, drawn from implications of Julia Kristeva's musings on Bakhtin in "Word, Dialogue and Novel" (1986, 35–37) is that adaptation is a nexus for, and mosaic of, context, writing/directing subjects, originating texts and intertexts, discursive practices, and viewers/readers. In this way, I see it as containing but going beyond a palimpsest that "stages multiple texts simultaneously" (Collard 2010, 83). Film obviously is an important part of this nexus, and for this book's purposes film adaptation is central, but adaptation is systemic in culture and not limited to the movement from literature to film.

This book will pursue and interrogate more closely the insights that post-structuralist and postmodernist critics such as Staiger, Ray, Hutcheon, Brooker, and Leitch have brought to this debate. Some of the key ideas that will be explored in helping to understand film adaptation include dialogism, intertextuality, indeterminacy, decentering, freeplay, and dissemination. These are concepts that arise more from rhetorical and textual issues than from cultural ones, pushing this analysis more in the direction of neo-formalism and postmodernism than toward cultural criticism, although these are all applied within the American context. Others such as Robert Ray in *A Certain Tendency of the Hollywood Cinema, 1930–1980* (1985) or *The ABCs of Classic Hollywood* (2008) have analyzed formal and thematic paradigms and American ideology in Hollywood cinema, mainly using structuralism and semiotics with cultural and psychological criticism, but that is not the direction of this study. Nor is Jameson's choice of postmodernism as "postindustrial society...consumer society, media society, information society, electronic society or high tech" (Marcus 1993, 229). Nor is it a political-economy analysis of the film industry. This study is specifically about postmodern textuality within a contemporary American-film frame of reference, though not all the directors and actors are American. Within and alongside these concepts are others such as supplementation and substitution, bricolage, and the myth of filiation. Another postmodern theory is that of ethnocriticism that also plays an important part in this study but mainly in relation to textuality rather than to critiquing American culture and ideology or pointing out the politics and economics of the film industry.

Key terms that help to organize chapters of this study of adaptation include "supplementation and surplus," "freeplay adaptation," "intertextual doubling," "ironized intertextuality," "dialogic citation," and "double- and hyper-palimpsets." These are defined in Chapter 1 but elaborated upon in the introductions to the relevant films in the subsequent chapters. Few have examined adaptations specifically through postmodern lenses, and no one has focused on modern American films per se in relation to postmodernism. By undertaking both of these, I hope to offer new insights into adaptation theory and bring a new awareness to adaptation studies and American culture. This book is also designed to demonstrate that intertextual analysis opens up adaptation to the entire field of relevant textual relationships, holding out a promise of interesting complexity and enriched study in criticism. By this means, this study should appeal to advanced undergraduate and graduate students as well as faculty members in adaptation studies, English studies, film studies, and American studies, as well as in critical theory in seeing the ways that postmodern theories can provide an analytic and help explore, open up, and see relationships among various literary, filmic, and cultural texts.

With an introduction and six chapters, this book includes eight case studies, comprehensive analyses of 16 films exploring certain premises of postmodern enquiry in relation to American films, extensive allusions to several others, and commentary on works of fiction. I have chosen a case-study methodology to explore particular texts in detail. I have also chosen to restrict this study to the dynamics of the intertextual relationship of literature (short story, fiction, drama, and nonfiction) and American film rather than to branch into other arts such as painting and music or into aspects of popular culture such as comic books, board games, role-playing games, and video games that would detract from a specific focus on American literature and film.

I have selected American films that exercise various discursive and textual strategies and relationships of adaptation as seen through the lens of postmodernism and that explore different American social and cultural issues. The book moves from adaptation to supplementation and citation, from what might seem the simplest and most direct kind of adaptation to that which might seem the most complex, and from films produced by big commercial studios to those produced by independent and avant-garde studios. This is a topic far more extensive than a single book can cover, and many films could be used to explore the range of topics, and readers will undoubtedly have their own favorites, but my choices include: *Six Degrees of Separation* (non-fiction to drama and then film); *Short Cuts* and *Smoke Signals* (short fiction collected into ensemble films or focused narratives); *Age of Innocence, Gangs of New York*, and two versions of *The Great Gatsby* (fiction and nonfiction that lead to intertextual cross-referencing as well as interrelated novels and film arising

from them); *Do the Right Thing* and *SMOKE* (films that draw on common cultural documents and create a dialogue with them and between the films themselves); *Broken Flowers* (a film that briefly cites the Lolita canon); and *Snow White: A Tale of Terror, Snow White: The Fairest of Them All, Enchanted, Snow White and the Huntsman*, and *Mirror Mirror* (films that riff off of Disney's *Snow White and the Seven Dwarfs* and the Grimm brothers). The films also have been selected for their contemporary relevance, though Disney's *Snow White*, for example, is a legacy film.

Following this Introduction, Chapter 1 (Modernism/ Postmodernism and Origin/Intertextual Play in Adaptation Theory) will discuss the governing principles, contributions, and limitations of modernism and postmodernism to adaptation theory, and will lay out the working vocabulary and ideas for the book.

Chapter 2 (Adaptation, Surplus Value, and Supplementation in *Six Degrees of Separation* and *Short Cuts*)interrogates adaptation that is nearly one-to-one with the original—a seemingly perfect repetition—for as Derrida notes of supplementation, surplus value changes the result and alters the original as well. Traditionally, faithfulness/fidelity studies assumed that a film incremental to a written source was an impoverishment. Supplementation and surplus suggest that, on the contrary, adaptations give added value to the originary source through fresh insights and help the reader and spectator to reassess meaning and value in all interrelated texts. This is the case with John Guare's *Six Degrees of Separation* that was drawn from newspaper accounts, then written as a play for the stage, and not much later adapted as a Hollywood film. With similar (but not identical) settings and scripts, this adaptation seems about as faithful as it can get, but this comfortable congruity is first problematized by the newspaper accounts of the young thief David Hampton, upon which the play is based. Consequently, "original," "adaptation," and "authentic meaning" need to be reassessed in this surprisingly postmodern instance where a "true story" (Leitch 2007) lies behind a drama and film adaptation and which helps the audience reassess such postmodern concepts as cosmopolitanism.

Another kind of adaptation comes from multiple sources unified in a film to form yet another entity, that is, adaptation that nods in the direction of Derrida's freeplay and which Corrigan calls "poetic." According to Corrigan, "poetic films aim to intensify or make unfamiliar the formulas of conventional or mainstream movies" (1999, 31), and, in my opinion, freeplay adaptation, in contrast to full or literal adaptation, takes unspecified liberties in reducing, expanding, or reconfiguring anterior texts and contexts to create interest and alter meaning. (This does not mean that freely adapted texts are qualitatively better than literal adaptations, just that they take unspecified liberties and often go unnoticed, both of which are of special interest in postmodernism.) A significant case in point is the role of surplus and supplementation in Robert

Altman's *Short Cuts* that knits nine of Raymond Carver's short stories and one poem together in an ensemble film that draws from each of the individual pieces, extends and unifies them into an integrated film, and, in the process, raises significant questions about the individual and collective meaning of the texts and about adaptation itself. These questions are even more intriguing because Altman essentially assumes a double role of author and auteur as he collects, unifies, and introduces the stories at the same time as he writes the film script and directs the film.

Chapter 3 (Intertextual Doubling in *Age of Innocence, Gangs of New York*, and *The Great Gatsby*) considers (a) an instance of filmic "sources" playing off and doubling one another and (b) an instance of the intertextual doubling of novels leading to intertextual doubling of films. In intertextual doubling, words and phrases are repeated from text to text, creating unexpected links and altering meaning from one text to the other. It is not so common for films to be close to their precursor texts and yet play off one another in a larger dialogue, but this is precisely what happens in Martin Scorsese's film adaptations *Age of Innocence* and *Gangs of New York*. It is also not so common for one novel to play off another and for their film adaptation to follow a similar route. Yet, F. Scott Fitzgerald's novel *The Great Gatsby* plays off Edith Wharton's *Age of Innocence* as do some of the films they spawned, especially Jack Clayton's *The Great Gatsby*, Baz Luhrmann's *The Great Gatsby*, and Scorsese's *The Age of Innocence*.

Scorsese has used Edith Wharton's novel *Age of Innocence* to create a film that shows the elegance and ruthlessness of nineteenth-century American robber barons who were a rich, self-absorbed, and oppressive "tribe" in New York City. *Gangs of New York*, another of Scorsese's films, adapts Herbert Asbury's lurid historical account by the same name and looks at the same period in New York City through the eyes of the Irish underclass and exploitative nativists. Both of these films are adaptations of literary documents, but, more than that, Scorsese's second film references the first in its use of "tribes," creating an intriguing self-referencing doubling. By this self-conscious intertextual doubling technique, Scorsese plays novelistic and filmic "texts" and classes off against each other, revealing deep abysses within culture, showing to what extent upper-class and lower-class tribes share a cultural matrix, and engaging in a meaningful freeplay of intertextuality even as he critiques nineteenth- and twentieth-century ethnic relations.

This freeplay of intertextual doubling also characterizes the relationship of *Age of Innocence* and *The Great Gatsby*, both in the novels themselves as well as in film adaptations. Over time, scholars have noted Wharton's influence on Fitzgerald, but not in *The Age of Innocence* and *The Great Gatsby*. None has noted the intertextual doubling of the novels' New York setting, party

structure and motifs, and vocabulary that point to concerns about class, clan, and communitarianism/individualistic freedom. However, this is not a straightforward doubling but an ironized one for, while *The Great Gatsby* may draw upon and even show some sympathy to the cultural attitudes of *The Age of Innocence*, relationships and approaches depicted in the Jazz Age are never the same as those of the Belle Epoch or the postmodern era. Both novels eschew the possibility of reliving the past or repeating textuality exactly. Just as importantly, films drawn from these novels—Jack Clayton's *The Great Gatsby* (1974), Baz Luhrmann's *The Great Gatsby* (2012), and Martin Scorsese's *The Age of Innocence* (1993)—also evidence a similar ironized intertextual doubling with Scorsese choosing bits from Clayton's film and Luhrmann choosing bits from both Scorsese and Clayton to explore money, position, and social stability/instability in societies 50 or a 150 years apart.

Chapter 4 (Freeplay, Citation, and Ethnocriticism: Single and Multiple Sources in *Smoke Signals, SMOKE,* and *Do the Right Thing*) is concerned with extensive and imaginative freeplay adaptation of sources. Linda Cahir would call these "traditional translations," but "traditional" does not cover the range of imaginative possibilities. Thomas Leitch would call it "adjustment" (2007, 208), taking a small narrative and using it as a fragment of, or seed for, a large film, a case in point being Wayne Wang's *SMOKE*, but that too does not account for the range of freeplay. For this film, Paul Auster, the scriptwriter, has taken one of his own short stories and embedded it into a full-length feature film that incorporates many of the short-story features but contextualized very differently. While acknowledging and embedding the short story, the film exceeds the story in being an interesting, complex, and playful postmodern adaptation premised on indeterminacy but useful in exploring race relations in modern New York City.

Another use of small fictions brought into a large context is illustrated by Sherman Alexie's *Smoke Signals,* in which Alexie as the scriptwriter has taken fragments of his own short stories and bits of a novel and woven them into a filmic narrative with altered premises, attitudes, and pleasures. Moreover, in the precursor writings of *The Lone Ranger and Tonto in Heaven* and *Reservation Blues,* Alexie was thought by critics to present a negative view of Native American relations with the rest of society both on and off the Indian reservations, but in *Smoke Signals* he blends several incidents from those texts to create a humorous and forgiving perspective on Native American and white relations. This kind of adaptation can have startling, creative, "ethnocritical" effects in this postmodern era.

Though *Gangs of New York* and *Smoke Signals* are mainly about ethnic strife and the conflict of cultures, they are also about racial strife, the very subject of *Do the Right Thing,* written and directed by Spike Lee. This film is

similar to what Leitch calls allusion (2007, 121): it has no originary story of its own but cites essays by Martin Luther King and Malcolm X and extensively references the Alex Haley–assisted version of *The Autobiography of Malcolm X*. In citation a film borrows words, images, or brief scenes from originary texts in order to develop intertextual dialogues that may explore issues but likely will remain open-ended. *Do the Right Thing* thus enters into a dialogue with King and Malcolm X, interrogating the human rights won by the black communities and raising the issue of peaceful integration or violent separation as ways of trying to come to grips with inner-city racial and economic problems.

Wayne Wang's *SMOKE* also enters into dialogue with *Do the Right Thing* in its similar Brooklyn setting as well as citation of the visual and verbal grammar of that film and its textual precursors. By referencing and reworking King, Malcolm X, and *Do the Right Thing*, *SMOKE* critiques *Do the Right Thing* and offers a new and interesting view of racial relations. This example of citation, postmodern intertextual freeplay, and critique addresses but lightens the burden of late twentieth-century racial tensions. These are palimpsests that inhabit *SMOKE*.

Chapter 5 (Palimpsests and Bricolage—Playful and Serious Citation in *Broken Flowers* and *Snow White's Offspring*) addresses more extensive uses of palimpsests in which traces of other texts inhabit a text. These may be single, multiple, even hyper-palimpsests, depending on whether there is only one previous text in question, a couple of texts, or a multitude of them that resonate in different ways for different purposes at different times.

Serious matters do not of necessity occupy the center stage of this postmodern enterprise for playfulness that can itself be the real point of certain forms of citation, and this fits well with Derrida's textual postmodernity and Barthes's "blissful" play. One film that plays with these ideas is Jim Jarmusch's *Broken Flowers*, which, to use Barthes's term in "From Work to Text," exposes the "myth of filiation," that is, the preexistence of certifiable meaning in a text. For Barthes, "citations which go to make up a text are anonymous, untraceable, and yet *already read*: they are quotations without inverted commas" (1977b, 160) and therefore without preexisting referentiality and meaning. In briefly citing Vladimir Nabokov's *Lolita*, *Broken Flowers* opens up a whole series of playful possibilities about the importance of that citation and the meaning of life in general. The film's citations, clues they offer, and search for paternal links send the viewer off in many directions and, in the process, begin a meta-discourse on how meaning is artificially constructed and expose the myth of filiation by rejecting the establishment of preexistent meaning or "paternity" lying outside oneself and/or text. This repudiation of filiation does not query social issues and human rights, but rather asks the

viewer, in a playful context, to think about how culture and textuality operate ontologically.

Citation can become even more complicated, and the Snow White palimpsest may well be the most postmodern of all, though Walt Disney's film of *Snow White and the Seven Dwarfs* is rarely acknowledged in adaptation criticism. The discussion in *Snow White*'s "Offspring: The Hyper-Palimpsest" begins by considering the relationship between the low-brow roots of the Snow White stories in the nineteenth century, their morphing into the theater at the turn of the century, and Disney's adaptation in 1937. This low-brow tendency also is apparent from cartoon and cartoon-like versions of the narrative including the "Snow White" cartoon (1932), the "Coal Black and De Sebben Dwarfs" cartoon (1943), and *Snow White and the Three Stooges* (1961).

However, unlike most films that emerge from self-professed low-brow culture, *Snow White and the Seven Dwarfs* also led to various pieces of fiction, including Donald Barthelme's novel called *Snow White*. This novel, taking place in a Manhattan apartment rather than in the folk-tale forest, evokes many of the same characters and narrative devices as the Disney film but takes it out of the romance tradition and contextualizes it within a postmodern self-conscious narrative, giving it a surrealistic aura and high-brow status.

This, however, is not the end of the Snow White story: *Snow White* continues to spawn new films and has entered into popular culture again and again, fairly recently in Michael Cohn's television adaptation *Snow White: A Tale of Terror* (1997), Caroline Thompson's Hallmark made-for-TV *Snow White: The Fairest of Them All* (2001), Kevin Lima's *Enchanted* (2007), and most recently *Snow White and the Huntsman* (2012) as well as *Mirror Mirror* (2012). The films offer new glimpses of Snow White and critique the precursor texts, but the last four self-consciously celebrate Disney's original *Snow White* at the same time that they offer a playful critique through parallels with other versions. Altogether, this continuous looping of narratives suggests the endless possibilities that the postmodern play of adaptation, supplementarity, and citation promises.

Chapter 6 (Conclusion) will briefly review some of ways postmodern theory can illuminate the relationships between sources and adaptations and open up the fluid freeplay of textuality and intertextuality. It will also look at other ways the films under consideration can be viewed, for example, through a consideration of genre, production studio, theme, and even the dominant culture and period.

1

Modernism/postmodernism and origin/intertextual play in adaptation theory

Modernism: High culture, poetic genius, and influence

In "Tradition and the Individual Talent," T. S. Eliot set out to discover what creates a literary mind and a community of critics. He found the answer in what he called the "historical sense" connecting writers and their predecessors:

> The historical sense involves a perception, not only of the pastness of the past, but of its presence; the historical sense compels a man to write not merely with his own generation in his bones, but with a feeling that the whole of the literature of Europe from Homer and within it the whole of the literature of his own country has a simultaneous existence and composes a simultaneous order. This historical sense, which is a sense of the timeless as well as of the temporal and of the timeless and of the temporal together, is what makes a writer traditional. And it is at the same time what makes a writer most acutely conscious of his place in time, of his own contemporaneity. (Eliot 1989, 26–27)

Eliot added, "No poet, no artist of any art, has his complete meaning alone" (1989, 27). By this definition, every work of art bears within it the DNA of other works, and, even if a work claims to be a self-conscious repudiation of previous works, that repudiation is situated in, and indebted to, knowledge of the past and the immediate cultural context.

Arguably, then, the interplay of short stories, novels, poems, dramas, films, and performances (including those on the Internet) forms the basis of

all art, either implicitly or explicitly, and Eliot's own poem "The Wasteland" is evidence of this theory at work as his explanatory footnotes anchor the poem in the various literary, mythical, and historical traditions from which it draws and in which it is situated.

Eliot's position is, however, even more specific and qualified than that. He not only argues for the interplay of art as such but for the view that artists are obligated to read widely in the history and literature of their culture, so that they have the broadest and deepest knowledge of the rich resources and various alternatives culture has to offer. Artists first of all must be learned, and second are required to construct ways that knowledge can be transmitted and transmuted to some new and highly original work.

Eliot is by no means alone in his view, but is part of a practice of referencing the past, if not exactly kowtowing to it before undertaking artistic creativity. Victorian critics such as Matthew Arnold and Walter Pater, who were his predecessors, did assume that tradition was richer and more valuable than individual modern counterparts, thus establishing a firm hierarchy in the production of literature and literary criticism. The best artists and critics, according to Pater, were those who immersed themselves in this rich tradition— the golden age, so that they had a basis for understanding modern pieces and could establish their place and contribute to the value of that tradition. This regard for tradition had implications not only for writers but society as a whole, as evidenced by Arnold who in *Culture and Anarchy* expressed the belief that the study of culture—"the best which has been thought and said in the world"—could develop the individual, restore balance to society, and help achieve "harmonious perfection" (1869, viii, xxiii). According to Leitch, this credo lasted more than a century and ruled American universities through the 1960s (2007, 4).

In asserting the rich "impersonality" of this tradition, Eliot also may have believed in some golden age of writing that forms the foundation for later works (as the twentieth-century critic Northrop Frye later claimed in *The Anatomy of Criticism*), but he does not state that anterior sources (if they could be identified fully) were necessarily superior to their modern descendants. Though he was talking mainly about high literature, not popular culture and film, he accords dignity to both the new work and sources of inspiration that lie behind it, and this, to a great extent, is what defines literary modernism.

What is important in Eliot's matrix is that authors are to be truly steeped in their tradition and learning, so that they are able to create interesting, challenging, and unique pieces of art that bear the imprint, however faint and delicate, of that earlier tradition. The audience who responds to this work of art must also be fully educated and grounded in that tradition and in theories

of art in order to ensure that writing and reading art are of the highest, most creative, and most significant sorts. In high modernism of which Eliot was a part something special historically was required of the artist, the specialized critic, and the general audience because all art has to be perceived in relation to its cultural matrix.

The anxiety of adaptation

Because poetic genius and cultural and historical background were so closely linked in modernism and also because of "an idolatry of form" (Bazin 2000, 22), it became important in twentieth-century criticism to show to what extent an artistic work was grounded in, and influenced by, an original or was part of a significant tradition and, at the same time, independent and itself "original." This process demonstrated the value of the modern piece of art while maintaining the integrity and primacy of the founding documents and their special importance for inspiration and literary creativity. Homer, the Bible, and Shakespeare were clearly integral to this process but, because they were considered unsurpassable and unassailable in their poetry, spirituality, and wonder, they were viewed as works of genius that stood in a class by themselves—and altogether lacking precedent. Other documents were simultaneously important for themselves and their place in the tradition.

At the heart of this practice was the anxiety that the modern work should draw from the tradition but stand on its own poetically. This "anxiety of influence," as Harold Bloom calls it (1973), arises from the Romantic notion that works of genius come directly from the poet's soul—and beyond that the soul of God, rather than derivation from other texts—coupled with the poet's need to be especially learned in the great cultural traditions. Reconciling independent genius and the influence of tradition created this anxiety.

Often considered the best of the high modernist poets, Eliot and Pound did not suffer so much from this anxiety because they personally received high acclaim for their writing and had indisputable claim to rich and varied cultural sources, but others found the tension between creativity and historical consciousness an intellectual burden. This was true in many genres, but film, especially, an artistic form that was born and reached maturity during this age of anxiety, did suffer from this tension because it was believed to sidestep the issue of genius and influence for adapting one text to another was considered a "mere" updating or mutation of an original and therefore falling short of artistic genius.

Adaptation's double use in art and science may have reinforced the negativity inherent in this view for, apart from referring to one form of artistic

representation morphing into another, the term "adaptation" is commonly used in physiology to mean a sense organ adjusting to varying conditions or in biology to the species' mutations in coping with changing circumstances as part of the evolutionary process. Thus, whether in art, physiology, or biology, adaptation does not bear the stamp of originality, but of mutation and permutation of a preexisting original. While scientists could talk positively (though many conservatives were also horrified) about the importance of adaptation in the production of various species, those in arts preferred to talk about the reification of historical tradition, poetic imagination, and genius. Although the artists' reaching into God's mind was no longer the central governing concept for modernists as it had been for the Romantics, true artists were thought to draw from the treasure trove of past literature and art and also plumb the depths of their conscious and, with the advent of Freud, unconscious to shed light on their own and others' special humanity.

Consequently, the nineteenth-century intersection of the Romantic conception of art with Darwin's theory of evolution described in *On the Origin of Species* (1859) magnified the ongoing concern about the abandonment of originality and specter of adaptation. While the former was about art and the latter biology, the original in relation to the adapted form was on everyone's mind, and it stayed there with the advent of the motion-picture industry (1888) and the adaptation of literature—first drama and then fiction (Corrigan 1999, 16)—to this new, technologized media.

To many, this process of film adaptation was an example not of God's hand at work, the surprise of genius, or the survival of the best and fittest but of a challenge to the integrity of tradition and historical consciousness because great themes, complex language, and nuanced plots were reduced to fit small-time frames, limited formats, and the visual specificities of motion pictures. The rapid development of technology and a belief in an increasing chasm between genuine creativity (with respect for tradition) and technological reproduction, and even between art and science marked the transition from the nineteenth to the twentieth centuries.

Although there was not necessarily a link to popular culture because of the invention of film, the process of adaptation became closely identified with the rise of popular culture in the early twentieth century and the movement away from high art. Popular culture posed a special problem for the prophets and patriarchs of high culture because it did not require knowledge of the great artistic traditions of Western culture and indeed seemed to hollow out the richness and integrity of the traditional ways of apprehending the artistic process, cultural institutions, and reality itself. This was equally true in all forms of the mass media—film, music, and radio broadcasting. According to Cartmell, Corrigan, and Whelehan, certain critics (e.g., William Hunter)

and novelists (e.g., Virginia Woolf) thought films were geared to the "lowest possible denominator" and watching them made "savages" of the viewers (2008, 1). Then, too, as Martin Halliwell points out, the commercial enterprise involved in film making and film's tendency toward "seamless worlds, linear narratives, a stable hierarchy of characters, humanist ideology, and tidy resolutions" went against the view of great artists as isolated and not-for-profit geniuses and the modernist repertory of "unreliable narrators, psychologically complex characters, fragmented perceptions, and mythical allusions" (2007, 90–91). Even when film adaptations were seen as classics in their own right, the modernistic primacy of the original written word was maintained over the spoken word, visual embodiment, or technologically engendered product in both high culture and popular culture.

To ensure the legitimacy of the written, some who adapted fiction looked principally at the literary aspects that made the originals so successful—themes, narrative action, plot and scene structures, characterization, imagery, and dialogue itself (Sobchack 2005, 112). Anything less was a compromise, so Timothy Corrigan identifies the questions needed to be answered concerning serious, faithful adaptations:

> (1) To what extent are the details of the settings and plot accurately retained or recreated? (2) To what extent do the nuance and complexity of the characters survive the adaptation? (3) To what extent are the themes and ideas of the source communicated in the adaptation? (4) To what extent has a different historical or cultural context altered the original? (5) To what extent has the change in the material or mode of communication (a printed page, a stage, 35 mm film) changed the meaning of the work for a reader or viewer? (1999, 20)

If Corrigan's questions 1–3 (concerning the transfer of plot, characterization, and theme) could all be answered "to a considerable extent," then Linda Cahir would call this a faithful "literal" interpretation with authorial integrity. If, in addition to the first three responses, questions 4 and 5 were answered "to a considerable extent" (i.e., concerning the addition or deletion of material in order to make the film interesting in itself, stay within budget, and please the audience (2006, 21, 106)), then Cahir would call the film a "traditional interpretation" or adaptation of the "novel's integral meaning" but not quite so faithful. Of course, as James O'Brien and Ned Borden find, many critics still assume that a fine and successful literary work is inherently compromised when adapted as a film for the latter, even when it tries to be serious art, and can only succeed through simplified plots, glamorized characters, optimized basic premises, and romanticized endings (1997, 114–115).

There is a whole range of modernistic assumptions contributing to this view of more-or-less faithful adaptation (whether strictly literal or loosely traditional) that goes more deeply into culture than the previously discussed status of tradition would suggest. As Frederic Jameson notes, modernism contained a "depth model" hermeneutic based on a binary structure, with the first term (e.g., the "original") in the privileged position and the other (e.g., the "copy") in the inferior position: in addition to the original and copy, these artistic binaries consisted of the "center" and the "margins," the "inside" and "outside" of culture, the "authenticity" and "inauthenticity" of execution, and others as well (1993, 318ff). Jameson draws these distinctions from Jacques Derrida's exploration of the ways in which Western ontology was built upon systemic binary oppositions. Within this paradigm of binary oppositions, adaptation, not being original or unique, is outside, on the margin, inauthentic, and absent—akin to a copy as opposed to an original. As Jameson—who supports this modernist construct—remarks, "What we must now stress... is the degree to which the high-modernist conception of a unique style (along with the accompanying collective ideals of an artist or political vanguard or avant-garde), themselves stand or fall along with the older notion (or experience) of the so-called centered subject" (1993, 319). His is the view that the "authors" occupy a center themselves, an "authority" that allows them to create works of originality and importance in a style that is manifestly their own and conscious of their place in history. A centered subject and a centered work in a unique and individual style go hand in hand with artistic authority and historical centeredness, a view to which Arnold, Pater, and Eliot could subscribe.

In keeping with these modernist perspectives, many others who write about adaptation, says Naremore, tend "to be narrow in range, inherently respectful of the 'precursor text,' and constitutive of a series of binary oppositions that poststructuralist theory has taught us to deconstruct: literature versus cinema, high culture versus mass culture, original versus copy" (2000, 2). In a similar vein, Linda Hutcheon argues that this modernist conception continues with the critiques of new forms in the present era for, "whether it be in the form of a videogame or a musical, an adaptation is likely to be greeted as minor and subsidiary and certainly never as good as the 'original'" (2006, xii). Though many films are more complex than their originating texts, there is a lingering assumption that the original is centered and complex in ways that the adaptation can never hope to achieve.

This privileging of the original over the adaptation is based upon cultural conceptions of morality as well. Stam is annoyed by the old moralistic terminology condemning a film's deviation from a founding text:

Terms like "infidelity," "betrayal," "deformation," "violation," "bastardization," "vulgarization," and "desecration" proliferate in adaptation discourse, each word carrying its specific charge of opprobrium. "Infidelity" carries overtones of Victorian prudishness; "betrayal" evokes ethical perfidy; "bastardization" connotes illegitimacy; "deformation" implies aesthetic disgust and monstrosity; "violation" calls to mind sexual violence; "vulgarization" conjures up class degradation; and "desecration" intimates religious sacrilege and blasphemy. (2005a, 3)

He does not believe that fidelity in adaptation can ever be actualized, simply because of the different mediums and discourses at work, so this kind of moralistic language is offensive.

Strikingly, this language of morality laid on adaptation is based on binary gender conceptions as well. Metaphors of faithfulness, fidelity, compromised virtue, unfaithfulness, and even violation used to describe the film's dependency on, or departure from, valid artistic sources all suggest that film is gendered as a weak female against the strong male work of art from which it draws its sustenance. To a certain degree, this patriarchal model of criticism might arise from the fact that high modernism tended to be male dominated, whether in art, music, or literature, but it probably goes deeper than that. In this patriarchal coding, film as a female form is always at a disadvantage when attempting to stand alone, for it is said to gain its significance and virtue in relation to the way in which it recognizes and serves the male-gendered work of art. In this gendered relationship, film is only complete when paired or married to fiction and judged within the traditional framework of male–female romantic relations.

Because film was mechanically driven and technologically based and produced, many thought it could not be inspired by the same kind of higher genius as literature, music, and painting, but certain directors—auteurs— were thought to transcend the inherent limitations of technology through their individual creative spirit, personal style, directing ability, and even script writing. This post–World War II view, theorized initially by François Truffaut and applied to French and American directors in particular, closely followed modernist notions of individual genius and inspiration but granted films an agency previously denied them by high culture. However, this perspective that grew quickly in France and the United States did not overcome biases about adaptation or make adaptation per se a recognizable part of criticism and academic structures. Indeed, directors who adapted texts were still called "adapters" not auteurs, so this paradigmatic shift assisted in precluding adaptations from both film studies and literary studies.

Postmodernism: Textuality, intertextuality, pastiche/bricolage, freeplay, and interculturalism

The postmodern period marks an undoing of this modernist prejudice against adaptations (1) by rethinking the characteristic Western modes of thought and philosophy (2) along with the terminology pertaining to the historical context and "originary," anterior, antecedent, or foundational works in relation to later reformulations, and (3) by giving new values to both the original and adaptation. This was undertaken especially by the modern French philosophers who strongly critiqued the German philosophic tradition (especially of Hegel), and it is a number of these who have become central to postmodernism.

Though antecedent to postmodernism, Walter Benjamin is one who helped to initiate anti-hierarchizing gestures. In "The Translator's Task" of 1923, he questioned the binary of original and translation and put aside fidelity to an original source as important and thought of translation as a "mode" in itself that becomes an "echo," which "can produce a reverberation" of the original (1997, 152, 159). He also noted that the translation should "liberate the language in the work by rewriting it" (1997, 163).

Some 40 years later, Michel Foucault questioned "the historical episteme of the dialectic" (Con Davis & Schleifer 1991, 203) and the concomitant discursive units, practices, and expectations. In *The Order of Things* (originally published in French in 1966), Foucault credits a short story of Jorge Luis Borges for having given him the impetus to begin tackling Western conceptions of thought and culture (1970, xv). In Borges's short story, a Chinese philosopher classified animals in an oddly random and humorous manner far different from the Aristotelian order of things. From this example, Foucault concludes that, because systems of classification and categorization are cultural and arbitrary, they are ultimately contestable, so he sets about to query modern discursive formations and representations, especially through an interrogation of Western dialectic thinking. His tackling of a totalizing modernistic dialectic results in a hard look at historical assumptions, conceptions, and discursive practices and ways in which these can be explored, exposed, and possibly overturned. Among these, as Foucault notes in his essay "What Is an Author," is the privileged, "transcendental" position of the author (1977, 120) who, through various systems of attribution and valorization, was said to have established the unity, uniformity, and subjectivity of his/her text but whom Foucault claims is "dead," that is, no longer in control of the discourse,

subjectivity, or circulation of the text. From this, it is a small leap to think about the problematic dialectic of a dominant, controlling written text and a subordinate film adaptation.

Jean-François Lyotard is another who problematizes the dominance of parent works in relation to daughter texts. He notes that an original often has been viewed as a master- or meta-narrative (1984, xxiv) with fullness, integrity, and indisputable "presence"—what another postmodern critic, Jacques Derrida, terms "totalization" (1993, 236), a third, Roland Barthes, calls a "work" with its normative cultural values of stable meaning, communication, and authorial intention (1977b, 155–164), and a fourth, Mikhail Bakhtin, refers to as the "authoritative word" with transcendental meaning (1981, 342). In this way, high value was given to those works that marked the reputed beginning of an artistic process/tradition, were deemed to be significant markers in the stages of its development, or were identified with a famous author. These were part of the groundwork and rhetoric of the master narrative.

Still, insofar as film adaptations shadowed the original works, were judged to have little original content, and were not "authored" or even auteured, they were viewed as "impoverished," lacking materiality and integrity in themselves, characterized by "absence," and governed by language lacking authority and transcendence—fragmented and untotalized. In that way, they shared only indirectly in the master narrative. In Derrida's words, "the absence of a center" was taken as the "absence of a subject and the absence of an author..." (1993, 234)—truly a denial of participation in the master narrative or transcendent language.

As Lyotard's, Derrida's, Barthes's, and Bakhtin's rhetoric imports, however, postmodernism helped to rethink the primary tests of faith in the concept of adaptation. Part of this was through reevaluating the status of the master narrative, reviewing the value of the copy in relation to an original, rethinking the whole issue of originality, and interrogating the language of criticism. In good part, this was done through a consideration of the play of intertextuality across the field of texts.

While T. S. Eliot in "Tradition and the Individual Talent" was one of the first to comment on the interdependency of texts (Haberer 2007), he did so in order to situate the textual importance and authority of a work in relation to its place within tradition—to locate the serious artistic implications of cause and effect and artistic differences. He is not alone in this respect: as Graham Allen argues in *Intertextuality*, Gérard Genette and Michael Riffaterre follow Eliot's plan in aiming for "critical certainty, or at least for the possibility of saying definite, stable and incontrovertible things about literary texts" and their cultural context (2000, 4).

This primacy of originary texts and new landmarks, however, has been seriously eroded by several post-structural and postmodern studies,[1] first and foremost Roland Barthes's "The Death of the Author" (first published 1968) and Michel Foucault's "What Is an Author?" (first published 1969). In his early essay Barthes notes that although "the Author is thought to *nourish* the book" and seems bound together with it, the moment he/she has entered into the writing act, language is substituted for the person, the "voice loses its origin, [and] the author enters into his own death" (1977a, 144, 142). He adds "we know now that a text is not a line of words releasing a single 'theological' meaning (the 'message' of the Author-God) but a multi-dimensional space in which a variety of writings, none of them original, blend and clash... [The author's] only power is to mix writings, to counter the ones with the others, in such a way as never to rest on any one of them" (1977a, 146). Foucault picks up the notion of the death of the author, arguing that "granting a primordial status to writing" "sustains the privileges of the author," reinscribing in "transcendental terms the theological affirmation of its sacred origin or a critical belief in its creative nature" (1977, 120). Both Barthes and Foucault contend that an author is merely "a function of discourse" (Foucault 1977, 124). Everything, they argue, is culturally constructed across a wide field, and they question authorial knowledge, the primacy of originary texts, the self-contained identity of the human subject, and the inerrancy of history, concluding that there is no such thing as objectivity, the singularity of the human imagination, or the elevated status of particular signifieds, including the author. For Barthes, "text" and "intertext" (as opposed to "work" and "author") incorporate and convey plural, contestable meanings and depend for their existence upon dynamic interaction with the audience (1977b, 155–164). His assertion of the author's death, freeplay of the text, and new emphasis on intertextuality has a certain shock value, but none means that the author is totally voiceless, absent, or "dead," nor does it literally nullify an authorial role and perception; it means that the author—his/her voice and intention—is only one among many and, like all else, is drawn from and part of cultural constructs. Consequently, if "authors" are always presenting their views through their own cultural milieu, subjective lenses, and limited ranges of imagination, then these have the same value as other constructs and require

[1]Barthes, Foucault, and Derrida have all been classified as structuralists in their attempts to delineate the structures of knowledge, language, and culture in the West. However, as John Sturrock notes, all three were relativists who differed from other structuralists (Claude Lévi-Strauss and Jacques Lacan) who wanted to discover "the functioning of the human psyche in general" (1979, 5). It is the relativism of Barthes, Foucault, and Derrida that led them into post-structuralism in the 1970s and by extension into postmodernism. In this study I will mainly reference those works from the 1970s forward that are considered post-structural and postmodern.

multiple perspectives to approach anything akin to truth. Also, if all insight is culturally based and organized, then individual subjectivity and authority are merely part of a general cultural subjectivity.

If singularity and transcendental authority are no longer present textually, then multiple perspectives and multiplicity are heightened and reflect other shifting historical, linguistic, and fictional perspectives. In *The Pursuit of Signs*, Jonathan Culler picks up this idea, arguing that literature, like language itself, finds meaning not in the search for single originary texts but within a system of relationships. He maintains that

> Literary works are to be considered not as autonomous entities, "organic wholes," but as intertextual constructs: sequences which have meaning in relation to other texts which they take up, cite, parody, refute, or generally transform. A text can be read only in relation to other texts, and it is made possible by the codes which animate the discursive space of a culture. The work is a product not of a biographically defined individual about whom information could be accumulated, but of writing itself. To write a poem the author had to take on the character of poet, and it is that semiotic function of poet or writer rather than the biographical function of author which is relevant to discussion of the text. (1981, 38)

Allen implicitly agrees with Culler's post-structuralist position and, in fact, takes it further, contending that "authors of literary works do not just select words from a language system, they select plots, generic features, aspects of character, images, ways of narrating, even phrases and sentences from previous literary texts and from the literary tradition" (2000, 11). Allen draws the theoretical framework for this position as much from Julia Kristeva in "The Bounded Text" (1980) as from Roland Barthes in *Image-Music-Text* (1977b), both of whom argue that there can never be an independent text for everything has been taken from a register of possibilities within culture; nothing is original, and everything is always already intertextual.

It is hard to refute the position that specific works of literature and film derive their existence from a matrix of possibilities generated by the sum total of literary and filmic texts or the view that creativity does not exist apart from a register of possibilities within culture. Barthes is even more outspokenly inclusive about the play of intertextuality when he says that one text is never a product of another "original" one:

> We know now that a text is not a line of words releasing a single "theological" meaning (the "message" of the Author-God) but a multidimensional space in which a variety of writings, none of them original, blend and clash.

> The text is a tissue of quotations drawn from the innumerable centres of culture...the writer can only imitate a gesture that is always anterior, never original. (1977a, 146–147)

Following in the footsteps of Ferdinand de Saussure, who argued that the relationships in language constitute the basis of human culture, and of Claude Lévi-Strauss, who argued that language and culture are a random cobbling together of "tinkerings," Jacques Derrida argues that language and culture are "bricolage" or tinkerings drawn from culture and put together without "presence," that is, individual identity or originality. In fact, Derrida argues that language is a constantly adapting, nontotalized, freeplay of textuality and "infinite substitutions in the closure of a finite ensemble" (1993, 236), a concept that can be applied to all discursive and adaptative textual practices. He further argues that "this movement of the freeplay, permitted by the lack, the absence of a center or origin, is the movement of *supplementarity*. One cannot determine the center, the sign which *supplements* it, which takes its place in its absence—because this sign adds itself, occurs in addition, over and above, come as a *supplement*" (1993, 236–237). He perceives that there is no center, no master narrative for everything is, of necessity, hybrid, intertextual, and nontotalized, and, by that measure, so are so-called original and adapted texts. The only real point is whether adaptation is interesting and artistically inspired or whether it is dull and pedestrian, not whether it is original, part of a center or master narrative, or some kind of copy.

Derrida argues against interpretive narrations that evoke and try to restore an origin, and he urges that a new kind of understanding is necessary for a consideration of texts. As he notes in "Structure, Sign, and Play":

> There are thus two interpretations of interpretation, of structure, of sign, of freeplay. The one seeks to decipher dreams of deciphering, a truth or an origin which is free from freeplay and from the order of the sign, and lives like an exile the necessity of interpretation. The other, which is no longer turned toward the origin, affirms freeplay and tries to pass beyond man and humanism... (1993, 240)

He identifies all of culture and language as a field of freeplay, though societies try to form cohesive structures and hierarchies, give certain discursive practices ascendency over others, and accord "some ideas as being self-evident, having transcendency or 'presence'" (Slethaug 1993, 146). Citations or quick glimpses into originating documents do not try to stay attached to an origin in the same way as traditional forms of adaptation but instead open up this field of freeplay and infinite substitution.

MODERNISM/POSTMODERNISM **25**

Meaning for Barthes, Foucault, Derrida, and Bakhtin is open, dialogically negotiated, and distributed across the system, leaving little basis or reason for the traditional hierarchized binary oppositions that Jameson and others prefer either on the basis of reputed "firsts," important milestones, or the privileging of some kind of totalized master narrative. In Allen's words,

> As Barthes reminds us, the very word "text" is, if we remember its original meanings, "a tissue, a woven fabric"... The idea of the text, and thus of intertextuality, depends, as Barthes argues, on the figure of the web, the weave, the garment (text) woven from the threads of the "already written" and the "already read." Every text has its meaning, therefore, in relation to other texts... [T]his relationality can itself be figured in various ways: it can involve the radical plurality of the sign, the relation between signs and texts and the cultural text, the relation between a text and the literary system, or the transformative relation between one text and another text. (2000, 6)

The postmodern critique is thus enabled and empowered in affirming contextuality and unprivileged intertextuality in language and culture. As Bliss Cua Lim notes, the recognition of this contextuality and intertextuality also opens up a significant space for the spectator or "reader" of the film, who must be sensitive to a number of different features beyond a simple one-to-one textual relationship:

> "Source novels" are never the measure of "film adaptations." A single novel as a principal yardstick or comparison-text for cinematic meaning forgets that discourses have no fealty to originals, but are echoing chambers whose resonances are difficult to exhaust. The model of novel-film dyad, whether conceived as correspondence or transformation might unwittingly confine our understanding to "the dungeon of a single context." The source-adaptation paradigm excludes not only other, perhaps more salient intertexts, but more crucially, the "rejoinder" of the spectator, whose response to the film may have little or nothing to do with the novel it adapts... (2005, 165)

Critics like Jameson, however, object to this late capitalist inauthentic "postliteracy" as a "random cannibalization of all the styles of the past, the play of random stylistic allusion, and...the increasing primacy of the 'neo'" (1993, 321) in which everything is a copy without substance and individual merit or commoditized simulacrum without value. What Jameson objects to so directly is that the previous meaningful categories and dichotomies of modernism have been compromised and even abandoned, resulting in an

inability to distinguish between good and bad art. The values of inside and outside, authentic and inauthentic, original and copy, and latent and manifest that were so important to the centeredness of the subject and the text are now blurred and meaningless, so that adaptation, derivation, translation, and copy have the same cultural currency as the original. Not only that, but, because there is a "linguistic fragmentation of social life," the distinction between a full and partial adaptation now disappears, opening the way for bricolage and the play of textuality within the arts—the "freeplay of repetition and the repetition of freeplay" (Derrida 1993, 240).

However, the rethinking of these hierarchizing paradigms and binary oppositions not only relates to language and art but also to cultural groups. Many theoreticians think that the interrogation of race, ethnicity, and related cultural domains is as much part of postmodern resistance as are dialogism, intertextuality, and the freeplay of the signifier. As noted by bell hooks and Louis Owens, respectively African American and Native American critics, postmodern theory was for many years controlled by white writers, editors, and publishing presses, who, while undoing binarities in language and philosophy and using such terms as the "other," often neglected representation from ethnic and racial groups that have been systematically dominated and oppressed over many generations. So, although postmodernism claims to review history, language, art, and culture by opening doors to those who have been neglected or mistreated in the past, in fact some critics have been insensitive and even harmful to the multicultural perspectives of ethnicity and ethnic writing. Consequently, many within the African American and Native American communities worry that the emphasis on postmodern play, intertextuality, subjectivity, and hybridity, for starters, actually takes back some of the hard-won rights that ethnic groups have achieved in society. These ethnocritics want this postmodern intertextual enterprise to be inclusive of interculturalism and racial equality and use the theories for socially constructive ends. Any discussion of postmodern adaptation and citation consequently needs to take into consideration the views of those who consider themselves postmodern spokespeople of their communities.

Postmodern adaptation theory

Robert Ray, Linda Hutcheon, Dennis Cutchin, and Dudley Andrew, among others, have picked up the rhetoric of postmodernism to speak of the way the signification process and intertextuality free up discursive enquiry in the relationship between original and adaptation. For Hutcheon, intertextuality and the play of textuality are central parts of the spirit and mechanics of

adaptation that can be subdivided into the process of adaptation, the product generated, and the process of reception. As she says of this intertextual play, "we experience adaptations (*as adaptations*) as palimpsests through our memory of other works that resonate through repetition with variation" (2006, 8). Dennis Cutchins says much the same thing in noting that seeing a film adaptation requires remembering the original source and the current adaptation at once (2010, 88), though the adaptative experience no longer privileges the primary text over the iteration. In this sense, Hutcheon joins Dudley Andrew, who queries the "transcendent order" of the traditional paradigms (2000, 28); she does so by cherishing a "de-hierarchizing impulse, a desire to challenge the explicitly and implicitly negative cultural evaluation of things like postmodernism, parody, and now, adaptation, which are seen as secondary and inferior" (2006, xii).

Andrew, Ray, Hutcheon, and Leitch assume a postmodern posture in finding that everything is "derived," though those like Jameson worry that this playing with textual adaptation is "mere" pastiche, "the imitation of a peculiar or unique, idiosyncratic style, the wearing of a linguistic mask" (1993, 320–321). His concern about the demise of specifically authored literary works predates the rapid escalation of postliterary cultural "texts" such as comic books, board games, role-playing games, and video games that form the basis of adaptation. As Leitch remarks in his provocative chapter "Postliterary Adaptation":

> *Superman* (1978), *Batman* (1989), *The Phantom* (1996), *X-Men* (2000), *Spiderman* (2002), *and Hulk* (2003) are all based on comic books. *Die Another Day* (2003), like the last several James Bond adventures the Academy of Motion Picture Arts and Sciences has deemed eligible for the Best Adapted Screenplay competition, is based on a franchise character, not any particular novel by Ian Fleming or anyone else. *Pokémon: The First Movie* (1999) is an adaptation of a card game, *Dungeons and Dragons* (2000) of a role-playing game, *American Splendor* (2003) of a reality-based comic strip. *My Big Fat Greek Wedding* (2002), nominated for an Academy Award for Best Original Screenplay, is based on Nia Vardalos's stand-up comedy sketches. Even *Adaptation* (2002), nominated the same year in the Best Adapted Screenplay category, turns its ostensible source into a wildly self-reflexive parable by grafting onto Susan Orlean's nonfictional 1998 book *The Orchid Thief* a preposterous fictional story about its screenwriter's inability to adapt that source. (2007, 257)

Clearly, adaptations within the last decade loosen up definitions of a text, foster dialogue between texts, take intertextuality to new limits, inhabit ever-

expanding postmodern spaces, and are well-rewarded for it with theater attendance and institutional awards.

Ironically, many comic books and video games could be considered full adaptations that reference and rework a particular source text, but more likely go well beyond a single adaptation and disseminate meaning in striking new ways. In certain instances, these new forms may take up only a few allusive language and image citations from texts, building upon and decentering these in many different idiosyncratic ways especially through dialogism and intertextuality.

Although Robert Ray is better known for stressing ideology in films through theories of overdetermination and transformation based on Althusserian Marxism, Lévi-Strauss, and Freud (1985, 11–12), he was one of the first to see Derrida's notion of citation at work in the adaptation process. As he says, "The film adaptation, in Derridean language, is not simply a faded imitation of a superior authentic original: it is a 'citation' grafted into a new context, and thereby inevitably refunctioned. Therefore, far from destroying the literary source's meaning, adaptation 'disseminates' it in a process that Benjamin found democratizing" (Ray 2000, 45). When used with reference to film, citation exceeds literal adaptations or pastiche, referencing themes, styles, and modes to refer to, form something different from, and simultaneously overlay or enter into dialogue with those individual sources in the manner of a palimpsest.

Although dialogism, decentering, and intertextuality become code words for the postmodern textual enterprise as applied to adaptation, several supporting concepts are important in order to understand the basic relationships. These will be more fully discussed at the beginning of the relevant chapters, so the notions will only be raised briefly here.

One of these is Derrida's notion of surplus value and supplementation. Once a text—literary or cultural—has been adapted, the adaptation and originating source/s enter into a complex relationship in which the original cannot be thought to have all the "presence" and value and the adaptation cannot be thought to be the reduced or impoverished text but one that has supplementary features that go beyond the original, forcing the viewer to see the surplus value at work in the new text and to rethink the original in terms of this renewal. Original and adaptation are simultaneously impoverished and enriched in this unstable relationship.

Although adaptations may have only a single source text, many have embedded multiple sources into a new framework or fabric. These adaptations may have some fidelity, but embedded within a new context, they move in a new or different direction than the source text. Whether drawn from a single source or multiple ones, the adaptation exceeds the limits of the source/s,

denying hierarchy and suggesting that meaning is indeterminate for both origin and adaptation. Indeterminacy and de-hierarchization, then, are key features of this postmodern enterprise. As palimpsests, the originals may peek through, but they cannot control the freeplay of meaning of this bricolage or bring totalization of unity to multiplicitous texts. Thus, they open up a play of indeterminate meaning or, as Derrida would have it, the freeplay of textuality. Because the concept of play is so ambiguous within Western culture, the notion of textual play might suggest frivolity and meaninglessness, but play is never void of meaning, and some instances can be quite serious.

One of the more serious kinds is ethnographic play in which the texts explicitly or implicitly interrogate present, historical, and imagined relationships of different ethnic and racial groups in order to subvert and rupture traditional hierarchies and attitudes and to query difference between the self and other. As Derrida would say, "difference" becomes "*différance*," his italics suggesting similarity functioning together with irreducible difference. This does not authorize a simple response either embracing or dismissing racial difference but of exploring their complex relationships in culture. Ethnographic play is considered an important postmodern construct.

For many, intertextuality and play may seem somewhat innocent in their aims, even in the case of ethnocriticism, but for others, going beyond either boundless play or ethnocriticism can become textually and socially disruptive and revolutionary. In these latter cases, one text may be drawn from another, but it also may confront it, using its conventions and characteristics to undermine its style, ideas, and issues. This might seem particularly true of parody, but it functions with other adaptations that are entirely respectful of their sources and need to free the originary texts from their cultural and literary repressions.

As part of the postmodern enterprise and fully related to such evolving concepts of intertextuality, something else is happening—writers and directors are using a variety of sources to interrogate what Roland Barthes calls the "*myth of filiation*" (1977b, 160)—that reproduction of the parent—by using a variety of sources to create one film narrative, drawing on a single narrative text to construct many films, or referencing cultural textuality in general to build film narratives. They enter into dialogue, supplement, and subvert origin by combining sources through citation, exposing the *filiation* or undue respect for origin, and then undermining that through the various narrative characteristics and techniques. The use of pastiche, bricolage, and palimpsest, where the many originals are cobbled together, overwritten, and exposed, becomes a particularly fruitful way to go against the dominance of origin and liberate the freeplay of textuality and meaning. In addition, seeing how text builds upon text after text, highlighting and subverting the multiple

present and previous manifestations, refuses originality or "real" presence and leaves the interplay of textuality in constant motion, not promising or giving any stabilization of text and meaning. These are some of the most important of the postmodern terms, definitions, and concepts at play in this postmodern process.

Though Andrew, Hutcheon, and, to some extent, even Leitch unsettle the texts in various ways, they do maintain part of the modernist paradigm of totalization by assuming that adaptations should be "deliberate, announced, and extended revisitations of prior works" (Hutcheon 2006, xiv). Andrew cautions that "the explicit, foregrounded relation of a cinematic text to a well-constructed original text from which it derives and which in some sense it strives to reconstruct provides the analyst with a clear and useful 'laboratory' condition that should not be neglected" (2000, 29). He finds "borrowing" from "continuing forms or archetypes in culture," the "intersecting" of a microcosmic film and the macrocosmic original, and "transforming sources" from one sign system to another endlessly fascinating (2000, 30–34). Hutcheon pushes the argument further while still setting limits, arguing that adaptations could be "multilaminated" and relate to several founding texts, but their "engagement with these other works...are extended ones, not passing allusions" (2006, 21), giving them a central hermeneutic identity or focus. In short, these critics pay little, if any, attention to *citation*, fragmentary adaptations, or even adaptative glimpses, though Leitch for one shows how, in *The Street Fighter*, "the virtual absence of textual markers" and allusions to the video game "Street Fighter II" does not impede its effectiveness (2007, 273). Still, Leitch is inclined to attribute these fragmentary allusions to marketing appeal and does not seem comfortable drawing the conclusion that citation in itself is a valid manifestation of adaptation.

In this respect, many critics, despite their credentials and outlook, seem to devalue citations and minor or fragmented intertextual referencing. In that way, they continue the old relationship of the adaptation serving the patriarchal source and do not account for the rich complexity that citations provide.

I would argue that citation and fragmentary, allusive adaptations are just as important as adaptations on a large scale, as a discursive technique that revisits and critiques other works for structural and thematic purposes as well as formulating new discourses. This discursivity can be a full-scale single adaptation or citation, multiple adaptations/citations of the same source, or one adaptation/citation using multiple sources. Any of these may be handled in serious, playful, or parodic ways, depending upon the artistic purposes and preferred genre. Of course, looking at citation as part of the process opens the entire field of adaptation to freeplay. Indeed, this postmodern milieu is not just about fiction or drama leading to film, but film leading to film and fiction

and drama, or any combination of the above—and more. This helps rethink the process, paradigm, and standards of creativity across a greater spectrum of texts.

In short, the postmodern play and "pleasure" of the literature-film intertext envisioned by Barthes and Derrida come from repetition with infinite variations that include numerous degrees of adaptation and citation. Perhaps "pleasure" (unbridled freeplay apart from recourse to authority) is even more exaggerated in citation because the scriptwriters and directors do not feel an overarching allegiance to the precursor. Citation does not require the director to be faithful to a certain textual tradition and never has to hint at the possibility that it is a replication. In this "postmodern age of cultural recycling" (Hutcheon 2006, 3), the farther away from the original text the adaptation or citation strays, the more likely it is to share in postmodern play and indeterminacy.

The use of citation as cultural recycling also has similarities with mash-up culture in which aspects of two or more texts are used together to create a new product. Initially, mash-ups were pieces of music with different styles used together, but now this technique applies to videos that combine other videos as well as apps that fuse other apps for ease of use. This is a postmodern phenomenon, though it may lack the self-consciousness of film adaptation and citation, where the role of the audience is to keep the separate pieces in mind even while viewing the new product. This is certainly a worthwhile phenomenon to explore, but this study is restricted to literature–film and film–film links.

Certainly, there are many adaptations in this postmodern age that are full and nicely historicized, but there are many more—including those with greater or lesser degrees of citation—that revel in the freeplay of repetition with significant differences. The following chapters will explore various kinds of full (but not faithful) adaptation, and the latter chapters will concentrate on citation. The immediately following chapter will explore the ways in which Derridean views of surplus value and supplementation assist the reader in understanding the complex relationship of a historical "true story" to John Guare's drama adaptation of *Six Degrees of Separation* and then to the Fred Schapisi's film adaptation. All instances of adaptation are governed by principles of supplementation, so this discussion will help situate that issue.

2

Adaptation, surplus value, and supplementation in *Six Degrees of Separation* and *Short Cuts*

For the first half of the twentieth century, when critics looked down on film, judging it by how well it reflected, or was faithful to, an antecedent originating text, it was, by and large, a fruitless endeavor, for it is impossible for faithfulness to be a useful criterion when fiction and film are different rhetorical, semiotic, technical, and cultural forms of expression.

Concepts drawn from, among others, the structuralism of Ferdinand De Saussure, the dialogism of Mikhail Bakhtin, and the postmodernism of Jacques Derrida, however, have opened the door for new evaluations of adaptation. These views cannot be readily gathered into one definitive concept, but taken together they deny the "authoritative word" and transcendental meaning of language, literature, and film (Bakhtin 1981, 342) and suggest that there can be no single fixed or faithful kind of adaptation but an infinite variety of relations depending upon context, intention, and execution.

Of these theoreticians, Derrida in particular is useful in revisiting the notion of close adaptation or what Leitch calls celebration (2007, 96–98) because he takes it upon himself to challenge the dichotomies that form the roots of culture, of which the original and copy is one pair. As he notes of many cultural modes (e.g., speech and writing), that is deemed to be the original (speech) is given a privileged position and granted "presence," and what is considered the secondary form (writing) is looked upon as an imperfect and incomplete derivative, substitute, or replacement sign system without integrity or presence and therefore characterized by "absence," bearing with it the loss of the original. This impoverished copy, however, is also a supplement that adds something, a surplus value. In adding something, the supplement may bring surplus to a replete form or it may fill out an incomplete form—or paradoxically both at the same time. Supplement, then, is diminishment, replacement, and

addition that challenge the original even as they complete or supersede it. In *Of Grammatology*, Derrida argues that when something is added to an original that it resembles, it interrogates its own surplus value as well. This complex interplay helps to reverse deeply rooted hierarchical paradigms and helps to rethink the dichotomy or binary opposition of prose original and the film adaptation. Surplus and supplementation, like the original and the adaptation or copy themselves, are informed by Derridean notions of instability that provide the metaphors and concepts undergirding unpredictable change in personal and social identities.

Derrida queries these conceptual and rhetorical paradigms that culture regards as unassailable or "closed" and that diminish the value of the supplement. Throughout his writing, he attempts to rethink the paradigms, provoke openings, and subvert closed rhetorical constructs and systems, and this is of assistance in rethinking the concept of faithful or close adaptation. Indeed, in the spirit of Derrida's play with language, "close" as in "proximate" can be regarded as "closed" in adaptation as well, which postmodernism helps to pry open for the issue is not so much what is forgotten or lost of the original or what is gained in the adaptation or translation but the complex interplay of both that helps to rethink art and culture.

The relationship of surplus, supplement, and value is an important concept in adaptation because new information and techniques added to old approaches and textual antecedents decenter and destabilize the old and open up new readings without recourse to stable meaning. This hermeneutic raises interesting perspectives in the theory and practice of adaptation, whether in those that appear faithful to the antecedent or originary texts or whether they differ radically. The question is no longer to what extent an adapted film is faithful to its original but how even the smallest surplus unsettles meaning in both the original and adaptation, inaugurating creative uncertainty and instability and a dialogue between the original and the adaptation.

John Guare's *Six Degrees of Separation* is a case in point in which Derridean notions of the supplement add value and generate instability and openness instead of stability and closure. Based on the life of David Hampton, the teenaged son of an attorney from Buffalo, New York, it was scripted and produced as a play on Broadway and then adapted as a film by Fred Schepisi with Guare writing the film script, leaving most of the original dramatic script and tone intact in the film. Direct adaptation from drama to film had happened before in such "translations" as Tennessee William's *Streetcar Named Desire*, so there is nothing necessarily postmodern about this process of direct transformation. But substitution and supplementation do raise a postmodern question about the kind, value, and stability of meaning when surplus biography, news accounts, and direct transformation help the texts

to interrogate their own fictive status in content and methodology. They put the concept of transformation in a new perspective, and the self-interrogation raises metafictive or metafilmic questions that drive the film adaptation of *Six Degrees of Separation* in a particularly postmodern direction. This notion of substitution and supplementation provides the postmodern analytic for this study, but the ironizing of the postmodern idea of the cosmopolitan—the person who has the ability to change identity at will—also assists in assessing these adaptations.

Supplementation and surplus also underlie Robert Altman's selection and transformation of Raymond Carver's stories in the film *Short Cuts*. The setting of these nine stories and one poem, arbitrarily selected by Altman for inclusion in a single film, has been relocated from a variety of communities in Northern California and the Pacific Northwest to a single suburban setting in Los Angeles. Altman also gives certain characters roles throughout the entire narrative rather than have them appearing in brief segments as the short story form would seem to require. Altman's locating these short narratives in an integrated ensemble film with a single urban setting violates the geographical and rhetorical boundaries of the original short stories, but it also expands and extends (supplements) the sense of risk, vulnerability, and instability that inhabits each of the original short stories. Because adapted ensemble films depend upon multiple characters and multiple situations and lack a single narrative trajectory, they are characterized by supplementation as a generic component. In this way, they generate a surplus when narratives are put together in a larger structure, calling into question stabilized meaning in these texts, adaptations, and culture in general. In this kind of expansion, supplementation, interweaving, or aggregation, the film is able to draw on several pieces of fiction to create a heightened complexity of character, theme, and subject matter.

In their uses of supplementation, both Guare and Altman use *and* abuse "faithfulness" in order to rupture the boundaries of conventional notions of adaptation and show how a self-conscious awareness of surplus destabilizes traditional assumptions of life and textuality.

Surplus, supplementation, and transformation in John Guare's *Six Degrees of Separation*

A young 19-year-old black by the name of David Hampton gained notoriety in 1983 after he was "arraigned on charges of petty larceny, criminal impersonation and fraudulent accosting" (Witchel 1990, 2) and convicted of

"attempted burglary" (Barry 2003, 1). Witty and charming, he had worked his way into New York City society by passing himself off as David Poitier, the reputed son of Sidney Poitier.

On one famous occasion, he gained admission to the apartment of Osborn Elliott, Dean of the Columbia School of Journalism, and his wife Inger, who took him in for the night, and then he surreptitiously brought a male hustler into his bedroom. The Elliotts were outraged by this betrayal of their hospitality, threw Hampton out, eventually alerted the police, and talked about the incident with their circle of friends, including the playwright John Guare. Others such as the actor Gary Sinese were similarly conned around the same time.

After the Elliott and Sinese episodes, Hampton was apprehended, convicted, asked to make restitution to those he conned, and banned from New York City. But he came back to the city, did not make restitution, and was then sentenced to one to four years in prison. He eventually died in 2003 of AIDS-related causes, some 20 years after he was arrested, 13 years after the play *Six Degrees of Separation* first appeared, and 10 years after the film came out.

John Guare took the newspaper accounts and his friends' story and turned them into a play, *Six Degrees of Separation*. First performed at the Mitzi E. Newhouse Theater at New York's Lincoln Center in 1990 with Stockard Channing as Ouisa Kittredge, John Cunningham as her husband Flan, and James McDaniel as the intruder Paul "Poitier," Guare's drama was an instant success. The narrative was even more widely acclaimed with the 1993 production of the film, scripted by Guare himself, directed by Fred Schepisi, and again starring Stockard Channing as Ouisa, but changing to Donald Sutherland as Flan, and Will Smith as Paul.

Except for the conclusion, the film's plot follows that of the earlier stage production in its portrayal of the dilemma of the Kittredges (nee Elliotts), two middle-aged, white, upper-middle-class urbanites, and their encounter with this young gay black who insinuated himself into their apartment one evening, forever disrupting their lives. Based on the same historical and cultural accounts, the plots are almost identical and correspond thematically, and the dialogues bear many similarities though not entirely congruent. In this regard, *Six Degrees of Separation* is, to a great extent, "filmed theatre," in which the film stays strikingly close to the production of the play (Bazin 1971a, 84–85; Cahir 2006, 158). This likeness supposedly guarantees continuity, order, and stable meaning.

It is, then, not at all surprising that, in commenting on the themes, critics have seen the play and film as indistinguishable and have generally neither taken the historical background into consideration as an interpretive factor nor taken changes in setting and focus into consideration. What applies to

one is said to reflect on the other: (a) thematically they underscore the view that "chance meetings with exactly the right people can permanently alter unexamined lives" as indicated by "a single uninvited guest...who manages to tap into [the hosts'] fears, desires and hilariously fatuous daydreams," utterly rearranging their lives (Maslin 1993, 1); (b) they stress Ouisa's liberation from stale materialism, dull conventionality, and "desire to bask in the glow of the rich and the famous" (Rich "Schisms" 1990a, 1; Rich "Stage View" 1990b, 1); (c) as the double-sided Kandinsky painting in the Kittredges' apartment suggests, both play and film demonstrate that life is a combination of chaos and order in no certain mixture (Slethaug 2000, ix–x; 2002b, 74–75); (d) they describe the optimism and perils involved in the "vexed history of U. S. race relations" (Román 1993, 199), especially in the urban context of the late 1980s and, in a related sense, "blackness provokes a mixture of liberal guilt and uncertainty" (Clum 1992, 221); (e) they do the public a great disservice by perpetuating the politics of opposition between America's dominant white and underclass black cultures but rendering invisible the gay culture, this despite Ouisa's appreciation of Paul's cleverness and her eventual acceptance of his homosexuality (Román 1993); and (f) they unnecessarily exploit "the uncovered penis, the naked male body..., sexual chaos, mystery, the unknown, homosexuality" (Clum 1992, 221).

I agree that the play and film both center on the disproportionate disruption caused by Paul, which indicates the chaotic interplay of order and disorder, and that they celebrate Ouisa's growing awareness of herself and her relationship to the world at large. I also agree that the play addresses the transformation of American urban identity but that it does not really do much to change the audience's perception of the politics of class, race, gender, or sexual orientation. These are all themes and issues of the play and carried over into the adapted film.

However, these congruities do raise questions, making "audiences leave wondering where the facts stop and Mr. Guare's [and Mr. Schepisi's] imagination begins" (Witchel 1990, 1). I would argue that the historical incident, play adaptation, and film adaptation each has a different focus on the characters and "take" on the uncertainty that besets their lives and that the play and film as supplement questions the authoritative and transcendental word, destabilizes meaning, and denies totalization across all of these. I would also argue that it is the presence of the historical incident that creates the first significant unstable textual marker for this process, but also that it is Paul himself who serves as a supplement, adding to and disrupting the lives of his hosts.

Before heading into the grounding historical accounts and adaptations of *Six Degrees of Separation*, let me take a moment to review some of

the postmodern views on the truth of history. Perhaps one of the first to interrogate this idea at length was Michel Foucault in *The Order of Things* who argued that history—in this case "the historical analysis of scientific discourse"—should be subject to a "theory of discursive practice" (1970, xiv); that is, history does not exist apart from discursive strategies and practices and so is inherently mediated and therefore not an independent entity. Jean-Louis Comolli transfers the argument about historical truth to film, convinced that "there is no 'historical film' that is not fiction first: how indeed could the past be filmed live?" (1978, 42). He extends his thesis by noting that the presence of the actor further compromises the truth of history:

> If the imaginary person, even in a historical fiction, has no other body than that of the actor playing him, the historical character, filmed, has at least two bodies, that of the imagery and that of the actor who represents him for us. There are at least two bodies in competition, one body too much. (1978, 44)

Janet Staiger also picks up the thread of this argument in "Securing the Fictional Narrative as a Tale of the Historical Real" when she critiques historical authenticity in the film *The Return of Martin Guerre*. She queries "the ideological and psycho-analytical implications of our narrativization of the historical real" in film and, following the lead of Foucault, stresses that "true stories"—or history as narrative—are mediated by various language and semiotic systems (1989, 393–395), so that "simple" truth is always complexified. Bringing the argument into the contemporary forum, Thomas Leitch in "Based on a True Story" mentions that, of the post-literary adaptations, those based on true stories are "more problematic and more seldom treated as adaptation" (2007, 281) though deserving and complex. He maintains that

> "Based on a true story" indicates a source text that both is and is not a text, one that carries some markers common to most source texts but not others. Most source texts have authors and publishers who have sold the adaptation rights in return for a given amount of money and a screen credit. But "a true story" is authorless, publisherless, agentless. Because the description may be claimed or not at the filmmakers' pleasure, it appears only when it is to the film's advantage. (2007, 282)

These views of truth and history fundamentally help to critique Guare's *Six Degrees of Separation*.

In the case of *Six Degrees of Separation*, no rights to the story were ever sold because there were numerous newspaper accounts familiar to most New

Yorkers. The story did have some authors/authority, but the newspaper bylines were not particularly memorable, and the incident entered the public domain almost as an urban myth about a young black kid who scammed people by claiming to be the son of Sidney Poitier as well as about the surprising naiveté and vulnerability of otherwise seemingly sophisticated and street-smart New Yorkers such as a university dean and a well-known actor who were so easily conned into letting the bogus Paul Poitier into their apartments.

The "true story" and historical biography

As Leitch notes, grounding an adaptation in a true story "appeals to the authority of a master text that has all the authority of a precursor novel or play or story with none of their drawbacks" (2007, 289). He goes on to say that these foundational true stories usually are chosen because of a particular moral they illustrate:

> All of these claims—Don't blame us; Isn't this sad (or inspiring or heroic)? Stranger than fiction; Now it can be told; Behind the headlines; Explaining the inexplicable—not only a transcendental precursor master text but set that master text against an inferior alternative intertext whose competing authority is trumped by the true story. (2007, 288)

Obviously, the particular moral in focus means omitting details that do not serve that feature, so the discursive strategy and practices do shape the "truth." These background stories generate interest, yield morals, and serve as a springboard for the thematic design of the adaptation, but they are not stable in meaning.

Because, as stated above, the *New York Times* account of David Hampton was known to most of the audience when Guare's dramatic production first appeared, it was not only a factor in the structuring and thematizing of the play but in its reception and interpretation. Before the opening curtain, most of the audience knew from the reviews and public conversation in New York City that the Paul Poitier character was based on David Hampton and thus concerned the real-life actions of a con-artist who was able to transform himself into a genteel member of society. This is information lying outside the play and thus supplementation that affects the audience response, simultaneously adding to and working with as well as against Guare's narrative.

New Yorkers were intrigued that David Hampton could so effortlessly gain admission to the private lives and apartments of New Yorkers by his working knowledge of their lives and his ability to imitate their language and

behavior. This was a period well before the Internet, Facebook, LinkedIn, and Twitter, so private information did not circulate readily, and people were used to being able to keep their lives private and information confidential. That Hampton was able to gain access on several occasions to different celebrities was fascinating. That he wanted to gain access was part-and-parcel of a pervasive view in America that rich whites enjoyed more privileges and status—had more value—than other classes and races (Dyer 1997, 1–40). Moreover, the fact that Hampton was caught, convicted, and sentenced to repay his debts and stay away from New York City was also intriguing and seemed like just desserts.

Though David clearly had a magnetic personality that worked in gaining access to the lives of upper-class New Yorkers, people found it particularly fascinating how convincing he was in the role he played and how he seemed to have been taken over and inhabited by his adapted personae. Indeed, one of his victims, Robert Stammer, a student at Connecticut College, referred to "the strength" of that persona (Witchel 1990, 1).

The audience's awareness of Hampton's impersonation also meant that they had knowledge which the characters in the play lacked, and, in conceptions of drama, this kind of insight coupled with the dramatic personae's lack of what is called tragic irony. Traditionally, the audience with such knowledge feels a particular anxiety because their knowledge cannot hold back the continuous unfolding of the drama or the inevitability of fate. In *Six Degrees*, Paul's immoral acts and the characters' failure to realize their vulnerability must also play out in their inevitability, though it does not result in death or explicit tragic effects but only adds to the allure and mystery of his own background and fate.

The media accounts, then, had a supplementary background value for the first New York audiences who knew of the antics, moral compromises, and legal issues of David Hampton, even though the play focused almost exclusively on the lives of those conned. This was also true of the first audiences of the film, but new information about Hampton would change that for later audiences. The news of David's tragic death of AIDS-related diseases wrenched the urban myth away from David's intrigue and mystery to the realities of life for gay males and black prisoners in America. This new awareness of David's fate means that the contemporary audience cannot have precisely the same reaction to the film as those first audiences of the drama and film. This latter information supplements the "true" story, play, and film in ways that irrevocably alter the historical narrative and the implications of the adaptations, forcing the audience to refocus on the fate of this black youth and others like him and also to consider the instability of meaning in origin and adaptation.

The "true story" and popular scientific theory

The title *Six Degrees of Separation* is drawn from a passage that is particularly critical to a comprehension of both drama and film adaptations. Ouisa Kittredge dimly remembers some idea about the relatedness of people and says, "everybody on this planet is separated by only six other people. Six degrees of separation," to which she adds, "I am bound to everyone on this planet by a trail of six people" (Guare 1992, 45). In Ouisa's mind, this concept of six degrees of separation—which the play and the film together have helped to popularize—represents biological links, basic communication, and psychological and spiritual affinities for she believes "that despite differences, there is a fundamental humanity shared by all people" (Román 1993, 198) and "hunger...for a human connection and perhaps a spiritual one" (Rich "Schisms" 1990a, 1).

In Ouisa's mind, this idea of six degrees of separation becomes especially relevant because of the sudden entry into her life of Paul, the young black who becomes "a new door, opening up into other worlds" (Guare 1990, 45). In the space of little more than an evening, she comes to love him and to feel a peculiar affinity with him growing out of his geniality and aspirations to follow in her and Flan's footsteps, and she begins to perceive him as one who should be nurtured as her spiritual son and heir. This popular scientific theory, then, becomes a second "true story" and supplement behind the play and drama because it is used as a founding account for the perceptions of the characters in this contemporary moment.

However, Guare uses this six-degree theory ironically, so, while the audience and the characters share its allure, the drama and film deny the validity of it. In her great enthusiasm for Paul, Ouisa in both the play and the film neglects to note the enormity of these degrees of separation: although she does acknowledge the difficulty of finding the "right six people," she fails to recognize that the statistical probability of one in every six people being somehow connected through social or ancestral links does not mean they share a fundamental sense of personal or social identity. Her clumsy and strained relationship with her own children ought to be lesson enough that related DNA strands do not guarantee affinity, and her real and cultural (as opposed to spiritual and imagined) differences with Paul are greater than she cares to admit. The world does not have predictably neat relationships and will not conform to her vision of it, as illustrated by Paul himself and other broken connections and tragic social, familial, and cultural schisms in her life.

This concept of six degrees of separation is a surplus construct that the dramatist/script writer has laid entirely over the original accounts of David

Hampton's intrusion into the lives and apartments of wealthy New Yorkers, but is thought in popular culture to have a validity of its own. Because he made claims to be the son of Sidney Poitier, the historical incident thus renders the romance of *Six Degrees* ironic from the outset. Indeed, the title of one early review, "The Life of Fakery and Delusion in John Guare's 'Six Degrees'" (Witchel 1990, 1), made it so abundantly clear to the public that the play was based on a recent scam that almost no one in the audience would have been prepared to accept Ouisa's elaborate claims for the romantic relevance of the scientific theory to her situation. One "true story" thus faces another, interrogating both in the process and destabilizing meaning across the spectrum.

Transformation, cosmopolitanism, and supplementation in the drama and film adaptations

The initial "true" historical accounts of David Hampton's intrusions focused on his capacity for self-transformation, and the drama and film adaptations of *Six Degrees of Separation* continue that focus by depicting Paul Poitier's desire and ability to transform himself during his intrusions as well as through his effects on the lives of his victims, especially Ouisa Kittredge. In effect, the governing theme of both the drama and film adaptations becomes self- and social-transformation (or supplementation because it is added to or a replacement of the original state of being)—ironic for Paul, meaningful for Ouisa, and something else for Flan and the other characters. In this respect, there is little difference between the drama and the film. As well, the drama and the film drop most of the legal issues embodied in David's "true story," except that, when he disappears, it is suggested that he might have been incarcerated by the police. Consequently, the supplementation of the adaptations is also impoverishing for it truncates the life of the real black youth and neglects to consider the strong racial and cultural factors that went into/ were suppressed by the self-transformation. In this way, supplementation is at once substitution, surplus, and impoverishment.

Though identity transformation is an intriguing part of the ethos of the American dream, it has never been a straightforward concept as the disparate examples of Ben Franklin and Jay Gatsby demonstrate. Because of the supposed benefits of self-transformation, it is, however, no surprise that unemployed youths—regardless of color—would aspire to reinvent their lives in the towers of Manhattan. For many recent sociologists, this is a laudable postmodern ideal and tendency. In *Beyond Ethnicity: Consent and Descent in American Culture* (1986), Werner Sollers argues that identity for the new

generation stands at a crossroads between cultural codes, beliefs, and rites inherited through blood and ideology (descent) and those taken from outside by the individual (consent). In this postmodern and globalized context, the ethnic identity of consent is not fixed but constantly in flux. In *Postethnic America* (1995), David Hollinger makes a similar case, favoring voluntary "cosmopolitan" postethnic affiliations over involuntary "pluralist" affiliations derived from blood and pervasive cultural ideology. For both Sollers and Hollinger, the postethnic postmodern person has the ability to choose—cosmopolitanism—his or her cultural direction, identity, and ideology and not to stay trapped in an inherited value system.

That is precisely what Paul attempts in *Six Degrees of Separation*. He rejects the ideology, culture, and racial constraints of his personal background and attempts to transform himself from a localist to a cosmopolitan. There is a strong sense that a part of this is a wish to transform himself from poor to rich and black to white. However, the true story, the drama, and the film all deny him the power of the cosmopolitan supplement even as they offer it to Louisa. What the play and the film focus on is that Paul's adopted persona initially functioned so well because he so cleverly piqued his victims' interest, was quick witted, played on everyone's desires, and reified their style of life, in the process giving him a warrant for his own cosmopolitan identity and role as supplement in their lives. When he shows up at the Kittredges' door, supposedly having been mugged, they find him attractive and congenial because he is handsome and articulate, asserts that he is the son of the actor Sidney Poitier, claims to know, and to have gone to school with, their children, shares their tastes and lifestyle/ money, is able to "speak their language," and tells the kind of stories they like to hear: in short, he is able to simulate their interests, preferences, and tastes, and adapt to their preferred life narratives and act out their ideals. He is a true cosmopolitan. The play and film, then, are in part about constructing and supplementing life narratives and acting them out.

Among the primary narratives Paul constructs as part of his supplementary cosmopolitan identity are those that affirm family and community connections. Paul flatters the Kittredges by giving them what they most want to hear—that their two children at Harvard (Talbot and Woody) proudly affirm their love and respect for their parents and that the parents themselves have a place in the cultural fabric of the city. By confirming the children's love, Paul affirms Flan and Ouisa's parenting abilities and supports the family as the most stable and meaningful unit of human relationships. He also makes the Kittredges feel that they are intricately and stably tied to the community and cultural life of New York by offering them acting parts in Sidney Poitier's *Cats*. They are not only commercial purveyors of culture through buying and selling art but are fully imbricated within it.

In short, Paul reads people like coherent texts, offering stability or adventure by confirming their desires, something he seems able to do regardless of social level. And, though the preppy Poitier semblance is one that he cultivates with the Kittredges, as a cosmopolitan he is able to change life narratives when it suits him. When he meets Rick and Elizabeth, the young actors from Utah, they accept him because he seems to share their simple lifestyle, sense of striving to make ends meet, and aspirations for a better life. He also introduces Rick to a spirit of gaiety, adventure, and homoerotic pleasure, while all the time unconscionably spending Rick and Elizabeth's short supply of money. Paul is able to size up people and deliver the conscious and unconscious narratives that they most want to hear, in the process masking his own sexual and cultural identity, so that in becoming the supplement he conforms to other people's requirements, expectations, and dreams.

There is a limitation to his self-invention, however: he can only achieve his transformation, become a postmodern cosmopolitan, comfortably decenter others' lives, and reify himself as a supplementary sign because he claims to come from a sophisticated and wealthy background and because his victims do not know about the discrepancy between his real background, education, culture, and sexual orientation and their own. So, his cosmopolitan identity and transformative qualities are built on deception and illusion. Self-transformation and cosmopolitanism—the play of surplus and supplementation—are thus simultaneously enriching and impoverishing, liberating and problematic for Paul and those whose lives he touches.

However, the question of Paul's postmodern cosmopolitanism is still larger than the lack of integrity in his own supposed transformation. While his persona has a certain magnetism because of his affability, good looks, bravado, and daring, and while he holds the stage well in his evening with the Kittredges, his cosmopolitan identity is drawn from, and parasitic of, their white world, not his black world, accounting for the reasons why so many critics feel that the existence of the New York social and racial underclass is not adequately represented. This discrepancy also raises questions about the value of a postethnic, postmodern model of identity and transformation disconnected from past experience, present economic and social facts, and the ongoing racial barriers in America.

The "true story" suggests that Paul merely used the Elliots/Kittredges and that he was the net beneficiary, but the drama and film adaptations demonstrate that in developing his cosmopolitanism he clearly introduces something extra into their lives even while he takes something from them. Although the Kittredges' lives are superficially ordered, like their apartment, the advent of Paul shows something missing for the white elite, demonstrates how quickly their well-being can be shattered, and reveals how much they

have to readjust and transform their perceptions and lives as a result—even while they and Paul are inevitably thrown back to localism and away from the new cosmopolitan identities. In this way the drama and film supplement and further ironize the historical account, raising questions about choice and durability in this postmodern age.

The braided themes of transformation, cosmopolitanism, and supplementation against the constraints of race and class are further ironized because Paul learns to know the Kittredges under almost the same conditions as their "King Midas rich" white South African dinner guest, Geoffrey (Guare 1990, 12), and their worldview is identified with the attractions of entitlement, wealth, and globalization (for many sociologists cosmopolitanism and globalization are much the same). Geoffrey's friendship with the Kittredges also begins through their children; both he and Paul have an interest in art and literature; and all have cash-flow problems while claiming to be supported by wealth. Paul claims to have resources from his father but needs help for the night; the Kittredges have a grand lifestyle but worry that they will not raise the two million required to buy and then sell the Cézanne in an international marketplace, a failure that could bury them in debt; and, while "Geoffrey might not have the price of a dinner he easily might have two million dollars" (Guare 1990, 13). All of them may have a problem with financial capital, but they fabricate cultural capital to suit the audience and so acquire the necessary financial capital. Ouisa is impressed that Geoffrey and Paul like expensive art, and, even after Paul disappoints her by picking up a gay male hustler for his one-night stand, she is flattered that he wishes to follow their profession of buying and selling art—as indeed does Geoffrey in buying into their scheme to purchase and sell a Cézanne. There is, however, a massive difference in the ability of Paul, Geoffrey, and the Kittredges to recover from a lack of capital, though the adaptations do not directly address this. Paul is pulled back to the local, not by choice but by discovery, whereas Geoffrey and the Kittredges have financial capital and whiteness that facilitate their choices for postmodern cosmopolitanism. In short, Paul is stuck with his poverty and racial identity for a postethnic, cosmopolitan identity is not so much a matter of choice as of money, social place, and race.

Paul's actions, however, force Ouisa to alter her preconceptions, preoccupations, and role—to query the narcissistic gaze of her upper-class, very white, heterosexual world and to develop a consciousness of "others" who, if offered the capital and better circumstances, could play the elite social game. Also the death of the real David Hampton from AIDS-related diseases reminded the later audience that the black underclass in America historically has not been able to share in these transformations and may continue to be denied that opportunity. Both the drama and film adaptations,

then, are supplementary in going beyond the "true story" in emphasizing transformation and cosmopolitanism in personal and social identity, but also impoverished in demonstrating that the great inequities lying behind the social structures stand in the way of postethnic and postmodern choice. Derrida's play of supplementation is very serious indeed.

Beyond true story and drama adaptation—the film

In going beyond the true story/ies, both drama and film adaptation of *Six Degrees of Separation* share many features, but the film exceeds the drama in its handling of *mise-en-scène* (especially as an expression of class and wealth), use of color and structure, and choices that Louisa finally makes. These differences in the film stress the value of the imagination and the problematic of postmodern cosmopolitanism and self-transformation.

Both the drama and play were designed to be performed in one sitting under 2 hrs—90 min for the drama and 1 hr and 52 min for the film, and the sequencing and intensity are similar. However, the handling of setting is an important way in which *Six Degrees of Separation* as a film differs from drama, emphasizing issues of cosmopolitanism. While drama is "theatrical" in its "self-contained scenes" (Halliwell 2007, 93) and in the kind and degree of action that the stage can accommodate, film exceeds those confines, providing a broader contextual perspective and more varied settings, background narrative, and a larger sense of motion.

Affluent setting and opening shots

The Mitzi E. Newhouse Theater where the drama was first produced had a thrust stage with the actors sitting in the front row and the audience sitting three-quarters of the way around it. According to Guare,

> Tony Walton designed a deceptively simple set: a bright red carpeted disc, two red sofas, and, hanging over the stage, a framed double-sided Kandinsky which slowly revolved before the play began and when it was over. He encased the back wall, made of black scrim, in a gilt picture frame and then divided that into two levels. The openings on either level were framed in gold. When actors appeared in the upper level doors, the set would give the feeling they floated in the dark. The geometric interplay between the circle of the bright red disc and the rectangle of the back wall caused a palpable tension. (1990, 9)

The double-sided Kandinsky floating above the stage, black scrim and gilt picture frame design, and red carpet and sofas create a minimalist perspective, emphasize dramatic intertextual links to modernist art, and provide a sparse setting for the action and dialogue.

At the opening of the drama, the two main characters, Ouisa and Flan, emerge on this stage distressed, edgy, and fearful about an intruder in their apartment during the night, anxious about the vulnerability of their lives and possessions. They speak to each other and then address the audience directly before a flashback begins of the previous evening's encounter with their rich friend Geoffrey from South Africa and the intruder Paul. The evening conversation moves effortlessly and glibly from South African apartheid to Gorbachev and the coal miner strikes, to popular music, to the diversity and costs of restaurants on the East Side, and to a description of a Cézanne that Flan and Ouisa are trying to buy and then sell to a Japanese. Then the supplement changes everything: the bruised Paul arrives, changes their lives, and accounts for the reasons they are so excited and distressed.

In contrast to the drama, the film begins with an introductory list of credits situated against a series of close-ups of a partially painted canvas, one that emphasizes the actual fabric of the canvas as well as splotches of paint— perhaps in anticipation of the blank spaces of the Cézanne painting to which Flan (Donald Sutherland) later refers. The canvas shots are then replaced by a panoramic shot of New York City ending over Central Park before moving through the window to the Kittredges' living room. These shots of the canvas and the city highlight an urban and global cosmopolitanism and joie de vivre that differs significantly from the play.

The opening shots of the characters take place in a cinnamon-red painted living room in an upper-floor East Side apartment overlooking Central Park. It is filled with expensive paintings, knickknacks, and overstuffed furniture, projecting a sense of affluence and orchestrated taste rather than minimalistic modernism. There is no Kandinsky painting in the opening shots, and when it does appear resting on an easel, it does not dominate the scene as in the stage version but simply becomes an expensive art object in an upscale apartment (see Figure 2.1).

This combined panorama of the city and depiction of wealth and comfort at the beginning of the film supplements, exceeds, and displaces that of the drama in its realism, texture, and sense of place. This combination runs throughout the film and strongly marks the distinctive supplemental qualities of this production.

When the film dialogue between Ouisa (Stockard Channing) and Flan commences, they are as agitated as in the drama, but their account of the evening episode is told to entertain friends at a wedding reception rather

FIGURE 2.1 *Ouisa (Stockard Channing) and the Kandinsky in* Six Degrees of Separation.

than to the audience directly, hinting at the upper-class social network that provides the basis of their urban lives. As the Kittredges tell their account, the camera moves from their living room to the church and reception and then back to their living quarters and eventually to their bedroom and that of their daughter's, where Paul (Will Smith) will sleep. Consequently, the opening of the film takes place in multiple interior lavish and expensive spaces and offers grand panoramic shots of the city. The interior shots create a sense that the Kittredges and their friends all live in a penthouse atmosphere overlooking the city, above the life of the street and not well connected with it. Similarly, the panoramic views of the city are mostly shot from the air or high buildings, giving an architectural and structural overview, set apart from gritty street life. This clearly emphasizes the cosmopolitan and global, not the local, and indicates why Paul should want access to this consumers' paradise.

This elitist isolation, so much more pronounced in the film than in the drama, grounds the couple's fear for their safety and possessions (a Kandinsky, a Degas, and a silver Victorian inkwell). While they both want the two million dollars from Geoffrey (Ian McKellen) to flip the Cézanne, Flan is shown to be slightly more materialistic than Ouisa. With the advent of Paul, his consumerism becomes the basic point of tension that highlights their personalities and values throughout the film and finally leads to their separation at the end.

Art and imagination—color and structure

One of the most important features of the Kittredge household is the art that hangs on their walls, becoming connected with imagination but also

cosmopolitan choices and consumerism. In the popular view, art and imagination are aligned, but in the film adaptation of *Six Degrees of Separation*, art as imagination is replaced by art as commodification, hence another supplement. Because possessions and wealth are much more heightened and intense in the film than in the drama, the film more strongly suggests that (a) wealth and possessions have usurped, supplemented, and supplanted the active imagination for New York elites, (b) that Paul's "Poitier" persona is strongly identified with an imagination that is both regenerative and destructive, and (c) that Paul wants to transform himself though cosmopolitanism as a choice is only possible for the well-to-do.

When Paul arrives at the Kittredges' door, it is in the middle of their conversation to convince Geoffrey to give them the money to buy the Cézanne, clearly the commodification of art. By contrast, Paul has no money, offers them nothing, and takes nothing material except the shirt they give him but opens up imaginative doors for them while also affirming their lifestyle. He does this to confirm his cosmopolitan choice. He tells them of his supposed mugging close to the statue of Balto the Husky located physically below their apartment in Central Park, but really a whole civilization away. He tells them of his relationship to Sidney Poitier and of the possibility of their being part of the cast of *Cats*, which his "father" will direct. He keeps the conversation moving and holds them spellbound when he tells stories and makes intelligent comments about the connection between the imagination and self-examination, the fear that the modern age is suffering from emotional and intellectual paralysis of the imagination, the surprisingly negative social consequences of *Catcher in the Rye*, and other complex issues. And he manages to cook a fabulous feast from a few leftovers, tuna, pasta, and vegetables. All of these suggest an active imagination at work.

Paul's highly fictitious account of his background and reasons for coming to their apartment marks the beginning of a self-conscious exploration of imagination in *Six Degrees*. In both the drama and film adaptations, Paul laments that "one of the great tragedies of our times [is] the death of the imagination because what else is paralysis?" He adds, "imagination has been so debased that imagination, being imaginative, rather than being the linchpin of our existence, now stands as a synonym for something outside ourselves." He then sums up, "I believe the imagination is the passport that we create to help take us into the real world. I believe the imagination is merely another phrase for what is most uniquely us." At some idealized level, he may be right as imagination applies to humanity, and certainly he proves imaginative in the way he enters the Kittredges' domain. But he is wrong in thinking that imagination can maintain his cosmopolitanism in the consumer capital of the world visualized through the elegance and artifice of the apartments of Kitty

(Mary Beth Hurt) and Larkin (Bruce Davison) and of Dr. Fine (Richard Masur), all of whom have given him easy access.

Paul is also strongly identified with the pink shirt, which the Kittredges have given him to replace his own bloodied one. For them, it is merely another shirt that happens to be available in their house when he arrives with his own torn and bloody, but for Paul its pinkness represents the allure of the exotic, hitherto barred to him. This is also another form of supplementation and displacement. (This emphasis on the shirt also intertextually references Jay Gatsby's collection of shirts which Daisy cries over in his mansion, reinforcing the self-invented cosmopolitanism of the two men.) In the film adaptation, the pink shirt shares the coloration of the Kittredges' apartment, with its rooms of a rosy antique red. Paul's "color"—both his blackness and his identification with pink—represents an exotic, imaginative life, and an emotional, passionate coloration partly absent from the Kittredges' lives, though not from their decor. However, there is a sense that each looks at the other as remote and exoticized: the Kittredge's wealth and art dealership hold an allure for Paul because they represent affluence, style, comfort, and whiteness not within his grasp, and Paul's handsome youthful blackness, supposed pedigree, and links to the theater hold a cosmopolitan allure for the Kittredges because that, correspondingly, is glamorous and remote from them.

At the end of the first evening's conversation, after Geoffrey leaves and Paul goes to bed, Flan is deeply touched by the amazing events of the evening and confesses:

> This is what I dreamt. I didn't dream, so much as realize this. I feel so close to the paintings. I'm not just selling, like pieces of meat. I remembered why I loved paintings in the first place, what got me into this. I thought... dreamt...remembered...how easy it is for a painter to lose a painting.

He continues by noting that it is the painting's colors that especially attracted him,

> I dreamt of color. I dreamt of our son's pink shirt. I dreamt of pinks and yellows and the new Van Gogh the Museum of Modern Art got. And the irises that sold for $53.9 million. And, wishing a Van Gogh was mine. I looked at my English hand-lasted shoes and thought of Van Gogh's tragic shoes, and remembered me as I was—a painter losing a painting. Loses the structure, loses the sense of it. You lose the painting.

The colors Flan mentions are at once the yellows of Van Gogh and the pinks of Monet, and these blur with Paul's shirt. Ultimately, however, he moves away

from the importance of color and ends on commodification and structure, which dominate his sensibility until the end of the film and suggest that he cannot focus on imagination by itself.

Ouisa, too, is attracted by color, but with less commodification. She talks about having been to the Sistine Chapel, having seen Michelangelo's wonderful colors released by the restoration, and, in a moment of joy and abandon, having slapped the hand of God as he reaches out to Adam. At the film's conclusion, she says, in worrying about the loss of Paul, "A burst of color. Pink shirt." The burst of pink is identified with a powerful feeling of imaginative freshness, divine communication, and transcendence, in which, as a result of Paul's intervention in their lives, she can again imaginatively touch the hand of God—which she does as she walks out on Flan. With the Kittredges, everything has had its place, paid for and maintained by the sale of art. Art, intrinsically important to them, had become commodity, something to be bought and sold, to impress others with the quality of their lives. Paul's presence—his surplus value—revives their love of color, passion, and imagination, but in the film it is only Ouisa who can live with that separate from commodification, and so she leaves Flan.

Indeed, the role of the unconscious, marked by allusions throughout the play to Jung, Freud, and the unconscious, is restricted to color in the film: the unconscious has been repressed by reason and day-to-day activities, limiting the Kittredges' engagement with life. It is, then, appropriate that Paul not only supplements the Kittredges' lives by intruding physically in their apartment, but by appearing psychologically and transcendentally to Ouisa in dreams. Paul's colorful intrusion reorders their conscious and unconscious priorities and gives vent to emotions that have been deeply repressed. This appears to be a wholly positive supplementation.

Nevertheless, although Paul represents the colorful, liberating freedom of the imagination and the unconscious, he also represents its disordered side. Traditionally in literature and art, the imagination is linked not just to hope, creative possibilities, and a sense of renewal, but to confusion, delusion, illusion, and fantasy. Paul's theft of Trent Conway's belongings, his affair with the gay hustler in the Kittredges' bedroom and Kitty's and Larkin's as well, and his responsibility for Rick's death—all are in keeping with the uncontrolled side of the imagination. They are also reminders that his desire for postmodern cosmopolitanism is falsely positioned for him and others. Paul and the imagination are, then, real and symbolic manifestations of desires, supplementations, and transformations operative at every level of the Kittredges' lives, but in different ways for Flan and Ouisa.

This doubleness of the imagination and postmodern cosmopolitanism is replicated in one of the main symbols of the play and film adaptation—

the double, two-sided Kandinsky painting. Although both sides are equally colorful, one side of the painting, geometric and somber, arranges objects in an orderly fashion, and the other side, wild and vivid, consists of random splashes of paint, the two sides taken together representing the juxtaposition of randomness with programmatic structure. This doubleness is not so much a value judgment on the choices Flan and Ouisa make in their lives as a recognition that they have choices and can manipulate them. This becomes quite apparent in the film: although the painting is put on an easel, the Kittredges change its position from time to time as events happen. For example, when Paul first shows up and entertains the Kittredges, the orderly side of the Kandinsky is on display, but, when their children visit and show open hostility to Flan and Louisa, the chaotic side of the painting is on display. At other times, the changes seem entirely unconnected with the action.

Paul's going to jail represents a loss of choice and creative imagination to Ouisa, who, in her own subdued and orderly way, is utterly distraught. She has promised to take Paul to the police station and help him in his confession concerning Rick's suicide. She is not able to honor her commitment and, indeed, cannot even determine whether Paul has been booked, is imprisoned, or has died. Part of her great sadness springs from her growing love for Paul and humility over his yearning to share their "paltry" life, but part of it comes from his importance to her as a representative of the imagination. After Paul is thrown out of their apartment, he appears to her in a dream and announces himself as the imagination:

> The imagination. It's there to sort out your nightmare, to show you the exit from the maze of your nightmare, to transform the nightmare into dreams that become your bedrock. If we don't listen to that voice, it dies. It shrivels. It vanishes. The imagination is not our escape. On the contrary, the imagination is the place we are all trying to get to.

Similarly, at the end of the film, as Ouisa looks at a florist shop filled with colorful flowers, he appears dream-like as a reflection in the glass saying "The Kandinsky. It's painted on two sides," reminding her of the range of choices she has in her life.

Paul is the supplement with value, and his color and life demonstrate the complexity of this imagination: it can bring moments of catastrophe and sorrow, but it also brings wonderful release from the daily grind of life. When Paul disappears and possibly dies, he becomes to Ouisa what *Catcher In the Rye* was to him—"the death of the imagination." After the brief interlude in their lives, he disappears without a trace (they do not even know his last name).

Paul's wanting two sets of parents—Sidney Poitier and the Kittredges—and ignoring his own illustrates the importance of imagination as repression, transformation, re-invention, and cosmopolitanism. He has attempted to hyphenate his name to become Paul Poitier-Kittredge, possibly reflecting his real background in Boston, the voguish life of a black film star, and the white upper-class life of commerce and art. The combination suggests identification of the real and the imaginative and of the creative and delusive aspects of the imagination. But when the Kittredges drive him away and he disappears, his unique and imaginative coloration also fades, leaving Flan and Ouisa with a sense of emptiness, which their narratives partly help to fill and also which Ouisa's dreams of Paul help to fill. Perhaps their own cosmopolitanism is dead as well.

When Ouisa and Flan tell the audience and their friends about the disruptive and disorderly arrival of Paul into their lives, their anecdotal account reduces it to an orderly narrative, just as they had earlier reduced great global cataclysms to conversational anecdotes. As they talked about these disruptions, they were able to wrap the catastrophes in nicely packaged narratives, which is not unlike what Geoffrey had done at the beginning of the film. As Ouisa remarked then, "Geoffrey called and our tempests settled into showers and life was manageable." She added, "he made a sudden pattern in life's little tea leaves." These stories embody the life of imagination, but they also supplement and replace Paul's existence, demonstrating how textual surplus is deprivation and enhancement. Ironically, too, the triumph of their imagination is due to the death of Paul and the desire for cosmopolitanism that he represents.

The film's ending

The film adaptation ends with Ouisa walking away alone from an elaborate formal dinner and the constraints of a business and social life closely identified with her husband. The film makes it clear that Ouisa and her growing sense of independence from Flan are identified with Paul and the surplus, unruly, and unpredictable imagination, while Flan is associated with structure, reason, and commerce. Ouisa tells him, "We're a terrible match," and indeed they are. Symbolically, he loves the structural qualities of Cézanne's paintings as well as their coloration, whereas Ouisa focuses on randomness and color, declaring that she is "a collage of unaccounted-for brush strokes. I am all random." She asks without hope of an answer, "how much of your life can you account for?" This comes after a flippant exchange between them, with Ouisa identifying God with Sidney Poitier and Flan identifying Him with Geoffrey, this difference suggesting the gap between qualities of color, imagination, and

transcendental insight and those of practicality, reason, and consumerism. In this scene, Ouisa is also able to make the kinds of choices that Paul cannot because she has the means and status to do so. She truly can be a postmodern cosmopolitan, leaving behind the localism that Flan represents. She can also turn Paul from mere supplementation to transcendental signified, displacing the old center of her life and creating a new one.

This ending is not at all explicit in the play. In the play Ouisa may have grown and matured, but she does not walk away from the dinner party and her spouse: she stays and raises her questions without making a decisive exit. In the play, the ongoing order is sustained though partly transformed, while in the film the prevailing order is disrupted, and life cannot return to its status quo, forcing Flan and Ouisa to develop independently. The advent and demise of Paul as surplus has different effects in each scenario. Surplus enriches and impoverishes, and this postmodern paradox is fundamental to an understanding of the film adaptation—both as content and as analytic.

Seeing these two different conclusions helps the audience to recognize and reflect on the ways that similar narratives can have very different endings and meanings. To a considerable extent, this becomes a self-referential metafilmic device by which the narratives call attention to their status as narratives rather than to reference a reality outside the play or film.

Conclusion

Each of the narratives involved with *Six Degrees of Separation*, then, has a different focus as exemplified by the ending. In the "true" historical story underlying the play, the reader has no idea what has happened to the Elliotts— the Kittredge equivalents—because the focus is entirely on David Hampton as intruder and as convicted and imprisoned felon. The drama focuses on the desire for postmodern cosmopolitanism and transformation of each character, including Ouisa's acknowledgment that she and Flan are a "terrible match," but concluding with her decision to stay at the dinner party and then exit together with Flan to attend an art auction. The film ends with the same acknowledgment that they are a "terrible match," but Ouisa asserts her cosmopolitanism and walks away from Flan, apparently to begin a new life on her own, one not so completely governed by structure and commodification. Throughout these three, Paul as supplement is simultaneously surplus and impoverishment, but each version importantly has a different focus, conclusion, and final point to make about the imagination, transformation, cosmopolitanism, and the supplementation that Paul is and brings, suggesting that the analytic of surplus and substitution is useful in interrogating entire narratives in life and art.

If these triple narratives—the true story, the play, and the film—and their very different inner worlds leave the audience on the edge of many possibilities, so does Altman's *Short Cuts* in which the characters are also strangely linked though inhabiting very different sectors of society in Los Angeles. The paradoxical link between impoverishment and supplementation in adaptation and life is just as important in the film's handling of Carver's stories as it is in Guare's narratives in *Six Degrees of Separation*.

E Pluribus Unum: Raymond Carver's fiction and Robert Altman's *Short Cuts*

Reading the factual account of David Hampton against the stage and film versions of *Six Degrees of Separation* illustrates the value of postmodern supplementation, adding surplus historical value that tends to ironize the dramatic and filmic adaptations as well as the original, thereby altering the play's and film's response and meaning for the audience. The supplemental value of the historical dimension also points to other kinds of surplus within the play, notably the role of imagination that has been suppressed and truncated in the Kittredges' lives and which Paul liberates as well as the ironizing of the intertwined postmodern concepts of cosmopolitanism and transformation.

Robert Altman's *Short Cuts* (1993), an ensemble film based on Raymond Carver's stories, appeared in the same year as the film *Six Degrees of Separation* and also creates surplus value over the originals. This is an instance in which the director clearly cares both about the integrity and singularity of Carver's stories and the authenticity and unity of his own film. As adapter, Altman reshaped, interwove, transformed, and went well beyond nine of Carver's stories and one poem; as auteur, he wrote (along with Frank Barhydt) and published the screenplay of the film; and, as editor and critic, he selected, introduced, and published Carver's stories and poem in the collection also called *Short Cuts*. His role as director of the ensemble film indicates his creativity and originality, and his role of editor indicates his deep respect for Carver's original stories and suggests that Altman saw himself as responsible for the original fiction in some way as well. He is, then, clearly self-conscious and inherently playful about this double role, so that his edition of the stories and poem is sutured to the adaptation, creating a "revision" (Leitch 2007, 106) and "interweaving" (Leitch 2008, 69) that were never part of Carver's enterprise. The resultant film and edition beg questions about the stitching together of separate stories and about the interconnected functions of adapter, auteur, and author, highlighting issues of singularity, unity, multiplicity, and duplicity all at once.

Insofar as there is no one short story that the film is built upon, but rather a pastiche of interwoven stories and a poem—what Altman calls a "mosaic" ("Introduction" 1993, 7)—this combination creates a different kind of surplus value and supplementation from Guare's for the fictional antecedents are many and varied, and the total is substantially greater than the sum of the parts. Moreover, these stories have been deliberately selected and grouped to create a certain perspective in the film that exists apart from Carver's individual texts. Similarly, the music in the film adds a new dimension and becomes its own double to the Carver/Altman narrative, working well together with the development of the characters as well as the focus on the suburban complex of Los Angeles.

The short-story collection

Short Cuts, a collection of Carver's stories gathered and grouped together by Altman, "capture the wonderful idiosyncrasies of human behavior...that exist amid the randomness of life's experiences" (Altman "Introduction" 1993, 7). Importantly, they concern the way in which things "just happen to people and cause their lives to take a turn" (Altman "Introduction" 1993, 7), minor things that suddenly balloon into major issues, disrupting the way the characters live their lives, altering their perception of reality, and leaving some emotionally scarred and marooned. They also comprise principles of selection, relationship, and pattern that could translate well into film. Altman's grouping of Carver's stories in the collection itself creates a thematic structure and trajectory, confirming that arrangement itself creates new meaning apart from the content and structure of each story and that it, too, is supplementary.

Similar to the postmodern fiction of Pynchon, Barth, and DeLillo, Altman demonstrates how little things balloon into major catastrophes, points to the capriciousness and unpredictability of life, and suggests the sudden and precipitous descent into chaos and tragedy or, alternatively, something strikingly new, refreshing, and stabilizing. The first six stories in Altman's collection seem ordered with regard to the way in which the obsessions and traumas caused by the minor incidents escalate, going from incidental to significant and from curious to serious, but also in some cases from negative to positive. The last three stories and the concluding poem seem consistently bleaker and end on strikingly negative notes not unlike those of Cormac McCarthy depicting the sudden, quixotic, and irreversible absurdities of the universe. This selection and ordering not only portray a mainly unforgiving urban environment but also a postmodern sensibility governed by a lack of reason, spiritual center, or control over life and the environment.

These stories, discussed here briefly in the order in which they appear in Altman's collection, each pose a central dilemma for the protagonists and/ or narrators that arises from some small thing that forever changes human relationships and ways of life. In Carver's "Neighbors," the minor incident concerns Bill and Arlene Miller's innocent but disconcerting obsession with putting on the clothes of their neighbors Harriet and Jim Stone after they agree to watch their apartment while their friends are away on holiday. This attempt at co-opting their friends' style of life comes to nothing when they mistakenly lock their neighbor's key in the apartment as they leave one day. Still, they have experienced something that disrupts their normal thinking and acting, so that they cannot "go home again." In "They're Not Your Husband," it is Earl Ober's accidental overhearing of derisive comments about his wife Doreen who works at a local coffee shop that makes him obsessive about her diet and appearance, jeopardizing her health and their relationship. Until that moment, they were a reasonably happy couple, and he was proud of his wife and her work and content with their sexual relationship. In "Vitamins," the unnamed narrator thinks of himself as a lothario and tries to start a relationship with his wife's co-worker Donna, but this unravels when they stop at a bar and a "spade" named Nelson fresh from Vietnam propositions her and she shows some interest, saying later that she could have used the money he was willing to pay her. Though she is intrigued, the narrator is threatened and humiliated by this encounter and slinks home to his wife. His lothario days are not likely over, but this awakening will stay with him for things will keep falling, in the words of the last line of the story (*Short Cuts* 1993, 45). In "Will You Please Be Quiet, Please?" Ralph Wyman queries his wife Marian about an incident some years before in which she left a party with an acquaintance to get a bottle of liquor and came back later than expected. She never acknowledged that anything out of the ordinary happened, and the incident was dropped though not resolved until Ralph pushes her on this occasion and she admits to a sexual encounter. This revelation destroys the equanimity of their relationship and throws Ralph into a long night's journey of the soul but also opens a space for resolution, forgiveness, and love. In "So Much Water So Close to Home," the narrator Claire cannot get over the fact that her husband Stuart did not quit his fishing trip immediately when he and his friends found the body of a dead girl floating in the water. After he tells her of the circumstance, Claire keeps her physical and emotional distance, nurses her rage over a period of weeks, and suspiciously searches for some connection between the dead girl and Stuart. Stuart considers himself an innocent victim of Claire's outrage, and her misdirected accusations and negative emotions nearly destroy their relationship but finally begin to abate at the conclusion of the story, though with no certain result. In "A Small Good

Thing" Howard and Ann Weiss lead an idealized suburban life until their eight-year-old son Scotty inadvertently steps into the street on his way to school and is knocked down by a hit-and-run driver. His death throws both parents into despair and then into rage when the baker harasses them about not picking up an expensive birthday cake they had ordered for Scotty's birthday. Though devastated by their loss, their initially hostile encounter with the baker turns into affirmation and forgiveness as he apologizes and they put aside their anger and share bread and consolation. This is the most extended, gripping, sad, and yet redemptive of all the stories.

The last three stories and the concluding poem interrogate and even undo the guardedly optimistic trajectory of the first six, leaving open the issue of whether people can forgive and forget, learn from their experiences, go forward from an incident that threatens to undo them, or bring order to the chaos of their lives. In "Jerry and Molly and Sam," the main character Al feels his life coming apart with the threat of losing his job, telling too many lies to his wife Betty, paying more rent than he can afford, and being trapped in a liaison with Jill that he knows to be wrong. His way of putting his life in order is to get rid of Suzy, a dog that he hates, but his family relationship descends into turmoil over the dog's disappearance, and he must find her and bring her back. He hopes that his restoration of the dog will bring order and harmony, but his lack of self-knowledge, personal responsibility, and love for his family indicates that the dog is the least of his problems and that he himself is the greatest threat. In "Collectors" the narrator seems unable to stir himself to any kind of decision and waits for something to happen, which in some odd way does when the vacuum salesman Aubrey Bell comes to his house and cleans the rug and mattresses as a prize for Mrs. Slater, who might or might not be the narrator's wife. The story is, however, inconclusive about the identity of the narrator, his motivations, his deep inertia, or his future. In the most horrific of the tales, the "best friends" Bill Jamison and Jerry Roberts leave their wives (Linda Jamison and Carol Roberts) and families one Sunday, go drinking and playing pool, and then chase two girls on bicycles before Jerry ends up beating both of them to death with a rock. Though there is little to predict that Jerry could be so murderous, his dropping out of school in his senior year of high school to get married, working at undemanding jobs, and having a family too early leave him immature, claustrophobic, increasingly uncommunicative, vulnerable, and, in this case, murderous. This story moves from order, normalcy, and average American family lives to chaos, hostility, and horror in a brief moment and for no good reason or motivation. As Bill says, "He never knew what Jerry wanted. But it started and ended with a rock. Jerry used the same rock on both girls..." (*Short Cuts* 1993, 154). The poem "Lemonade" that concludes

Altman's collection of Carver's narratives shares this movement from stability to chaos with the stories, but with a much sadder and elegiac tone because the tragedy is caused by forces entirely beyond the control of any human. In it, the confident handyman Jim Sears loses his son in the river, is stricken with Parkinson's disease, and wants "nothing more now than to just die. But dying is for the sweetest ones. And he remembers sweetness, when life was sweet, and sweetly he was given that other lifetime" (*Short Cuts* 1993, 157). Peace is reserved for the dead, and turmoil and despair are the lot of the living, whether caused by other human beings or forces of nature.

The film adaptation

As Robert Self remarks, Carver wrote these stories over a period of years, devised various versions of them, and did not link or unify them (2002, 252), so Altman's choices and arrangement in his published collection of *Short Cuts* are arbitrarily chosen for his own purposes in the film to indicate how the characters cross paths, encounter their own and others' weaknesses, and find ways to go on with shattered lives.

Another interesting factor in this adaptation process is that, although Altman is listed as the director, three people were involved in assembling the stories and writing and producing the film. According to Tess Gallagher, Raymond Carver's wife in the last decade before his death, she, Altman, and the principal scriptwriter Frank Barhydt worked closely together in choosing the stories, interpreting them, and creating the film *Short Cuts*, though it was Barhydt who drafted the first version of the screenplay and Altman and Barhydt who then went on to write a second draft together. Altman had worked with Barhydt for many years, and both had a deep love and respect for Raymond Carver and his stories. The three worked well together for Gallagher knew all of Carver's materials and was flexible about the film medium, Barhydt had a good command of Carver's range of stories and language, and Altman had a keen sense of how to visualize the narratives.

This is a case, then, of a group of collaborating aficionados, an ensemble team, turning independent stories into an ensemble film. This postmodern breaking down of the author-auteur-adapter domain (reminiscent of what Roland Barthes and Michel Foucault both had to say about the death of individual authorial control), the assembling of the three-person writing and advising team, and the forming of a pastiche film create a postmodern loop which lessens or even denies authorial responsibility and in which origin and outcome are more or less indistinguishable.

Although the outlines of Carver's narratives remain in Altman's film adaptation, many of the characters' names have changed, the story lines have shifted, and the overall tenor is more cynical, contributing to the effect that Altman does not "pretend that the characters control their destinies" or that "their actions will produce a satisfactory outcome. He likes the messiness and coincidence of real life, where you can do your best, and some days it's just not good enough. [Altman] doesn't reproduce Raymond Carver's stories so much as his attitude" (Ebert 1993, 2).

All of the stories that Altman selected for the published edition following the film do appear in the film in some fashion, but the poem "Lemonade" does not. Yet, as Altman interestingly remarks, the poem is the founding document, "the basis of the whole picture." Moreover, he claims that the "Lemonade story is really a perfect example of what all the film is about…what all the stories are about. They're about those little crossroads that we constantly meet in our lives…and to try to figure out which one of those road branches got us to where the dilemma is, it's almost impossible" (Kaplan and Dorr 1993). In Derridean terms, the omitted "Lemonade" portion demonstrates the postmodern position fully insofar as what is apparently absent is wholly present.

Something that was clearly absent in both the short stories and poem but which is central to the film is the music and musicians (as had earlier been the case with Altman's Nashville and would be later in Kansas City) as a foil to characterization and dialogue. When Gallagher, Barhydt, and Altman drew the narratives together for the film, they incorporated music not just for a background musical score but as a fully conceptualized presence best seen in the cellist Zoe Trainer (Lori Singer) and her mother Tess Trainer (Annie Ross), a widowed jazz singer. The sensitive Zoe and her self-absorbed mother together introduce jazz (Annie Ross's singing) and American classical music (Singer's playing of the Victor Herbert Cello Concerto #2), adding a significant supplemental value to the narrative structure, themes, and characterization.

While both women love music, they choose wholly different forms and do not understand or sympathize with each other's preferences, but the importance of their characterization and preferences goes beyond that. As Krin Gabbard remarks, Tess is an improviser while Zoe needs scripts, and Tess wears her emotions on her sleeves while Zoe bottles hers up. These characteristics not only sum up their own remarkable differences, but those of the other characters in the film as well (2000, 143). Zoe's relationship to her mother is basically broken, as are other relationships in the film, and the music highlights that division even as it links several "short cuts," providing the "glue" that holds the scenes together (Gabbard 2000, 143). It also punctuates the American content and focus of the film and provides a way to interrogate high and popular culture in the United States, a key part of the contemporary postmodern agenda.

It is, then, especially noteworthy that Gallagher describes the entire construction of the film and the film itself in terms of music and especially in the rhetoric of jazz—an unusual way of describing the production of a film. This is fascinating rhetoric because she is so aware of the process of transforming one text to another that she feels quite comfortable jumping out of typical adaptation rhetoric into an entirely different semiotic system to signify the transformative powers necessary for a successful adaptation.

In this postmodern blending of semiotic systems, "both stories and film use the whole keyboard of human proclivities," and Gallagher remarks that:

> Altman and Barhydt's scripting keeps the calamitous momentum of action up all the way to the end by scooping up the characters in their separate quiverings in an earthquake. This is a step past the mock, symphonic finale of Nashville. The blues singing of Annie Ross as the widow Tess, played off the cello-undertow of Lori Singer, is also an Altman/Barhydt addition to Carver… (1993, 12, 13)

Of jazz itself and Altman and Barhydt working together, Gallagher further says:

> The two would perform variations like jazz musicians on the Carver stories, inventing their own characters to add to his, getting scenes onto colored note cards that let them visualize the wide mosaic on the wall behind them at the initial production office in Malibu. Once, on the phone, Bob and I had talked about how scenes could go more than one way. The scripting of the stories began to reflect this variability of direction. I mentioned to Bob in a follow-up letter that such exploration was deep in the spirit of poetry… (1993, 9)

The idea that Carver's short stories serve as musical notations upon which film makers create jazz-like riffs confirms the postmodern perspective that making a film depends upon multiple narratives and groups of people (rather than a single auteur) working together. In the "Introduction" that he wrote to Short Cuts, Altman himself remarks on this collaborative process and the unique product formed by that:

> We've taken liberties with Carver's work: characters have crossed over from one story to another; they connect by various linking devices; names may have changed. And though some purists and Carver fans may be upset, this film has been a serious collaboration between the actors, my co-writer Frank Barhydt, and the Carver material in this collection. (1993, 7–8)

Written in the same year, Gallagher riffs on collaboration and the necessary breaking of the original mold: "Altman and Barhydt broke the frames on the

stories and allowed the characters to affect each other's worlds or not, as if to suggest that we are both more 'in this together' *and* alone than we ever suspected" (1993, 9).

With its inclusion of music, multiple narratives, and calamitous action, this ensemble film has immeasurable surplus value, though

> behind, under and inside this script remain the nine short stories and one poem, "Lemonade," of Raymond Carver. His clarity and precision, the elisions of his characters' speech, the ways they glance off each other in conversation, bruise, circle, plead, lie or seek to persuade are unmistakably carried forward from Carver. As Frank is quick to acknowledge, much of Carver's dialogue was just too good not to use. But it couldn't simply carry at other times either. Film, as Frank puts it, is "wordier." Sometimes an action demands two lines in film where one serves on the page. Sometimes a written thought or attitude will take a series of actions to translate onto film. (Gallagher 1993, 9)

In this comment, Gallagher gets at the need for film adaptation to evoke the anterior work in some meaningful ways, but, as she goes on to say, the final product must have its own authenticity:

> What I keep admiring in this film script is the way the stories more than coexist. The failure of so many scripts of Carver stories by others I'd seen prior to the Altman/Barhydt project had been to stay so close to the originals that a robotic pandering to the text resulted. They were like someone ice skating with an osprey's egg on which the bird is still nesting. Nothing new came to the stories and they were damp with poignant silences. (1993, 9)

To this Altman himself adds that Gallagher "knew that artists in different fields must use their own skills and vision to do their work," so that a film must emerge as something unique in itself. He adds, "cinematic equivalents of literary material manifest themselves in unexpected ways" ("Introduction," 1993, 8).

Other than the supplemental inclusion of music and musicians and the way they affect characterization and cohesion, another important thing to notice in the film's "cinematic equivalent" of Carver's stories is that the location changes from various small town and rural settings of west-coast California, Oregon, and Washington to suburban Los Angeles. This supplementation is an impoverishment of the rural and a surplus of the urban, though without positive or negative valences. Setting thus becomes an anchor for the

film, much like Altman's earlier *Nashville*. Christine Geraghty stresses the importance of "space" and "landscape" in her study of successful film adaptations (2008, 7), and this is borne out in *Short Cuts*. Setting helps to bring together the diverse and unrelated narratives and subplots of this film, so that the characters brought forward from the written accounts inhabit the same geographical space and environment and can "cross paths" even while the kernels of the stories of their lives can be kept more or less as Carver had them. As Silvey remarks, contemporary ensemble films such as *Magnolia, Crash*, and *Short Cuts* that incorporate a whole range of characters and subplots without a main plot

> feature an assembly of individual characters, each initially strangers to one another. We follow scenes from their personal lives, but as the films proceed we are shown how these strangers often unwittingly affect each others' lives both in the public and private domain. Their personal dilemmas mirror one another's and they often cross paths with one another on the street. In effect these interconnections, unrecognised by the characters but displayed for us, prompt us to consider the world as a map or system wherein we each are related to one another whether we are conscious of it or not. (2009, 2)

Silvey sees these as "network narratives" and "cognitive mappings" projecting the world as interconnected though fluid. This is akin to Altman's perception of Los Angeles as a freeway connecting suburban towns:

> One of the reasons we transposed the settings from the Pacific Northwest to Southern California was that we wanted to place the action in a vast suburban setting so that it would be fortuitous for the characters to meet. There were logistical considerations as well, but we wanted the linkages to be accidental. The setting is untapped Los Angeles, which is also Carver country, not Hollywood or Beverly Hills—but Downey, Watts, Compton, Pomona, Glendale—American suburbia, the names you hear about on the freeway reports. ("Introduction," 1993, 9)

These towns do not form a tightly knit community but have linkages that the highway brings.

These suburban communities are not restricted to one street or one kind of dwelling, but incorporate the following: the trailer house of the Piggots; the apartments of the Bushes and Stones; the condominium of the Trainers; the modest homes of the Shepards, Weathers, Kanes, and Kaisers; and the upscale homes of the Finnigans and Wymans. It also includes various work

environments, ranging from Andy Bitkower's bakery to Doreen Piggot's diner, Ralph Wyman's hospital, Marian Wyman's studio, and Howard Finnigan's broadcasting center. In addition, there are a number of different streets, road networks, and recreational environments, including city parks and more remote fishing areas. In these towns and networks, there are clear divisions of income, race, and culture that threaten to fracture the relationships at every turn. These are more than the idiosyncrasies that Altman noticed of Carver's stories or the small things that forever change things; they are major fractures and fault lines that threaten to split the characters' lives and the city's existence.

While Los Angles may provide the background and point of connection for disparate characters, Hsuan L. Hsu argues that ensemble films such as *Short Cuts* often use Los Angeles to focus on particular issues and approaches because it has assumed a certain dark cultural profile and symbolic value in previous films. Thus, the use of Los Angeles intertextually references a range of noir and edgy films that have gone before:

> LA ensemble films focus more exclusively on interpersonal, sexual, and psychological issues. They also share a fascination (at least at a superficial level) with class stratification and racial tension, the mundane perils of driving in LA, and the unifying terror of the city's natural disasters. Thus, Short Cuts is bookended by a Medfly epidemic and an earthquake. (2006, 133)

As intimated, this persistent image of a risky, dangerous Los Angeles owes something to its representation as a "dark" city in Raymond Chandler's detective fiction and noir and neo-noir films such as *The Big Sleep*, Altman's own *The Long Goodbye*, and *Chinatown*.

Because each cluster of characters has its own story or plot—however much they overlap, it is suburban Los Angeles itself that becomes the focus, unifying agent, and raison d'être. If anything, this strategy makes the narratives relevant to the film audiences who in the latter part of the twentieth century are more urban and less rural or small town than they were in Carver's own period, so this adaptation brings those stories up to date. The urban setting also allows for discrepancies and interactions of class and income in ways that the short stories individually might not. The noir element, however, suggests that the city remains what it was when noir was first conceptualized in an earlier period of Los Angeles.

Another characteristic that sets the film aside from the stories but builds upon their conceptual arrangement is the "calamitous" beginning and end

(Gallagher 1993, 13) that generates a sense of postmodern anxiety. The film begins with a swarm of helicopters flying in formation over Los Angeles spraying insecticide for Medfly and with the television media's and various characters' responses to this. As Vincent Canby notes of this apocalyptic opening, "the helicopters menace as they pretend to protect. Their rotors chop the air and puncture the eardrums. With bright red and green wing lights ablink, the machines have the cold precision of android policemen, waggishly festooned" (1993, 1). These helicopters share some of the same characteristics as those in *Apocalypse Now*, reinforcing a sense of barbaric and chaotic human conflict. The film ends with an earthquake, once again with the response by characters and the media. The earthquake occurs at the same time that one of the characters bludgeons another to death. These are threatening and brutal events, the one socially and culturally induced and the other an act of nature, but both impacting on the lives of the characters, creating anxiety and altering their lives forever. Both contribute to a far more threatening and ominous tone than in the stories.

The film's use of the helicopters and choice of the phrase "war on the Medfly" (*Short Cuts* script 1993, 19)[1] establish Los Angeles as a battle zone in which the characters react to each other and this external threat. In just a few minutes of the opening, the film introduces the principal characters, their households and workplaces, their occasional interactions, and, in several instances, their reactions to "the war."

Covering the spraying of Melathion is Howard Finnigan (Bruce Davison) of the local television station, and the camera follows him from his coverage to his comfortable home with his wife Ann (Andie MacDowell) and eight-year-old son Casey (Zane Cassidy).[2] Next, the camera goes to the concert hall, where Claire and Stuart Kane (Anne Archer and Fred Ward) and Marian and Dr. Ralph Wyman (Julianne Moore and Matthew Modine) listen to Zoe Trainer playing the Trout Quintet on her cello.[3] Next, the camera focuses on Lois Kaiser (Jennifer Jason Leigh) carrying on a pornographic conversation while she takes care of her small children; her husband Jerry (Chris Penn), who services swimming pools, covers his car to protect it against the Medfly spray and comes into the house,

[1] When I am citing from the film script of *Short Cuts*, I will do so as "*Short Cuts* script" and will do so for ease of reference. Where there are discrepancies with the film, I will cite the film's dialogue.
[2] Ann, Howard, and Casey Finnigan are drawn from the characters of Ann, Howard, and Scotty Weiss in "A Small Good Thing."
[3] As mentioned previously, the characters of Zoe and Tess Trainer are not drawn from Carver's fiction. Marian and Ralph Wyman are based on character of the same name in "Will You Please Be Quiet, Please," and Claire and Stuart Kane are based on characters of the same name in "So Much Water So Close to Home."

overhearing his wife's pornographic conversation and watching with apparent disinterest but really suffering acute agitation and ongoing emasculation.[4] Meanwhile, Earl Piggot (Tom Waits), whom the camera has followed down the highway under the roar of the helicopters, parks his limo at the 24-Hour Café to see his wife Doreen (Lily Tomlin), who works as a waitress. Serving as a counterpoint to these glimpses, Tess Trainer sings "Prisoner of Life" at the local jazz club.[5] Bill and Honey Bush (Robert Downey Jr. and Lili Taylor) meet at the jazz club with their African American neighbors, Jim and Harriet Stone (Michael Beach and Andi Chapman), to go over their responsibilities of feeding the fish and minding the apartment while their friends go on vacation.[6] Finally, the camera focuses on the Shepard household in disarray as Gene and Sherry Shephard (Tim Robbins and Madeleine Stowe) shut the windows and doors to prevent the spray from coming into their house and quarrel about bringing the dog Suzy in the house to protect her from the insecticide. Arrogant and loud, Gene stalks out for the evening.[7] A little later, after revisiting some of the first characters, the camera focuses on one of the helicopter pilots, Stormy Weathers (Peter Gallagher), who is separated from his wife Betty (Frances McDormand) but tries to connect with his son Chad (Jarrett Lennon).[8]

These opening shots sandwiched together with the aggressive helicopters present disconnected, exterior, mundane images of the city, surrounding areas, and relationships, which are then replaced by interior, more realistic and dark portrayals that establish connections between characters but hardly a sense of community. This sense of a war zone is something that was not accomplished by the fiction and raises a pervasive sense of anxiety.

This sense of anxiety is somewhat mitigated by commonalities of American domestic and work life—Claire and Stuart Kane go to dinner at Marian and Ralph Wyman's home, Ralph is the doctor who cares for Casey after he is knocked down by Doreen Piggot's car, Sherry Shepard is the sister of Marian Wyman, Gene Shepard is having an affair with Betty Weathers, Claire Kane and Ann Finnigan go to the same baker Andy Bitkower (Lyle Lovett) at the same time though without communicating, Tess and Zoe Trainer live next door to the Finnigans, and Jerry Kaiser services both of their swimming pools the day after the helicopters spray the area, and so on. This is the rhythm of a

[4] Jerry and Lois Kaiser are based on Jerry and Carol Roberts from "Tell the Women We're Going."

[5] Earl and Doreen Piggot are based on Earl and Doreen Ober of "They're Not Your Husband."

[6] Bill and Honey Bush and their vacationing neighbors, Jim and Harriet Stone, are based on Bill and Arlene Miller and Jim and Harriet Stone of "Neighbors."

[7] Gene and Sherry Shepard and the dog Suzy are based on Al and Betty and the dog Suzy of "Jerry and Molly and Sam."

[8] Stormy Weathers and his ex-wife Betty are based on the unnamed narrator and Mrs. Slater of "Collectors."

suburb where people bump into each other both randomly and intentionally and share certain relationships without anyone being known to everyone or being intimate.

This sense of anxiety is also mitigated by a positive cultural landscape in some of the opening shots. Zoe Trainer enjoys playing the cello in concert, and the Wymans and Kanes like listening to that concert and making arrangements to get together some evening for dinner—though their income, occupations, and interests are at variance. Tess Trainer takes pleasure in singing at the jazz bar, and the audience delights in her dusky tones and the club atmosphere. Bill and Arlene Miller show neighborly consideration in meeting with Jim and Harriet Stone who are going on holiday and need someone to take care of their fish. These activities bring people of diverse backgrounds and incomes together in the city in a more or less harmonious way—though it is mainly illusory.

Much of this provisional elegiac tone is based on the Finnigan and Stone families. Howard and Ann Finnigan get along well together and with their son Casey and do not want for physical or emotional resources. Howard is a prominent news anchor and cares deeply for his family. A racially integrated couple, Harriet and Jim Stone are hardworking, neighborly, and have a stable relationship, though they are seen only briefly.

Other relationships, such as those of Bill and Honey Bush, which seem initially stable, later show fault lines as the film exhibits more gritty realism. When trying on the clothes of Jim while he is away on holiday, and when becoming aroused by making up his wife as a battered victim and taking her picture in the Stones' apartment, Bill is clearly in psychological jeopardy. Similarly, while Doreen and Earl (Honey's parents) initially seem happy together, she has had to put up with his alcoholic binges and physical abuse in the past and now has to cope with his insensitive comments on her weight. Money is an issue for them. Then, too, it is Doreen who accidently hits Casey with her car and, while she is repentant and wants to take the little boy home, she fails to report the accident to the police, so she becomes a hit-and-run driver responsible for the boy's death. She is not a mean woman, however, and the film does not project blame on her. The most disastrous of the relationships is that of Gene and Sherry. An unethical policeman, Gene has carried on a number of affairs besides that of Betty Weathers. His wife knows of these but does not really care, either about the affairs themselves or Gene, so there is no emotional or spiritual center to their relationship. Many of these are cynical, self-serving people, and their portrayals are close to the bone of Carver's fiction as the characters barely keep themselves in check.

As Gallagher remarks, the film has "reverberating themes of infidelity, denial, sexual exploitation, the alcoholic merry-go-round, irrevocable loss in

the death of a child, anonymous and grotesque death in the neglect of the [drowned] woman...and the disappearance of certain characters into fantasy" (1993, 12), and these reflect the short stories. One thing that brings these stories together is the way that the characters' truths, realities, and little worlds—their "verities" as Gallagher has it (1993, 9)—give way so suddenly. Living "on the precarious rim of possibility," they undergo "the dive and swoop of fortune which takes us a step beyond mere courage to that helpless place we all hit at some point where we realize anything could and does happen..." (Gallagher 1993, 9). As one person and couple after another risks exposure, ruptures relationships, experiences pain and loss, endures suffering, and feels emotional paralysis, any notion of an ideal suburban culture, family, or work environment disappears and is shown to be little other than an American myth. The existence of so many characters suffering from various problems adds a collective weight to the film that is not there in the fiction. Moreover, what the film shows is that so many of the characters' actions are trivial, and yet they have serious consequences for themselves and others not because of social or divine plans, but because of chance and luck. Casey is the nicest kid, but it is bad luck that he does not think for a moment and walks in front of Doreen's car. It is also bad luck that Doreen, a really nice woman, happens to be driving her car when Casey walks in front of it. Yet, both suffer from it. Casey dies, his parents are distraught (see Figure 2.2), and, although she is unaware that she has killed Casey, Doreen worries about the boy and about getting caught.

There are times when some kind of justice—human or divine—would seem to demand that certain characters are pulled up short in their lives. The policeman Gene is such an arrogant loud mouth, so unfaithful to his wife, and

FIGURE 2.2 *The Finnegans (Jack Lemmon, Andi MacDowell, and Bruce Davison) at Casey's Bedside in* Short Cuts.

so callous toward his family that the narrative calls out for retributive justice that will not come. For him life will likely continue as it has, and he will never come to any particular awareness of his failings and ways to redeem himself.

In other cases, too, justice should be better served. The little boy Casey does not deserve to die, and Ann and Howard Finnigan do not deserve to have their lives ripped apart by his loss. They also do not deserve to be harassed by the baker over their failure to pick up the cake. Still, Gallagher speaks of redemption in these tales. As she remarks,

> In Altman's film, as with Ray's stories, the questions *are* the redemption. What we do with our recognitions, once we gaze into their harsh and tender mirrors, is really on our own ground, outside both the stories and the film. That's the provocative nature of art itself. It says what *is*, as honestly and truly as it can envision it. On this count both Altman and Carver are relentlessly true. They both reach these truths lyrically. Altman's lyricism works by dislocating the narrative, by jump-starting it, by allowing it to love its lost causes even as it leapfrogs them onto the wet cement of the next enormous instant. (1993, 14)

For Gallagher redemption comes from the self-questioning that the characters and the audience undergo, which can lead to constructive ways of dealing with the crises. The "redemptive interior voices" offer a look at the exposed souls of these "baffled Middle–American characters" (Gallagher 1993, 11–12). The baker and the Finnigans are perfect examples of that for, when the baker apologizes profusely, they accept it and shore up their loss with fellowship and food. The same is true of the Wymans. Once the truth of Marian's infidelity is on the table, despite the emotional wrenching Ralph feels, they seem to come together in a tentative way through Marian's showing how much she cares for him and how far behind her the infidelity really is. In the case of Claire and Stuart Kane, she does not accept his explanation and reasons even though they ring of honesty, so she makes life difficult for him and may well abort their relationship. Questioning reality and putting the truth on the table can—but may not—lead to self-interrogation and acts of redemption. Certainly they may not lead to kindness and grace, though these too might be possible.

In brief, as an ensemble film, *Short Cuts* does not have the kind of unity of action and plot that an audience often expects of Hollywood. Still, the conception and unity of place carry the action forward so that some of the characters meet and some do not, but they all bump along on the streets of Los Angeles and road of life, having their assumptions and realities constantly tested and have to continue on anyway. The characters often repeat their

mistakes, and the mistakes of one family somehow replicate those of others, creating a sense of meaningless surplus that effectively undermines causation, teleology, and personal responsibility. Here surplus and supplementation magnify the problems of the human condition and undermine any sense of self-control.

The ensemble film emphasizing a strange and chaotic relationship between connected and disconnected lives is in itself a postmodern technique of supplementation. The film shows how interesting Altman's, Barhydt's, and Gallagher's collaborative and multiplicitous adaptation can be, and it also indicates how an ensemble film goes beyond the limitations of the short story form in creating this complex web of human relationships in an American city. Aside from the postmodern analytic of origin in relation to adaptation, the content of the film is also postmodern in its depiction of an angst-ridden society where people have little control, do not function rationality, lack a spiritual center, and are victims of government and nature.

To conclude this chapter on adaptation, surplus value, and supplementation, it is fair to say that the film adaptations of *Six Degrees of Separation* and *Short Cuts* both exceed and supplement their originals—whether newspaper accounts, dramas, or short fiction—in scope and complexity. A significant part of this complexity is the *mise-en-scène* itself: instead of Guare's minimalist stage set, the film adaptation of *Six Degrees* uses a number of elegant rooms in the Kittredge household, various restaurants and hot spots around the city, as well as a profile of New York City itself through panning shots from above; instead of small Northwest towns and rural settings, *Short Cuts* chooses various suburban sites in Los Angeles, emphasizing the huge discrepancies in educational background and class structure of the characters and drawing on other filmic presentations of a film-noir city. In both cases the cities nearly become characters and personalities themselves, which is something that the anterior sources do not show.

Added to the *mise-en-scène* is the increasing complexity—rather than simplification—of the plot along with its refusal to put forward a Hollywood ending. A newspaper account has difficulty providing the motivation for the people it mentions, and it cannot elaborate on the intimate lives of those that are only touched in the original. Similarly, in drama and short fiction, much of the action must be demonstrated by rhetorical innuendo; in films thoughts can be indicated by the small details of characters' expression, but can arguably more effectively use the visuals of setting, landscape, and action—to say nothing of the musical score and presence of musicians as characters. Traditional adaptation critics might see these as missing the subtle nuances of the original, hence deprivation and loss, but clearly a surplus value is gained by these other semiotic forms.

These film adaptations enter into a dialogue with their originals interrogating and decentering their originary meaning, allowing the freeplay of textuality that brings new meaning to the adaptations and to the anterior forms as well. This freeplay is also a characteristic of novels themselves, as demonstrated by F. Scott Fitzgerald's *The Great Gatsby* which carries on a structural intertextual dialogue with Wharton's *The Age of Innocence*, something that also happens with their several film adaptations as well, including that of Martin Scorsese's *Age of Innocence* relationship with Jack Clayton's and Baz Luhrmann's versions of *The Great Gatsby*, but especially with his own *Gangs of New York*, which scripted and produced in ways that interact with each other to bring home new intercultural significance and intertextual meaning.

3

Intertextual doubling in *The Age of Innocence, Gangs of New York,* and *The Great Gatsby*

As Roland Barthes, Julie Kristeva, Jonathan Culler, and others point out, intertextuality goes well beyond linking a single text to its origin, but allows for the complete range of textual relationships within culture, resulting in historical discontinuity, indeterminacy, decanonization, and fragmentation. One special way in which intertextual relationships are developed is that of intertextual doubling in which rhetorical terms and images are subtly repeated from text to text creating unexpected links, altering expectations, and resulting in radically revised meaning. As Graham Allen argues:

> We can see that from its beginning the concept of intertextuality is meant to designate a kind of language which, because of its embodiment of otherness, is against, beyond and resistant to (mono)logic. Such language is socially disruptive, revolutionary even. Intertextuality encompasses that aspect of literary and other kinds of texts which struggles against and subverts reasons, the belief in unity of meaning or of the human subject, and which is therefore subversive to all ideas of the logical and unquestionable. (2000, 45)

Thomas Leitch calls this "colonization" (2007, 109), and Kamilla Elliott calls it a "ventriloquist concept" in which adaptation "blatantly empties out the novel's signs and fills them with new filmic spirits" (2003, 143).

Culler sees this concept of intertextuality as socially disruptive, but finds that particularly true where metaphor is concerned: "the value of the metaphor, the value of our experience of the metaphor, lies in its innovatory, inaugural force. Indeed, our whole notion of literature makes it not a transcription of preexisting thoughts but a series of radical and inaugural acts: acts of

imposition which create meaning" (1981, 39). Intertextuality, then, particularly when embedded with metaphor, is the "inaugural" force and "imposition" of new textual significance. Closely related or filiated texts (Barthes 1977b, 160) might be the most aligned and stabilizing in their use of metaphor, but Barthes opts for a more radical hermeneutic, arguing that metaphor becomes revolutionary through intertextuality.

Because of the history of adaptation criticism, there is the temptation to judge films on the basis of likeness in content, style, and meaning between filiated texts, but intertextuality is more about innovative and revolutionary ways of perceiving textuality, cultural matrices, and emergent meaning. Indeed, one way of looking at the process of intertextuality is that, in identifying the discursive similarities and differences in texts, both the anterior texts— originary texts and cultural textuality in general—and adaptations undergo a transformation in their cultural construction. As Allen notes in integrating his own understanding with Kristeva's *Revolution in Poetic Language*, "Intertextuality is thus understood as 'the passage from one sign system to another' which involves 'an altering of the thetic *position*—the destruction of the old position and the formation of a new one'" (2000, 53). When certain signs and sign systems are repeated or doubled, that very process can open up and destabilize intertextual relationships and systems of meaning.

This process is especially true in the adaptation of Edith Wharton's novel of the gilded age, *Age of Innocence*, by well-known auteur Martin Scorsese. This film is a fairly faithful adaptation of Wharton's novel, but it was followed by an adaptation of Herbert Asbury's *Gangs of New York* that was not faithful or traditional. Wharton's semi-autobiographical novel concerned the New York elite beginning around 1870, and Scorsese focused on this white, upper-class society in the same way she did, drawing the dimensions of his characters and language according to her specifications, even to the extent of using Wharton's original language in Joanne Woodward's voice-over. By contrast with Wharton's tightly structured novel, Asbury's original text was comprised of highly sensationalized, anecdotal accounts of the history, culture, poverty, and crime of the Five Points area of New York City, and Scorsese sets it first in 1844 and then focuses on the period leading up to and including the Civil War draft riots of 1863. Asbury's account did not have a fictional plot as such and did not cohere in a particular historical fashion, so the film adaptation of it was of necessity a loose one knit together by the entirely fictional relationship of Amsterdam (Leonardo DiCaprio), Jenny (Cameron Diaz), and Bill the Butcher (Daniel Day-Lewis).

What Scorsese does with these two films is especially interesting and innovative intertextually: not only does he adapt two different texts written from the 1920s for two films that explore the widely divergent cultural

enclaves of related historical and geographical areas of nineteenth-century New York City, but his film *Age of Innocence* self-consciously provides a second "source" for metaphor in his treatment of *Gangs of New York*, raising intertextual questions about "original" sources.

This textual pluralism is part and parcel of the play of postmodernism, for, Todd Gitlin notes, intertextual doubling "consistently splices genres, attitudes, styles. It relishes the blurring or juxtaposition of forms (fiction-non-fiction), stances (straight-ironic), moods (violent-comic), cultural levels (high-low). It disdains originality and fancies copies, repetition, the recombination of hand-me-down scraps" (1988, 35). In this way, the intertextual doubling or augmenting of one novel, one work of nonfiction, and two films informs the interplay of *Gangs of New York* and *Age of Innocence*.

Moments of marked intertextuality become the pivotal points to understand the narrative arguments in works that correspond closely, and in *Gangs of New York* and *Age of Innocence*, these moments especially depend upon the rhetorical repetition of the metaphor of "tribes."

Based on Edith Wharton's novel *Age of Innocence* that shows the elegance and ruthlessness of late nineteenth-century American culture, the film indicates to what extent the dominant figures in New York society were a self-absorbed and oppressive class-bound "tribe" who loathed to let their members depart from the social codes that were in place. *Gangs of New York* looks at nineteenth-century New York through the eyes of the Irish underclass and deliberately picks up the metaphor of tribes. Grounded in Herbert Asbury's lurid historical account, the film weaves a tale about the conflict between the nativists and the Irish immigrant tribes that is at the margins of adaptation— very nearly citation in its loose treatment of the original subject matter. Still, both of these films are true to the originary documents in spirit and play off one another, indicating how New York can become the home to very different tribes and class structures that seem hardly to touch each other's existence until upset by some great ethnic and racial cataclysm. In depicting different New York City classes, the films play off against each other, revealing the deep abysses within culture but also showing to what extent upper-class and lower-class tribes share a cultural identity not only in the nineteenth century but now as well.

Scorsese's decision to focus on the notion of tribe is particularly interesting in view of Samuel Huntington's article "The Clash of Civilization?" that came out the same summer as the film adaptation of *Age of Innocence* and stressed the problematic of tribalism, arguing that "the dominating source of conflict will be cultural" in the "conflicting pulls of tribalism and globalism" (1993, 22). Tribalism seemed then, as it is now, to be on people's minds as a regional, national, and international problem.

This repetition of "tribes" becomes "symptomatic," as *Freud* and Derrida would say, of particular psychological and textual repressions and, therefore, stresses both in the individual and national psyches. By doubling intertextual tropes in this fashion, the films pull up to consciousness episodes from a time that culture would rather forget—but does so at its own peril.

If *Gangs of New York* helps to undercut the upper-class tribalism of *The Age of Innocence*, so does F. Scott Fitzgerald's novel *The Great Gatsby* and its film adaptations by Jack Clayton and Baz Luhrmann. Though a generation apart, Wharton and Fitzgerald were acquaintances, and both respected the other's fiction: this is especially true of Fitzgerald's attitude to Wharton's writing. Despite the fact that both novels were set in New York City, no one has made the case that *The Great Gatsby* was indebted to *The Age of Innocence* in vocabulary, setting, themes, and structure. Yet, I argue that this seems to be the case, but in an ironized way, with Nick Carraway, Jay Gatsby, and Tom and Daisy Buchanan, among others, undoing the tribalism that held old New York clans together in the 1870s but not with the creation of a more progressive society. By picking up vocabulary of *The Age of Innocence*, revisiting themes of family responsibility and social duty as well as the perils of the outsider and the self-delusions of the protagonist, and positioning the narrative on a series of dinners and parties, Fitzgerald nods ironically in Wharton's direction. This ironized intertextual doubling makes it clear that there is no going back to any nostalgic affirmation of the values of old New York society, but it also cannot wholly reaffirm what has happened with the rise of great financial empires, shocking displays of wealth, and rampant individualism. The freedom to throw over the shackles of tradition that Newland Archer wistfully hoped for in *The Age of Innocence* have not made a kinder, better, and more tolerant city.

This is also true of Clayton's and Luhrmann's adaptations, both of which stress Gatsby's and Daisy's love affair but which, if anything, play on the party structure and motif even more than did Fitzgerald's and Wharton's novel. The parties themselves, then, provide structure, metaphor, and meaning for this ironized intertextual doubling.

Tribalization as intertextual symptom: Scorcese's *The Age of Innocence* and *Gangs of New York*

February 26, 1993, and September 11, 2001, are etched in the American consciousness as the dates that terrorists first bombed and finally brought down the World Trade Center in New York City, but few people realize that two

of Martin Scorsese's films set in New York City, *The Age of Innocence* and *Gangs of New York*, are intertextually marked with those events. *The Age of Innocence* was released on September 17, 1993, a few months after the initial bombing, and *Gangs of New York* was to have been released on December 21, 2001, shortly after the terrorist attack, but was delayed almost exactly a year because the release of such a violent film about a city in distress would be considered inappropriate. As Miramax spokesman Harvey Weinstein remarked,

> Our decision to postpone the film's release is based on its setting in downtown Manhattan during the Civil War in the midst of the 1860's draft riots—one of the most difficult and challenging times in American history. In light of the ever-changing current events, we have chosen to err on the side of sensitivity and postpone the wide release of the film until 2002. (Grossberg 2001)

It is no doubt coincidence that *The Age of Innocence* and *Gangs of New York* share this historical stage and cultural textuality in such a pronounced way, but they are also intricately bound up in some of the root causes for the terrorist attacks because both of them address the negative effects of tribalism and ethnicity in the United States over such a long period of time. As such, tribalism becomes a metaphor or "symptom" of a larger American problem, and an awareness of it pushes the United States to a new understanding and perhaps "cure." It is this aspect that marks the film adaptation of both *The Age of Innocence* and *Gangs of New York*.

In *Now a Major Motion Picture: Film Adaptations of Literature and Drama*, Christine Geraghty argues that transformations from literature to film are not just "words to image" but also "space and landscapes" that transform and re-imagine New York's cityscapes in Scorsese's films (2008, 7). To that, following Derrida's line of thought, should be added the particular tropes that are used in regard to the City because they are visual and ideological.

In "Force and Signification," Jacques Derrida asserts "metaphor in general [marks] the passage from one existent to another, or from one signified meaning to another" (1978, 31–32), and, in "Freud and the Scene of Writing," he undoes this "passage" by noting that metaphors are "symptoms" of repressed ideological conceptions, unrecognized differences, and unarticulated issues. He finds it necessary to discover "the *symptomatic* form of the return of the repressed: the metaphor of writing which haunts European discourse, and the systematic contradictions of the ontotheological exclusion of the trace. The repression of writing as the repression of that which threatens presence and mastering of absence" (Derrida "Freud" 1978, 247).

The use of "tribe" in *The Age of Innocence* and *Gangs of New York* thus is not just a metaphor for kinship relations but of cultural traces and symptoms of something veiled and repressed which needs to be uncovered and disclosed to augment reassessment and inaugurate change. Because the term is used both with reference to the rich in one film as well as the immigrant poor in the other, the term has a profound intertextual doubling that calls special attention to the repressed. Here that repressed includes a current memory loss of the appalling divide between wealth and poverty that brought on the violence and immigrant warfare of the 1860s and 1870s New York City, and, more importantly, of "otherness," exclusion, and racism that blacken the heart of American democracy.

This use adds to the sense of New York and its people as a "layered city" simultaneously "fractured and interlocking" (Geraghty 2008, 172). In support, Peter Marcuse notes that American cities consist of luxury areas inhabited by the rich, gentrified professionals, the tenements of the unskilled workers, and the abandoned areas inhabited by the homeless and miserably poor (2002, 94–114). Unlike other large urban areas, however, in New York City these often were not widely separated in the development of the city and had random ways of overlapping. This is also the case in the contemporary configuration, giving the film viewer glimpses of "true stories" (Leitch 2007) that surface in the film.

The film *The Age of Innocence*, based directly on Edith Wharton's novel of the same name, looks closely at the 1870s "old New York gentility" (Wharton 1996, 7), who lived above 34th Street between Broadway and Fifth Avenue.[1] Armed with soft-spoken assurance, taste, and elegance, they stuck closely to and protected the community that gave them strength, ways of thinking, and codes of conduct and dress. Indeed, Joanne Woodward's third-person voice-over in the film refers to these American blue-bloods as a "tribe," picking up Edith Wharton's rhetoric of the novel and suggesting, among other things, that these wealthy New Yorkers lived in the same area, prided themselves on being ethnically and racially similar, married one another, shared particular rituals and customs, and closed ranks in defending their collective rights, privileges, and social identity. They were, according to Wharton, a "social race" whose "inscrutable totem terrors [were similar to those] that had ruled the destinies of [their] forefathers thousands of years ago" (1996, 4, 296). Part of their totem terrors is based on heritage and racial purity for Wharton links the beautiful and bohemian Ellen Olenska (played in the film by Michelle Pfeiffer) to the

[1] Ellen Olenska lives on West 23rd Street, considered too far downtown to be fashionable and away from the danger posed by newly landed poor Europeans (Wharton 1996, 55). Indeed, one of the characters, the journalist Ned Winsett, calls it a "slum" (Wharton 1996, 100). I am citing the novel here and other places for ease of reference where there is no verbal discrepancy between the novel and film.

"anti-immigrationist sentiment contemporaneous to this novel" (Bauer 1994, 171), suggesting a triple reinforcement of ethnic exclusion and anti-immigrant, nativist sentiment in the nineteenth, twentieth, and twenty-first centuries.[2] It would be too strong to say that Mrs. Catherine Mingott (Miriam Margolyes), the central matriarch (see Figure 3.1), her progeny, and their network of relations were vicious or violent[3] in enforcing their rules, but the protagonist Newland Archer (Daniel Day-Lewis) called it an "armed camp" (Wharton 1996, 277), and Ellen's infractions clearly caused great alarm, resulting in censure, isolation, and rejection. These were cultural and psychological battles, which bore a resemblance to armed conflicts.

The 2002 film adaptation of *Gangs of New York* is set just a few years earlier in 1862 (though it opens in 1844) and explores the battles of Irish, Italian gangs, and nativist gangs in downtown New York around Five Points, roughly between city hall and Canal Street.[4] Both immigrant and anti-immigrant gangs

FIGURE 3.1 *Mrs. Mingott (Miriam Margolyes) as the head of the New York tribe in* The Age of Innocence.

[2] In the nineteenth century from the 1840s (the beginning of *Gangs of New York*) to the turn of the century (the end of *The Age of Innocence*), the 1920s (1920 for the publication of Wharton's account and 1928 for Asbury's account), and 1993 and 2001 for the attacks on the World Trade Center.

[3] In an interview for the trailer of the film, Daniel Day-Lewis calls these wealthy New Yorkers violent. One of my colleagues, Dr. Maureen Sabine, called Mrs. Mingott's painting of the savage Indian attacks hanging on her walls as an indication of the hidden violence in this family's dealings with each other.

[4] According to Frances Carle (Asbury) (2014, np), "the most wretched of New York City's slums in the 1800's (sic) was an area called Five Points, named for the five points created by the intersection of Anthony (now Worth), Orange (now Baxter), and Cross (now Park) Streets. The area formed a 'truncated triangle about one mile square' and was 'bounded by Canal Street, the Bowery, Chatham' (now Park Row), 'Pearl, and Centre Streets.' Paradise Square, a small triangular park, was located between Anthony (now Worth) and Cross (now Park) Streets and converged into Orange Street (now Baxter). These slums no longer exist, having been replaced by city, state, and federal courthouses and the area known as Chinatown" (Asbury 1928,3–4).

are courted and to some extent controlled by Boss Tweed (Jim Broadbent) and other corrupt Tammany Hall politicians, who line their pockets with revenue from this wretched area of bars, brothels, and filthy tenements. In absolute terms, Five Points is not that many streets from those of uptown bluebloods,[5] and these disparate groups would not have been able to ignore each other completely, though a world apart in privilege and influence. This is especially true because in 1811 De Witt Clinton's New York City commission deliberately laid out a grid plan to enact a democratic city where the classes could not hide from each other, though it could not eliminate tribalism. The narrative lens of this film, Amsterdam Vallon (Leonardo DiCaprio), three times refers to downtown Irish, Italian, and nativist gangs as "tribes," echoing the rhetoric of *The Age of Innocence* (see the gathering of the tribes under Vallon in Figure 3.2).

These references to tribes did not appear in Herbert Asbury's 1928 historical account, *Gangs of New York*, on which the film is loosely based.[6] In fact, there is precious little in Scorsese's *Gangs of New York* that was taken directly from Asbury's account. As Linda Cahir remarks,

> When Scorsese made Asbury's compendium into the film *Gangs of New York* (2002), he did so by conceptualising the pith of Asbury's work; by

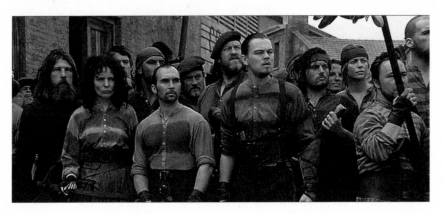

FIGURE 3.2 *Amsterdam Vallon (Leonardo DiCaprio) and his Irish tribe in* Gangs of New York.

[5]Newland Archer's father-in-law, Mr. Welland, has his eye on a house on East 39th Street close to what is now Times Square, a "neighbourhood… thought remote" (Wharton 1996, 58) because it is too far uptown.

[6]Linda Cahir (2006, 30–35) has a useful case study of Scorsese's adaptation of Asbury's *Gangs of New York*, and she begins it by noting that the original *Gangs* is largely a "sketch book" and therefore virtually "unfilmable."

getting at the heart of Asbury's subject; by doing so with evident technical skill; by audaciously omitting the largest portion of Asbury's writing, while preserving its integral elements; and by including characters and incidents that were never in Asbury's book. In short, Scorsese succeeded in translating Asbury's potentially unfilmable work by creating a radical translation of Asbury's work. (2006, 30)

Cahir further remarks that, while very little was directly taken from the book, "the film remains faithful to the book's fascination with the times, to its regard for history and historical minutiae, to the book's understanding of human nature, to its unflinching rendering of situational violence, and to its commitment to expose the political and ethical corruption engendered by the unremitting poverty of New York City's Five Points area" (2006, 31). This is precisely what Geraghty argues (2008, 184–189). In other words, Cahir and Geraghty extend the definition of faithfulness to include the spirit, historical grounding, and space of Asbury's account. This definition gets at the basis of Kristeva's and Barthes's notion of intertextuality insofar as it points to the entire cultural textuality of Scorsese's *Gangs of New York*, not just one particular originating text. The film engages in this intertextual play to remind the viewers of these all-but-forgotten incidents that shaped American history and cultural consciousness and to force some serious rethinking about cultural relationships.

Given Scorsese's tendency to ignore many aspects of Asbury's *Gangs of New York* in favor of creating a broader historical and cultural context, his use of *The Age of Innocence*—both Wharton's book and his own film adaptation— is especially intriguing. The *mise-en-scène* of Manhattan, similar dates of 1862 (*Gangs*)and the 1870s (*Age*), class and gang demarcations, and especially the surprising repetition of the term "tribe" mark *Gangs of New York* and *The Age of Innocence* as important thematic bookends and instances of intertextual doubling. These links are strengthened by the fact that both films are drawn from Asbury's and Wharton's texts from the 1920s that responded to the strong anti-immigration sentiment of that time. It is certainly no secret that most of Scorsese's films—including *Mean Streets, Taxi Driver, GoodFellas, and Raging Bull*—deal with New York, but *The Age of Innocence* and *Gangs of New York* form a distinct pair in many respects, not only in director, *mise-en-scène*, time, and rhetoric. Both movies had the same scriptwriter, Jay Cocks—though Scorsese cowrote *The Age of Innocence* (Evans 2012, 172); both used the same set designer, Dante Ferretti; and both featured Daniel Day-Lewis in key roles (Newland Archer in *Age of Innocence* and Bill "the Butcher" Cutting in *Gangs of New York*). This in itself is intertextual. Indeed, as Ferretti remarks in the trailer to the DVD of *Gangs of New York*, Scorsese began working seriously on that film while engaged in the filming of *The Age*

of Innocence, and Ferretti himself started work on the set design at that time as well. In short, while these films deal with widely disparate classes of New York society, there is much explicitly and implicitly that brings them together, so they are instances of intertextual doubling in ways far beyond many other films in production, style, content, and nuance.

In a 2002 interview with Tyler Anbinder and Jay Cocks, the *Gotham Gazette* New York City Book Club asked if "New York, as Leonardo DiCaprio in the movie puts it, [were] 'a city full of tribes and war-chiefs'" and if it were true that "our great city was born in blood and tribulation" as the film suggests. Anbinder responded that DiCaprio

> is right in the sense that New Yorkers certainly thought about themselves very much as Protestant or Catholic, Irish, or German, etc., and so the city was divided to a large extent. The blood part is also true in that the city was a very riotous place in the 19th century. It was common to read about election days, for example, "a quiet day at the polls, only two killed." So public violence was more common, especially in the political realm, than we imagine. On the other hand, gangs were not fighting in the streets every day, not even every month, often not even every year. The huge melees depicted in the movie were very rare events. And the kind of Super Bowl of gang warfare...did not take place in the 19th century in Five Points. (Gotham "Interview" 2002, np)

The *Gotham Gazette*'s question and Anbinder's response do highlight the issue of tribes, but the issue is more complicated, for some tribes had an established presence, while others contested their places: the protagonist Amsterdam Vallon argues that his Irish tribe previously had no legitimate place within New York City and that his father, from "ancient lands of combat"[7] "tried to carve a corner in this country for his tribe"; meanwhile, the tribe of *The Age of Innocence* continues to dominate, even though its numbers fall each year in relation to the swelling tide of immigrants. By this comparison, Scorsese heightens the perception that the United States as a whole was beset with racial prejudices, ethnic divisions, and class tensions that needed to give way before the United States could mature as a nation. The fact that many of Scorsese's films depict a gritty New York of tough, underclass Italians in which these tensions still play out suggests that this national ideal is a long time in birth.

[7]Although I am using the official script in Scorsese's published version of *Gangs of New York*, there are discrepancies between that text and the film itself. When something is said in the film that is not in the published script, I will quote the passage with no citation information.

The use of "tribe" and "tribal" is a curious and important inclusion by Wharton and the films. Edith Wharton was self-trained in anthropology at the time the so-called father of American anthropology, Franz Boas, was formulating the discipline at Columbia, and her use of "tribe" in *The Age of Innocence* bears the imprint of this anthropological study. In this novel about New York high society, she carefully uses "tribe" five times—twice at the onset, once in the middle, and twice at the end—and uses "tribal" four times—once each at the beginning and end and twice in the middle.[8] She also uses related terms like "race," "band," "clan," "family," "rite," "customs," "tradition," "code," "primitive," and "savage" along with a comparison of New York to ancient cultures (e.g., Egypt and its hieroglyphics) as a means of highlighting her conception that modern tribes do not differ significantly from ancient ones.

The film adaptation of *The Age of Innocence* picks up these terms, using "tribal order" early and "whole tribe" late in the film, usages that correspond almost exactly to Wharton's placement and understanding of the terms. Each of these instances in the film is given special emphasis because Joanne Woodward's authoritative third person voice-over delivers them. Interestingly, *Gangs of New York* uses "tribe" three times, delivered by the protagonist and narrative lens, Amsterdam Vallon, early and late in the film in nearly the same strategic places as *The Age of Innocence*, balancing the rhetorical weighting of the two films. That neither "tribe" nor "tribal" was part of Asbury's account suggests that its use was not only deliberate, but meant to bind the two films together rhetorically and thematically.

Both *The Age of Innocence* and *Gangs of New York* use "tribe" to build on the concept of the "other." For the upper social strata of *The Age of Innocence*, the "other" consists of those who had less money and were not established Anglo-American empire builders. Family leaders like Catherine Mingott could contemplate marrying their daughters to English and European men so long as they were rich or noble, from the appropriate geographical areas (English and Northern European) and ethnic backgrounds, and comfortable with conservative Protestant American social values. When those like her granddaughter Ellen Olenska breached these social values by first marrying and then wanting to divorce a Polish count of questionable religion and ethnicity—and thereby assaulting the collective reputation of uptown New Yorkers, they were deliberately shunned.

For the underprivileged of downtown Manhattan, the "other" was a more complicated issue. For those like Bill Cutting (based on the historical figure

[8]"Tribe" appears on pages 12, 27, 149, and 276 (twice). "Tribal" appears on pages 55, 207 (twice), and 276.

of Bill the Butcher), whose father served on the American side in the War of 1812, the other comprised those immigrants hordes, mainly Irish Catholics, who invaded Manhattan in huge numbers in the mid-nineteenth century—Bill says 15,000 Irish a week got off the boats in New York in 1862—and were prepared to work for rock-bottom wages and huddle together in the shanties and tenements of Five Points. For those like Amsterdam, the other consisted of those already established in New York City, other immigrant groups jostling for places and jobs, as well as those who abandoned their Irish culture and Roman Catholic faith to assimilate into the new cityscape. In all of these instances, the other comprised those who were by birth or design outside one's own ethnic culture and expectations.

Part of the tension in both films comes from the difficulties of ethnic confrontation and resultant psychological and physical violence. There is a sense in which the rhetoric of these films suggests that this ethnic confrontation was part of an old, even Old Testament, idea of "an eye for an eye" that must be, and perhaps has been, superseded by forgiveness, but the totality of the films works against this religious reading in favor of one that exposes racial and social fissures. In *The Age of Innocence*, those of non-Anglo-American background are hidden from view, cleansed if you will, masking the negative outcome of tribal exclusion. A hint of this great excluded underclass is represented by Ellen Olenska's Italian maid, Nastasia (Cristina Pronzati), who scuttles silently in and out of the rooms, and, in Wharton's account, completely non-plusses Newland Archer:

> The door was opened by a swarthy foreign-looking maid, with a prominent bosom under a gay neckerchief, whom he vaguely fancied to be Sicilian. She welcomed him with all her white teeth, and answering his inquiries by a head-shake of incomprehension led him through the narrow hall into a low firelit drawing-room… He knew that the southern races communicated with each other in the language of pantomime, and was mortified to find her shrugs and smiles so unintelligible. (1996, 56)

Importantly, in the novel this encounter with Nastasia comes directly after Wharton elaborates on the Mingott tribe:

> Packed in the family landau they rolled from one tribal doorstep to another, and Archer, when the afternoon's round was over, parted from his betrothed with the feeling that he had been shown off like a wild animal cunningly trapped. He supposed that his readings in anthropology caused him to take such a coarse view of what was after all a simple and natural demonstration of family feeling. (1996, 55–56)

By juxtaposing Mingott tribal customs—including Archer's feeling that he is like a trapped wild animal—with allusions to the "southern races," the novel raises the specter of racial antagonism and rhetorically forces the reader to recognize that northerners and southerners and Americans and Europeans alike have customs incomprehensible to those outside their groups, a trait that the film follows visually. Part of the thrust of the novel's argument is to demonstrate that language and culture are not transparent even to those within the group, regardless of what they believe: Archer himself fails to comprehend what goes on in his own household, though he follows the customs. As Nastasia's presence intimates in relation to Ellen and Archer, he never really understands the communication process or how intention and ideology hide behind tribal behavior.

Ellen herself, married to a disreputable Polish count she is trying to divorce, seems to be something of an immigrant, and, despite her blood ties to the Mingotts, ethnically "other" since leaving New York for Europe in early childhood. In other ways, too, she is linked to "tribal" strangeness—gipsy in behavior and/or dress as a child, Oriental in costume (gaudy clothes and amber instead of conservative dresses and precious stones)[9] and interior decoration (Chinese accent pieces in the film), carelessness about her place of residence (downtown, close to the artist quarter), addiction to the company of actors and writers, and suspect moral relationships with Julius Beaufort (Stuart Wilson), Lawrence Lefferts (Richard E. Grant), and her husband's secretary M. Rivière (Jonathan Pryce), to say nothing of Newland Archer himself. She may enjoy the affection of her grandmother Catherine, but, in other respects, she is an isolated "foreigner" until she conforms to her tribe's wishes by removing herself to Europe.

Though presumably wealthy in his own right, Julius Beaufort, who married Regina Dallas (Mary Beth Hurt) of the Mingott clan and who is Ellen's companion (if not lover), is also an immigrant, supposedly of genteel English background but with possible shades of Jewishness. Unlike Ellen's, his blood or lineage is in question in the Anglo-American upper-class community, and his mores and values are at odds with the rest of his family—he consorts with artists, jeopardizes his own well-being and the reputation of the family by improvident investments, places a large nude picture on his wall (forcing his guests to observe it in their approach to his ballroom), fathers an illegitimate child, and eventually marries his mistress Fanny Ring and moves around the

[9]In the novel she is said, as a child, to be dressed "in crimson merino and amber beads, like a gipsy foundling" (Wharton 1996, 48) when she should have been dressed in mourning for her dead parents.

world. Most thought "his habits were dissipated, his tongue was bitter, [and] his antecedents were mysterious" (1996, 20), so they were not at all sad when his fortunes failed—though this failure affected the rest of the tribe who had invested money with him.

In *The Age of Innocence*, there are almost no blacks. Though in the novel Mrs. Mingott herself has a "mulatto" maid, "her white teeth shining like a keyboard" (1996, 245), in the film even this mention has been excluded. This growing African American part of the New York social fabric has almost no impact on the established families, and neither novel nor film makes it an issue. Their very absence, however, suggests the extent to which the New York elites are deeply tribal, non-inclusive, and quietly racist: they do not give voice to the ethnic and racial groups that are crowding into the city. Indeed, although Wharton hints at this problem, she says almost nothing about it for reasons that we can only guess—they played no part in her own experience of growing up, she continued to be isolated from them in her mature life, or she wanted to indicate that New Yorkers were living in a world that deliberately, and to their peril, ignored other tribes and immigrant ethnic groups.[10] What the film portrays is much like what Richard Dyer has to say about the predominance of whites in the self-construction of American society:

> In fact for most of the time white people speak about nothing but white people, it's just that we couch it in terms of "people" in general. Research—into books, museums, the press, advertising, films, television, software—repeatedly shows that in Western representation whites are overwhelmingly and disproportionately predominant, have the central and elaborated roles, and above all are placed as the norm, the ordinary, the standard. Whites are everywhere in representation. Yet precisely because of this and their placing as norm they seem not to be represented to themselves *as* whites but as people who are variously gendered, classed, sexualized and abled. (1997, 3)

Together, Nastasia, Ellen, Julius, and the unmentioned blacks, then, represent an assault on white tribalism (skin color, values, and norms) in Old New York society. Ellen's and Julius's style of life represents a "real threat to established

[10]The actual pattern of migration and immigration during this period accounts for the Irish disintegration into gangs and Bill's defensive patriotism, though it can never justify tribal atrocities and the treatment of immigrants. Until 1819, there were no restrictions on immigration into the United States, and it remained a favorite destination for Europe's tired, poor, and huddled masses and those in search of adventure and better economic opportunities. Even after 1819, when Congress began to establish some limits, immigration to the United States accelerated so rapidly that by 1890 the population was set at 62,979,766, up from slightly more than 2,000,000 on the eve of the Revolution—only 85 years earlier (Brinkley 2004, 61).

patterns of life and thought...not from business but from Bohemia, a culture that lies outside the lethargic and colorless society of the élite. In its proximity, the Bohemian clan challenges Old New York's hold on its most intelligent, imaginative, sensitive members" (Joslin 1991, 92). The Sicilian and black servants are altogether "othered," without recognition, identity, or voice. This absence of diversity is, indeed, a symptom of an operative ideology of exclusion and tribal identity. It is an ideology that forms a bridge between Wharton's own vision in the novel, the immigration debates of the 1920s, Scorsese's films, and post-9/11 America.

If the whites are good at "othering" those perceived as non-whites, then the non-whites are also good at othering compatriots who fail to fit into their mores and values: every group learns othering quickly. As the title suggests, *Gangs of New York* is about the armed conflict between New York City's various immigrant and nativist groups who other one another. The immigrants are divided into such gangs as the Kerryonians, Chichesters, Roach Guards, Plug Uglies, Shirt Tails, and Dead Rabbits, each with a separate constituency and identity—many carried on directly from competing gangs in Ireland. Amsterdam Vallon of the Dead Rabbits represents the legacy of these immigrant gangs, whereas Bill Cutting represents reactionary, nonimmigrant gangs. Indeed, Bill Cutting's group, "The Natives," see themselves as defining the "foreign invaders" from Europe and Asia and defending the United States against them as well as migrant blacks from the south. As Richard Dyer finds in *Whites*, white people in Western culture "had so very much more control over the definition of themselves and indeed of others than have those others" (1997, xiii), and they had the means to enforce these definitions. In several scenes, Bill is wrapped in the flag of the United States or appears against the background of the flag. Indeed, the glass eye that replaced the one he lost in a gang fight with the immigrant gang leader "Priest" Vallon has been imprinted with the American eagle, suggesting links between American patriotism and deep-seated exclusion, exploitation, and racism, in the North as well as the South.

These Irish and "southern" foreign invaders were thought to undermine the racial purity of the United States and put at risk the values and sometimes even the lives of the white majority. As Noel Ignatiev remarks in *How the Irish Became White*, "in the early years Irish were frequently referred to as 'niggers turned inside out'; the Negroes, for their part, were sometimes called 'smoked Irish'" (1995, 49). Whether black or Irish, they threatened the culture and values of the existing white New Yorkers. The fact that no African Americans appear in *The Age of Innocence* and few in *Gangs of New York* does not mean that racial prejudice was not part of the social equation, only that it took a form not entirely recognizable today when perceptions of race have changed.

Asbury's account makes it clear that the vice-ridden and violent underclass was a "dangerous nuisance" for "almost a hundred years" in New York City (1928, xiii), and, as Jorge Luis Borges remarks in his "Foreword," this

> chaotic story takes place in the cellars of old breweries turned into Negro tenements, in a seedy, three-story New York City filled with gangs of thugs like the Swamp Angels, who would swarm out of labyrinthine sewers on marauding expeditions; gangs of cutthroats like the Daybreak Boys, who recruited precocious murderers of ten and eleven years old; brazen, solitary giants like the Plug Uglies, whose stiff bowler hats stuffed with wool and whose vast shirttails blowing in the wind of the slums might provoke a passerby's [sic] improbable smile, but who carried huge bludgeons in their right hands and long, narrow pistols; and gangs of street toughs like the Dead Rabbit gang, who entered into battle under the banner of their mascot impaled upon a pike. (1998, xi–xii)

The film makes it clear that these gangs were even more pernicious and deadly than Borges intimates, juxtaposing their gang warfare with the anti-draft riots that threatened to destroy the entire city.

The immigrant Irish tribes of *Gangs of New York* and the upper-class tribes of *The Age of Innocence* seem worlds apart, but, in fact, would have been forced to recognize each other's presence in a hundred different ways. The film, taking its cue from Wharton's own choice of words, suggests that, apart from their vast discrepancies of material wealth and social privilege, these groups had much in common as "tribes." Lloyd Eby was among the first to pick up on Scorsese's construction of tribalism in various films and its relation to Wharton's, though he did so in 1993 before the filming of *Gangs of New York*. Eby says,

> Like Scorsese's movies about tribal Italian Americans and what they impose on their members, Wharton wrote about tribes—their rules and customs, and the way they bend, mold, conform, and even break individuals. In both cases, there's no real way for the individual to escape from the power and control of the tribe. Archer seems weak and indecisive, but he chooses to remain within his group, and to do so is to give up Countess Olenska. Daniel Day-Lewis has gone so far as to call Wharton's people violent, even though their violence is covert, not overt like that of Scorsese's usual goodfellas. So, although there are different codes of communication and conduct, and differences of time, place, and social class, there is a parallel between *The Age of Innocence* and Scorsese's other films. (1993, 128)

"Tribes" and "tribal" are interesting choices of words and not usually applied to modern Caucasian Europeans or Americans but conventionally associated in Westerners' minds with rural Africans, Asians, Middle Easterners, and Native Americans whose local cultures are defined by distinct territory and common blood, language, religion, economic behavior, and social customs and who have not embraced modernism or the capitalist economy. The Africa Policy Information Center warns that the term "tribe" often carries unfortunate connotations of primitiveness: "At best, any interpretation of African events that relies on the idea of tribe contributes no understanding of specific issues in specific countries. At worst, it perpetuates the idea that African identities and conflicts are in some way more 'primitive' than those in other parts of the world." To avoid this negative connotation, the Africa Policy Information Center prefers "people, ethnic group, nationality, community, village, chiefdom, or kin-group" as more appropriate terms, but in both of Scorsese's films ties to ancient customs and connotations of primitivism suggest the retrograde quality of class and ethnic intolerance in these New York City urban tribes.[11] Intertextual doubling in metaphors and descriptions of tribalism thus reveal the great abyss in American society between espoused principles of acceptance and equality and the reality of prejudice and race and class antagonism.

In commenting on *Gangs of New York*, Leonard DiCaprio says that everything boils down to territory, and in this film it is the infamous Five Points. The Mingott tribe's territory is uptown Manhattan around Fifth Avenue and 39th Street (rather than in the developing middle-class suburbs made possible by trains and other forms of mass transportation). They are inland, away from the frightening and chaotic harbors, where the Irish dominate. Between the rich and the Irish tenements are the much less costly houses and apartments of the artists, shop owners, and "'new people' whom New York was beginning to dread and yet be drawn to." All these tribes try to retain or grasp new territory.

Territory is important, but common blood is an important reason to want territory and is a key requisite in defining tribe. In *Gangs of New York*, those from the same national background and/or ethnic blood ties live together, and when the family or tribe has been assaulted, someone must pay. Amsterdam Vallon sets out to avenge his father's death by killing Bill Cutting, in the process mobilizing the New York Irish for a devastating battle.

[11]Wharton does use the term "primitive" four times in the novel, twice in reference to old buildings, once in relation to something old and premodern, and once in relation to someone who is basic and without guile. None of these correspond to her use of "tribe" and "tribal."

In the *The Age of Innocence*, the Newland Archer–May Welland (Winona Ryder) marriage unites the two main clans of the uptown gentry (Joslin 1991, 91)[12] who then marginalize Ellen—the threat to tribal cohesion— until she bends to their wishes. The rich guard themselves by paying close heed to Sillerton Jackson (Alec McCowen) who knows the "family" and "cousinships" and can "elucidate such complicated questions as that of the connection between the Mingotts (through the Thorleys) with the Dallases of South Carolina, and that of the relationship of the elder branch of Philadelphia Thorleys to the Albany Chiverses," creating a sense of the tight web of relationships in "the unruffled surface of New York society" (Wharton 1996, 8). He is also able to recount which family members have married into European nobility, on the whole a good thing to them, except when those marriages call into question rank, blood, and custom. These bad matches are only part of the "scandals and mysteries" that this class remembers as a way of keeping themselves obedient to custom. In a tribe, then, blood counts for a great deal, but so do common cultural ways of speech, acts, and habitation that arise from those ties.

In *The Age of Innocence*, Lawrence Lefferts is an expert on custom or ritual, and his "knowledge of form" "upholds the social status quo by heeding the 'bond' or covenant" between them (Joslin 1991, 90). This knowledge is also a weapon against those who would step out of line or attempt to join the circle without the proper pedigree—though, of course, Julius Beaufort, the young Catherine Mingott, and others are exceptions to this rule. With few qualitative distinctions between them, important customs include moral behavior, decency, and honor as well as taste and form. Indeed, in the novel Archer thinks of the first hours of his engagement to May as "sacramental," and the narrator describes his morality as a doctrine, indicating that custom, form, and deportment are ritualized and venerated like religion (Wharton 1996, 7, 20). The "ritual of ignoring the 'unpleasant'" (Wharton 1996, 21), however, is equally reprehensible. Ellen Olenska's divorce proceedings against her husband raise the specter of indecency, immorality, and the unpleasantness of public scrutiny into the private lives of the old moneyed class in New York. This is not tolerable.

In contrast to the elegance of upper Manhattan described in *The Age of Innocence*, *Gangs of New York* takes place in streets called "Murderer's Alley" and "Gates of Hell" with their mixture of lawlessness, poverty, violence, whorehouses, dancehalls, bars, and opium dens. Still, men like Priest and

[12]In speaking of the Wellands and Archers as tribes, Joslin follows Wharton's lead, but it seems to me that they are subgroups or clans of the larger wealthy Old New York Anglo-American tribe.

Amsterdam Vallon have important customs and codes of honor, thinking of themselves as warriors from "ancient lands of combat." Indeed, the battle between Bill Cutting of the Nativists and Priest Vallon (Liam Neeson) of the Dead Rabbits has an orchestrated quality like an ancient Greek drama. Moreover, when Bill kills Priest, he refuses to allow anyone to desecrate his body and later keeps a picture of him like a religious icon, commensurate with the implications of his name, Priest. Of course, actual religion is part of the cocktail of violence, and the Dead Rabbits go into battle with their weapons, crosses, and prayers.

Although social customs are less elegantly described in *Gangs of New York* than in *The Age of Innocence*, their effect is the same—an insularity that actively discriminates against others outside the tribe and that prevents a comprehensive improvement of living conditions. With Catholic Irish against Protestant Irish and Irish against Italian and Jew, Tammany Hall could exploit the disharmony, filling its coffers from the slum landlords without having to inaugurate costly social improvements. As Amsterdam acknowledges, when, as a seasoned adult, he reflects on this battle, this place "full of tribes" was not a city, but "a furnace where a city someday might be forged." Metaphors of intercultural tribalism thus expose the difficult circumstances for those in, or coming to, America when they do not conform to the implicit rules. As Barthes and Kristeva argue, exposing the filial relationships of texts exposes this intercultural complicity and reveals the symptoms of society's false logic.

Amsterdam's story in *Gangs of New York* ends with a city exhausted by the violence and destruction of the anti-draft riots precipitated by the Enrollment Act of Conscription of 1863 designed to draft 25,000 men from Manhattan and another 7,000 from Brooklyn into the war against the South. Because the rich could buy their way out of this draft at $300 a person, it was the poor and middle income men who were victimized. Hence, the riots were led by the Irish, Poles, and Germans against the government, the rich, and the blacks— all of whom they perceived to be their enemies—and put down by the Union military, ironically arriving fresh from the Battle of Gettysburg, where huge numbers died as a result of national racial and ethnic exclusion. As the city begins battling the government, Amsterdam and his Irish compatriots are preparing their own ritualized combat against Bill Cutting and the nativists. Amsterdam says, "tribes were gathered, drums were beaten," and he expects to win the day. However, interrupted by the militia's cannon assaults and slaughter in breaking up the riots, Bill and Amsterdam end up lying a few feet from each other in the debris. Despite their personal injuries and the decimation of their tribes, Amsterdam will not quit until he personally finishes Bill off.

Amsterdam notes that the City was "born of blood and great tribulation" and "delivered, with everything they knew swept away." To emphasize this, the film finishes with five iconic images of the city: After Amsterdam buries his dead on the Brooklyn side, he and Jenny look across the East River to Manhattan, and as they do, images of the skyline advance in time over 130 years. The first is of the burning city that Amsterdam sees, but that fades into a cityscape of similar scale foregrounded by the Brooklyn Bridge that was begun in 1870 and completed in 1883, some 20 years after the draft riots. Representing a sense of modernity and international recognition, the Brooklyn Bridge stays in the foreground in the next three shots that first show the Civic Center that replaced Five Points, then the cityscape with new skyscrapers including the Empire State Building, and finally one that contains the Twin Towers. These shots of the city advancing in scale and time suggest the allaying of tribalism and the increasing modernizing and civilizing of the city. However, the fact that the Twin Towers were destroyed between the film's completion and its release suggests that the message of the end is ironized: the ultimate lesson might be that tribalism can never be eliminated and the City will have more such struggles in the future.

The fact that *The Age of Innocence* was released in the same year as the first bombing of the World Trade Center and that *Gangs of New York* was to have been released just after 9/11 (and probably denied Academy Awards because of its explosive and concentrated violence) suggests that all is not quiet and equitable in the streets of New York, the highways of America, or the flight paths of the world. The lessons must be constantly relearned that the negative effects of tribalism, exclusion, and racism are repeated by successive generations and continue to have terrible consequences. Scorsese's intertextual doubling of Wharton and Asbury extends well into culture as a whole, revealing the magnitude of the problem of American and international tribalism.

The actual history of the Five Points area supports some of this reading because it was 50 years before the traces of poverty and tribalism disappeared. The horrible infrastructure in downtown New York did not burn down with the draft riots but stayed much the same until 1877—about the time of the setting of *The Age of Innocence*, when the Danish immigrant Jacob Riis shamed the city by exposing the conditions through his deeply disturbing photographs and narrative, *How the Other Half Lives*. His exposé led the city to clean up the area, tear down the tenements, and establish housing and sanitary legislation to prevent a repetition of those conditions. The process of rebuilding was further assisted when skyscrapers were built a generation later, and when the city destroyed many of the tenements to erect government buildings. Only

in 1914, however, were the gangs "definitely on the run when John Purroy Mitchel was elected Mayor on a reform ticket," "and his Commissioners of Police, Douglas I. McKay and Arthur Woods, completed the rout by sending to prison some three hundred gangsters, including many of the shining lights of the underworld" (Asbury 1928, xiv).

In brief, Scorsese's intertextual use of "tribes," however attenuated in both *The Age of Innocence* and *Gangs of New York*, is socially disruptive by illustrating that "America was born of blood and great tribulation" in the drawing rooms *and* the streets, and both scorned diversity and inclusiveness in favor of ethnic division and exclusion. This is the profound lesson of intertextual doubling in the film adaptations of Asbury's and Wharton's accounts. Intertextuality, then, in related and seemingly unrelated pieces of art with symptomatically doubling language, brings home profound truths about personal and national identities.

Ironized intertextuality: *The Age of Innocence* and *The Great Gatsby*

Upon meeting John Galsworthy in London in 1921, F. Scott Fitzgerald asserted that Galsworthy, Joseph Conrad, and Anatole France were the three living writers whom he most admired (Meyers 1994, 74), but I would argue that Edith Wharton was a more important mentor for him. As his biographer Jeffrey Meyers notes, when Fitzgerald first met Wharton at Charles Scribner's office in 1920, just after he published *This Side of Paradise*, "he impulsively threw himself at her feet and exclaimed: 'Could I let the author of *Ethan Frome* pass through New York without paying my respects?'" (Meyers 1994, 156). Fitzgerald's reaction is more than a touch histrionic but clearly demonstrates the awe that he felt for Wharton.

What is not noted in the account of this meeting and is obscured by Fitzgerald's respect for, and allusion to, *Ethan Frome* is that Wharton was publishing *The Age of Innocence* in four installments in the *Pictorial Review* from May to October of that year, would publish the entire book later in October, and would win the Pulitzer Prize for it in 1921. Just after this, Fitzgerald published *The Beautiful and the Damned* (1922), which critics at once believed to have been influenced by Wharton (Seldes 1926, 170). Intriguingly, 1922 is the year that Fitzgerald had begun to plan *The Great Gatsby*, which he took up again in 1923 and then pursued in earnest in 1924, shortly after he finished writing the dialogue for the film version of Wharton's

The Glimpses of the Moon (Evans 2012, 169). The press during those five years was full of Wharton's accomplishments, Fitzgerald was reading her (Roulston 1984, 59), and he was undoubtedly learning techniques that would assist in his writing.

There is no record of Fitzgerald and Wharton having met again until 1925, when Wharton invited him to tea at her summer place north of Paris in St. Brice-sous-Forêt after he had sent her an inscribed copy of his newly published *The Great Gatsby*. It is not certain why Fitzgerald chose to send her a copy, but she appreciated the gesture, responding that "I am touched at your sending me a copy, for I feel that to your generation, which has taken such a flying leap into the future, I must represent the literary equivalent of tufted furniture and gas chandeliers" (Lewis 1988, 481). She also paid Fitzgerald a great tribute by saying how much she liked

> Gatsby, or rather His Book, & how great a leap I think you have taken this time—in advance upon your previous work. My present quarrel with you is only this: that to make Gatsby really Great, you ought to have given us his early career (not from the cradle—but from his first visit to the yacht, if not before) instead of a short résumé of it. That would have *situated* him & and made his final tragedy a tragedy instead of a "fait divers" for the morning papers. (Lewis 1988, 481–482)

Though Wharton continued to think well of Fitzgerald's writing, he was apparently "awful" at her tea party.[13]

Fitzgerald's biographer Jeffrey Meyers explains Fitzgerald's foolish behavior toward Wharton in 1920 and his insulting behavior in 1925 as part of his discomfort in "the gulf between himself and his artistic heroes. Instead of living up to the dramatic occasion, he nervously erupted in gaucherie..." and bad manners (Meyers 1994, 156). It is quite possible, however, and this is what I argue, that he yearned for Wharton's good favor not so much because he was in awe of her reputation but because he owed her so much—her innovations in the novel of manners (Perosa 1965, 187); her ability to take a place like New York City, turn it into a subject, and

[13]There are differing accounts of the party, but apparently he drank more than he should have on the drive to her villa and afterwards tried to regale her with a story of a couple's night (presumably his and Zelda's) inadvertently spent in a brothel. Fitzgerald looked back on the afternoon with chagrin, and Wharton described the event as "awful" (Lewis 1988, 482), but it has achieved a sort of mythic status in the battle between the sensibilities and fiction of the Belle Epoch and the Jazz Generation. As a footnote, their meeting has given rise to a play, *Tea with Edie and Fitz*, currently playing at the Greenhouse Theater Center in Chicago.

give it a unique dramatic identity; her skill in sympathizing with characters such as Newland Archer in *The Age of Innocence* despite their huge fund of self-infatuation and self-delusion; her ability to view marriage, infidelity, and divorce from several vantage points; her sensitivity to the dilemma of outsiders in society; her "fixation with class" (Curnutt 2007, 103) and ability to "capture a social scene and satirize a social class" (Meyers 1994, 122); and her adeptness in using parties and social events to structure fiction, define eras and people, and formulate important themes. Indeed, Michael Millgate, Frederick J. Hoffman, Henry Dan Piper, Robert Roulston, Robert Emmet Long, and Helen Killoran all agree that many of Fitzgerald's narratives, including the *Great Gatsby*, were influenced by Wharton, and variously include *Ethan Frome, The Spark, The Custom of the Country*, and *The Glimpses of the Moon* as the most likely inspirations (Long 1984, 105; Roulston 1984, 59, 61; Killoran 1990, 223–224).

In short, as Gilbert Seldes was the first to note in 1925 and again in 1926, after having talked to Fitzgerald about it, Wharton's large shadow rested heavily upon *The Great Gatsby* (1926, 170), not least because "the book is written as a series of scenes, the method which Fitzgerald derived from Henry James through Mrs. Wharton" (Seldes 1984, 271).[14] Most critics assume that "series of scenes" refers to James's scenic method of development, but, with the exception of Brian Way, that interpretation does not account for the "series." Way, however, attributes this intertextuality completely to James, while I think it is linked to *The Age of Innocence* as the sequence of parties that accounts heavily for the structure and meaning of both novels.

This latter connection to Wharton might well have been there from the start, for in 1922, when Fitzgerald was first envisioning *The Great Gatsby* and was about ready to begin working on the dialogue to Wharton's *The Glimpses of the Moon*, he told Maxwell Perkins that his story would be set in 1885 in both the Mid-West and New York City (Piper 1962, 322; also see O'Hagan 2013), a strong indication that he was already forging intertextual ties with *The Age of Innocence* through the New York location and period. Although I will touch upon other aspects, it is the intertext of the rhetoric of parties, class, communitarianism and family *vs* freedom, and the outsider that I want to discuss because these are what so define and contribute to the ironized intertextuality not only of Wharton's *The Age of Innocence* and Fitzgerald's *The Great Gatsby*, but also the adaptations that arise from them: Scorsese's 1993 *Age of Innocence*, Jack Clayton's 1974 *The Great Gatsby*, and Baz Luhrmann's 2012 *The Great Gatsby*. I will not take up the three other

[14]Also see Malcolm Cowley (1953, xviii) and Arthur Mizener (1959, 186) who endorse this view.

adaptations of *The Great Gatsby*, that is, Herbert Brenon's 1926 version (now lost), Elliot Nugent's 1949 noir version, and Robert Markowitz's A&E 2000 television version.

Establishing the textual base: Wharton (novel) and Scorsese (film)

Although Wharton was nearly 60 when she wrote *The Age of Innocence*, she looked back fondly on the socializing of the elite in the post-Civil War New York City of her youth. First of all, she liked the leisurely pace of life and the "order, manners, and civilizing influence" of that society (Jabbur 2012, 264), though she was quite aware of the claustrophobic and imprisoning "custom and conventions" (1996, 97). She also liked the social intimacy and elegant gatherings of the old moneyed class in that period. As Maureen E. Montgomery notes in "Leisured Lives," most entertainment for the old New York elite of British and Dutch descent "took place in private homes, dinner being the 'most frequent distraction'" and the "chief nocturnal outing to a commercial venue was a visit to the theater" (2012, 235). Formal dancing in homes was also popular, and the waltz was a favorite. These affairs for the elite were to be tasteful but understated without lavish displays of wealth and publicity, in keeping with group identity and trust, though with the wave of industrialization after the Civil War those with new money gravitated to public rather than private settings, were given to heightened displays of wealth, and focused more on individual achievement than group cohesion. When new money and public parties began to be ascendant, groups like the Patriarchs and individuals like Mrs. Astor with her group of Four Hundred kept watch on admission to the elite circle but still could not contain the transformation from pyramidal communitarianism to increasingly finance-based, individualist society.

As Laura Dluzynski Quinn remarks, *The Age of Innocence* is premised on the assumption that achieving communitarian harmony, common cultural goals, and social purposes requires some sacrifice of individual freedom: "Wharton makes an analogy between the fashionable world of Old New York and ancient tribes in order to emphasize the benefits and limitations common to both types of communal body: in each, the individual must sacrifice a certain amount of freedom in order to enjoy the group's protection and security" (notes in Wharton 1996, 299). That does not mean, however, that within the Old New York elite there were not internal disparities and fractures:

New York, as far back as the mind of man could travel, had been divided into the two great fundamental groups of the Mingotts and Mansons and all

their clan, who cared about eating and clothes and money, and the Archer-Newland-van-der-Luyden tribe, who were devoted to travel, horticulture and the best fiction, and looked down on the grosser forms of pleasure. (Wharton 1996, 27)

The Mingotts and the Mansons represent the clout of money and the ability to flout tradition when necessary, while the Archer/Newland/van der Luyden tribe epitomizes the strength of tradition and culture, family solidarity, and sense of duty going all the way back through English colonists to the original Dutch settlers. The book as a whole represents the ways in which these clans and cultural dimensions are intertwined while interrogating those relationships both publicly and privately.

Central to *The Age of Innocence* is the issue of alliances and marriage, and soirees were ways for families to get together, link generations, and prepare and sustain the groundwork of marriage. They were also ways to alienate, exclude, and "eradicate" those outside the tribal compacts and protect those within, so that they became tools and weapons of family and social structure. Because marriage and family relationships were perceived as the glue that held these clans together, threats of infidelity and divorce had to be dealt with by whatever social and economic means necessary, and parties were one of those means. Throughout the novel, the narrator used the words "trust," "duty," and "rules" when speaking of the bonds and boundaries necessary to uphold marriage and other forms of tribal structure and the word "freedom" to describe the aspirations and feelings of the characters who wanted to escape those bonds. What the text notes was the increasing pressure to move away from strong social and family relationships to a freer, individualized society. The notion of tribes, ruling clans, and marriage compacts, then, was central to a well-regulated society, though certain forms of freedom provided a nice counterpoint, and the novel articulates the tension through the various soirees and parties. This is what I wish to explore in particular.

The fiction conveys this sense of the "ruling clans" in *The Age of Innocence* (1996, 39) and the threat to their integrity through the rhetoric of parties, including balls, formal dinners, and a wedding, each with its own social and family *raison d'être*, intended outcome, and grace and elegance. In each of these, the narrator carefully describes: the people in attendance; the characteristics of the architecture and interior décor; the kind and quality of clothing, jewelry, table settings, food, and flowers; the flow of the event; and the modes of transportation—all the things that worked together to achieve and celebrate family and social cohesion. However, chapters are also organized around intimate conversations about social relationships, betrothal visits, business affairs of the family, and planning sessions for the larger events. The latter do not constitute parties as such, and consequently I will

not treat them, but they do establish patterns of intimacy, manners of the privileged class, and individual personalities and identities that are important to understanding the key relationships and configuration of larger gatherings and parties.

The novel opens with the privileged Old New Yorkers watching Christine Nilsson singing Marguerite's aria, "M'ama... non m'ama," in the opera *Faust* (about marriage betrayal) and also scrutinizing the various members of their society, especially Newland Archer and his fiancée May Welland as well as her newly arrived cousin Countess Ellen Olenska, a woman of questionable reputation because of her long life in Europe, quest for personal freedom, marriage to a libertine Polish Catholic Count, affair with his French secretary, and, paradoxically, separation from both. The evening at the opera thus introduces the main characters and their relationship while it also serves to indicate the primacy of tradition and public morality in the family structure as well as the possibility of infidelity. It also serves as a segue into the Beaufort ball in which Archer and May's engagement is announced.

Indeed, the centrality of the opera *Faust* in opening the first half of the book is echoed in the second half of the book by another performance of *Faust* that leads importantly and ironically to the wedding of Newland Archer and May Welland. As he stands at the front of the church awaiting his bride, Newland remarks on the parallel of operas and weddings, commenting to himself:

"How like a first night at the Opera!" he thought, recognizing all the same faces in the same boxes (no, pews), and wondering if, when the Last Trump sounded, Mrs. Selfridge Merry would be there with the same towering ostrich feathers in her bonnet, and Mrs. Beaufort with the same diamond earrings and the same smile—and whether suitable proscenium seats were already prepared for them in another world. (1996, 148)

Not only does Newland think about the participants in the drama of the wedding but of those who watch it and thus have a share in performative elements—tradition, demeanor, and dress. That it is *Faust* he sees again just before his wedding is prophetic of his own entanglement with Ellen.

The splendor of *Faust* at the beginning of the novel is paired with that of the ball of Regina and Julius Beaufort, the former related to the redoubtable Mrs. Manson Mingott and the latter an arrogant English banker with something "regrettable" and "mysterious" in his personality and lineage and a questionable tendency to mix with artists, though tolerated because of his immense wealth and marriage into the Mingott clan. Despite the question of his mysterious origins, arrogance, near-public infidelities, and mixing with socially questionable people, no one would think of missing the Beaufort

annual ball in one of the most fashionable and distinguished homes in New York City, and the novel's description makes it clear that this is one of the most important social events of the season with no expense spared and with social decorum scrupulously observed. It is in this setting that Newland's engagement to May is formally announced after which he steals a kiss from her, a liberty that would have been frowned upon had others observed it. (In fact, when Newland kisses her on the lips a second time in St. Augustine at a later point, it is clear that May is uncomfortable with this violation of social custom and moral behavior because kisses should be reserved for marriage (1996, 116).) Contributing to the decorous and elegant ball is the playing of Johan Strauss's Blue Danube waltz, which represents the communal harmony of the social gathering. The transportation from the opera to the ball is also shown to contribute to a gracious style of life as the opera staff and private servants help the ladies and gentlemen in and out of their private broughams, family landaus, or public Brown coupés. Even transportation has its social value and measured pace for this class in the time of horse and carriage, though at times it, too, could be used to undermine those family and social values.

Although various small dinners with three or four guests and theater events are referred to after this opening, none has the sheer symbolic and performative value of the opera, Beaufort ball, and wedding in reinforcing social and family values. This is partly true because the opera/ball opening of Book 1 and the opera/Archer-Welland wedding opening of Book 2 show the characters' relationships and personal motives to be as forceful as the spectacle itself. There are also two large dinner parties that follow in the same mode: one is the formal dinner sponsored by the van der Luydens after the ruling families turn down the invitations for Lovell Mingott's dinner in honor of Ellen Olenska; another is Archer and May's farewell dinner for Ellen on the evening before she leaves for Paris permanently. In the first, the van der Luydens set out to teach the ruling clans a lesson by hosting an even more elaborate family dinner than the Mingotts had planned in honor of Ellen and by inviting their relative, the visiting Duke of St. Austrey, as a lure and anchor. Because of the van der Luydens' unparalleled status in New York City society and because of the inclusion of an English aristocrat, no one would consider turning down that invitation, though the dinner is to honor a fallen women. Thus, this dinner and its table assert the primacy and integrity of the family, maintain the importance of social hierarchy, and put gainsayers in their place. In the second instance, the dinner hosted by Archer and May is designed to show their full-fledged entry into New York society as a married couple, and the extended family uses that occasion to make sure the marriage and family remain intact by packing Ellen off to Europe at the end of the dinner

so that she can no longer tempt Archer. This has the effect of maintaining May's and the family's honor, making Archer understand that he must stand by her, and once again asserting the value of family solidarity. Both of these elaborate parties demonstrate social place, protect family, and teach moral lessons. In each of these parties, the novel goes to great length to itemize the table settings, the elaborate floral arrangements of roses and orchids, the importance of the seating arrangement, and significant snippets of conversations to demonstrate materially the value of family.

Key to the contest between the protection and erosion of family are Newland, May, and Ellen Olenska. It is May who represents family values and integrity of tradition, and she and her family go to extreme lengths to protect that, though telling Archer explicitly about it is not one of the weapons in their arsenal; he should have a tacit understanding of the situation. Ellen is the temptress and European outsider who tries to find the right path even as she goes against tradition and family solidarity by forming a strong emotional attachment to Archer—and perhaps Beaufort. Archer himself simultaneously upholds the structure of family represented by his marriage to May but also interrogates that by his wish for emotional freedom and personal independence represented by his infatuation with Ellen. What he is not aware of until after May's death is his failure to understand her insight into his relationship with Ellen, the way in which May manipulates the situation in her own favor, and the very specific role of the family in exorcising the cancer of his emotional if not sexual infidelity. He remains stubbornly blind until his son reveals the depth of his self-deception when they are in Paris together after May's death.

Scorsese's film adaptation of *The Age of Innocence* (1993) is mainly faithful to the novel, but reshaped for specific dramatic reasons, primarily to highlight the intensity of Archer's (Daniel Day-Lewis) love for Ellen (Michelle Pfeiffer) and also to show the powerful influence of their families in suppressing this turn of events. This reshaping is accomplished by the leisurely pace of the film, the private conversations between Archer and Ellen and between Archer and May (Winona Ryder), and especially the stunning visuals of the parties meant to show the power of the families.

First of all, as with the novel, the film has a very slow and leisurely pace well suited to the carefully constructed lives of Archer, Ellen, May, and their families as well as an evocation of the Belle Epoch period itself. Second, the conversations between Archer and Ellen and Archer and May have an understated quality not only to show depths of unreleased passion but also Archer's complete misapprehension of May and the family. With Ellen and Archer the conversations often take place in rooms with the glowing embers in the fireplace reflecting the depths of their passion as do the occasions when

he kisses her shoe in front of the fireplace and when he slowly removes her glove in the carriage upon her return from Washington. In his conversations with May, Archer assumes that she is wholly innocent of guile, passion, and understanding—hence Age of Innocence—but is wholly mistaken in that. As they face each other and the camera zooms in on May's troubled or too-joyful expressions, it becomes clear that she understands much more than Archer thinks, though he discovers that too late. Third, the force of the families is shown in public entertainment as well as the family parties held in honor of Ellen. Although Scorsese's production designer of *The Age of Innocence*, Dante Fernetti, rightfully stated that "color, artwork and food" are the key elements to the success of Scorsese's film (Evans 2012, 172), these are gathered together within the rhetorical frame of the families' tasteful soirees which range from small dinner parties to elaborate formal balls in order to show family solidarity. These demonstrate how "Archer's family held fast to the old ways," how they think American society superior to the "wicked old societies" of Europe, and how these parties are part of an arsenal to protect and sustain the values and honor of the old families even as those values are changing. The parties, then, are not meant as mere entertainment but as part of the politics of the family as well as weaponry to put down assaults on family honor and integrity.

In picking up the rhetoric of parties, the film starts at precisely the same place as the novel—the production of the opera *Faust* and the Beauforts' elegant ball, though preceded by Saul Bass's title sequence of the rapidly unfolding roses seen through a screen of elegant handwriting and old lace. Wrapped together, the visuals of the title sequence, the opera, and the ball give an exquisite sense of richness, elegance, grace, social decorum, and suppressed passion. When Ellen and Archer are introduced at the opera by Mrs. Welland (Geraldine Chaplin) in the presence of May, it is obvious that they are immediately attracted to each other, but Archer is careful to follow American restraint in not kissing Ellen's outstretched hand.

The ball itself has the same sense of elegance and restraint with Archer and May's polite distance from each other—even with his stolen kiss. The house of Julius Beaufort (Stuart Wilson) and his wife Regina (Mary Beth Hurt), where the ball is held, is grand, sumptuous, unrestrained, and slightly daring with the picture of a nude called "Return of Spring" featured in a prominent position to goad the elite to look outside themselves and their rules. Although the dancing and formal dress perpetuate decorum and tradition, the painting and the presence of Julius Beaufort suggest that all is not entirely conventional or quite above board in this old New York society. That may be the same with the dancing, but its function is to shore up social values and privilege. While the preferred dance in the novel is the waltz as represented

by "The Blue Danube," the film centers on Strauss's "Vienna Blood Overture," written to celebrate the wedding of the Emperor Franz Josef's daughter and Prince Leopold of Bavaria. This latter piece reinforces the function of these balls to strengthen the family relationships of the old New York society, but also gives way to a more prominent visual emphasis on the cotillion, which is almost militaristic in its force and precision with the couples parading around the room under the glittering chandelier. As Montgomery notes, the cotillion or "German" became a standard feature for the large balls; in it there was "nothing spontaneous or individualistic," and "set figures had to be rehearsed in advance; the assignment of leading roles reinforced status and cultivation; and the dance had to be performed as a group, thereby encouraging group identity within a hierarchical framework" (Montgomery 2012, 235). The dance, then, clearly sets the scene for the strength of clans, tradition, and formality—"the old ways"—in the face of a growing sense of freedom among the young.

The battle between the new ways and the old ways is reasserted through the other two large parties and involves trust, duty, rules, and freedom—all words used frequently throughout the film with reference to Archer's duty to family and the rules to enforce it in contrast to Ellen's quest for monetary, intellectual, moral, and even aesthetic freedom. Of course, Archer envies this freedom as well, but in the end puts it aside when he is defeated by the larger family. Even Mrs. Mingott (Miriam Margolyes), one of the richest, most intellectually free and independent figures in the film, reminds Archer of his responsibility to May and the family: "We should remember that marriage is marriage, and Ellen is still a wife." She believes in and protects the honor of the family. The two large parties at the center of the film—the first to honor Ellen's homecoming from Europe and a degenerate husband and the second as a farewell to Ellen—thus demonstrate the force of the rules that Mrs. Mingott, May, and the entire family structure evoke in order to ensure its strength and continuity.

In the case of the first significant party, Mrs. Mingott had planned to hold a formal dinner in honor of Ellen with appropriate accoutrements, so as to make certain that the old New York families would know that her family stood behind Ellen regardless of her damaged reputation. However, New York declined to come, and the dinner was aborted until the van der Luydens took over. Because of their status above all other New York families, no one would dare decline, and the elegance of their rooms and special decorations not only implicitly denoted wealth and good taste but also enforced family solidarity and hierarchical status. Their very best plate (the Trevenna George II setting, as well as the "Lowestoft" of the East India Company and the Dagonet Crown Derby); the handsomest of the guests' diamonds, emeralds, pearls, and ostrich feathers; the number of courses, dishes per course, and Roman punch

offering a hint of alcohol; the elaborate and diverse flower arrangements;[15] and the additional footmen—all collectively symbolized the strength of tradition and money and gave the "lesson" that the van der Luydens, Wellands, and Archers wanted to teach about the value of their family within the old New York hierarchy.

Ironically, while the party had the intended effect on the community, it also gave Archer and Ellen a chance to get together, undermining part of the lesson the party was designed to teach. Between the time of this party and his wedding to May, Archer's emotions to Ellen deepened (though without sexual consummation), but that came to an end when Archer realized that by persuading Ellen not to have a divorce, he had precluded their being married or otherwise joined. Because Ellen accepted the view that she must "sacrifice" herself to "spare scandal," she says to Archer, "I can't love you unless I give you up." By that she meant that he must give her up as well in order to be wholly honest and at one with the family. From that Archer came to believe that his life with May was a "false" one of duty and that his life with Ellen could be his "real" though unrealized life, but he had no means to make it happen.

The second party came nearly two years after the first, and while Archer and Ellen did not see each other for 18 months of that period, when she reappeared in New York/Boston after a prolonged stay in Washington, DC, he thought that the "past had come again into the present," that time could be turned back, responsibility to May obliterated, and he and Ellen could begin again. The family, however, had other ideas, and this second party came after May had told Ellen that she was pregnant (she didn't know that for sure) and the families decided it was time for Ellen to return to Europe, thereby making sure that Archer knew the difference between his illusion that the past could be revisited and the reality of his present responsibilities. This second party, however, was not hosted by the van der Luydens or Mrs. Mingott but by Archer and May as their first formal party. Thus, without realizing it, Archer was complicit in Ellen's removal and in his own "imprisonment," as he eventually came to see it. Though a strictly family occasion, it had all the elements of the first large formal party—two borrowed footmen, a hired chef, several courses and the Roman punch, their best dishes and silver, spectacular arrangements of flowers (especially roses), and gilded cards for

[15]The film communicates other symbolic value in the flowers as well throughout the text. For instance, Archer gives May lilies of the valley that represent her youth and innocence; he gives Ellen yellow roses that stand for strong emotion and love; Beaufort's gift of orchids and red roses to Ellen has sexual overtones; and the van der Luydens' carnations represent the exoticism of the upper class.

the menus. The second party mirrors the first, but another generation has taken over the responsibility of giving it.

The scale of the formality, then, has a great deal to do with the seriousness of the family consequences, and the film's choice of vocabulary in and around these affairs—trust, duty, rules, responsibility, sacrifice—is carefully chosen to convey that seriousness as do Archer's final words about himself when he turns down his son's invitation to visit the Countess Olenska in Paris: he says to tell Ellen he's "old fashioned." Ultimately he was still keeping the faith that to love her, he must give her up, and he did not seem unhappy with that resolution. To some extent, he, Ellen, and May all had to give something up and sacrifice themselves in return for love, respect, and family, and the very existence of his children and his ties to the broader family is a testimony to the success of that.

Ironic intertextuality: Wharton's The Age of Innocence and Fitzgerald's The Great Gatsby

In contrast with the Belle Epoch and the values that situate Wharton's and Scorsese's texts, it is the Jazz Age that situates the productions of *The Great Gatsby* and ironizes the intertextual relationships. A key difference between the Belle Epoch and Jazz Age characterizations (both novels and film adaptations) is that predictability, leisurely pace, good manners, emphasis on solid family structure, understated wealth, and sacrifice have been replaced more or less by their antithesis—chaos, frenetic pace, bad manners, growing acceptance of open infidelity and divorce as normative, over-the-top wealth, and selfishness. Even Fitzgerald, known among his friends and the press as representing the bad behavior of the Jazz Age, commented in *Crack Up* that the period was "the most expensive orgy in history" with a "whole race going hedonistic, deciding on pleasure" (1931, 15, 21), a comment decidedly critical of the age. As Meyers remarks, the Jazz generation was freed from the old rules by wealth, alcohol, and automobiles (1994, 59), and as Sinclair notes, "the freedom from stricture that jazz represented, juxtaposed against rigid rules of adherence from earlier genres, serves as a synecdoche of the times as a whole. This decade of dramatic change, also known as 'The Roaring Twenties,' reflected the frenetic pace mirrored in the notes that punctuated its essence" (2012, 303). This synecdoche can be seen at work in the onset of one of Gatsby's huge parties in *The Great Gatsby*:

> By seven o'clock the orchestra has arrived, no thin five-piece affair, but a whole pitful of oboes and trombones and saxophones and viols and cornets and piccolos, and low and high drums. The last swimmers have come in from the beach now and are dressing up-stairs; the cars from New York are

parked five deep in the drive, and already the halls and salons and verandas are gaudy with primary colors, and hair shorn in strange new ways, and shawls beyond the dreams of Castile. The bar is in full swing, and floating rounds of cocktails permeate the garden outside, until the air is alive with chatter and laughter, and casual innuendo and introductions forgotten on the spot, and enthusiastic meetings between women who never knew each other's names.

The lights grow brighter as the earth lurches away from the sun, and now the orchestra is playing yellow cocktail music, and the opera of voices pitches a key higher. Laughter is easier minute by minute, spilled with prodigality, tipped out at a cheerful word. The groups change more swiftly, swell with new arrivals, dissolve and form in the same breath; already there are wanderers, confident girls who weave here and there among the stouter and more stable, become for a sharp, joyous moment the center of a group, and then, excited with triumph, glide on through the sea-change of faces and voices and color under the constantly changing light. (1925, 40)

The classical music (waltzes, cotillions, and operas, among others) of the Belle Epoch has been replaced by syncopated jazz and blues rhythms, the fox trot, and the Charleston with their new social freedom and sexual innuendos.

Interestingly, Fitzgerald's narrative of the Jazz Age riffs off *The Age of Innocence*, and the meaning of that is there in remarkable intertextual relationships, including vocabulary, setting, themes, and the party structure. In vocabulary, *The Great Gatsby* picks up some of the favorite terms of *The Age of Innocence* that included "clan," "class," "duty," "rules," "honesty," and "old," to refer to the obligations of the "old" New York upper class to cohere in a family and social alliance to protect their relationship, reputation, and financial interests. "Old" is sprinkled liberally in almost every chapter in referencing institutions, traditions, and customs that bind the upper-class together, shore up the social network of contemporary New Yorkers with a link to the colonial past, and require certain duties. "Freedom" is another common term and used to connote individualism and subversion of duty to this family alliance.

While *The Great Gatsby* never uses tribe, in the very first chapter Nick refers to his clan (1925, 2) with great affection and only a few paragraphs later to "the freedom of the neighborhood" in West Egg (1925, 4)—a place filled with new money and film stars before that industry moved to Hollywood.[16]

[16]Fitzgerald's use of parties came largely out of his own experience, especially when he lived in Great Neck on the north shore of Long Island from 1922 to 1924. It was here that he met writers and film celebrities who hung out in New York before the film industry moved to California (Meyers 1994, 97).

Although Nick speaks at length about the importance of his family, his "interior rules" and great sense of honesty (1925, 59–60), he later helps to install his married cousin Daisy in a relationship with Gatsby, which is at odds with the values of his professed Midwest sensibility, so the notions of clan, duty, rules, and honesty are ironized. Perhaps only freedom is not.

Nick is also quite aware of class. In the drunken party in Myrtle's apartment, he notes that Myrtle thinks of herself as above others who live and work in her apartment building and as having married down to George Wilson (hence justifying her relationship with the wealthy Tom), while her friend Lucille McKee thinks of herself as having escaped the trap of marrying down in class. Although Nick lets the reader decide the implications of these observations, this discussion is ironic because, while class is an issue for all of them, with the exception of Tom Buchanan and Nick many of these are people clinging to the bottom rungs of the class system, and not one of that group (not even Nick, Tom, and Daisy) can be considered an old New Yorker or insider in the social or political scene. People here are not of an upper-class clan or tribe imbricated into the social network in the same way of those in *The Age of Innocence*, so the text is exploring the downside of freedom from duty to those networks and constraints. Indeed, Tom and Daisy never accept any responsibility for their actions, so for them freedom means a lack of commitment, responsibility, conscience, ties to one place, and identity with one group or clan. Even the list of some of the participants in one of Gatsby's parties helps to ironize the use of clan and class: with names resonating of the animal and sea life, they include Doctor Webster Civet, the Hornbeams, Blackbuck, Edgar Beaver, the Fishguards, S. B. Whitebait, the Hammerheads, Beluga, and Catlips. Moreover, the use of "old" that generally referred to hereditary clan and class in *The Age of Innocence* functions ironically in *The Great Gatsby* for Gatsby affects the term "old sport" to sound as if he is from an old English family and Oxford background, thereby perpetuating a lie about himself, his ethnicity, and his origins.[17] Consequently, the intertextual use of vocabulary ironizes terms about family, class, and duty, as well as ethnicity and origin.

Thematically, clan, family, outsiders, and self-deception in *The Great Gatsby* bear a strong ironized intertextual relationship with *The Age of Innocence*. Both novels are chiefly about clan and family—and threats to them, though considerably ironized in *The Great Gatsby*. Though *The Age of Innocence* has real sympathy for Archer and Ellen's love, the resolution

[17]It is also possible that Leffert's use of "old brick" and "old chap" in *The Age of Innocence* (Wharton 1996, 281) (when he asks Archer to perpetuate a lie about his attendance at the club), forms an intertextual link with Gatsby's use of "old sport." Both have the ring of inauthenticity.

of the plot hinges on Ellen's expulsion to save Archer and May's marriage. Ironically, Daisy and Tom's marriage is also intact at the end of *The Great Gatsby*, though it is Gatsby's illicit love of Daisy, self-deception about their relationship, and unfailing hope to marry her that draws the reader's attention and sympathy and becomes the center of the tragedy. The case for family is made by both Nick and Tom, though this is ironized and though others make the case for infidelity and divorce. As noted earlier, Nick talks quite openly about the value of family and finally leaves New York City to return to that network in the Midwest. Tom is the most vocal defender of family ("Nowadays people begin by sneering at family life and family institutions, and next they'll throw everything overboard and have intermarriage between white and black" (1925, 130)), especially as he confronts Gatsby about his background and relationship to Daisy, but sounds outrageously hypocritical because of his own affairs over the years of his marriage to Daisy and sounds stupidly bigoted in lumping unfaithfulness together with intermarriage. Myrtle, her sister Catherine, Lucille McKee, and even Jordan Baker all accept infidelity and divorce: as Jordan says, "Daisy ought to have something in her life" (1925, 81), which in her mind justifies infidelity with Gatsby. What *The Age of Innocence* affirms, then, in the way of the value of sacrifice for family is interrogated in *The Great Gatsby*—though never entirely abandoned as an idea, as indicated by Nick's condemnation of the "whole damn bunch" in New York and return to the Midwest (1925, 154). It is also never completely abandoned because Gatsby only wants to be married to Daisy: he does not want to take her as a mistress.

Both books, too, are about outsiders. Ellen Olenska is the chief outsider in *The Age of Innocence* by virtue of her relationships (of whatever sort) with the Count, the secretary, Beaufort, Archer, and even Lefferts, her consorting with artists and others beneath her station, and her status as a woman trying out new modes of freedom. In *The Great Gatsby*, all the main characters are outsiders: Nick from Minnesota, Gatsby from North Dakota, Daisy from Louisville, and Tom from Chicago. Their associates and friends are not part of the New York City elite and so are outsiders in class if not geography. Gatsby, of course, is the primary outsider and the one who tries hard to remake his life and gain wealth, so that he is socially acceptable to Daisy who comes from greater wealth and social status. For Gatsby, Daisy represents everything that is beautiful about the moneyed class above him: he says "her voice is full of money," thinks that she gleams "like silver, safe and proud above the hot struggles of the poor," and believes her world "redolent of orchids and pleasant, cheerful snobbery and orchestras which set the rhythm of the year" (1925, 120, 150, 151). For Gatsby, Daisy could have been surrounded by the orchids and roses of the van der Luydens' living room. In both books, outsiders

are punished, but not consistently so, and many survive quite well, especially if they are rich enough. Tom, Daisy, and Julius Beaufort all endure and move on, while Gatsby and Ellen suffer.

As with Archer and Ellen earlier, Gatsby is full of self-delusion about Daisy and her love of him. It is obviously true that she was in love with him for the month they were together in Louisville but became increasingly detached from him as he fought in Europe and then almost forgot about him for eight years until Gatsby bought the house across the bay and threw his elaborate parties. His love, ironically "founded securely on a fairy's wing," his "capacity for wonder," "his incorruptible dream," and his unending hope that he could turn back time and history in order to consummate his relationship with Daisy (1925, 100, 182, 155), all show the same kind of self-delusion and wish to turn back time as Archer, though one protagonist survives into old age and the other is shot to death in his pool. Meaningfully, the attempt to re-invoke the past is central to both novels. Ironically, Archer survives because something even older than his previous love for Ellen—family solidarity—saves him from making an irreparable mistake. Gatsby does not have that, and only counts his development from his days with Dan Cody and introduction to Daisy, so the past as embodied in family and social networks cannot buoy him up.

This ironized intertextuality of class, duty, freedom, the outsider, and time is carried over in the parties, which account for themes and structure in both *The Age of Innocence* and *The Great Gatsby*. If anything, the parties in *The Great Gatsby* are more assertively structural and thematic than *The Age of Innocence* prototype, though they are certainly strong there as well. Every chapter but one in *The Great Gatsby* is built around a party or social event, and the first two-thirds of *The Great Gatsby* (six chapters out of a total of nine) present a kind of romance of parties and go from (1) the Buchanans' elegant dinner party on a patio that resonates of a small Mingott/Archer/Welland dinner; to (2) Myrtle's wild, drunken party in the apartment Tom Buchanan keeps for her on 158th Street in Washington Heights (a whole world away from the fashionable southern tip of Manhattan); to (3) Gatsby's elaborate and excessive party at his palatial mansion in West Egg (what Nick calls his "elaborate road-house" (1925, 64)); to (4) Gatsby and Nick's lunch at the Forty-Second Street cellar speakeasy where Nick meets Wolfsheim; to (5) the tea party Nick hosts so that Gatsby can meet Daisy, which also extends to Gatsby's mansion where he shows off his house and especially his shirts to Daisy; and finally to (6) Gatsby's last big party to which Tom and Daisy are invited and which Daisy does not like. This is the end of the romance of parties, though none of these first six parties is the tasteful soiree, elegant dinner, ball, opera, or wedding of *The Age of Innocence*, but, for the most part, wild and extravagant parties fueled by wealth, consumption, alcohol,

and open sexuality, and facilitated by the automobile and modern technology (even the Buchanans' first elegant dinner party for Nick and Jordan Baker is interrupted by Myrtle's telephone call to Tom and by an undercurrent of infidelity, dishonesty, cynicism, and unhappiness).

These first six parties all lack the manners and emphasis on the family and social solidarity of *The Age of Innocence*, so that their reflecting the party motif and structure in such a way that undermines stability and family is quite ironic. It is, however, in Chapters 7–9 that the tragic dimension triumphs. Though Chapter 7 is also a party chapter beginning with drinks and lunch for Gatsby, Jordan, and Nick at the Buchanan's house, moving to the disastrous liquor-fuelled party at the Plaza Hotel when Daisy refuses to reaffirm Gatsby's wish for her separation from Tom, and ending with the ill-fated death of Myrtle, it announces itself as an anti-party: "It was when curiosity about Gatsby was at its highest that the lights in his house failed to go on one Saturday night—and, as obscurely as it had begun, his career as Trimalchio was over" (1925, 113). The Trimalchio allusion, however, is not only about hosting parties but also about death—which occurs for Myrtle in Chapter 7 and for Gatsby in Chapter 8 with his lonely funeral (the final party attended by Nick, the minister, Gatsby's father, the owl-eyed man, the servants, and the postman) in Chapter 9.

The fact that Nick refers to Gatsby as Trimalchio (1925, 113), that Fitzgerald's working title for the novel was "Trimalchio," and that one of the titles that he kept coming back to as an alternative to his editor Maxwell Perkins' choice of *The Great Gatsby* was "Trimalchio in West Egg" gets to the heart of these parties, the tragic ending, and this ironized intertextuality. "Trimalchio" alludes to a character drawn from Petronius's *Satyricon*: in the section titled "Cena Trimalchionis" or "The Banquet of Trimalchio" in the *Satyricon*, Trimalchio created an excessively lavish and debauched party with exotic food and drink culminating in an acting-out of his own funeral. If Gatsby is Trimalchio, it is with his real funeral rather than an acting-out of one. Fitzgerald's choice of Trimalchio and the funeral is likely related at least in part to his telling a friend that "parties are a form of suicide. I love them, but the old Catholic in me secretly disapproves" (Meyers 1994, 71), a comment that seems a little disingenuous, for Fitzgerald often celebrated his own misbehavior and eviction from clubs and houses because of his "rambunctious parties" (Meyers 1994, 77). It does, however, shed light on his comment that "the Jazz Age 'eventually overreached itself less through lack of morals than through lack of taste'" (Kunz 2012, 77). In other words, the combined lack of morals and taste—that is of values coupled with "class, money and knowledge gained from travel and education, along with personal and professional networks" (Chance 2012, 199)—is the ironizing factor between Fitzgerald's and Wharton's handling of parties and between their film adaptations as well. Both novels and their

adaptations use parties as a display of wealth, consumerism, and power and as a foil to the relationships of the main characters, though Fitzgerald's novel and adaptations call attention to the wildness of the parties themselves and undermine Gatsby's real love for Daisy while Wharton's novel and its adaptation underscores the rules of propriety and politeness that held the old New York tribe together.

Also central to the parties of *The Great Gatsby* is the automobile, one of the first instances in which the automobile is used for dramatic scenes in fiction (Meyers 1994, 69). Because Gatsby's, Nick's, and Tom and Daisy's houses are on Long Island, some distance from each other and New York City itself, public and private transportation are both essential, but public transportation is de-emphasized: Tom and Nick do take a train into the city to Myrtle's apartment and Nick takes the train to work and from the city to the Buchanans for the ill-fated final party, but otherwise the automobile is central. In introducing himself to the reader, Nick notes that he drives a Dodge over to the Buchanans' first dinner. Tom and Daisy have a new blue coupé, and Tom has promised to sell his old car to Myrtle's husband Wilson. Tom himself has a notorious history of driving, and in one instance ripped a front wheel off his car while on a fling with a hotel chambermaid. The guests to Gatsby's parties all come from the city in cars that line up several deep on Gatsby's driveway: one drunk driver even rips off a wheel there. Gatsby's automobile, which Nick and Gatsby drive to the Forty-Second Street speakeasy and which Gatsby and Daisy later drive into the City for the final party at the Plaza, is described as huge and showy, a "circus wagon" without taste: "It was a rich cream color, bright with nickel, swollen here and there in its monstrous length with triumphant hat-boxes and supper-boxes and tool-boxes, and terraced with a labyrinth of wind-shields that mirrored a dozen suns" (1925, 64, 121). This car becomes the killing machine of Myrtle and by extension of Gatsby himself. Indeed, automobiles in the book have an allure because they are simultaneously bright, enticing, dangerous, and deadly—not unlike the allure of Daisy, her white living room, and the moneyed class for Gatsby. Indeed, when Nick returns to the Midwest, he never mentions automobiles but speaks with nostalgia about the trains and horses and carriages, those vestiges of more stable times and stronger social ties:

That's my Middle West—not the wheat or the prairies or the lost Swede towns, but the thrilling returning trains of my youth, and the street lamps and sleigh bells in the frosty dark and the shadows of holly wreaths thrown by lighted windows on the snow. I am part of that, a little solemn with the feel of those long winters, a little complacent from growing up in the Carraway house in a city where dwellings are still called through decades by a family's name. (1925, 177)

This is a paragraph that, without the references to the Midwest, could have been written by Wharton of the old New Yorkers, and reaffirms the values of a communitarian society with the family at the center. But this paragraph is followed by Jordan Baker's comment to Nick that she was wrong about him, that she had thought he was "an honest, straightforward person," but he was not (1925, 179). So the ending of the book has a nostalgic longing for the integrity of a past age—even from Nick who joins Gatsby in beating on, "boats against the current, borne back ceaselessly into the past" (1925, 182)—that also emulates Archer in reflecting on old New York and his relationship with Ellen. But in both books there is an understanding of the final impossibility of going back completely: Gatsby is dead, Nick knows of his complicity in that affair and death, and Archer chooses not to renew his relationship with Ellen in Paris. The nostalgia that marks the end of both books is ironized, but it is doubly so in *The Great Gatsby* because of its intertextual relation to *The Age of Innocence*.

Doubly ironic postmodern intertextuality: The interplay of Scorsese's The Age of Innocence *and Clayton's and* Luhrmann's The Great Gatsby

Thus far, this chapter has explored the intertextual play between Wharton's *The Age of Innocence* and Fitzgerald's *The Great Gatsby* as well as Scorsese's film adaptation of Wharton's novel. The intertextuality of adaptation, however, becomes more labyrinthine because Scorsese's *The Age of Innocence* (1993) riffs off Jack Clayton's important adaptation of *The Great Gatsby* (1974), and Baz Luhrmann's recent adaptation of *The Great Gatsby* (2012) riffs off both of them. The result is a very complex and interesting ironic postmodern interplay of textuality about differences in personal and social identity between the Belle Epoch and the Jazz Age.

All three of these films follow a party sequence to achieve their goals: with its measured tone and pace, Scorsese's *The Age of Innocence* shows how the parties contribute to the stability and control in old New York society; Clayton's *The Great Gatsby* depicts more parties (12 in all) than the book to contrast Gatsby's (Robert Redford) meditation on the green light and his mellow, almost moral, relationship with Daisy (Mia Farrow) as opposed to the frenetic and amoral party scenes; and Luhrmann's *The Great Gatsby* presents the fewest parties (only seven in all), but they are more wildly extravagant affairs that disrupt traditional family and social patterns through freedoms based on new gender equality, sexual liberation, technology, consumption, alcohol, and wild music.

There is a sense in which all three of these films cultivate a leisurely pace at least at the outset: Scorsese's to define the mood of the times and pastimes of his wealthy and entitled characters, Clayton's to contrast the relationship of Daisy and Gatsby with other, more chaotic lives around them, and Luhrmann's to indulge briefly in Gatsby's meditation on the green light and survey of the mansion before focusing on what this noisy and chaotic period was all about. Clayton's begins very slowly, with a title sequence in which the camera unhurriedly pans over Gatsby's mansion, enormous yellow car, swimming pool and swaying curtains on the terrace, and darkened rooms. The camera also takes in the contents of Gatsby's bedroom including the memorabilia of Daisy's life. Much of this is repeated at the film's end. This measured tone is also reflected later in the leisurely dynamics of their love and slow-moving intimate conversations in which Gatsby tries to move Daisy to renounce Tom (Bruce Dern) and marry him. This pace enhances that relationship, making it seem different and more special than the affairs and actions of others—especially in comparison with Myrtle (Karen Black) and Tom's loud, brutal, and tawdry affair. In Clayton's version Nick's (Sam Waterston) voice-over only begins with his tumultuous ride to the Buchanans' mansion in a small rowboat

This pace and introduction of the party sequence follows the book closely and partly serves as the basis for Scorsese's The Age of Innocence, which also has a leisurely introduction to the characters and elegant homes and also uses the voice-over, in this case of Joanne Woodward. Indeed, even the image of Gatsby's closed and darkened ballroom in Clayton's production carries over to Scorsese's in that the Beauforts' ballroom lies in quiet darkness until it suddenly awakens for the ball after the opera. Luhrmann's title sequence echoes that leisurely pace and meditative image of Gatsby (Leonardo DiCaprio) as well, with a series of shots of his Art-Deco JG monogram first done in black and white and then in elegant glowing gold before dissolving into the green light of Daisy's dock, hinting at Gatsby's obsession with her and the reason for his opulence. The image then morphs into snowflakes that, looking like stars in the firmament, fall on the Perkins Sanitarium. This image is accompanied by Nick's (Tobey Maguire) voice-over about the advice his father gave him as a young boy that he should not judge others, a comment justifying his seemingly neutral observation that other people drank too much at that time as well his defense of Gatsby's hope and sensitivity rather than condemnation of his gangsterism and home breaking. This scene ends with Nick's interview with a psychiatrist, who tries to get to the roots of Nick's mental difficulties—morbid alcoholism, insomnia, fits of anger, and anxiety, all symptoms of a conflicted person under great psychological and ethical

stress. To that we might add his struggle with his deviation from his Midwest belief system and his own place in Gatsby's death.

At this point, Luhrmann shifts the emphasis to images of a wild and chaotic New York City: masses of working people crowded into busy streets (reminiscent of Charlie Chaplin's *Modern Times*), the noise and congestion of cars and people of Times Square, the "golden roar" of the spiraling stock market on Wall Street, the production and consumption of cheap and plentiful booze, fantastic parties where morals "were looser," and the huge new buildings going up all punctuated by the beat and lyrics of hip-hop—in short reinforcing Nick's belief that "the tempo of the city approached hysteria." These culminate in the contrasting images of Nick's small Arts and Crafts house beside Gatsby's ostentatious Normandy-style castle, and Daisy and Tom's enormous Georgian pillared mansion and polo grounds. Collectively, these images give an intertwined sense of Gatsby's hope embodied in the green light, the frenetic financial and popular culture scene, and Nick's developing trauma—part of which is the schizophrenia he feels being simultaneously "within and without, enchanted and held by the inexhaustible variety of life": he is at once observer and participant, guiltless and culpable.

After the introductions that all start from a still point, all three films structure their narratives on the parties and use them to make observations about the characters, their class, and the age. These parties, which as noted earlier are strongly located in the novels, are such powerful thematic and structural centers that every film adaptation uses them, only increasing or decreasing the numbers to stress their particular emphasis.

The **first party** in Clayton's and Luhrmann's productions of *The Great Gatsby* is that of Tom and Daisy's dinner in East Egg. Luhrmann adapts Clayton's visuals of the white room, enormous billowing gauzy curtains, and Daisy (Carry Mulligan) and Jordan (Elizabeth Debicki) lying listless on the couches as well as the elegant table on the terrace set with the best china and crystal candelabra—a scene that also resonates with dinners from Scorsese's *The Age of Innocence*. Despite similar images, Luhrmann changes the focus, beginning with Tom's (Joel Edgerton) aggressive and dangerous athleticism as a polo player and friend, close-ups of his tight bulging pants (as opposed to the women's legs and bottoms in Clayton's depiction of Gatsby's large parties), and Daisy's expensive diamond jewelry—ring, earrings, and bracelets. As with Clayton, he incorporates an intrusive telephone call from Myrtle (Isla Fisher) but focuses on it more visually and audibly, punctuated by Nick's noting its "shrill metallic urgency." At this first party, aggression, technology, and immorality intrude into this seeming paradise, indicating that the sense of repose and the allure of whiteness are false and dangerous. Although

Clayton completes this party with a nostalgic image of Tom and Daisy in the golden afternoon light on the dock waving goodbye to Nick, Luhrmann does not use that lambent image, but instead closes this scene with a night shot of Nick and Daisy strolling in the rose garden and Gatsby standing in front of his castle looking toward the green light on Daisy's dock. Paradoxically, however, Clayton's image of Tom and Daisy in waning sunlight is carried over to Scorsese's *The Age of Innocence* when Archer sees Ellen standing on the pier in the golden sunlight and walks away without greeting her, thereby not initiating an affair at that time (see Figure 3.3).

FIGURE 3.3 *A comparison of sunset shots in Clayton's* The Great Gatsby *(top) and* Scorsese's The Age of Innocence *(bottom).*

The first parties in *The Great Gatsby* and *The Age of Innocence* adaptations give way to others, which, as previously noted, are strategically formal and elegant in *The Age of Innocence* but in *The Great Gatsby* raucous and noisy. The **second party** in Fitzgerald's novel depicts a small wild party in Myrtle's apartment and a huge wild party at Gatsby's as the **third**. Although Luhrmann's adaptation continues in that vein, emphasizing the wildness of both, Clayton's adaptation reverses that, downplaying the wildness of Myrtle's party in order to emphasize Tom's brutality to her. Exaggerating this brutality and the drug- and liquor-fueled environment, Luhrmann's rendition of Myrtle's party is more a Satyricon, emphasizing an explicit tie-in of music, booze, sexuality, and popular culture with the stylized jazz musician playing the trumpet on the fire escape outside Myrtle's apartment. In contrast with the whiteness of the Buchannan household interior, this apartment is done in bright red, evoking the "Red Studio" by Henri Matisse—or a bordello. In doing a pan shot of the city around Myrtle's apartment, Luhrmann also brings to mind noir images of the construction of the New York skyscrapers with visuals seemingly drawn from the Chrysler Building (though slightly anachronistic), which tie in with earlier noisy images of Times Square. Both depictions of Myrtyle's party are punctuated by Nick and Tom's movement through the Valley of Ashes and encounter with the Wilsons, revealing that the high life of New York City and Long Island is built on a legacy of economic and social dependency, poverty, and despair—something that does not appear in Scorsese's *The Age of Innocence*, but is certainly there in *The Gangs of New York*.

By contrast, the first big party at Gatsby's (again, the second for Clayton and third for Luhrmann) is clearly celebrative and open to everyone, containing a free cocktail bar, groaning tables of food, a jazz orchestra, Charleston and fox trot dancing, and lots of laughter and drunken behavior. Clayton begins with the setting up of tents, the bringing in of large bouquets of flowers, and the catering of fresh fish, meats, champagne, and other food and drink for the hungry and thirsty guests—images perhaps leading to the elaborate food preparation envisioned for Mrs. Mingott's party to recognize Ellen in Scorsese's *The Age of Innocence*, an intertextual feature that helps to establish not only the lavishness and plenty of the rich, but the special social purposes of such parties—in Scorsese to teach the lesson of family loyalty and in Clayton to indicate the planning that goes into Gatsby's attempts to lure Daisy to his home and create a family.

Both Myrtle and Gatsby's wild parties are juxtaposed with two other low-key elite parties (his **fourth** and **fifth parties**) that follow in Clayton's version—a formal garden party at the Buchanans' with the men in formal dress and the

women in flowing dresses and large hats followed by an elegant but more informal event at a golf course in which Jordan participates and cheats. These two affairs do show a class difference at play (not just a money difference) with the Buchanans able to show wealth in a different, more tasteful way in East Egg than Gatsby in West Egg. These five parties of Clayton present different levels of class and social behavior, but Tom's affair with Myrtle as well as Jordan's immoral sports behavior both indicate that a lack of integrity is not restricted to any one social stratum.

The **sixth party** in Clayton's adaptation and the **third** in Luhrmann's are at Gatsby's, but the first that Nick is invited to. In Clayton's rendition, this party of Gatsby's is bigger and splashier than the first, with the camera focusing on the orchestra, the dancing (at poolside and in the ballroom), the drinking, the smoking, and the erotics of the party—that is, the camera zooming in on the legs, hips, slips, and short skirts of the female dancers, indicating a new kind of gender and sexual liberation as well as objectification of the scantily clad female. The camera also focuses on particular people such as the twins dressed in yellow and the opera singer who tries to compete with the orchestra playing a Charleston, suggesting competing ideologies at work. It is at this party in both versions that the viewer hears all the rumors about Gatsby and his past, though the emphasis is on young adults having a hilarious, utterly free time. Luhrmann's version of the party, which Nick calls an "amusement park" in one breath and a "kaleidoscopic carnival" in another, begins with the frantic driving of the cars up to Gatsby's mansion and people emptying out into a space replete with bathing facilities, fountains, bars, gambling tables, huge Wurlitzer organ high up in the ballroom, and various venues for entertainment acts, including the fireworks finale. People come in every form of dress and undress, but, unlike *The Age of Innocence* where the women are reluctant to show off their newest and best clothes, at Gatsby's they have to be new and trendy, showing the rapid spread of consumption across all classes. As with the earlier images of chaotic action and populist noise of Times Square and Wall Street of 1922 depicted by Luhrmann, collectively these emphasize the power of money, the social freedoms of the newly rich, and the illegal flow of alcohol. In this way, Luhrmann intertextually builds on Clayton's version while referencing his own previous films, such as *Moulin Rouge*, but both Gatsby films also beg the question about what has been gained or lost since the Belle Epoch of *The Age of Innocence*, which does seem an innocent age compared to the financial and moral crassness of the Jazz Age.

The **seventh** party in Clayton's adaptation and **fourth** in Luhrmann's occur on the following day as Gatsby and Nick drive for lunch to the City to meet Wolfsheim (played by Howard Da Silva in Clayton's version), who tells about the shooting of Rosy Rosenthal as well as his role in the making of

Gatsby. Though a relatively safe drive into the city and a low-key affair at a city businessmen's club in Clayton's production, it is one of the many episodes where everybody seems to be sweating profusely, including Gatsby and Tom who first meet here, and indicative of the heat of summer as well as the stresses that this age, relationship, and freedom bring. It is not the "contest of virtue" that Roland Barthes found in the portrayal of sweating Romans in 1950s movies, but it is "the very locus of tragedy, which perspiration is intended to represent" (2012, 20). In contrast, this party in Luhrmann's adaptation stresses noise, speed, and Gatsby's bad driving over the Long Island and Queensboro Bridge roads in his oversized yellow circus car that seem the perfect outrageous accompaniment to the lies he tells Nick about himself and his past. (It is interesting that at some level noise and speed equal dishonesty and lack of integrity in Luhrmann's production, and quiet equal love and integrity in Clayton's.) On the bridge in Luhrmann's film, Nick sees the rising of a new fast generation of blacks who can also drink champagne, play hip-hop music, and celebrate in new, fast cars chauffeured by white drivers—reversing the traditional social patterns of black–white relationships, but not necessarily improving society. When Nick meets Meyer Wolfsheim (Amitabh Bachchan) in the barber shop leading to the speakeasy, however, the old stereotype of Jewish facial features and pronunciation ("gonnection") is strongly reinforced. The lunch is at a speakeasy (or "temple of virtue" as Tom describes it) in the back of a barber shop, with its repeated air of carnivalesque with drinking, stage acts, and easy black–white interaction and casual touching based on liquor and jazz. After this drive and lunch at the speakeasy, Nick meets Jordan in and around Times Square to talk about what Jordan knows about Gatsby and Daisy's background and Gatsby's request to set up a tea between them. In these first four events, then, Luhrmann combines carnivalesque, Satyricon parties with images of glitzy cars and fast, careless driving as well as Times Square surroundings, to convey a sense of recklessness, material consumption, and attractive but dangerous breaking down of social and legal taboos. Nick is conflicted about his role in this, torn between family responsibility and new friendships and social mores. Again, this situation differs in almost all respects with that of *The Age of Innocence*, where there are no blacks and where the depiction of Beaufort's reputed Jewishness is handled in a delicate and off-handed way, suggesting restraint but also the unspoken prejudice of a high-context culture.

The **eighth** party in Clayton's adaptation and **fifth** in Luhrmann's is the tea party that Nick sets up to connect Gatsby and Daisy after which they walk over to Gatsby's house. In both films, Nick sets the stage, but Gatsby tries to control the situation, manicuring the lawns, landscaping the area between their houses, and bringing massive bouquets of flowers over to

Nick's (white roses in Clayton's and orchids of soft colors in Luhrmann's), and in both bringing over an impressive silver service and desserts for tea. Despite Gatsby's need for control in both films, he is clearly anxious and embarrassed about meeting Daisy for the first time in many years—not since before her marriage to Tom. The white color of the flowers (Daisy's favorite) and the clock ticking away on the mantel are reminders that Gatsby wants to, and believes he can, return to an "age of innocence," a more innocent time unsullied by Daisy's intervening marriage. In Luhrmann's film, he knocks the clock over, indicating the perilous nature of his wish to turn time back. Perhaps the whiteness of the convertible Daisy drives in Clayton's production signifies that as well. The party extends to Gatsby's mansion as he shows Daisy how rich he is. However, in Luhrmann's version, this seems to extend over several days as Daisy's and Gatsby's attire changes frequently. Gatsby enjoys showing off his possessions, saying that he "likes all things that are modern" (a direct take from Mrs. Mingott in both Wharton's and Scorsese's *The Age of Innocence*), revealing his massive Wurlitzer organ and monogram on the glossy marble floors, throwing his colorful shirts over the balcony railing to Daisy, showing Daisy his scrapbook of articles about her, and making Daisy aware of how much he longed for her over the years. The embarrassment and unspoken physical attraction of both Gatsby and Daisy is not unlike that of Archer and Ellen in *The Age of Innocence*, and it is possible Scorsese took some lessons from Clayton.

Taking place privately over a series of days in both film productions of *The Great Gatsby*, their getting to know one another is unhurried, and at one time in Clayton's production as they reach for each other, their hands just short of touching, they seem like Michelangelo's Adam and God reaching for each other, a sign of the beginning of life and awareness, not an even continuation of things gone before. In Luhrmann's production, this same point is made by shots of Gatsby meeting Dan Cody on his yacht and sailing with him for five years, indicating the origin of his reinvented life that led to his calling himself Jay Gatsby, an infatuation with money, and "how to dress, act, and speak as a gentleman." Clayton's depiction of this episode in detail remedies the weakness Wharton saw in the novel—that the time spent with Cody in formulating Gatsby's reinvention was never fully articulated. However, in Luhrmann's film, this is offset by shots of Gatsby's impoverished North Dakota heritage as the James Gatz he rejected, images rooted in the photographs of Dorothea Lange that contributed so much to John Ford's adaptation of the Okie camps in Steinbeck's *Grapes of Wrath*. Indeed, in both adaptations, Gatsby wants to wipe out his impoverished past and embrace Cody and Daisy as his origins. In Clayton's production this is reinforced by Gatsby's putting on his army uniform and Daisy's donning the dress of her 17-year-old youth and dancing to the

waltz "What'll I do." This waltz has the effect of eliminating the razzle-dazzle of Gatsby's big raucous parties that neither of them seem to enjoy. In Clayton, this is also followed by Daisy's request that Jay be her lover and Gatsby's assertion that he wants to be her husband—in effect reversing the pattern of *The Age of Innocence* in which Archer would take Ellen for his love but, out of deference for their families, she would not settle for less than a husband.

The **ninth** party for Clayton and the **sixth** party of Luhrmann is Gatsby's huge affair that both Daisy and Tom attend, and that they appear not to have liked. Though in Clayton's adaptation the lawn is covered with red and white tents, tables, and dance floors, and in Luhrmann's the party is seen inside the mansion and on the terrace through screens of tinsel, in both films the house is brilliant with lighting and bouquets of flowers, the men in tuxes and the women in glittering sequin dresses and head-pieces, dancing by and in the water to large orchestras (in Luhrmann's film, particularly orchestras with blacks) and drinking unlimited supplies of champagne and cocktails. In Clayton's version a negative pall is cast as Tom recounts the animal-sounding names of the guests—Leach, Hornbeam, Hammerhead, Roebuck, Beluga, and so forth, and this is hinted at in Luhrmann's as well. In Luhrmann's film, this is also the time that Daisy kisses Gatsby fully and says she wants to run away with him, but Gatsby is bemused by this because he wants marriage and respectability, in effect the values of *The Age of Innocence* that seem so far removed from these circumstances. This is the last of the big parties and in Clayton's film gives way to Gatsby's and Daisy's intimate afternoons at his mansion, but ends up in Luhrmann's with Nick's opinion that Gatsby should not ask too much of Daisy and Gatsby's assertion that he can repeat the past and can begin afresh with Daisy as if Tom and their marriage never existed. In Luhrmann's this also leads to a flashback of Gatsby's original relationship with Daisy, their fatal kiss that changed the world for him, and her opening up to him "like a flower"—with all the sexual innuendos present in Scorsese's title sequence of the rapidly opening roses in *The Age of Innocence*.

The **tenth** party for Clayton (and **seventh** and **last** for Luhrmann) consists of two events—Gatsby, Jordan, and Nick coming to Tom and Daisy Buchanan's mansion for lunch and the subsequent ride to the Plaza hotel in the City as a means of escaping the extreme heat. Although it is Gatsby's idea to have the party so that Daisy can tell Tom she is leaving him, Tom is in control in both versions, not allowing Daisy's and Gatsby's intimate glances and professions of love to go unchallenged. Indeed, in both Clayton's and Luhrmann's adaptations, the look on Tom's face is that of a ruthless hunter when Daisy coos that Gatsby looks cool like a figure in an advertisement. Tom's predatory posture puts the list of names mentioned at Gatsby's last big party into a new perspective: they do not just represent the non-elite backgrounds of the

guests but suggest predator–prey relationships that anticipate Tom's role in Gatsby's death: his putting Wilson on Gatsby's trail; and his control of Daisy and their marriage as hypocritical, conscienceless, and sinister. In Luhrmann's film, it is this predatory posture that marks Tom's reckless driving into the city for the party at the Plaza hotel, endangering himself, his passengers, and others on the road. Indeed, he and Gatsby race their cars side by side on the Queensboro Bridge, endangering all around them. This wild-animal competition carries over to the hotel as Tom first attacks Gatsby verbally, to which Gatsby responds physically—an act of aggressive anger that was not characteristic of Gatsby in the novel or Clayton's film but in Luhrmann indicates his fear of losing Daisy. Tom's assertive control of the situation is not unlike in kind (though certainly degree) the family's control of the destiny of Archer and Ellen as indicated by the very violent images of Indian massacres and dead animals on Mrs. Mingott's walls.

When Myrtle ostensibly was hit by Gatsby speeding back to West Egg, it thus initially seems to be a continuation of his irresponsibility and, in Luhrmann, retaliatory aggression, though it turns out to be Daisy's "vast carelessness" and inability to take responsibility and Tom's murderous comments to Wilson designed to make Gatsby "pay." As Wilson later walks onto the terrace by Gatsby's pool in both Clayton's and Luhrmann's narratives, intending to avenge his wife's unfaithfulness and death, the billowing curtains are reminiscent of those at Nick's first dinner with Daisy, reinforcing the view that predatoriness is a way of life with the Buchanans and the moneyed class, despite appearances to the contrary.

The **eleventh** (or **twelfth** if the Buchanans' dinner and Plaza parties count as two) party for Clayton is Gatsby's funeral. (Luhrmann's adaptation does not include images of the funeral.) Gatsby is never called Trimalchio in Clayton's adaptation, so this funeral cannot be as neatly tied to the gayer parties as it was in the novel, but this anti-party is the final send-off of Gatsby, the end of his dream as the hearse takes him to the cemetery. With only Nick, Gatsby's father, the minister, and two servants in attendance, it is a lonely end to Gatsby's dream and one that sends Nick packing for the Midwest. Clayton's ending also ties back to the beginning of the film for all the panning shots of Gatsby's small possessions in the title sequence are reviewed as Gatsby's father picks up the memorabilia and leaves his half-eaten sandwich on the dressing table. It is also a mixed tribute to Gatsby's dream insofar as Gatsby's father shows Nick Gatsby's copy of *Hopalong Cassidy* in which Gatsby had written his Franklinesque boyhood daily schedule and moral guide, which could lead him to social and financial success. The recitation of this in the hearse and at the graveside indicates that death has been present from the start in Gatsby's re-formation, and the story that began wistfully and slowly as

a tribute to Gatsby's dream is seen to contain its death and Gatsby's own at the same time. It is only Nick who profits emotionally and intellectually from this knowledge. *The Age of Innocence* also ends with death, that of May, and, as with Nick, that results in knowledge and understanding for Archer, who does not attempt to enter into a new relationship with Ellen.

Although Luhrmann ends the parties with the Plaza Hotel incident, the concluding images of the film also reflect the opening scenes of the film, in this case Nick's writing at the sanitarium. The snowflakes of the introductory scene become the floating letters rising above the finished manuscript and the city before finally coalescing into the memorable concluding line, "So we beat on, boats against the current, borne ceaselessly into the past," and highlighted by the blinking green light. The rolling credits at the end also return to the iconic golden Art Deco images of the beginning, which then turn black and white with the green light reappearing in its middle becoming Jay Gatsby's monogram. While these are not the same images as Clayton's, the technique of revisiting the images presented at the beginning is the same, a subtle reminder that the death of the dream is implicit in its origins in versions of *The Great Gatsby* and *The Age of Innocence*, but the differences between the narratives lie in the way in which these frustrated dreams have been incorporated by the societies.

In adaptations of *The Great Gatsby*, as with Scorsese's, Wharton's, and Fitzgerald's texts before, the parties are linked by transportation that is front and center and related to the aspirations and weaknesses of the characters and the times. In Clayton's and Luhrmann's productions, the automobile especially links the wild parties, rendered more graphic than in the novel by their bright colors, engine sounds, and loud honking, but also as instruments and conveyances of death in Myrtle's accident and Gatsby's killing and, in Clayton's version, the funeral. In Clayton's version Tom and Daisy have a blue coupe, Daisy a white convertible, Jordan a red convertible, and Gatsby a yellow "circus wagon"—and this at a time when Henry Ford thought all cars should be black. Indeed, the only significant black car in Clayton's film is the hearse. In Luhrmann's adaptation, Gatsby also has a yellow car, Tom and Daisy their blue coupe as well as a blue convertible roadster, and Nick a black coupe, which he only drives once, but many others (blacks included) have bright, extravagant cars. In both films, people are judged by these cars, but that can also be ironic.

Of the various drivers, Gatsby seems to be the most careful driver in Clayton's film but not in Luhrmann's, Jordan a reckless and rotten driver in Clayton's film, and Tom an aggressive driver and Daisy a murderous driver in both versions and one who will not take responsibility for Myrtle's death. Unlike the novel, in Clayton's adaptation, Nick seems not to have a car and

travels by boat, train, or others' cars, and even in Luhrmann's adaptation hardly drives. This is in keeping with his role as an observer and commentator rather than a "driver" of the action or mistakes, but, of course, that does not absolve him of responsibility for his role in the affair.

As the credits roll at the end of Clayton's film, the automobile continues to dominate. The cheery song "Ain't we got fun" accompanies a group of men and women trooping into mainly black cars that will take them to more parties, and Gatsby's yellow car stands by itself in an otherwise empty garage at his mansion. The house is silent and dark, but the car sits there, ready to roll. In Luhrmann's film, the car is much more central to the roaring action than in Clayton's, though the attribution of ownership is less important. Almost everyone, including Gatsby, is a careless driver in Luhrmann's adaptation, perhaps because the age itself is careless, not just the rotten bunch that Nick says includes Jordan and the Buchanans.

Clayton's and Luhrmann's textual interplay of automobility builds on the importance of transportation in Fitzgerald's and Wharton's novels as well as Scorsese's film. In all of these, modes of transportation are indicators of social class and, pun intended, social mobility; they are also indicative of transitions in time from horse-drawn vehicles to the automobile and of social changes accompanying that. In Scorsese's *The Age of Innocence*, the cars at the end of the film are more indicative of time moving on than they are of social standing; indeed, they seem to go along with stable development and Archer's being at peace with himself over time. In *The Great Gatsby* novel and adaptations, the car is attractive and alluring but representative of social upheaval and disparity of class and income. In all of these cases, they are nicely in sync with parties as indicators of individual, family, and social priorities, goals, and behavior.

The automobiles, the parties, the rule of money and class, the conflict between family honor and individual freedom, and the role of the outsider—all of these in this intertextual matrix relate to issues of idealism and social morality; the freedom of the independent individual with reference to family and social structure; the attempt to capture something individual and free in the face of American materialism; the lure of money and the predatory power of the rich, whether successful men or entitled women; and the limited possibilities of love founded on the illusions of youth. While I cannot agree with Marius Bewley that F. Scott Fitzgerald "was the first of the great American writers to have found that a 'treatable' class, with its accompanying manners, really did exist in America—to have found it sufficiently, at any rate, to have been able to create characters who are representative of a socially solid and defined group rather than symbolic embodiments of the ultimate American solitude, or two-dimensional figures in the American morality play" (1985, 25), I would agree that he was able to discover those patterns of class in his age.

But I would argue that he learned this in good part from Edith Wharton, especially through the rhetoric of parties that become central to identifying culture and class from one age to the next, from the Belle Epoch to the Jazz Age. I would also argue that this relationship has been built upon and enhanced by the intertextual interaction of Scorsese's *The Age of Innocence* and Clayton's and Luhrmann's adaptations of *The Great Gatsby* that make these relevant to massive social changes in the twenty-first century as well.

4

Freeplay, citation, and ethnocriticism: Single and multiple sources in *Smoke Signals, SMOKE,* and *Do the Right Thing*

Postmodern positions, regardless of what they call themselves... are all based upon models both of Western "scientific," "social-scientific," "rational," "historical" modes of thought, and of non-Western "religious," "biogenetic," "mythic," or vaguely specified "Indian" modes, that are grossly overgeneralized... so that they may be reified as categories presumptively in (binary) opposition to each other.

KRUPAT, ETHNOCRITICISM

Although John Guare's *Six Degrees of Separation*, Wharton's *Age of Innocence*, and F. Scott Fitzgerald's *The Great Gatsby* are adapted more-or-less directly into film, and although particular narrative features and attitudes of Raymond Carver's stories make their way into the adaptation of *Short Cuts*, films are never one with their anterior sources. This is particularly noticeable when a film only briefly cites another text rather than to base the whole film on one original source. Sometimes these freeplay adaptations draw fragments from one text, others cite them, and still others create a pastiche. These citations are a favorite kind of postmodern play, and these days probably more films are citational than fully adaptive.

The impoverishment, supplementation, surplus value, and indeterminate meaning that enter into freeplay and citational textuality take many different forms. One is the intertextual doubling of rhetorical images and terms, exemplified in *Age of Innocence* and *Gangs of New York* that draw quite different films strategically together. Another is the poetic license taken in freeplay adaptations when short fictions are turned into feature-length films as in *SMOKE* or when several stories are brought together to create a single unified film, as in *Smoke Signals*. There are infinite variations of citations as when films like *Do the Right Thing* draw upon rhetorical documents and speeches to make a statement about race relations in America, or when one film like *SMOKE* enters into an intertextual dialogue with another film like *Do the Right Thing*.

In one instance, Sherman Alexie has used several of his short stories in his collection *The Lone Ranger and Tonto Fistfight in Heaven* and to a lesser degree parts of his novel *Reservation Blues* in creating a script for Chris Eyre's film *Smoke Signals*. In writing this script, Alexie never uses an entire short story, but, of the half dozen or so he does use, draws on some more liberally than others, so that the film itself takes considerable poetic license in expanding its framework.

In a second instance, Paul Auster has used his extremely short Christmas narrative, "auggie wren's christmas story," to include in *SMOKE*, a film directed by Wayne Wang, who worked hand in glove with Auster to make a sensitive production about life in Brooklyn. Moving from a story that takes 15 minutes to read to a film nearly two hours in length to watch suggests the extent of freeplay and elaboration required in developing a more complex construct.

However, the freeplay of adaptation in *SMOKE* does not end there for it also engages in an intertextual dialogue with Spike Lee's *Do the Right Thing*, which, I maintain, was its ideological springboard. The use of *SMOKE*, then, is especially relevant for it is simultaneously a highly complex adaptation of Auster's short piece of fiction and a citation of several elements of Lee's *Do the Right Thing*. This postmodern hybridity and intertextual doubling has serious multicultural purposes though done in a low-key manner.

In *Smoke Signals* and *SMOKE*, Alexie and Auster—the writers of the short stories—also wrote the film scripts, so that the adaptations spring from their own choices and purposes, however much those purposes have changed from the precursor fiction to the film. This in itself is a kind of postmodern feature where the author of the original narratives creates the film script, and where there seems to be no hint from the authors themselves that one form is superior to the other. My primary purpose in this chapter is to look at the ways freeplay adaptation and citation operate as a postmodern construct,

giving rise to indeterminacy of interpretation of the film and anterior story but with serious ethnocritic purposes in exposing and commenting on ethnicity and race in America.

In working with a postmodern analytic and exploring the postmodern in these adaptations, I wish to suggest ways that they engage postmodern discourse through their content, rhetoric, and multicultural sensibility. While postmodernism is many things to many people, some see it as upending traditional notions of social hierarchy and allowing the emergence of new cultural matrices and more inclusivity in race, ethnicity, and gender.

Four critics and their texts are helpful in this light based upon the use of African American and Native American culture in the films—the African American bell hooks and her essays "Postmodern Blackness" (1993) and three Native Americans and their texts, including Arnold Krupat's *Ethnocriticism* (1992), Louie Owens's *Mixedblood Messages: Literature, Film, Family, Place* (1998), and Gerald Vizenor's *Narrative Chance: Postmodern Discourse on Native American Indian Literatures* (1993). These critics, all writing at roughly the same time, are concerned about the impact of postmodernism on their communities and the best way to position their own experiences and understanding within that cultural context.

A self-pronounced postmodernist, Gerald Vizenor is the most sanguine of the critics, thinking that postmodernism is mainly about the play of language and that the real "word is there, in trees, water, air, and printed on paper where it has been at all times" (1993, x). In his opinion, ethnic writers can enter whatever discourse they wish and never feel threatened because something essential stands apart from the language game. Bell Hooks, however, cannot so easily accept that distinction, and she comments that many of her African American friends say "this [postmodern] stuff does not relate in any way to what's happening with black people" (1993, 510). In thinking about the relevance of postmodernism to black culture, she notes that postmodern academics often fail "to recognize a critical black presence in the culture" and "seem not to know black women exist or even to consider the possibility that we might be somewhere writing or saying something that should be listened to" (1993, 511, 512). Multicultural and postmodern code words like "difference" and "Other" that are supposed to have opened up the discourse to ethnic and gender identity have remained, she argues, in the hands of white male and female scholars, editors, and publishing houses who write and publish from the authoritative center, so that the racial minorities and women have "to find new ways to talk about racism and other politics of domination" that are related to identity and agency (1993, 512). She argues that in the best sense postmodernism encourages multiple experiences, perspectives,

and identities, so that all African American literature and film is not viewed as being of the same piece. In the best of all possible circumstances, "ruptures, surfaces, contextuality, and a host of other happenings create gaps that make space for oppositional practices" (1993, 518), which can be liberating and freeing for academic and nonacademic blacks. She is willing to take a risk on this but at the same time sounds a wary note.

Though hook's concerns sound as if they are limited to African Americans, they correspond closely with those of Native Americans Arnold Krupat and Louie Owens, who are both interested in the impact that postmodernism has on their cultures, are aware that postmodern and multicultural criticism has not always been entirely open to minorities, and want to be included in a new ethnically postmodern enterprise. They find that the academic center is still one of "critical imperialism" (Owens 1998, 49). More disturbingly, the authoritative voice that is said to represent them "still does not always hear more than the echo of its own voice or see very far beyond its own reflection" (Owens 1998, 48). Most disturbingly, even when their own voices get heard, "the indigenous 'text' is 'read' by those in power [and] may be mere surface appropriation, a shadow borrowing and simulacrum of tribal culture" (Owens 1998, 48). They find that, in taking on the causes of multiculturalism in "transcultural zones" within "dialogically agitated space," various groups risk losing their ethnic identity through it all (Owens 1998, 48). Consequently, as with hooks, indigenous critics find that it is necessary to have a better articulated model of "ethnocriticism" (Krupat 1992, 5) to find their voice and better cultural balance. This might well be termed "ethnocritical postmodernism," for they find a need to be part of a postmodern enterprise and share their literature and culture with the rest of the world, but they want to be careful that engaging with "authoritative discourse" and postmodern critical theory will be something "more than a new form of colonial enterprise" (Owens 1998, 51). Finally, Owens states that everyone engaged in the study of culture in whatever form needs to respect, celebrate, and "mediate without violating" the tenets of what we study (1998, 56). It is, then, critical in contextualizing various ethnic groups within this newly proclaimed multicultural postmodernism that the concerns of the community and respect for their identity be uppermost in this consideration. This cannot be merely the play of signification, but must take on board historical issues, community identity, strongly felt issues, and multiple voices and perspectives.

This chapter, then, will use a postmodern analytic to explore the indeterminacy, supplementation, and surplus of freeplay adaptations and citations and to use ethnocriticism to go into issues of ethnicity and race in texts constructed by Native Americans, African Americans, Asian Americans, and whites.

Ethnocriticism and adaptation: Sherman Alexie's *The Lone Ranger and Tonto Fistfight in Heaven* and Chris Eyre's *Smoke Signals*

every little war, every
little hurricane.
I'll take my Indian thumb
and my white fingers
on my strong right hand
and I'll take my white thumb
and my Indian fingers
on my clumsy left hand
and I'll make fists,
furious.

ALEXIE, "Reservation Mathematics"

Sherman Alexie first thought of himself as a poet, but then turned to writing fiction, and only with Chris Eyre's *Smoke Signals* did he turn to film, drawing from several of his own short stories and a novel to create the script. Certainly the film carries things over from the written narratives but with a strong sense of a playful and slightly humorous rendering of postmodern ethnocriticism.

In his 1972 comments on the Hollywood Western, Tom Engelhardt notes that, regardless of ethnic identity or national origin, movie audiences are meant to identify with white frontiersmen and settlers clustering in the ever-present and vulnerable circle of wagons or fort and to fear those darker beings, who come, "in the enveloping darkness, on the peripheries of human existence, at dawn or dusk, hooting and screeching, from nowhere like maggots, swarming, naked, painted, burning and killing for no reason, like animals..." (1972, 480). As Engelhardt further notes, this representation of Indians as the aggressive "Other" "forces us to flip history on its head. It makes the intruder exchange places in our eyes with the one intruded upon" (1972, 481). As with the Irish—who in the 1840s were thought by the whites to be upsetting proper society and manners, moral proprieties, good religion, and a rational economic scheme (Ignatiev 1995, 171), American Indians were looked down upon, but because they were in North America before the white man, those who opposed them could not espouse a nativist agenda with the same show of authority as they did with the Irish or Italians. That did not mean, however, that whites could bring themselves to support Native Americans but rather, because they were a darker color than the whites and with very different customs, to despise them.

Some 40 years after Engelhardt made his observations, things have changed in the representation of Native Americans in film and literature, but in certain respects some Americans cling to their stereotypical views. In *Tonto's Revenge* Rennard Strickland tells of a colleague's "experience attending a cowboy and Indian film at a theater in the heart of Sioux country and observing the Indian students in the audience rooting for the cavalry as they rush to massacre the Indian warriors" (1997, 18). For Native American writer Sherman Alexie, this tendency exists because Americans have failed to grasp that their stereotypes about Indians are not only historically false but that they condemn Indians to lurk forever in the dark behind the bluffs of frontier America instead of coming into the light of an increasingly urbanized, contemporary United States. He also recognizes that, when Native Americans are not identified with that frontier American setting, they are often forgotten altogether. As an example of such ethnic erasure, Stanley Corkin, in making the case that "frontier mythology defines national identity" with regard to capitalist enterprise and the spirit of expansion (2000, 66), never once mentions the actual exploitation and victimization of the Native American population that fueled this nationalist, imperialist, and expansionist ideology. His only concern is this image of the Western as a metaphor for national policy impacting upon other countries, not upon Native Americans. Native Americans, then, all too often are counted out and absented from such discussions. Consequently, as Alexie fears, Native American Indians are demonized, left behind the bluffs, or ignored.

The failure to provide Native American perspectives, to situate Indians in contemporary American culture, or to recognize their existence, fortunately has been remedied by a number of excellent Native American novelists, beginning with N. Scott Momaday, and including the likes of Leslie Marmon Silko, Michael Dorris, Louise Erdrich, Gerald Vizenor, Linda Hogan, Ivan Doig, and James Welch. Fiction by these writers has gained international recognition for stimulating narratives and sophisticated styles, as indicated by Momaday's breakthrough Pulitzer Prize in 1969 for *House Made of Dawn*. Sherman Alexie is another who has made his reputation in fiction and poetry by describing Native American culture both on the rural reservations in eastern Washington or northern Idaho and in such urban centers as Spokane and Seattle.

Representations in film are another matter, however. Although there has been some interest in depicting more historically authentic views of Native Americans than those presented in typical post–World War II Westerns, the reality of their lives and media perspectives still seems sadly underrepresented and diminished in mainstream Hollywood films. A film like the blockbuster *Dances with Wolves* (1990) is a case in point: although the film does generate sympathy for Native Americans, it is through the perspective of a white male

soldier in the nineteenth century. Films about contemporary Native Americans by Native Americans with Native American perspectives and starring Native Americans have been largely under-represented and underfunded. *Grand Avenue* (1995), based upon the Greg Sarris's novel of the same name, and Stuart Margolin's adaptation of Thomas King's *Medicine River* (1993) are two relatively recent Native American films that have helped to alter perceptions. Made for television, *Grand Avenue* broke some AC Nielsen rating records on HBO, and *Medicine River* received critical acclaim at the 1993 American Indian Film Festival in Taos. Neither, however, enjoyed the popular support that would lead to increased production possibilities for Native American films or that might alter public opinion on Indians in American society or their role in the Arts.

Before Sherman Alexie turned his hand to film, the Native American literary community was critical of him for not breaking down the old stereotypes. Some thought of him as a "colonized subject," representing himself and his culture "in ways that engage with the colonizer's own terms" (Owens 1998, 53). Owens, a well-respected critic of Native American literature, claims that Alexie's fiction

> too often simply reinforces all of the stereotypes desired by white readers: his destructiveness and self-loathing; there is no family or community center toward which his characters...might turn for coherence; and in the process of self-destruction the Indians provide Euramerican readers with pleasurable moments of dark humor or the titillation of bloodthirsty savagery. (1998, 79)

He adds that this stance is typical of "the tragic, causal parameters of modernism...in the form of 'Indian anger,' posing militantly while giving the white audience what it already knows and desires... offering Indian readers plenty of anger but no ground upon which to make a cultural stand" (Owens 1998, 81). This argument that Alexie's fiction has no cultural "coherence" or "ground" suggests that he fails the ethnocentric test of Krupat and Owens.

Although Alexie has become an increasingly popular author, in his early fiction he tended to run counter to Native American critics Krupat and Owens, who accept the view that most Native Americans are more or less "accommodated" if not assimilated into the dominant culture and do not need to be singled out for particular vices but do need ways to have their personal and cultural identity reified. Both see themselves as postmodern critics in a postmodern era, and want themselves and their people to be accepted as equal partners in American culture. Hence, Krupat's use of ethnocriticism as enunciated in his book *Ethnocriticism* (1992) becomes an important tool

in their assessment of ethnic literature, film, and culture with the aim of achieving Native American critical and cultural equality. Ethnocriticism goes beyond "mere" multiculturalism in recognizing the freeplay of language and culture and the deconstruction of traditional hierarchies and paradigms (including racial ones), making sure that Native American identity, talent, and perspectives are enhanced by this rather than lost, and doing this not in a hostile or sermonizing way, but in social engagement and humor.

Chris Eyre's 1998 film *Smoke Signals*, with Sherman Alexie as script writer, provided an important step in remedying this problem. Based on Alexie's *Reservation Blues* (1995)[1] and the first third of his collection of short stories, *The Lone Ranger and Tonto Fistfight in Heaven* (1993a), especially "This Is What It Means to Say Phoenix, Arizona," this film also contained many of Alexie's song lyrics. Co-produced by Alexie and Eyre, this adaptation tells the story of two Indian youths, Thomas Builds-the-Fire and his companion Victor Joseph, who journey from the Coeur d'Alene Indian Reservation in northern Idaho to Arizona to retrieve the pickup truck, money, and funeral ashes of Victor's father, Arnold Joseph.[2] Unique in using a Native American cast to depict a contemporary Native American situation, this film provides a sensitive glimpse into the lives of the two young men, so much so that "it received the Audience Award for Dramatic Films, the Filmmakers Trophy, a nomination for the Grand Jury Prize, and a special showing and reception hosted by Robert Redford" at the prestigious Sundance Film Festival (Kilpatrick 1999, 228). The film, however, presents a very different perception from the short story collection.

Although both concern contemporary Native American culture, the fiction and film adaptation have contrasting aims and methods: the fiction gives a comprehensive representation of the entire Spokane Reservation community and includes Alexie's typically critical and cynical view of the systemic problems of unemployment, poverty, hunger, inadequate housing, violence, drugs, alcoholism, and premature death in a culture increasingly removed from its traditional moorings. Both *The Lone Ranger and Tonto Fistfight in Heaven* and *Reservation Blues* tend to blame the influence of European American culture on Native Americans and to depict Native Americans as a group who "drink themselves to death, beat one another senseless, and survive for the

[1]Certain of the characters like Thomas Builds-the-Fire and Victor Joseph appear in *Reservation Blues* and also appear in the short stories. The germ of the road trip to pick up Victor's father's ashes is taken from the novel and from the short story "This Is What It Means to Say Phoenix, Arizona."

[2]In the short story collection, Arnold is Victor's uncle, not his father (Alexie 1993a, 2). The setting, too, is changed for the collection of short stories takes place on the Spokane Indian Reservation.

moment with brutal, self-destructive humor" (Owens 1998, 78). By contrast, the film presents the story of two Native American youths on the Coeur d'Alene reservation who go on a road trip to Arizona to collect the remains of a father and in the process discover identity and find friendship. The film, then, engages the Western and the road genre in a postmodern way to suggest a new perspective on the lives of Native Americans.

Although Jacquelyn Kilpatrick thinks that Alexie's "clichéd stereotypes" of "alcoholism, injustice, and loneliness" are carried over into Eyre's film adaptation (1999, 23), I believe that *Smoke Signals* overcomes most of these stereotypes, fully humanizes Native Americans, better accepts the cross-racial, cross-cultural, and mixed blood relationships than the fiction, and ultimately takes a postmodern position close to that of Owens and Vizenor.[3] In my opinion, contrary to Alexie's fiction, the film *Smoke Signals* presents a warm-hearted, compassionate view of Victor and Thomas through the medium of the road narrative and engages the audience on the level of humor and sentiment even while it gently critiques the dominant white society and ongoing racist treatments of Native Americans.

The difference between these two genres—fiction and film—is especially meaningful through the lens of the postmodern ethnocriticism of hooks, Owens, Krupat, and Vizenor coupled with postmodern indeterminacy and uncertainty, in which it is fully implicated. In both book and film, chaotic elements—weather and fire—are foundational causes of natural catastrophe, but they are also governing metaphors that address the uncertainties and indeterminacies of the main characters, the social conditions of Native Americans, and the sudden changes that mark a new way of thinking and acting. Their use is also related to the degrees of optimism or pessimism about the future prospects of Native Americans.

Hurricanes: The Lone Ranger and Tonto Fistfight in Heaven

Alexie's short story collection *The Lone Ranger and Tonto Fistfight in Heaven* contains some 22 stories, detailing the lives of families on the Spokane Indian

[3]Although it is not the purpose of this chapter to address the politics of the argument about an essentialized Native American identity as opposed to a cross-race identity (i.e., the debate between Alexie's and Gerald Vizenor's positions) identified in Louis Owens' *Mixedblood Messages* (1998, 74–81), it might well be that the criticism leveled against Alexie's position in *Reservation Blues* and *The Lone Ranger and Tonto Fistfight in Heaven* resulted in a more accommodating view of cross-race relations in the film.

Reservation, rather than the Coeur d'Alene Reservation of the film. (As these reservations are very close together, one in eastern Washington and the other in northern Idaho, little distinction is made between them from the stories to the film, though perhaps the setting in Coeur d'Alene seems more remote than one around Spokane, Washington.) The collection especially focuses on the two boys, Victor Joseph and Thomas Builds-the-Fire, whose relationship has had its ups and downs in childhood, but who have been bonded by the death of Victor's father in Phoenix, Arizona. In many ways their relationship exemplifies others who share the grief and happiness of life on the reservation.

Of these stories, only five contribute significantly to the characterization of Victor and Thomas and assist in Alexie's development of the script of *Smoke Signals*. These include "Every Little Hurricane," "Because My Father Always Said He Was the Only Indian Who Saw Jimi Hendrix Play 'The Star-Spangled Banner' at Woodstock," "The Only Traffic Signal on the Reservation Doesn't Flash Red Anymore," "This Is What It Means To Say Phoenix, Arizona," and the title story of the collection "The Lone Ranger and Tonto Fistfight in Heaven." A couple more stories develop the characters of Victor and Thomas but do not contribute significantly, if at all, to the film. These include "A Drug Called Tradition," "All I Wanted to Do Was Dance," and "The Trial of Thomas Builds-the-Fire."

The Lone Ranger and Tonto Fistfight in Heaven opens with a story called "Every Little Hurricane" that establishes the primary image for the collection concerning a great storm that hit Spokane, Washington, in January 1976: "Although it was winter, the nearest ocean four hundred miles away, and the Tribal Weatherman asleep because of boredom, a hurricane dropped from the sky in 1976 and fell so hard on the Spokane Indian Reservation that it knocked Victor from bed and his latest nightmare" (Alexie 1993a, 1). As might be expected, this spontaneous and unpredictable storm causes a huge sweep of destruction around Spokane, but is itself a mirror reflection of the nightmare that envelops Victor's house this particular New Year's Eve:

> During that night, his aunt Nezzy broke her arm when an unidentified Indian woman pushed her down the stairs. Eugene Boyd broke a door playing indoor basketball. Lester FallsApart passed out on top of the stove and somebody turned the burners on high. James Many Horses sat in the corner and told so many bad jokes that three or four Indians threw him out the door into the snow…James didn't spend very much time alone in the snow. Soon Seymour and Lester were there, too. Seymour was thrown out because he kept flirting with all the women. Lester was there to cool off his burns. Soon everybody from the party was out on the lawn, dancing in the snow, fucking in the snow, fighting in the snow. (Alexie 1993a, 10)

Having thrown this noisy and raucous New Year's Eve party in the midst of the hurricane, Victor's drunk parents eventually pass out in their bedroom after his equally drunk uncles Adolph and Arnold try to kill one another in a violent fight. As the narrator observes, continuing to draw on the rhetoric of weather patterns, "The two Indians raged across the room at each other. One was tall and heavy, the other was short, muscular. High-pressure and low-pressure fronts" (Alexie 1993a, 2).

The nine-year-old Victor, watching all this in his pajamas, has no control over these developments or his environment. He is lonely and nonplussed, but what he fails to recognize at this young age is that his parents also have little control over their social and political environment. For all practical purposes, they are all innocents caught in a cultural hurricane of increasing white settlement and cultural encroachments, commodification and commercialization, and adverse US government policy.

As suggested by these passages, the imagery of the hurricane weaves itself through the account of the New Year's debacle, the contemporary ground situation of the reservation, Victor's own emotions, and, by extension, the historical legacy of Native Americans. The hurricane is at once a real phenomenon and a metaphor for the various forces that disrupt the broader Native American society. In another story, "The Lone Ranger and Tonto Fistfight in Heaven," the storm is also compared to other destructive forces like the "earthquake [that] comes roaring through your body and soul, and it's the only earthquake you'll ever feel. But it damages so much, cracks the foundations of your life forever" (Alexie 1993a, 209). The macrocosmic natural activities of the hurricane or earthquake are mirrored in the microcosmic social activities of the tribe and thoughts and actions of the characters.

Though Victor's role in this party, the fight, and the hurricane is primarily as an observer, witness, and victim, he is hardly without emotion. As he watches his uncles fight in "Every Little Hurricane," the guests trash the house, and his parents sleep off their drunk, he shares the helplessness of his people for five hundred years in post-Colombian America:

Witnesses. They were all witnesses and nothing more. For hundreds of years, Indians were witnesses to crimes of an epic scale. Victor's uncles were in the midst of a misdemeanor that would remain one even if somebody was to die. One Indian killing another did not create a special kind of storm. This little kind of hurricane was generic. It didn't even deserve a name. (Alexie 1993a, 3)

Importantly, the story takes place in 1976, the bicentennial anniversary of American Independence, an occasion that also marks the expansion of

white settlement beyond the Appalachian Mountains into the middle and western North America, eventually nearly destroying the various Native American cultures and population. July 4th comes up in several stories, including "Amusements" and "This Is What It Means to Say Phoenix, Arizona." As Thomas says, "It's strange how us Indians celebrate the Fourth of July. It ain't like it was *our* independence everybody was fighting for" (Alexie 1993a, 63). In this way, Alexie's narrative joins a long list of bicentennial cinemas—for example, *Jaws, Nashville*, and *Rocky*—that query and ironize the values that drove the early Republic and that still dominate, but the Native Americans have a particular stake and claim on this ironized holiday because on the heels of American independence came the exploitation of the West and the near eradication of the Native American population. Victor's internal hurricane may seem small by comparison with those that have enveloped Indians across America since the arrival of the whites, but it is equally devastating, and he experiences the same sense of destruction and loss:

> In other nightmares, in his everyday reality, Victor watched his father take a drink of vodka on a completely empty stomach. Victor could hear that near-poison fall, then hit, flesh and blood, nerve and vein. Maybe it was like lightning tearing an old tree into halves. Maybe it was like a wall of water, a reservation tsunami, crashing onto a small beach. Maybe it was like Hiroshima or Nagasaki. Maybe it was like all that. May be. (Alexie 1993a, 6)

Hurricanes, earthquakes, and lightning are all manifestations of unavoidable disorder in nature, but the extermination of the Japanese in Hiroshima and Nagasaki in a split moment or the Indians in America over half a millennium is unnatural and human-caused and could have been avoided.

Victor's life is a case in point. "Every Little Hurricane" does document the unsettling and catastrophic experiences of nature and the natives on this particular New Year's Eve, which have the potential to "destroy the reservation and leave only random debris and broken furniture" (Alexie 1993a, 11), but destruction and death are not inevitabilities from all causes. Despite Victor's worst fears, the uncles do not kill one another, the house remains standing, and Victor finds temporary respite "between his parents, his alcoholic and dreamless parents, his mother and father. Victor licked his index finger and raised it into the air to test the wind. Velocity. Direction. Sleep approaching" (Alexie 1993a, 10). Other stories in the collection note that his mother stops drinking, though Victor's father abandons his mother and himself, so the story lacks redemption and a "Hollywood-end."

The fiction makes clear that this event in Victor's life is not unlike that occurring regularly on the reservation or governing Native Americans in general:

"Victor closed his eyes tightly. He said his prayers just in case his parents had been wrong about God all those years. He listened for hours to every little hurricane spun from the larger hurricane that battered the reservation." Moreover, "it was over. Victor closed his eyes, fell asleep. It was over. The hurricane that fell out of the sky in 1976 left before sunrise, and all the Indians, the eternal survivors, gathered to count their losses." (Alexie 1993a, 10, 11)

In "The Only Traffic Signal on the Reservation Doesn't Flash Red Anymore," the narrator Victor elaborates on Indians as survivors:

It's hard to be optimistic on the reservation. When a glass sits on a table here, people don't wonder if it's half filled or half empty. They just hope it's good beer. Still, Indians have a way of surviving. But it's almost like Indians can easily survive the big stuff. Mass murder, loss of language and land rights. It's the small things that hurt the most. The white waitress who wouldn't take an order, Tonto, the Washington Redskins. (Alexie 1993a, 49)

Such disorder and carnage reproduced at every level from the largest to the smallest suggest not only the ongoing, systemic violence by whites and natives alike but also some better possibilities because, if Victor's case is representative of his people, then Native Americans in general have a chance about their condition at century's end, despite seeming gloom and cynicism. Certainly, one of the most common themes running throughout the book is that, despite calamities, Native Americans have survived and can continue to do so. Metaphorically speaking, if hurricane rains and snow swell the rivers, bringing about ruin, they also allow the conditions for salmon to rise, and the salmon rising represents a fresh beginning. This can be a typical cycle of exhaustion and renewal. As Thomas reminds his listeners in "The Lone Ranger and Tonto Fistfight in Heaven," "Nothing stops, cousin...Nothing stops" (Alexie 1993a, 75).

The remainder of the short story collection shows the extreme difficulty of achieving such a positive resolution, however, and, in terms of the dominant image, the family hurricane continues—and by extension the hurricane in Indian culture. The story "Because My Father Always Said He Was the Only Indian Who Saw Jimi Hendrix Play 'The Star-Spangled Banner' at Woodstock" notes that Victor's father goes to prison for wielding a gun in his protest against the

Vietnam War, that his marriage to Victor's mother falls apart amidst increasing violence, and that, after leaving the family and traveling to various cities in the West, he eventually settles into a lonely existence in Phoenix (Alexie 1993a, 25, 27, 34). "This Is What It Means to Say Phoenix, Arizona" notes that Victor's father dies alone of a heart attack in his trailer house in Arizona and is not discovered for a week (Alexie 1993a, 60). Victor and Thomas fly down together to retrieve the ashes. "All I Wanted to Do Was Dance" reveals that, despite Victor's promise as a basketball star in high school and as a breadwinner, he loses his basketball skills and compromises his employment opportunities because of alcoholism, which, along with drugs, become a long-term problem for him and the reservation as a whole. After he gives up alcohol, he becomes addicted to Pepsi, which may seem a benign substitute for alcohol but is another unhealthy commodity introduced through the marketing pressures of non-Native Americans. Under these circumstances, as Victor notes when he narrates the story, "The Only Traffic Signal on the Reservation Doesn't Flash Red Anymore," "it's hard to be optimistic on the reservation" (Alexie 1993a, 49).

Still, as Victor also acknowledges, despite the many personal and cultural obstacles, a resolution of sorts may be possible, if the broader picture can be brought into focus. Ultimately, the small embarrassments—racial insensitivity, prejudice, stereotypes such as Tonto's stoicism and subordinate position to the Lone Ranger (Alexie 1993a, 155, 170), and the products of white rewritings of Native culture—may diminish and give way to a new, more authentic representation of Native Americans. It is, perhaps, through the art of story-telling that such remedies appear. Victor's pulling these incidents together and turning them into ordered narratives suggest the extraordinarily positive power of language and the imagination. His ability to link personal, communal, and national narratives is an indication of a highly creative consciousness that is able to rescue some order from cultural hurricanes.

Although Victor is an important actor in this Native American drama and the narrator of "Every Little Hurricane" and several other stories, it is Thomas Builds-the-Fire who is the central storyteller, whose humanity, creativity, and imagination we admire, and who particularly assists in ordering the chaos of reservation life. Since early childhood, "that crazy Indian story teller with ratty old braids and broken teeth" (Alexie 1993a, 66) felt compelled to narrate his stories, visions, and dreams that are often described in terms of Native traditions. He is so completely given over to his storytelling that many people on the reservation refuse to listen to him, but they do respect his talent: "Some people say he got dropped on his head when he was little. Some of the old people think he's magic" (Alexie 1993a, 20).

The reality is that Thomas has the ability through story-telling to realize other encouraging, even magical possibilities, and it is clear that his visions

have prescience and credibility. For example, when only seven years old, he told Victor:

> Your father's heart is weak. He is afraid of his own family. He is afraid of you. Late at night he sits in the dark. Watches the television until there's nothing but that white noise. Sometimes he feels like he wants to buy a motorcycle and ride away. He wants to run and hide. He doesn't want to be found. (Alexie 1993a, 61)

Not only does Thomas understand Victor's father's loneliness and guilt, but he has a vision that results in his view that they were to "take care of each other" (Alexie 1993a, 69): Victor's father rescues Thomas from the burning house, and Thomas must see to it that he and Victor are finally reconciled, if only after the father's death. When given part of the ashes of Victor's father after cremation, he is able to reconfigure his inglorious death into something mystical and mythical. He says: "'I'm going to travel to Spokane Falls one last time and toss these ashes into the water. And your father will rise like a salmon, leap over the bridge, over me, and find his way home. It will be beautiful. His teeth will shine like silver, like a rainbow. He will rise, Victor, he will rise'" (Alexie 1993a, 74). Though the stories do not suggest that Victor's father magically rises like a salmon, Thomas has done his duty, and the father has risen in Victor's estimation. In short, Thomas is able to take the most mundane instances of reservation life and death and turn them into wonderful narratives and grand visions of the future. Through story-telling, he can take the narrative of failure and victimization and turn it into one of success, without being saccharine or maudlin.

He is also able to reinvent the past, turning disappointments and problems into a mythologized and magical reality. By reinventing the initial conditions, he allows for new possibilities. In the story "A Drug Called Tradition," Thomas's story-telling abilities help to recreate a past in which his friends are figures of courageous resistance, a heroic past that predates, or rescues order from, the chaos that white settlement wreaks. When Thomas threw a huge party after receiving money from Washington Water Power to put power lines across his property, he tried some drugs with Victor and Junior at a nearby "spiritual" spot on the lake. The drugs had varying effects on his boys, though in each instance, they returned to a re-created past: for Thomas they created wonderful, heroic dreams in which, among other things, Victor was an ancestor stealing a horse in the moonlight. This dream obviously comprises something beyond that of a mere drug-induced stupor for Victor himself, after the dream, hears voices and sees magic lights. Later, too, Big Mom, the tribe's medicine woman, indicates that she knows about these voices and

visions and gives him an ancient drum which, if he "played it a little, it might fill up the whole world" (Alexie 1993a, 23).

In a similar story, "The Trial of Thomas Builds-the-Fire," Thomas tells an assembled jury various stories of Native American resistance to colonial authority in 1858, stories that encourage his fellow Indians but frighten the white jury, leading to Thomas's imprisonment. In one story, Thomas recounts that he was one of 800 horses owned by a Spokane chief Til-co-axe and captured by Colonel Wright. The horse, described by Thomas as strong and brave, "lived that day, even escaped Colonel Wright, and galloped into other histories" (Alexie 1993a, 98). Telling this story inspires the Native American audience at Thomas's hearing, though another story he tells of Qualchan, a Coeur d'Alene warrior who was tricked into submission and hanged by Colonel Wright, dismays them. In still another tale, he describes his actions as a 16-year-old warrior, Wild Coyote, one of an Indian band who attacked and killed Colonel Steptoe's soldiers during the same period (Alexie 1993a, 100). These stories all help to reinvent and restore the past for Native Americans, and give them an ongoing sense of historical possibilities and pride, but the jury convicts Thomas of murdering "two soldiers in cold blood and with premeditation" (Alexie 1993a, 101), if only in his imagination. The whites, then, cannot tolerate historical accounts that differ from theirs, so the pattern of emerging pride and order for Native Americans is short-lived.

Of course, the stories of Tonto and the Lone Ranger also figure into Thomas's (and Alexie's) redefinition of history. Although the title of the collection of short stories seems to promise an important retelling of the Lone Ranger and Tonto stories, the book, with the exception of the cover illustration, leaves the implications largely to the reader, perhaps because Tonto had so little "voice" in the originals or perhaps because Thomas chooses not to reinterpret him. Unlike Muhammed Ali, who, in the title story, "The Lone Ranger and Tonto Fistfight in Heaven," is said to know the "power of his fists" as well as the "power of his words" (Alexie 1993a, 185), Tonto has been muted historically. In the radio series beginning in 1933, then a television show from 1949 to 1959, and finally in film adaptations (most recently in 2013), the iconic Lone Ranger and Tonto fought for law and justice in the American West. The concept of law and justice, however, belonged to and was defined by conquering whites and was related to Western expansion and white hegemony, so the figure of Tonto symbolized the erasing of ethnic identity and customs in favor of a nationalist, largely Eurocentric agenda.[4] Tonto's acquiescence to this national ideal is marked by his stoicism (Alexie 1993a, 155, 170). That acquiescence,

[4] I am indebted to Stuart Christie for this observation.

however, disappears on the cover illustration of the book. It is true that no words appear from Tonto's mouth, but he is clearly speaking, and his fighting contests the authority of the Lone Ranger, whose mouth is shut. We cannot know what Tonto's words might be or their meaning, but we can see that he has some new empowerment in heaven (or the future), if not in the past. He has escaped the Wild West, film production, and television programming that have so defined modern American culture and consciousness. However, a central concern within the short story collection is that, even with a voice, Native Americans are still mediated by the white culture, for the language available for their expression is mainly English. The fiction may self-consciously evoke a culture unhampered by the colonizer's tongue and language, but it does so only in the language of the colonizer.

Dreaming, drumming, dancing,[5] storytelling, reinventing the past, and inventing a future—these are the activities which connect Victor and Thomas to their ancient roots, traditions, and rhythms, bring new possibilities into existence, and give them a sense of structure, order, and meaning in the midst of the fluid, chaotic present. These are the ritualistic activities that are "comic acts of survival" (Vizenor 1990, 35) and discover meaning in the white noise of their environment (Alexie 1993a, 61). They are the activities that form resistance to assimilation and that, by implication, allow Tonto to fight the Lone Ranger and establish his own space, his bit of difference, in the American myth of assimilation.

The white noise, however, will likely remain. White noise is snow on the television screen (Alexie 1993a, 160, 191) or undifferentiated sound (198) lacking in particular meaning. Much of the white noise in this book is the whiteness of the material culture that surrounds the young men and blurs their sense of reality. For example, when Victor turns on the television instead of going for a run, he finds that everything becomes nearly indistinguishable, though, of course, as he says meaningfully with racial overtones, for "color complicated even the smallest events" (Alexie 1993a, 87). Alexie suggests that the government or white society deliberately uses noise to confuse and betray Native Americans (Alexie 1993a, 191–192) or that the whites are the noise. He also suggests that television programs create unacceptable simulacra, which has the effect of defacing authentic Native American culture and emotion for "every emotion… [is now] measured by the half hour" (Alexie 1993a, 198). Still, the narrator can take this confusion and duplicity and use it to his advantage, suggesting that rebellious and subversive meanings can be hidden within that noise, allowing Native Americans to negotiate the dominant white society.

[5]In "The Fun House" Thomas's aunt begins to dance her way into change (Alexie 1993a, 82).

However, what is also apparent in these imagined resistances to assimilation is that Owens has a point: Alexie's description of the real Native American culture is often too bleak for the characters are not given significant options and, despite the humor of the texts, are mired in the same kind of tribal problems that have been apparent for several hundred years. It is only through Thomas's imagination and visions that the Indian is able to escape the harsh cultural and economic environment of the reservation, and for many critics that is not enough.

Fires in Smoke Signals

In freeplay adaptation, taking a number of pieces of fiction and unifying them for the screen can be a major production and accomplishment. Clearly, some things must be left out and others added in this kind of adaptation. Alexie could not include so many of the Reservation population as he does in the short stories, nor, if the film were to be successful, could he speak of the various historical and mythical events included in the fiction, so he focuses just on Victor and Thomas and their relationship with Victor's father. Victor is tall, good looking, an athlete and basketball player, and popular, and Thomas is short, geeky, puny, a mystic and storyteller, and not popular.

By taking bits and pieces of the various stories, Alexie still gives a strong sense of Native American identity but follows a much more focused linear narrative to carry the film along. To do this, he engages both the Western and the road narrative, which are traditionally employed and dominated by white men as was the settlement of the West strongly invoked in both. Indeed, in *White*, Dyer mentions that "the Western is set at a point in history when the [white] project of the creation and settlement of a new society was underway but had been neither completed nor abandoned...Implicit in this...is a teleological narrative (a destiny), energetically and optimistically embraced, in the name of race (breeding, heterosexual reproduction)" (1997, 33). Alexie, then, takes these white narratives and genres, and, by turning them inside out, creates an indeterminate self-reflexive narrative that makes fun of its main characters, others on the Reservation, the whites on the road, even as it develops strong sympathy and compassion for Thomas and Victor.

In doing so, Alexie comes close to the views of Owen who admires the energy and Derridean *différance* that those on the postmodern ethnic borders bring to texts. Owen claims that, in "appropriating the master discourse— including the utterance 'Indian'—abrogating its authority, making the invaders' language our language, English with a lower-case *e*, and turning it against

the center," the current Native American writers are doing something creative and revolutionary. He maintains that "those who are writing back toward that decayed center" of Western writing are much more creative in their "anger, humor, bitterness, beauty, feuding, and deep sense of a real subject" than those in the mainstream who try to occupy that position (1998, 4, xv). Upending center and margins, reversing hierarchies, and substituting and supplementing—these are all part of the postmodern characteristics that inhabit his view of ethnocriticism in Native American writing.

Although, as mentioned earlier, Jacquelyn Kilpatrick argues that the "clichéd stereotypes" of "alcoholism, injustice, and loneliness" are carried over into Eyre's film based on the short stories (1999, 23), suggesting that the hierarchies have not changed, my belief is that characters in *Smoke Signals* upset the stereotypes by assuming responsibility for their behavior and showing that they are not just part of dysfunctional families, malfunctioning reservation life, or victims of systematic historical injustice. Alexie's humor carries over from fiction to film but without the dark and cynical view of tribal society that typified the written material before the film. The image of catastrophe does remain an important image in the film, though changed from hurricane to fire, but does not suggest cultural impotence and isolation. Moreover, the film adapts the stereotypically white road trip as its primary image and metaphor for cultural accommodation and coping. In this way postmodern ethnocriticism is at work, showing Indians as part of the fabric of the modern world but also indicating humorously and sardonically that this is a complicated matter, in which race simultaneously does and does not take a place but not creating a sense of victimization.

Unlike the short story collection that opens with a hurricane on New Year's Day, 1976, the movie begins with the broken-down KREZ radio van sitting at the broken traffic signal watching the almost nonexistent morning traffic on the Coeur d'Alene Indian Reservation in Idaho on July of 1976. The only traffic is a truck that splashes water as it goes by the van on this overcast, rainy day, but this shot is followed directly by the announcement of a big Fourth of July, bring-your-own-fireworks party at Mattie and John Builds-the-Fire, then the imagery of the fire that destroyed Thomas's house and killed his parents, and finally the movie title, *Smoke Signals*. The broken-down van and the single truck hint at a road film, but do not promise much.

Because this opening, dated July 4, 1976, lacks the destructive hurricane that opens the short story collection, it may seem more benign, though it shares the many features of stormy weather, fire, traffic, and noise in radio transmission that are all common instances of disruptive and potentially destructive phenomena. The date highlighted on the screen, however, immediately gets the attention of the audience who must at once think of the implications.

Unlike the hurricane, however, the fire that consumes Thomas's house, killing his mother and father, is like the catastrophic Hiroshima and Nagasaki of the short story and proves more destructive on a personal level than the hurricane to Victor and his family. This change of chaotic event not only shifts the focus from naturally caused to man-made caused catastrophe but also slightly from Victor to Thomas. Nonetheless, as the audience discovers later in the film, it is Victor's father who, when celebrating with lighted fireworks, inadvertently starts the fire, burning down the Builds-the-Fire house, killing Thomas's parents, and laying the basis for the consuming guilt that will destroy his relationship with his own family. This insignificant circumstance creating such a catastrophic result echoes, or is an allegory of, the insignificant arrival of a few ships of whites and the subsequent cataclysmic destruction of Native American lives and culture.[6]

More than the hurricane, then, the fire brings into sharp relief the characters of Victor and Thomas, who are born in the same year, share an uncanny relationship,[7] and have opposing views of their personal lives and the larger culture. As one of Thomas's opening statements in the film confirms, the experiences and attitudes of the two youths must be considered together: "You know, there are some children who aren't really children at all. They're just pillars of fire that burn everything they touch. And there are some children who are just pillars of ash that fall apart if you touch them. Me and Victor, we

[6]Although the fire is one important instance of the butterfly effect in the film, the book strategically refers to such a phenomenon on several occasions. For instance, in Thomas's story about the mouse that ran up his aunt's skirt, finally causing her to abandon her subservience to her husband's and son's wishes, the aunt chants, "One dumb mouse tore apart the whole damn house" (Alexie 1993a, 81), suggesting the importance of initial conditions in large-scale change. Moreover, another story narrated by Victor speculates on what might have happened to Native Americans if some tribe had drowned Columbus. That different initial condition might have changed the whole fate of Indians and even the face of racism.

[7]In *Reservation Blues*, Alexie indicates his knowledge of the doppelgänger tradition, in which each person in a pair becomes the alter ego or shadow of the other (1995, 44). In this novel, he seems to suggest that the whites are the shadows of the Natives and, therefore, closely connected or allied, but with the whites clearly being the unscrupulous and vicious victimizers. This paradigm resembles that of the relationship between Victor and Thomas, the first victimizing the second, but seemingly bound to him in a way that he does not understand. In a more wholly affirmative sense, it also resembles that of the traditional Native American view of God and the Christian one—one a feminine principle and the other a masculine one. As Checkers, one of the characters in the novel, says, "Big Mom felt like she came from a whole different part of God than Father Arnold did. Is that possible? Can God be broken into pieces like a jigsaw puzzle? What if it's like one of those puzzles that Indian kids buy at secondhand stores? You put it together and find out one or two pieces are missing." Thomas then adds, "I looked at Big Mom and thought that God must be made up mostly of Indian and woman pieces. Then I looked at Father Arnold and thought that God must be made up of white and man pieces. I don't know what's true" (1995, 205).

were children born of flame and ash" (1998, 154).[8] In short, Victor and Thomas have been subjected to, and subject others to, chaotic fires and flames, but endure until the fires become ashes, the quiet, relatively stable aftermath of the fires. The combination may finally result in a stronger, though diminished culture, but that possibility is indeterminate.

The date of this fire—the Fourth of July—in relation to the lives of the boys and their tribe is also important. Although New Year's Day (the short story) and the Fourth of July (the film) are part of the American 1976 bicentennial year, both are to be taken ironically with reference to the conquest and subjugation of Native Americans. The Fourth of July, however, seems to intensify the problem because the Indians on the Reservation are clearly participating in their own domination and cultural demise when they celebrate the American Revolution or War of Independence. As Gerald Vizenor remarks:

> The American Revolution became the reason for dominion over natives; at once, natives lost their sovereignty in the historical contradictions of a constitutional democracy. The Constitution of the United States commences with a national, editorial pronoun; the *we* embraces others in the name of a "more perfect union." The *we* was not native, but the other in the archive of democracy... (1998, 57)

It is doubly ironic, then, that the fire destroying the Builds-the-Fire home is set by Victor's father who drunkenly waves lighted fireworks overhead, inadvertently causing the deaths of Thomas's parents.[9] To a great extent this tragedy, which also eventually breaks up Victor's family, severing the relationship of Victor and his father, suggests the inadvertent complicity of Native Americans in their own subjugation, rendering them all children of fire and ash. Ironically, too, Victor's father later leaves home on Independence Day, seeking freedom from his family and conscience—the memories of his great mistake in setting fire to Thomas's house. Native Americans were and are not merely witnesses "and nothing more" (Alexie 1993a, 3), as the short story suggests, but actors in this great cultural tragedy, and Victor has to accept some kind of responsible role in his relationship with his father and Thomas.

There may be historical reasons for the disenfranchising of the Indians and causes that lie largely with the whites, but the film moves away from the

[8]When the film script and the film have identical language, I will cite the script for ease of reference. Where they differ, I will cite the film.

[9]In the short story collection the fire does not burn down the Builds-the-Fire house, but the Many Horses home, and the baby saved is James Many Horses, not Thomas.

victimization inherent in Alexie's fiction to advocate that Native Americans accept their culture for what it is and deal with it. The fire on the Fourth of July brings home the view that blame for personal and cultural tragedies must be accepted and shared to move forward on improvements and prevent further erosion of this ancient culture through rapid assimilation and commodification.

This sharing of responsibility and releasing of burdens of guilt or victimization are particularly important in the journey to Phoenix to pick up Arnold's possessions. In the short story "This Is What It Means to Say Phoenix, Arizona," the two boys fly to Phoenix to collect the ashes, $300 in the bank account, and the pickup truck, but in the film they participate in a road trip by bus.

The road genre is a remarkably "architextual" choice for the film because it is usually associated with a quest for self-discovery and often connected with a new understanding of society as well (Slethaug 2012a, 13–38). And, typically, in this quintessentially American genre, the vehicle for the discovery of self, friendship, family, and community is a car or truck that moves across the United States from East to West, and the hero a white man, as is the case of Jack Kerouac's novel *On the Road*. Although not a hard-and-fast rule, as indicated by John Ford's film *Grapes of Wrath* or Ridley Scott's *Thelma and Louise*, the vehicle is often identified with individual masculine self-discovery.

Rather than in a car or truck, Victor's process of self-discovery in *Smoke Signals* takes place on an Intermountain bus that moves from Northwest to Southwest and that serves as a symbol of male friendship, family unity, and communal identity—what Laderman calls a "traveling community" that appears in fiction like Tom Wolfe's *The Electric Kool-Aid Acid Test* and Douglas Brinkley's *The Majic Bus* and films like *Midnight Cowboy* and *Get on the Bus*.[10] As they sit beside each other, this bus brings Victor and Thomas into dialogue with each other and with the American culture outside the reservation and prepares Victor to accept his own weaknesses and those of his father. It also shows him and Thomas how to survive the dominant culture. Like the bus in Spike Lee's *Get on the Bus* (1996) or even the coach in John Ford's much earlier *Stagecoach* (1939), this vehicle engages in cultural critique, puts strangers in connection with each other, and emphasizes community, highlighting questions about differences, prejudices, stereotypes, and social roles but also about commonalities. The use of the bus itself, then, provides a kind of criticism of the common characteristics of the road genre even as it uses them—precisely what Owens was talking about the postmodern phenomenon of literature on the boundaries.

[10]Laderman (219) and Slethaug (2012, 174–175). See also Lackey (94) and Mills (85–109, 130).

Victor and Thomas's bus trip to Phoenix makes their interwoven identities quite clear. They have a history of playing together as children and standing aloof from each other as adolescents, mainly because Victor hates his absent father and Thomas goads him with positive accounts of him. With limited funds, however, Victor is dependent on Thomas's financial resources in picking up his father's effects after Arnold dies from a heart attack in Arizona, so he has to tolerate him (see Figure 4.1).

The two youths are pulled together by their goal to retrieve the belongings, Thomas's aim to restore Arnold's image in Victor's eyes, their status as the only Native Americans on the bus, and ultimately their position as a small minority in the United States because of the injustices of the past.

For the most part, the other passengers leave the two alone though they look at them suspiciously, as does the bus driver (whom, ironically, the film audience stares at suspiciously because of his beard, sunglasses, and odd looks), but, when two obnoxious racists take their seats, Victor and Thomas are forced to relocate but respond by singing "John Wayne's teeth," a comic reflection on this actor who not only portrayed the frontiersman's conquering of Native Americans, but physically embodied hegemonic ideology behind the frontier concept of Manifest Destiny. This clearly sends up John Wayne, his acting in films like *Stagecoach*, and the entire Western genre. (It also pushes the viewer to think of a similar sing-along on *Get on the Bus* that is both celebrative and highly political, but there it is communal, while here it is restricted to the Native American pair—though the accompanying tribal chanting and drums suggest a communal force off the bus.) So the song celebrates the triumph

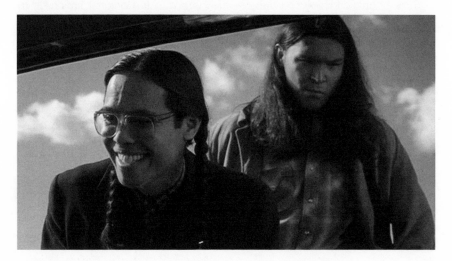

FIGURE 4.1 *Thomas celebrating Victor's need to take him to Phoenix in* Smoke Signals

of the endurance of Native Americans, despite the white man's attempts at their annihilation. For his part, Thomas continues to tell celebratory stories about Arnold Joseph, forcing Victor to reassess his anger toward his father, so that when they arrive at the trailer, Victor can begin to participate in a healing process that could symbolically restore his father and allow him to take the ashes back to his mother, thus closing the gap in the family circle.

The road trip to pick up Victor's father's ashes and possessions when he dies is thus very important personally and culturally for it means that Victor does accept responsibility for the legacy of his father, and the film builds toward their implicit reconciliation, if only in death. It is clear in the film that the difficult relationship between the youthful protagonists, Thomas and Victor, in some way involves the father for Thomas always asks about Victor's father and Victor, for his part, responds in embarrassment and rage to these questions. Because of his father's alcoholism, abuse of himself and his mother, and abandonment of them, Victor feels under duress and, consequently, attacks Thomas. When Victor finally understands that these abuses arise in some manner from his father's responsibility for the fire and that his father loved him and regretted leaving, he can finally let go his rage. This in turn leads to the final scenes of the films—Suzy Song's setting fire to Arnold's trailer in an act of ritualistic purification and the film's important questions: "How do we forgive our fathers?" and "If we forgive our fathers, what is left?"[11] Exorcising and purifying the past and forgiving our fathers—brown fathers and white fathers, the Lone Ranger and Tonto—is what the film is about, in order that we may begin the important process of rebuilding our personal and cultural lives, not on denial, but acceptance.

Suzy Song's torching the trailer, which is not in the original fiction, is by far the most vivid symbol of the cleansing process required for personal and cultural birth. When she lights the fire in an Indian ritual of purification in a trailer house that embodies the white man's intrusion into nature, it quite literally gets rid of the stench associated with Arnold Joseph's corruption in life and death. This fire also returns the film to its opening scene in which Arnold accidentally sets fire to the Builds-the-Fire house, killing Thomas's family and destroying his livelihood. That was a careless and catastrophic act, but Suzy's is a responsible, careful, and life-affirming act of order, creating a symbolic book-end effect for the film. This metaphor of purification and renewal continues as the two boys take Arnold's ashes to the Spokane River and as that river is portrayed from the bridge at the falls and also from some very high vantage point that captures the glory of the water. Effectively the boys accept their responsibility to Arnold, and water quenches the fire, allowing for sustained renewal.

[11]In the short stories, Suzy Song is one of the women on the Coeur d'Alene Reservation (117), not in Phoenix as in the film.

That accepting responsibility works can be seen in Victor's own character. Unlike the short story collection in which he, like his father, has an alcohol problem and needs "more saving than most anybody" (1993a, 203), in the film he is a teetotaler and manages to avoid being brought to trial over an accident because he can affirm that he has never had a drop of alcohol in his life. In this instance, the film clearly undermines the stereotype.

In other ways, too, the boys' road trip on the Intermountain bus plays with stereotypes but does not allow the boys to be victims of them. For example, Victor plays with the stereotype of the stoic Indian and tries to teach Thomas how to affect the toughness and seriousness of this image, but when their seats are taken by a couple of redneck whites, their recourse is not retaliation or despair but lively singing of a song called "John Wayne's teeth" that disproves the idea that the unsmiling stoic image is reserved for Native Americans. In addition, the singing shows how Native Americans can adapt to the larger American culture without losing their own voices. This in itself is a celebration.

Victor's homecoming is also altogether celebrative: he and his mother can share in his gift of his father's ashes, and he can take them to the Spokane Falls to allow his father to leap like a salmon (as Thomas puts it). In short, the homecoming is celebrative of his father's life, his connection to Native traditions, and his ability to negotiate the "foreign" American culture outside the reservation. It is also celebrative of Victor's future, for he has put to rest the demons of his past and has successfully left the reservation and returned.[12]

Victor and Thomas's psychological and spiritual journey, as represented by their road trip itself to pick up the effects of Victor's father, is thus a journey from isolation, alienation, and denial to acceptance, responsibility, and forgiveness. As suggested by the title, *Smoke Signals*, the film is about communication—between father and son, friends, past and present, and Native Americans and European Americans. When problematic issues are addressed and responsibility accepted, the unruly and destructive fires can be harnessed and made productive.

Smoke Signals, then, is one of those narratives that serves healing through encounters with the broader world rather than victimization (Vizenor 1990, 166). Unlike Alexie's collection of short stories that focuses variously on reservation life—except for the brief interlude of Thomas and Victor's flying to Phoenix to pick up Victor's father's ashes, money, and truck and the boys' return in that truck—the film is a sustained road movie that moves away from the airplane of the book to a bus and then a truck, maintaining that travel focus throughout.

[12]Arguably the narrative's need to have the boys return to the Reservation may suggest that Alexie's acceptance of cross-race culture is not very firmly in place; otherwise, one, or both, of the boys might have been able to stay in Phoenix.

Indeed, the weather van, the passing freight truck, a car which only goes backward,[13] the bus, and Arnold's truck are not only strategic to the plot but also primary symbols of communication and intercultural activity. The road is especially important for it is the conduit of uncertain flowing traffic and is also unpredictable as it twists and turns, leading unwary drivers into ever increasing difficulties. For the Indian, it is also a place of harassment by police who arrest them at will, but Victor has the means to circumvent that cultural trap.

Transportation is especially important because America is built on technology, and it was the technology of the ships that brought the whites to America and that of horses, wagons, and trains that conquered the Indians of the West. For Victor personally, it was the truck that took his father away, assisting him in leaving Coeur d'Alene and giving him independence and the means to disappear from the boy's life. Like fire itself, technology and transportation cannot be viewed just as bringers of disorder but of a new kind of order that can arise from the old. The broken-down weather van serves as a beacon to monitor life on the reservation and disseminate information from KREZ radio, almost like the drums and chanting of old; the car driven by the two women on the reservation goes backward and not forward, carrying its passengers away from a headlong pursuit into American values and commodification; the bus that takes the boys away from the reservation to Phoenix permits a spiritual homecoming. This is, then, a film about taking catastrophe, destructive technology, and ethnic and personal failure and turning them into good fortune, unambiguously taking control of the situation and bringing order out of confusion.

Through this film, Sherman Alexie has brought contemporary Native American experience in the United States to the silver screen, and he has done so with compassion and responsibility. He has not denied the systemic problems that plague life on the Reservation, nor has he denied that Native Americans must share the burden of guilt for them. He has shared with the audience, however, the psychological and spiritual joy of the two young men who come to accept the fires of their personal lives and cultural traditions and to move beyond them into a new kind of understanding of the present and anticipation of the future as well as into the past to reconstruct that which had special value.

This road trip by bus, ritual-fire purification of the trailer, and Victor's reconciliation with his dead father through a ritual committing of Arnold's ashes to the Spokane River taken together suggest that the film has taken a literary and film genre of the road and the Western and cultural phenomena used

[13]In the fiction, Jimmy One Horse is the driver of the car that goes in reverse (Alexie 1993a, 156), but in the film hilarious women drive it. In *Reservation Blues* Alexie describes a truck that only goes backward, driven by Simon.

for other purposes and rendered them postmodern in their supplementary adaptation, simultaneously interrogating and impoverishing the originals and enriching the present narrative. They simultaneously nod in the direction of the past and celebrate a contemporary Native American context, which is precisely what Owens argues of the value of ethnocriticism.

By and large, the film is affirmative, suggesting that with responsible action, Native Americans can effectively discover themselves, rediscover and protect their heritage, critique American culture, and not run away from the larger American society. This stance is a fairly dramatic departure from the fiction itself and suggests that the film has taken up the gauntlet in responding to the ethnocriticism of Owens, Krupat, and Vizenor, changing the game plan from modernistic victimization to postmodern engagement and also helping to nudge the predominantly white road narrative into an ethnic space. The very act of the critics' articulating the ethnic problems of Alexie's writing seems to have had a beneficial effect in the production of a film that is decidedly ethnic, intercultural, and postmodern all at once.

This free adaptation of several short stories into a well-focused film demonstrates the variety and complexity of postmodern intertextuality, but the appropriation of the Western and road genres to serve the purpose of exposing the white man's persistent exploitation of Native American culture also indicates the ways in which postmodernism can serve as a judgment on the whites' historical exploitation of ethnic and racial difference.

From Lee to Auster and Wang: Postmodern indeterminacy and racial relations in *Do the Right Thing* and *SMOKE*

"Raleigh was the person who introduced tobacco in England, and since he was a favorite of the Queen's—Queen Bess, he used to call her—smoking caught on as a fashion at court... Once, he made a bet with her that he could measure the weight of smoke... I admit it's strange. Almost like weighing someone's soul. But Sir Walter was a clever guy. First, he took an unsmoked cigar and put it on a balance and weighed it. Then he lit up and smoked the cigar, carefully tapping the ashes into the balance pan. When he was finished, he put the butt into the pan along with the ashes and weighed what was there. Then he subtracted that number from the original weight of the unsmoked cigar. The difference was the weight of the smoke."

PAUL BENJAMIN in PAUL AUSTER, SMOKE (25)

"For if you have worked in any serious way, you have your style—like the smoke from a fired cannon, like the ring in the water after the fish is pulled out or jumps back in."

EUDORA WELTY, *"Words into Fiction" (143)*

Sherman Alexie was able to take several of his collected stories that critiqued white exploitation of the Native American population over 500 years and, together with Chris Eyre, turn them into a highly regarded film that focused on exploitation in the contemporary period—and the Indians' complicity in that. In *Do the Right Thing*, Spike Lee, referencing Martin Luther King and Malcolm X, has also demonstrated how whites have continued to exploit ethnic and black communities, and his film presents an ambiguous ending as to whether this systemic exploitation might improve. But Paul Auster and Wayne Wang, referencing *Do the Right Thing* and its use of King and Malcolm X, show a more optimistic view of contemporary social and race relations in *SMOKE*. This is done through a highly complex freeplay adaptation of Auster's very short story and *Do the Right Thing* to a complex and gentle film that moves toward an optimistic conclusion about racial relations in New York City.

One thing that is especially thought-provoking about this intertextual freeplay is the racial identity and ethnicity of the writers and directors. Spike Lee is the most prominent African American director today; Paul Auster is a prominent white but Jewish writer. Wayne Wang is a Chinese American director, equally at home in Hong Kong and New York City and often interrogating the place of Asians in American culture. Having three artists of such talent and racial and ethnic complexity weigh in on race relations in the United States makes these films relevant to postmodern—and some would say postethnic—American culture in a special way.

Dialogic citation: Malcolm X's "Bullet" and Martin Luther King's "Ballot" in Do the Right Thing

When Spike Lee wrote, directed, and acted in Do the Right Thing (1989),[14] he portrayed the chaotic events of one day at Sal's Famous Pizzaria in the

[14]The film script of *Do the Right Thing* will henceforth be cited in the text as *DRT*. In addition to the "Foreword" and "Introduction," *DRT* consists of three main parts—"The Journal," "Production Notes," and "The Script." In the textual references, *DRT* by itself refers to the script, and I will indicate if the citation refers to the Journal or Production Notes.

Bedford-Stuyvesant area of Brooklyn, which ultimately led to the killing of one black youth, an attendant race riot, and the burning of the pizzeria. In portraying the main character's perception of a meltdown in black, white (mainly Italian American), and Korean American relations, the film self-consciously evokes Martin Luther King's and Malcolm X's views of race relations through the depiction of their photographic images at key points in the film, through statements by each at the conclusion, and, in the published copy of the film script, through a quotation from *The Autobiography of Malcolm X* as a headnote:

> The greatest miracle Christianity has achieved in America is that the black man in white Christian hands has not grown violent. It *is* a miracle that 22 million black people have not *risen up* against their oppressors—in which they would have been justified by all moral criteria, and even by the democratic tradition! It is a miracle that a nation of black people has so fervently continued to believe in a turn-the-other-cheek and heaven-for-you-after-you-die philosophy! It *is a miracle* that the American Black people have remained a peaceful people, while catching all the centuries of hell that they have caught, here in white man's heaven! The *miracle* is that the white man's puppet Negro "leaders," his preachers and the educated Negroes laden with degrees, and others who have been allowed to wax fat off their black poor brothers, have been able to hold the black masses quiet until now. (*DRT* 1989a, 120)

From the outset, many were concerned about the politics of *Do the Right Thing* because of the citing of Malcolm X's rhetoric, the advocating of violence, and the "necessity" of trashing the pizza parlor. When the film appeared, certain critics argued that the film's "inflammatory nature" could ignite "the flames of racial violence" (Grant 1997, 17), but others thought the film's stance on racial relations ambiguous. Indeed, some viewers did find "it too militant," but others thought the message "confused," and still others regarded "it the work of a middle-class director" "trying to play street-smart" (Ebert 1989, 1).

I agree with Vincent Canby (1989), Alan Stone (1995, 4), and Douglas Kellner (1997, 97) that the film mainly sides with Malcolm X's belief in the necessity

Parts of this discussion on *Do the Right Thing* have previously appeared in "Class, Ethnicity, Race, and Economic Opportunity: The Idea of Order in Scorsese's *Gangs of New York* and Spike Lee's *Do the Right Thing*." *Journal of American Studies* (South Korea). 40.1 (2008): 149–183, as well as in "Spike Lee, Martin Luther King, Malcolm X: The Politics of Domination and Difference" in *I Sing the Body Politic: History as Prophecy in Contemporary American Literature*. Ed. Peter Swirski. Montreal: McGill-Queen's University Press, 2009: 113–148.

of confrontation and violence—the "bullet"—as a tool to deal with racism and lack of black empowerment and ownership in businesses. Because the specter of violence is so sobering, however, the audience may well hope for King's peaceful alternative, but it is not clear how realistic this option is in a society that has generated such hostility between races. Perhaps a new way must be found. In this way the film engages in a dialogue with King and Malcolm X to explore alternatives to racial exploitation.

When Paul Auster wrote and Wayne Wang directed *SMOKE* in 1995, this mixed-race team created a network of citations to *Do the Right Thing* that qualified the import of Lee's vision in important ways; they set their story in the summer of 1990 (just a year after the release of *Do the Right Thing*) in another local hangout, the Brooklyn Cigar Company; described a racially mixed community in the same area of Brooklyn; echoed the main character's uncommon name (Mookie) and other verbal and visual rhetoric (intertextual doubling) in important places; and, importantly—according to the film script, showed portraits of Martin Luther King and John F. Kennedy on the wall in the concluding black-and-white sequence of the film (Lee *DRT* 1989a, 145).

These citations—rhetorical reiterations, repeated images, and intertextual echoes—become symptomatic of a much larger issue: how better to handle race relations in a time of civil unrest and how to provide a strong emotional and moral argument for tolerance and peaceful urban racial and ethnic relations—the "ballot." By its references to *Do the Right Thing*, this gentle, seemingly nonpolitical film *SMOKE* urges yet another look at racial politics through the writings of Martin Luther King, critiques *Do the Right Thing*'s cultural assumptions and ideological position, and makes a strong argument for racial respect and multiculturalism. It especially crafts a potent political statement against urban violence—one that is in keeping with Martin Luther King's aims—and thereby provides an alternative to violence and force. In effect, through referencing *Do the Right Thing*, King, and Malcolm X, *SMOKE* enters into dialogue with Lee's film and the positions of the two major spokesmen of the Civil Rights movement. This is an interesting instance of postmodern American dialogic citation for both films ground their arguments in fragments of King and Malcolm X, but *SMOKE* references *Do the Right Thing* even more than the Civil Rights spokesmen, creating a highly complex and thoughtful film that is neither cynical nor dismissive. This analysis will investigate briefly the context of racial relations in New York City in the late 1980s and 1990s; explore *Do the Right Thing*'s citation of Martin Luther King and Malcolm X; compare the two films in terms of community, work and ownership, literacy and language, and practice of citation; and draw conclusions about the differing political views—and, very importantly, visions of nation—in this dialogue.

New York City and racial relations

Although New York City is ranked among the most ethnically and racially mixed cities on the planet, racial conflicts have a long history there. Among the earliest are the Anti-draft Riots of 1863, the subject of *Gangs of New York* discussed in Chapter 3; led by the Irish demonstrating against a federal policy drafting recent immigrants into military service, this protest turned into a full-blown race riot that targeted blacks over fears of job losses if slaves were freed and could move freely to the North and undercut wages both for established Americans and immigrants.

The effects of changes in the immigration laws by the Hart-Celler Act of 1965 reprised these fears when large numbers from third-world countries (especially the Southeast Asian countries of Vietnam, Cambodia, and Laos) migrated to the United States, settling, working, and establishing businesses in many areas, including the black, working-class neighborhoods of Brooklyn. Many joined the ranks of unskilled workers competing for local jobs, and, notably, the entrepreneur-minded Chinese and Koreans replaced Italian and Jewish shop owners, often commuting into black neighborhoods on a daily basis and spending the profits outside these communities. New immigration, competition for jobs, and lack of black ownership in businesses serving these communities led to protests and riots.

These problems were especially acute in Brooklyn and Queens from 1986 to 1992, and this prompted Spike Lee to write *Do the Right Thing*, begun in 1987, though not released until June 1989. The year 1987 was a key time to begin writing a script critical of race relations and employment problems because the October stock market crash hastened the closure of local manufacturing firms, precipitated corporate layoffs, and led to city and state financial cuts because of lost tax revenue. The result of the crash seriously impacted on the jobs of the working class of Queens and Brooklyn, causing the so-called December 12 Movement, designed by the blacks to take back economic control of their neighborhoods.

Although violence growing out of these issues was concentrated mainly in black, Italian American, and Jewish American communities of Queens and Brooklyn, Asian Americans, too, were deeply embroiled. Koreans, for the most part, were innocent bystanders, but were thought by the black community to have special government financial support and regarded as arrogant and hostile to black customers. The December 12 Movement led to the "Tropic Market" incident between African American shoppers and Korean American proprietors and a resultant boycott of Korean grocery stores in 1988.

Consequently, in its representation of this racial and ethnic mosaic in Brooklyn, *Do the Right Thing* focuses on black–white relations but includes

selected Puerto Ricans (Mookie's girlfriend Tina and her mother) and Asian Americans (the neighborhood shop's Korean proprietor and his wife). In creating this community profile, the film suggests that racial relationships have not improved over time and that the peaceful coexistence urged by Martin Luther King is problematic and needs to be replaced by the stronger arm of Malcolm X—or still another alternative.

While *SMOKE* also focuses mainly on black–white relations, it similarly brings in Puerto Ricans (Auggie's girlfriend, Violet Sanchez de Jalapeno) and Asian Americans (the Chinese American bookstore clerk April Lee and, of course, implicitly the film's director Wayne Wang). This film presents a community at ease with racial relations, indicating that Martin Luther King's policies are the way forward. These two films, then, give similar representations of the relevant ethnic mix, though the cultural lens of *Do the Right Thing* is decidedly African American, while that of *SMOKE* is multiethnic and multicultural.

Community, work, language, and citation in Do the Right Thing

In establishing the relationships of these racial and ethnic groups, both films focus on community, work and ownership, and language, and it is clear that *Do the Right Thing* is "reading" and "citing" King and Malcolm X through this combination, and that *SMOKE* is "reading" and "citing" Lee as well as King, Malcolm X, and John F. Kennedy.

The action of *Do the Right Thing* is centered in Brooklyn as home to "more than half of New York City's African-American population" (Pouzoulet 1997, 33) but more specifically in the largely black, poor, inner-city Bed-Stuy neighborhood. Consequently, the opening shots of Rosie Perez dancing vigorously to the loud music of Public Enemy's "Fight the Powers" establishes the need for a "politics of resistance" (Pouzoulet 1997, 34) to deal with systemic racial/ economic issues.

In fact, Victoria Johnson argues that music throughout the film is linked to the politics of expression and commitment, though the music takes different forms in different places (1997, 55). In the opening, public discontent is strongly shown through the rap of Public Enemy, while the "jazz strains" in the film "hint at a barely repressed undercurrent of turbulence and unrest, and imply the tremendous frustrations and simmering threat of violence" (Johnson 1997, 60). Certainly, there are "string-orchestral strains of music" that "suggest a communal ideal" (Johnson 1997, 60), but these are not the dominant forms. The film, then, uses music as one of its key forms of citation to identify and interrogate the contemporary racial dilemma.

As the opening sequence makes clear in its intensive use of hot red colors along with its musical challenge to the "Powers," the black culture in Brooklyn represents the plight of blacks throughout the United States and, hence, metonymically is about nation. As Lee himself remarks, the film is self-consciously about the United States in its evocation of national and ethnic flags: "Flags will be a big visual motif in *Do the Right Thing*. The red, white, and blue Puerto Rican flag; the red, white, and green Italian flag; and the red, black, and green African-American flag. Cops will wear American flags on their uniforms." He adds that even "the fire hydrant-johnny pump should be painted fire-truck red" (Lee "Journal" 1989b, 83). The film is about race, resistance, and nation, and cites music and national colors to achieve this goal.

The two main characters representing polar-opposite positions to deal with racial issues in this black enclave are Mookie (Spike Lee) and Da Mayor (Ossie Davis). Mookie is young, unattached but a father, and irregularly employed— part of the poor, inner-city, black, economic underclass. He gets by on various low-level, dead-end jobs that do not require much education, and, according to his sister Jade, he has not taken enough responsibility in supporting and raising his young son who lives with his girlfriend and mother. He is on good terms with everyone on his street but is lazy and thinks strictly in terms of what he is hired to do and does not go beyond that because of his "feeling of helplessness, or powerlessness, that who you are and what effect you can have on things is absolutely nil, zero, jack shit, nada" (Lee 1989b, 64). He rankles from others' critical comments and will not take any physical or verbal abuse; he is also quick to voice out abusive comments, justifying Spike Lee's assertion that he is a manifestation of Malcolm X's views: "the character I play in *Do the Right Thing* is from the Malcolm X school of thought: 'An eye for an eye.' Fuck the turn-the-other-cheek shit…YO, IT'S AN EYE FOR AN EYE." He adds, "It's my character who sees a great injustice take place and starts the riot" (Lee 1989b, 34).[15] Though Lee is strong in his assertions, Mookie is not necessarily powerless, and it is not clear that a sense of injustice drives him forward.

Mookie's name is a clear indication of his blackness and of his position outside the mainstream. As Lee remarks, "My character's name will be MOOKIE. People might think of Mookie Wilson, who plays center field for the Mets. When I lived in the Cobble Hill section of Brooklyn as a kid, there was a guy named Mookie

[15]Lee's own position on Malcolm X as his "ancestor" might be mixed, but he acknowledges that people do think that he himself "is a wild-eyed Black militant, a baby Malcolm X." In the same passage, he says that people have also heard that he is "difficult to work with," and, while he claims this "is not the case at all," he does not refute the view that he could be thought of as a baby Malcolm X (Lee 1989b, 91).

who was a great softball pitcher. He was left-handed and could throw fast as shit. That's the first Mookie I knew" (Lee 1989a, 44). Mookies is also called Moulan Yan, a racist epithet suggestive of an assertive black identity.[16]

Unlike Mookie, Da Mayor is elderly, unemployed, and likes his beer, but, like Mookie, he has a certain kindness and good will. When Lee first conceived of this character in December 28, 1987, he was not altogether complimentary, accusing him of being "one of those Uncle Tom Handkerchief Niggers on the block. He's one of those people who love the white man more than he loves himself. He tries to stop the riot. He's in front of the pizzeria urging folks not to tear it down" (Lee 1989b, 35). This negative description drawn from *The Autobiography of Malcolm X*[17] has all the earmarks of a parody of Martin Luther King, but, hardly more than a week later in his January 9, 1988 entry in his journal of *Do the Right Thing*, Lee is much more complimentary:

> Da Mayor has a special thing for the young people. He feels he's seen it all and can teach these young kids something. Very few of the young kids bother to listen to him. They think he's just an old drunk, but he's not. He's got some valuable knowledge, if they'd only listen. One of the few kids who does listen is Mookie. He will always check on Da Mayor to see how he's doing or go to the store and get him a beer. (Lee 1989b, 52)

These are more-or-less conflicting views of Da Mayor—as an Uncle Tom and as a repository of wisdom—and hint at the film's deep ambivalence about him and the Martin Luther King tradition.

After brief opening shots of Mookie waking up his sister Jade in their apartment and that of Da Mayor waking in his, the action of *Do the Right Thing* switches to Sal's Famous Pizzeria with the Italian father Sal, his two sons, Pino and Vito, arriving to open it up. They represent the second element in this racial construct: they are hardworking but self-interested whites whose views of African Americans range from benign neglect to racist persecution and whose positions provide the fuel for the riot. As Lee notes, Sal's repeating the line "THIS IS AMERICA" is "key" to an understanding of the film for

[16]In the film script of *Do the Right Thing*, the racist Pino insults Mookie by calling him both Moulan Yan and nigger.

[17]In his *Autobiography*, Malcolm X clearly alludes to Martin Luther King and other black integrationists as Uncle Toms, viewing them as contemporary "house Negroes": "I'm not going to call any names. But if you make a list of the biggest Negro 'leaders,' so-called, in 1960, then you've named the ones who began to attack us 'field' Negroes who were sounding *insane*, talking that way about 'good massa'" (1999, 244). Shortly before, he made the context of this allusion clear: "In America for centuries it had been just fine as long as the victimized, brutalized and exploited black people had been grinning and begging and 'Yessa, Massa' and Uncle Tomming" (1999, 243).

exploitation of the blacks has been the defining issue for the United States over many generations (1989b, 67). The extreme heat of the day is symbolic of escalating tension in race relations in America, but it is also indicative of a random incident that can ignite explosively tragic incidents. According to Lee:

> It's been my observation that when the temperature rises beyond a certain point, people lose it. Little incidents can spark major conflicts. Bump into someone on the street and you're liable to get shot. A petty argument between husband and wife can launch a divorce proceeding. The heat makes everything explosive, including the racial climate of the city. Racial tensions in the city are high as it is, but when the weather is hot, forget about it. (1989b, 24)

It is immediately clear that Sal is an outsider to the community and at some risk on this hot day when he drives up in his 12-year-old El Dorado Cadillac from the Italian district of Bensonhurst. The car itself may suggest white upward social and economic mobility, but its age suggests that the pizzeria has not been making substantial profits.

Fruit-N-Veg Delight is the only other neighborhood shop and is owned by the Korean couple—the third element in this racial construct—who are FOBs (fresh off the boat) and do not seem to understand the products and brands that the community wants, but put in long hours. One of the Corner Men, ML, remarks that they turned an abandoned building into a flourishing store within a year's time from landing: "A motherfucking year off the motherfucking boat and got a good business in our neighborhood occupying a building that had been boarded up for longer than I care to remember and I've been here a long time" (Lee *DRT* 1989a, 174). The Koreans' skill in English is limited, however, and that may well contribute to the perception that they are rude to their black customers. However, while they are noticeably rude when Da Mayor wants to buy a Miller High Life beer, they are not provoked to violence by fiery Raheem and do not help to inflame the riot. Rather, they claim their affinity as people of color by saying "Me black, too."[18] Still, their presence in the film is a warning of the risk that Koreans and other Asian entrepreneurs take when they set up shop in black, inner-city communities, if they do not share in the overall cultural life and economic interdependency. Ownership without community membership becomes the crux of the tension in the film.

Despite Lee's contention that "in this script I want to show the Black working class" (Lee 1989b, 30), few others in this neighborhood seem to

[18]Quite tellingly, Lee takes this incident from the *Autobiography* of Malcolm X, in which the Asian entrepreneurs are Chinese rather than Korean. This is only one instance of many showing the extent to which Lee has carefully "cited" the writings of Malcolm X.

have a job.[19] With his history of short-term employment, Mookie has been delivering pizzas for only one month; groups of teenagers hang out on the streets with nothing to do; and older men and women, including the alcoholic Mayor, wander aimlessly. The frequent emphasis on the price of pizza and groceries and Mookie's careful counting of money suggest that economic dependence and the limited circulation of capital are huge negative factors in race relations. There is an atmosphere of compression and claustrophobia on this block, where the action indoors takes place either where Mookie is—his apartment, his girlfriend's apartment, and Sal's pizzeria—or where Da Mayor is. The action outdoors in this single city block is focused on the front of the pizzeria, a barren wall where the Corner Men sit and talk, the asphalt street and sidewalk overgrown with weeds, and the fire hydrant.

To a considerable extent, the film represents the community through photographs, here a critical form of intertextual doubling along with the music and national colors mentioned earlier. To celebrate his Italian heritage, Sal creates a "Wall of Fame" with photographs of significant Italians and Italian Americans, including Sophie Lauren, Luciano Pavarotti, Liza Minnelli, Mario Cuomo, Al Pacino, Sylvester Stallone, Frank Sinatra, Rocky Marciano, Perry Como, and Joe DiMaggio. His wall does not include African Americans, and so Buggin' Out insists that pictures of Malcolm X, Angela Davis, and Michael Jordan be included, and Raheem makes a similar demand. The other important pictures (for sale by the stuttering Smiley, who has cerebral palsy) are the hand-colored postcards of Martin Luther King and Malcolm X standing together (see Figure 4.2). The fact that Smiley moves in and out of the action about a dozen times as he listens to Malcolm X's "Ballot or the Bullet" speech and tries to sell the postcards suggests the overall importance of these Civil Rights figures to the action, but his inability to articulate their names—he always stutters—suggests the film's difficulty in choosing between their disparate political positions on race relations.[20]

[19]The film is to take place on Saturday, but nothing is really made of that in the film. Moreover, Lee's statements on blacks working in Brooklyn are decidedly mixed and even self-contradictory. On the one hand, he says, "Contrary to popular belief, we work. No welfare rolls here, pal, just hardworking people trying to make a decent living" (*DRT* 1989b, 30). On the other hand, he notes that Mookie is trapped in dead-end jobs and is lacking in responsibility.

[20]Roger Smith, the actor who plays Smiley, mentions his impressions of this character on the 30th unnumbered page of the picture section of *DRT*: "I listened, as I always did, to Smiley's tape of Malcolm X delivering his 'Ballot or the Bullet' speech. Malcolm has a line about how George Washington traded a Black man for a keg of molasses. Basically he's talking about the hypocrisy of American history." He continues, "I kept repeating the line about the keg of molasses; to Smiley this is a fantastic fact. Smiley is one of those people who snatches bits of history and they become fantastic legendary ideas to him. Like the fact that Mike Tyson sent his boxing gloves to Nelson Mandela to help fight apartheid (1989b)."

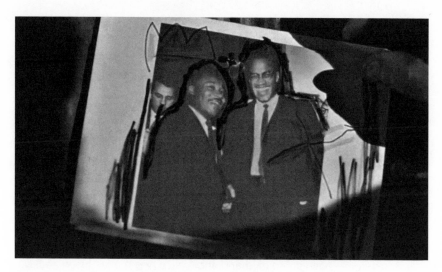

FIGURE 4.2 *The Celebrated Photo of Martin Luther King and Malcolm X in* Do the Right Thing

In its own way, the end of the film also "stutters" on these images. As Douglas Kellner notes, Smiley puts "a picture of Malcolm X and Martin Luther King standing side by side on the wall, thus fulfilling Raheem's desire to have black images in the pizzeria. But the picture is then shown burning, raising the question of whether this represents the futility of black politics in the present age and allegorically enacts the fading relevance of both Malcolm and Martin" (1997, 84).

The use of language and literacy in *Do the Right Thing* is critical and closely related to the sense of community and work, and the audience can only judge action and meaning by the kind and quality of sound. Most importantly, the language is, with the exception of the statements by King and Malcolm X at the conclusion, wholly oral. No one ever reads in the entire film. This fact may be related to the film's emphasis upon "music and expressive styles" and a social preference for oral language (Kellner 1997, 81), but more than likely says something about black communities being left out of quality education, and, therefore, an inability of many African Americans to enter the larger American culture that increasingly depends on the need to read. Spike Lee himself has been a strong spokesman for the black community's need for more and better educational opportunities and a strong critic when they fail to take advantage of those that are offered.

There are selected moments of quiet talk among the residents of this street, as indicated by members of the older generation like "Da Mayor" who "loves everybody" (Lee *DRT* 1989a, 136) and the Corner Men (Sweet Dick

Willie, Coconut Sid, and ML) [21] who are gentle and kindly and speak in more-or-less standard, even courtly, English. Even Mookie's and Sal's conversation after the riot bears the stamp of this kind of civility.

For the most part, however, the level of noise is extreme and threatening. Mark Reid argues that the film is filled with "*unthreatening* images," including that of "the consumption of alcohol, the inhaling of glue, and the smoking of marijuana" (1997, 8—his italics), but, whatever value is put on these cultural issues, the overall noise level *is* threatening and uncivil. The younger generation is angry and hostile: their music is loud and their language non-standard, aggressive, and filled with rude expletives. The film begins with the loud music of "Fight the Power," and the extreme decibel level is heightened with Radio Raheem's walking down the street with the rap music on full blast, drowning out the salsa of the Puerto Ricans, and turning it up in the pizzeria to force Sal to put representative black cultural figures on his photographic wall. Most conversations are loud and aggressive and the language abusive, both for the Italians and blacks, confirming that volume becomes a measure of power and control in a society where, otherwise, people have little positive control and responsibility for their own lives. The film's opening conversation between Sal and his sons is full of discontent, especially the older and more dissatisfied Pino, who wants to leave the neighborhood, is cruel to his brother Vito, offensive in his language, and given to call Mookie a stupid "nigger" (Lee *DRT* 1989a, 182–183). When Mookie arrives at work first thing in the morning at the beginning of the film, the conversation turns still more confrontational when, refusing to sweep the sidewalk, he dismisses Pino's request with "Fuck dat shit. I deliver pizzas. That's what I get paid for" (Lee *DRT* 1989a, 129). Although Mookie subsequently proves himself more sensitive in dealing with Tina and mediatory in intercultural relations, his heavily accented black language is harsh and uncompromising—he will not be pushed around by anyone, especially his boss's racially insensitive son. Other young people in the neighborhood are even louder when they confront the young white man, Clifton, who inadvertently steps on Buggin' Out's shoes, shout at the drunken Mayor, drink beer in groups, and cool off by releasing the water in the fire

[21]ML is played by the veteran actor Paul Benjamin, the name of one of the main characters in *SMOKE*, perhaps an important and playful indication of the ties to *Do the Right Thing* that Auster creates. In fact, according to Lee, Paul Benjamin was the "first actor to raise a question about the script [of *Do the Right Thing*]. He was worried that it showed nothing but lazy, shiftless Black people. It seemed to Paul that no one in the film had a job, and that his character and the other Corner Men just hung out all day." Lee countered that he was "talking about people who live in the bowels of the social-economic system, but still live with dignity and humor. Paul and I talked about it the next day and he understood" (Lee 1989c, 109). However, many would still believe that Paul had a point—the film may undermine its critique by showing an unemployed population with no substantial indication of the reasons for that.

hydrant. So, as nice and nonviolent as Da Mayor, Mother Sister, and the Corner Men are, they are powerless to suppress the anger that boils in the youth, tone down the volume, or prevent the riot that breaks out.[22]

Offensiveness in language is given a strong ethnic and racial edge through a "racial slur montage" (Lee *DRT* 1989a, 186). In this scene, one of the most noticed by critics, the characters look straight at the camera to deliver their offensive slurs: Mookie berates Italians, Pino lambasts blacks, Stevie denounces Koreans, Officer Long criticizes Puerto Ricans, and the Korean clerk rails against Jews. These are grotesquely humorous caricatures that provide markers of a deeply divided, racialized society where everyone hates different races or ethnic groups. That these soliloquies are carefully choreographed and stylized does not in any way diminish the level of noise, impoliteness, racial hostility, and downright abuse within them. It has some qualities of a Greek chorus but none of the community values that are often articulated by the chorus.

Partly obscured in this representation of community, work, and language and sound are the dueling texts of Martin Luther King and Malcolm X, especially King's "Give Us the Ballot—We Will Transform the South" and "I Have a Dream" and Malcolm X's *Autobiography* and "The Ballot or the Bullet." These texts are given prominence at the very end of the film when, after the riot between the Italian owners of the pizzeria and the local black community, the film screens comments by King ("Violence as a way of achieving racial justice is both impractical and immoral... a descending spiral ending in destruction for all") and by Malcolm X ("I don't even call it violence when it's self defense, I call it intelligence"). In this way *Do the Right Thing* alerts the audience to consider their views with respect to the entire incident because the texts background much of the language and images, and the film cannot be truly understood apart from the citation of them.

Metaphors that King used through "I Have a Dream" give voice to a peaceful way forward. Though he recognized that "this sweltering summer of the Negro's legitimate discontent will not pass until there is an invigorating autumn of freedom and equality" (1986b, 218), King assumed that the way to reach this cool period was by negotiation and integration. That could lead "sons of former slaves and sons of former slave-owners to sit down together at the table of brotherhood" (1986b, 219). King had in mind a peaceful process to take advantage of the promissory note authorized by the founding fathers:

When the architects of our Republic wrote the magnificent words of the Constitution and Declaration of Independence, they were signing a

[22]In many ways, Da Mayor looks a lot like the New York City mayor Dinkins, who was also accused of being ineffectual.

promissory note to which every American was to fall heir. This note was a promise that all men—yes, black men as well as white men—would be guaranteed the unalienable rights of life, liberty and pursuit of happiness. (1986b, 217)

These metaphors of food, money, and coolness to describe the benefits owed the black community are central to the plot of *Do the Right Thing* in its representation of a hot day when tempers flare and people are killed, when blacks are denied money to make their living, and when the tables meant to bring blacks and white together are used to further discrimination.

Malcolm X also picked up on this rhetoric of money, noting that, after "three hundred and ten years [in which they] worked in this country without a dime in return," blacks would now "collect for our investment" (1965, 32). The short supply of money for Mookie and others in his beaten-down neighborhood is clear evidence that this promissory note has not been delivered a quarter-century later either because whites are prejudiced and greedy and will not let it happen. As Malcolm X observed:

Now I watched brothers entwining themselves in the economic clutches of the white man who went home every night with another bag of the money drained out of the ghetto. I saw that the money, instead of helping the black man, was going to help enrich these white merchants, who usually lived in an "exclusive" area where a black man had better not get caught unless he worked there for somebody white. (1999, 197)

Because his black listeners have been poorly served and oppressed, Malcolm X issued his called to arms: blacks must wake up, see their victimization, and act "by whatever means necessary" (1965, 24) to overthrow the yoke of oppression in America. As he notes in "The Ballot or the Bullet," "22 million victims are waking up. Their eyes are coming open. They're beginning to see what they used to only look at" (1965, 26). The opening of the film thus repeats the Malcolm X's images of waking up, not only as Mookie and his sister awake, but as the radio announcer, Mister Señor Love Daddy of the We Love Radio Station, admonishes his listeners to wake up. Near the end of the film, as Mookie sees a great injustice when Raheem is killed by the police, his hooded lids begin to open, and he is the first to begin destroying the pizzeria of his Italian boss.

Do the Right Thing, then, engages in a citational freeplay of music, colors, and texts of Martin Luther King and Malcolm X to create a cultural dialogue about the way forward from the persistent exploitation of blacks in American

culture. No one citation forms the basis of the film or hints at a perfect cultural solution, but rather the citations all help to offer perspectives on racism in America.

Paul Auster's "auggie wren's christmas story" and Wayne Wang's SMOKE

In 1990 Paul Auster was asked to write a Christmas story for the *New York Times*, and, despite being Jewish, never having written a short story, and assuming such an attempt would result in a piece of "make-believe" (Auster 1995b, 3), he agreed to the project. The resultant six-page unconventional "auggie wren's christmas story," with its concluding portion about a warm-hearted, unexpected Christmas celebration between a middle-aged white man and an elderly blind black woman, is about constructing and telling stories and the difficulty of finding a unique artistic perspective and stance as well as about stealing and giving, lying and telling the truth, and the triumph of hope over adversity. It avoids Christian ideology, religious piety, and the popular sentiment of traditional Christmas stories, and is playfully postmodern in stressing a certain indeterminacy of characterization, event, and motives. Nevertheless, it proves affirmative and supports racial harmony.

Although postmodern fiction supposedly "has not shown itself very adaptable to film" (McFarlane 1996, 6), film director Wayne Wang found himself drawn into this "no-nonsense," self-contradictory, paradoxical story, and asked Paul Auster to write a script for film, which resulted in the two-hour *SMOKE* that elaborates on many characteristics and issues of the short story, but goes well beyond the original story in design, length, complexity, argument, and theme.

Exploring the relationship between make-believe (fantasy, fiction, and story) and reality, and transforming the postmodernity of fiction into that of film, Wayne Wang's involvement in the saga of *SMOKE* is an interesting one. Never having heard of Paul Auster, he stumbled across "auggie wren's christmas story" as he was reading the *New York Times* on Christmas Day, 1990. In his own words:

> As I started to read the story, I was quickly drawn into a complex world of reality and fiction, truth and lies, giving and taking. I was alternately moved to tears and laughing uncontrollably. Many of my own interesting Christmas-day experiences flashed through my mind. By the end, I felt that I had been given a wonderful Christmas gift by someone I was very close to. (1995, vii)

Wang's choice of language to describe the complexity of this film is close to Auster's in his interview with Annette Insdorf, an indication that the two see the narrative in similar terms. As Auster remarks, "everything gets turned upside down in 'Auggie Wren.' What's stealing? What's giving? What's lying? What's telling the truth? All these questions are reshuffled in rather odd and unorthodox ways" (1995b, 3). But the parallel goes one step further: when Wang finished the film, he wrote that it was a Christmas gift "to the moviegoing audience from Paul Auster and Wayne Wang" (1995, viii). This "Christmas gift," like many other gifts within the film, preserves certain qualities of the original story, but places them in a more elaborate and complex narrative with many allusions to, and citations of *Do the Right Thing*. In so doing, it picks up the story's addressing of postmodern uncertainty and indeterminism through postmodern freeplay, even while, through the citation of *Do the Right Thing*, it seriously addresses one of the most difficult issues of modern America— urban racial relations. "Auggie wren's christmas story," *SMOKE*, and *Do the Right Thing* thus beg to be compared. To do this, I will look briefly at the short story and then indicate how the film explores characters, techniques, and themes introduced in the short story, including the characters of Auggie and Granny Ethel, the interplay of color and black-and-white graphics,[23] and the emphasis on postmodern uncertainty and indeterminism. Finally, and most importantly, I will look at the way that *SMOKE* cites *Do the Right Thing* in order to assert a more positive view of racial relations than does Lee's film.

In this analysis I first wish to consider elements of Christmas myth and mystery and important "kernels" of narrative (Chatman 1978, 53) that have been maintained, deleted, or enhanced from story to film. This is little different in kind from what Thomas Leitch (2007) refers to as the "true story" lying behind a film that can on the basis of that be called an adaptation. I also want to explore "functional equivalents" (Bordwell 1985, 13), especially the blurring of generic conventions, that serve as correlations and disparities between the two forms. There are, then, really three different principle texts in this intertextual complex: the short story that was intended for a newspaper-reading audience; the film script adaptation that constructs the characters' discourse and details of the setting with its plans for the film; and the film adaptation itself which references *Do the Right Thing* in order to present a view of harmonious race relations in Brooklyn.

With the exception of the opening scene and the final narrative segment entitled "Auggie," *SMOKE* pretends to no particular faithfulness to the written

[23]In this study, I will hyphenate black and white when I am talking about these "colors" in film and photography, hence "black-and-white" to separate this technique from racial and ethical associations.

text. Rather, the film "intersects" (Andrew 1980, 10) with the short story to provide a "commentary" (Wagner 1975, 224) on the original narrative. More importantly, this freeplay adaptation creates an intertextual dialogue with *Do the Right Thing* to develop an alternative to Lee's view of racial relations.

Auster's "Auggie Wren's Christmas Story"

"Auggie wren's christmas story" primarily centers on the ritual of Christmas as embodied in the surprising relationship of Auggie Wren and Granny Ethel and their memorable Christmas dinner. As Todd Gitlin (1988) and Ihab Hassan (1986) note, postmodernism challenges and decenters traditional notions of aesthetics and cultural values, and interrogates master narratives, undermining their cultural authority and highlighting indeterminacy in their artistic and cultural representations. According to Joseph Natoli:

> The absence of a foundation of absolute and universal truth troubles the "self" grounded in reality as well as the word and world connection, that is, our capacity to validate a precise correspondence between what we say is going on in reality and what may actually be going on in reality. And it is the indeterminacy of our saying in reference to reality that converts fundamental truths—and all modified variations thereof—into challengeable narratives of truth. Selves are brought up within a clash of such narratives.
>
> So in the end, it is not some postmodern perversity that simply chooses to ignore fundamental truths of all stripes, from scientific to moral, but a recognition of the unreliability of our representing capacities, a pointing out of the distance between words and world. This breach is, for postmodernity, foundational. (1997, 70–71)

Inherited from Jacques Derrida and Roland Barthes, postmodern indeterminacy and undecidability are features concerned with the disjuncture between language and reality, suggesting that signification moves uncertainly among several alternatives at the same time.

As an annual religious, cultural, and commercial celebration, the event of Christmas balances precariously between religious observance and cultural celebration: some would like to see Christmas only as a religious event, some mainly as a cultural event, and some only as a cultural event. Christmas, then, is for many always already a postmodern indeterminate phenomenon with the signification moving uncertainly between the religious and secular, ceremonial and informal, collective and personal.

Auster's story picks up this postmodern indeterminacy in Auggie's odd celebration with the blind Granny Ethel: Auggie goes to see her to return a billfold dropped by her grandson Robert Goodwin (who, as a thief, has fled

the scene of a robbery), lies to her about being her grandson, finds himself strangely charmed by this eighty- or ninety-year-old woman, and enjoys wine that she has on hand with a feast of soup, chicken, potato salad, and chocolate cake that he purchases from a store. On a less positive note, Auggie takes a camera that presumably has been stolen by Ethel's grandson Robert. This Christmas celebration is, then, one of mixed motives and actions: it is about Auggie's giving Granny a moment of intense happiness balanced by his lying to her and stealing the camera, raising serious issues about ethics in a postmodern age. The episode mingles the false and the true, and this story itself, claimed by Auggie to be authentic, may well be false. As the character Paul Benjamin remarks:

> I paused for a moment, studying Auggie as a wicked grin spread across his face. I couldn't be sure, but the look in his eyes at that moment was so mysterious, so fraught with the glow of some inner delight, that it suddenly occurred to me that he had made the whole thing up. I was about to ask him if he'd been putting me on, but then I realized he would never tell. I had been tricked into believing him, and that was the only thing that mattered. As long as there's one person to believe it, there's no story that can't be true. (Auster 1995a, 156)

By analogy, of course, this narration and its mixed motives, as well as the question of truth and belief, beg the ultimate question of the authenticity of the Christmas event and story since the origin and conventions are uncertain at best. The question of authenticity and origin may, however, be the strongest feature of the Christmas celebration, allowing everyone to participate. It is the celebrant's and reader's ability to enjoy Christmas and its festivities—whether or not they are based on truth—that gives them a curious attraction and mysterious ambiguity. As Leitch says of various adaptations of Dickens' "Christmas Carol," a comment that holds equally true for *SMOKE*: "by establishing their worldly, ironic skepticism…so much more powerfully than their call to conversion, these films faithfully register the faithlessness of the modern world, or at least its resistance to traditional expressions of faith" (2007, 86).

Continuity in Auster's short story and Wang's SMOKE

The film preserves many of the critical details and themes of the short story, though they are positioned primarily as part of the opening sequence set in the cigar store and as a short 20-minute finale. Otherwise, the film presents

a greatly expanded narrative concerning the relationship of Auggie, Paul, and three new principle characters named Rashid, Cyrus, and Ruby as well as a number of new minor characters. The terminal section, called "Auggie," first presents a close-up in full color of Auggie telling his Christmas story to Paul at a restaurant. Then, while the credits are rolling, it visually presents in black-and-white Granny Ethel's wonderful joy and Auggie's happiness in creating this special feast for her, in what is perhaps the last Christmas of her life. By a significant pause, sideways glance, and flicker of Ethel's eyelids, the film suggests that Ethel understands this might be a game of make-believe, but it is such a wonderful game that inevitably it is as good as, and maybe even better than, the real thing. This conclusion to the film does not pass a negative judgment on the actions of the characters for engaging in such postures. The viewer accepts Auggie's lying and stealing as at least partly justified by the rest of his actions, even perhaps as the ambiguous claims of Christmas are justified by the happiness the holiday brings to people.

It is particularly in this terminal episode that Wang most fully exploits his postmodern techniques to create and check an optimistic tone, to install and subvert traditional Christmas feeling—to explore the indeterminacy that the short story first introduces. When Auggie tells Paul Benjamin this Christmas story, the camera slowly, but relentlessly, moves in on his face, finally centering on his mouth, which fills the screen. The camera also tracks Paul as observer, moving just as surely toward his face, culminating in his eyes as he watches Auggie. Like Auggie's mouth, Paul's eyes fill the entire screen on one occasion. Telling and seeing, constructing a story and looking at the truth and falsity of it—these are underlying motivations for the camera movement. But Wang does not stop there. At the very end in which the Caucasian Auggie's relationship with the black Granny Ethel is shown, the camera again focuses on faces (though not exclusively), but in black-and-white rather than color. The effect of the change in coloration blurs and fragments the focus on lying and truth and raises a question about the relationship of black-and-white footage and color in films and television, black and white in ethics, and the race relations of blacks and whites in America. The film shot in color concerns the lives of Paul, Auggie, Rashid, and Ruby in the borough of Brooklyn, whereas the black-and-white portion, while also beginning with Auggie's tobacco shop, quickly shifts to the Boerum Hills public housing projects. The opening shots in both the colored and black-and-white portions depict a generally pleasant, racially tolerant middle-class setting in this "great People's Republic of Brooklyn" (Insdorf 1995, 16), while the final segment shot in black-and-white shows the more oppressive housing of the New York City underclass, represented in this film by Rashid, Aunt Em, and Granny Ethel—all black.

This use of black-and-white also typifies the realistic photographs of Auggie (though the short story says they are in color) taken of the same undistinguished crossroads in Brooklyn over fourteen years. The use of black-and-white thus raises the issue of an American underclass, nodding in the direction of documentaries and such early films as *Grapes of Wrath*, and the incorporation of color and black-and-white in relation to idealism (and fantasy) and a hard-edged reality gestures in the direction of *The Wizard of Oz*. (This latter intertextual citation is quite explicit, given Rashid's aunt being called "Aunt Em.")

This central, ambiguous optimism is reinforced and further complicated by the mixture of the romantic and realistic evident in the interfilmic allusions within the movie. Auster refers to at least two films, often thought of as being for children and usually televised during the Christmas holidays, as if they somehow encapsulate the spirit of youth, innocence, and romance. The one mentioned earlier in reference to Aunt Em, *The Wizard of Oz*, self-consciously addresses the question of realism and romance in Dorothy's journey from prosaic Kansas to the fabulous land of Oz. The other, *Peter Pan*, also raises the issue of realism and romance in its depiction of a boy who must decide between the romance of Never-Never Land and the realism and responsibilities of his London home. This latter film is evoked when Auggie asks Ruby about her eye patch, accusing her of going around dressed like Captain Hook (Auster 1995a, 69). Designed to bring Ruby up short about her disfiguration, Auggie's wisecrack is reinforced again when Rashid questions his father about his prosthesis, and Cyrus responds calling it his hook (Auster 1995a, 75). These allusions remind the viewers of more romantic scenarios but also ironize the films, taking them from romance to realism and making the viewer doubly aware that innocence may also only be a fiction. This ironizing of innocence is also apparent in the penultimate song of the film, "You're innocent when you dream," which recounts the failures and disappointments of love, suggesting that innocence is a dream and people innocent only when dreaming. Dreams and dreaming are also problematized by the T-shirt that one of the patrons of the cigar store wears in the film script, saying, "If life is a dream, what happens when I wake up?" (Auster 1995a, 20).

Fantasy, dream, and reality are problematized, and this film does not surrender to easy polarities and binary oppositions. Because the film begs questions about the relationship of fantasy and reality, the use of black and white in relation to color and of references to optimistic children films self-consciously ironizes happiness, though it also offers hope for positive racial relations, thus continuing to ask, but not resolve, important and basic questions about life and art in America.

This moral and social indeterminacy intermingled with holiday happiness is borne out in the main part of the film in the relationship of Auggie, Paul, and Rashid. Each one of these men has lost someone of significant value: Auggie's fiancée Ruby left him when he failed to write to her while he was in Vietnam (Auster 1995a, 72), and he had no relationship with his alleged daughter Felicity; Auggie's purchase of Cuban cigars was ruined by Rashid's carelessness; Paul's father died at an early age (in the film script only) and his wife and unborn child were killed in a bizarre shoot-out; and Rashid's mother died in an auto accident and his father abandoned him as a young child. But each finally offers the others forgiveness, emotional support, and assistance. Though nearly all the families are dysfunctional, the film is never one of despair. Despite the problematic past of each character and the possibility for tragedy, *SMOKE* offers the viewer provisional gifts of hope and affirmation, which, after all, are quintessential to the Christmas message of seasonal, familial, and spiritual renewal. Thus, what Thomas Leitch calls the "true story" behind films (2007) continues to govern the adaptation, even while it is being interrogated.

Indeed, typical of bringing this "true story" forward, it is a film filled with gifts: Auster's and Wang's gift to the viewer, Auggie's presentation of a memorable day and feast to Granny Ethel as well as his gift of a story to Paul, Paul's offer to Rashid of a place to stay in thanks for saving him from being run down in traffic, Rashid's present of stolen money to Auggie as recompense for having ruined his investment in Cuban cigars, Auggie's offer of the same money to Ruby to assist Felicity, Rashid's gift of his pencil sketch to his newly discovered father, and Rashid's present of a television to Paul. These gifts—the very spirit of Christmas—confirm a sense of tenderness, kindness, compassion, and forgiveness, which preclude sustained tragedy. In two instances—Auggie's and Ruby's encounter with their derelict daughter and Rashid's fight with his newly discovered father—in which the action could take a decidedly negative and even tragic turn, it does not. These potentially difficult situations between parents and children end on a moderately hopeful note, though not a wildly optimistic one, just as the concluding story of Auggie and Ethel sounds hopeful, though built on a lie. Thus, the story and film have an uncertain mixture of the romantic and realistic, of postmodern mystery and manners.

A related postmodern indeterminacy in the story, film script, and film is the self-reflexive consideration of the role of art, which is also significantly related to the ritual of Christmas, the basis of Auggie's going to see Ethel. The narrator in all three is a writer with a sense of self-consciousness about the literary process: in almost the exact words of Paul Auster's autobiographical

statement about his reaction to an invitation to write a story about Christmas, the narrator in the short story tells about his misgivings:

> A man from the *New York Times* called me and asked if I would be willing to write a short story that would appear in the paper on Christmas morning. My first impulse was to say no, but the man was very charming and persistent, and by the end of the conversation I told him I would give it a try. The moment I hung up the phone, however, I fell into a deep panic. What did I know about Christmas? I asked myself. What did I know about writing short stories on commission?

I spent the next several days in despair, warring with the ghosts of Dickens, O. Henry and other masters of the Yuletide spirit. The very phrase "Christmas story" had unpleasant associations for me, evoking dreadful outpourings of hypocritical mush and treacle. Even at their best, Christmas stories were no more than wish-fulfillment dreams, fairy tales for adults, and I'd be damned if I'd ever allowed myself to writing something like that. And yet, how could anyone propose to write an unsentimental Christmas story? (1995a, 153)

This self-reflexive comment about Christmas narratives clearly begs the question of the uncertain status of this piece of writing. To satisfy the ritualistic quality of the occasion and the traditional requirements of Christmas narrative, the narrator must conform to certain cultural expectations, social codes, and narrative conventions but also recognize the need to express his own voice and define his own art. This dilemma, of course, goes to the heart of the artistic process: how a writer can make a story recognizable within a given set of conventions and yet stand out in some particular fashion.

In the story, pictorial art, especially photography, is similar to that of writing, for Auggie Wren, too, "considered himself an artist" (Auster 1995a, 151) in taking more than four thousand pictures of the corner of Atlantic Avenue and Clinton Street in Brooklyn over a period of 14 years, and it is the narrator's picture on a book jacket of his novel that forms the initial bond between the two men. Thus, the issue of photographic and narrative representation becomes central to both story and film. Attuned to considering each object of art—whether fiction or photograph—as an individual work, the narrator is initially dismayed to discover the "numbing onslaught of repetition" and "unrelenting delirium of redundant images" (Auster 1995a, 152) in Auggie's photos, but finally learns to slow down, look at, and explore the subtle differences marked by "natural time" and "human time" in each picture. Arguably, fiction is similar in that the reader must read slowly and carefully to gain insight and appreciation, and the viewer of *SMOKE* is forced to observe carefully and analytically as the film

moves slowly and deliberately from one character portrait to another. Clearly, photography, fiction, and film have many elements of conventional experience and the ritualistic, but in each case it is the details of place and event related to time and the individual's perspective that allows the artist to break out of the ordinary and make an artistic difference. Like life itself, repetition and ritual in Christmas, writing, film, and photography may dull perception, but it is the role of the artist to alter that in some special fashion, to allow a closer look at, and a unique perspective on, life. As the narrator in the short story says of Auggie and his thousands of pictures,

> He was right, of course. If you don't take the time to look, you'll never manage to see anything. I picked up another album and forced myself to go more deliberately. I paid closer attention to details, took note of shifts in the weather, watched for the changing angles of light as the seasons advanced. Eventually, I was able to detect subtle differences in the traffic flow, to anticipate the rhythm of the different days (the commotion of workday mornings, the relative stillness of weekends, the contrast between Saturdays and Sundays). And then, little by little, I began to recognize the faces of the people in the background, the passers-by on their way to work, the same people in the same spot every morning, living an instant of their lives in the field of Auggie's camera. (Auster 1995a, 152)

SMOKE picks up from the short story on both Paul's writing and Auggie's photographs, but adds yet another dimension: Rashid's drawing. Rashid may be untutored in his art and is not at all self-reflective but uses his abilities to sketch his estranged father's place of business and then slips the picture under his door one day as a parting gift. A piece of art, then, may have some special aesthetic merit, but it may also simply be an unexpected gift from the heart, another way of breaking out of commonplace and prosaic reality.[24] Christmas and art, then, are both ways of breaking out of the ordinary, but may themselves become time-worn and repetitive, in need of re-evaluation and defamiliarization. Religious and cultural observances, like art itself, must change while maintaining some basic continuity. This indeterminate interplay

[24]Art enters the film script and movie in several ways. Paul and Rashid buy books of art in the bookstore, there are references to such artists as Rembrandt, and Christian art is seen on the walls of Granny Ethel's apartment and Auggie's cigar store. In addition, a book cover illustrating Christian saints is shown on an upper shelf of the bookstore. These all suggest the way high and low art has been taken into culture.

of ritualistic practice and significant artistic moment is critical in festival, story, and film as well as photography and drawing.

A critic who has much to say about the various ways in which festivals and fiction mimic and undermine daily patterns of authority and who stresses the need for constant reformation is Mikhail Bakhtin, whose "carnivalesque" encompasses these aspects. As he mentions in "Discourse in the Novel,"

> At the time when poetry was accomplishing the task of cultural, national and political centralization of the verbal-ideological world in the higher official socio-ideological levels, on the lower levels, on the stages of local fairs and at buffoon spectacles, the heteroglossia of the clown sounded forth, ridiculing all "languages" and dialects; there developed the literature of the *fabliaux* and *Schwänke* of street songs, folksayings, anecdotes, where there was no language-center at all, where there was to be found a lively play with the "languages" of poets, scholars, monks, knights and others, where all "languages" were masks and where no language could claim to be an authentic, incontestable face. (1981, 273)

Bakhtin's comments may appear only neatly coincidental with Auster's writing and the critique of master narratives, except that Auster himself in the film self-consciously evokes Bakhtin's name when talking about literary and philosophical pieces that have been wasted. The writer Paul mentions that the only copy of a manuscript by Bakhtin literally went up in smoke during the occupation of Leningrad in 1942 when Bakhtin used the pages of his book for cigarette wrappers. The reference to Bakhtin is not necessary for the film and, indeed, all but slides by, subsumed as it is in an account of the inestimable value of smoke. By evoking his name, however, Auster indicates a self-conscious awareness of his antecedents in exploring the value of festivals, writing, art, and smoking. (Indeed, with references to Sir Walter Raleigh, Raleigh cigarettes, Queen Elizabeth I [or Bess], and Bakhtin, there is a sort of playful intertext of tobacco and meta-narrative of smoking.) [25]

This self-reflexivity concerning ritual and art gives this particular narrative an interesting postmodern character, for postmodernity concerns a self-aware, paradoxical continuation and disruption of custom and artistic process. In that spirit Linda Hutcheon argues that

[25]This self-conscious intertextuality is further supported in the film script by references to Herman Melville. The underlying meaning of these is less obvious than those relating to Bakhtin, but might well refer to Melville's self-stated intention to write subversive short stories, stories that could be enjoyed on one level while very easily subverting that enjoyment on another.

Postmodernism is a fundamentally contradictory enterprise: its art forms (and its theory) at once use and abuse, install and then destabilize convention in parodic ways, self-consciously pointing both to their own inherent paradoxes and provisionality and, of course, to their critical or ironic re-reading of the art of the past. (1988, 23)

Auggie's unexpected celebration with Granny Ethel, the narrator's decision to write the short story, and the conception of art, then, are governed by this provisionality, self-consciousness, and indeterminacy. They are also governed by the random and stochastic, being at the wrong or "right place at the right time" (Auster 1995c, 31). It is totally unexpected, random, and serendipitous that Paul's wife is killed by a stray bullet, that Rashid's mother is killed in an auto accident, that Auggie meets Granny, that the narrator is asked to write a story, that he uses Auggie's account for that story, and that anything artistic can grow out of Christmas ritual and photographic replication. Self-consciousness and indeterminacy, however, do not rule out the possibility, and even probability, that something wonderful can happen in each case. What happens is, of course, indeterminate, and the reader of the story and script and the viewer of the film are never quite certain that anything is resolved thematically, for ritual and story are at once old and new, ritualistic and innovative, sentimental and unsentimental, conformist and romantic. This is the paradoxical nature of the postmodern for "there is no dialectic…The result of this deliberate refusal to resolve contradictions is a contesting of what Lyotard…calls the totalizing master narratives of our culture, those systems by which we usually unify and order (and smooth over) any contradictions in order to make them fit" (Hutcheon 1988, x).

We might call this indeterminate paradox in "auggie wren's christmas story" and *SMOKE* an "ironized, paradoxical epiphany," a term that neatly fits both the Christmas and narrative events. (It is interesting and relevant that the mentally challenged Jimmy confuses paradox with paradise, linking the two in the viewer's mind.) In the religious sense, of course, Epiphany refers to the season just after Christmas celebrating the special insight and recognition given the three wise men as they looked at the infant Jesus, born in the most common of circumstances. In James Joyce's sense, an epiphany is a special unbidden moment of illumination in a narrative about one's personal, social, and cultural situation. Both the religious and literary usage underscores a new stage of awareness, though Auster suggests that familiar patterns and constraints coexist with this new insight.

This notion of sight and insight is especially embodied in the eye imagery of the story and film. In both, Granny Ethel is blind, and Auggie has a special

"look in his eyes" when telling his story (Auster 1995a, 156). Indeed, Auggie's name is similar to the German *augen*, to see, and his camera gives him a special extra "eye" to see with. In the film, the camera moves directly to Paul's eyes, which fill the screen, as he hears Auggie telling the story. Then, too, in both story and film, the narrator/Paul is told to slow down and look carefully at Auggie's pictures, and, when he does, he learns to appreciate the familiar, even seeing his dead wife in a fresh way. In the film, lacking her artificial eye, the "blue marble," Ruby has a patch to cover this missing eye, and Auggie maintains in the script that she has "an eye that couldn't see, an eye that couldn't shed any tears" (Auster 1995c, 38). And, arguably, Auster in playing upon Paul's name (Paul Auster, Paul Benjamin, Paul Benjamin Cole) reminds the reader of the blinded St. Paul who is credited with "seeing" in a new way, universalizing the Christian message.[26] Story and film, then, ask the readers to be freed by new sight, insight, illumination, and epiphany, but they also suggest we are simultaneously blind and constrained. In a postmodern sense, constraint and freedom, blindness and insight, are simultaneous, ongoing, and enfolded within each other. Christmas is constrained by ritual and art by convention, but unless the artist is also able to suggest the particular and personal in the midst of the constraint, art cannot exist. This is the Derridean paradoxical indeterminacy of "both/and" instead of "either/or," which so fully characterizes both the story and the film.

The film's image of smoke and smoking, though mainly absent from the story, is central to an appreciation of this ironized, paradoxical epiphany for smoke is simultaneously nothing and something. It is almost nothing for, as the film reports of Queen Elizabeth, smoke, being neither solid nor liquid, is virtually impossible to measure, and yet it can be seen, felt, and experienced. Indeed, as a signifier, smoke floats easily among several signifieds. As Auster himself remarks, smoke is

[26]This question of names increases within the film, raising a fundamental issue about identity. Paul Benjamin's name is appropriated by Rashid, who tells Cyrus (who at this point does not know Rashid is his son) that it is his name. But, of course, Rashid is not his name either; he chooses it to disguise his given name of Thomas Jefferson Cole, in the process raising a question in the viewer's mind about his African American roots, Rashid currently being a more politically acceptable black name than Thomas Jefferson. This issue of naming is doubly complicated when Rashid tells the young woman clerk in the bookstore that he is the father of Paul Benjamin, thereby inverting lineage, patrimony, and age. Then, too, the film changes the name of Granny Ethel's grandson from Robert Goodwin to Roger Goodwin, and his theft of the books in the cigar store in the black-and-white conclusion to the film is a match shot or mirror image of that of the white boy stealing books at the beginning of the film. Names, family relationships, and social roles thus circulate in a humorous and indeterminate way, emphasizing the interrogation of personal, racial, and cultural identity.

many things all at once. It refers to the cigar store, of course, but also to the way smoke can obscure things and make them illegible. Smoke is something that is never fixed, that is constantly changing shape. In the same way that the characters in the film keep changing as their lives intersect. Smoke signals...smoke screens...smoke drifting through the air. (Insdorf 1995, 13)

Because of its Native American origins and Raleigh's introducing and popularizing it in England, tobacco is also strongly identified as an American icon.

Such references to tobacco, smoke, and smoking nonetheless raise ethical considerations. With the story set and published in 1990 and the film released in 1995, Auster raises the issue of social taboos: what was once a fashionable pastime is now considered hazardous for health and, therefore, "under erasure." Auggie complains that "they will legislate us out of business," and Vinnie responds, "They catch you smoking tobacco, they'll stand you up against the wall and shoot you" (1995c, 38). The film self-consciously addresses the dangers of smoking but also suggests that smoking brings a group of men together in the cigar store, creating and sustaining community. It is, after all, Paul's need for his Dutch Schimmelpennicks that brings him into Auggie's circle in the first place, and it is while smoking and drinking coffee in a restaurant that Auggie tells Paul his memorable Christmas story. Then, too, the film script lists such Hollywood "personalities" as Groucho Marx, George Burns, Clint Eastwood, and Frankenstein's monster who are identified with smoking (1995c, 19) and whose pictures appear in the cigar store, therefore reinforcing the intertextual and interfilmic qualities. Paul Auster also admits that it was while he was smoking his "beloved Schimmelpennicks" that he conceived the idea of "auggie wren's christmas story" (Insdorf 1995, 3). All the main characters, except the youth Rashid, smoke on a regular basis, and, in one moment of companionship in front of a televised baseball game, Rashid tries smoking a cigar with Paul. Smoke itself, then, is both nothing and something, dangerous to the body and beneficial to the community and soul. How does one weigh smoke and calculate these aspects? Certainly not by an unthinking acceptance either of a politically correct view of smoking or of a totally subversive view.

This critiquing of predominant social and cultural positions is apparent in structural and textual features of the film *SMOKE* and its printed texts. Perhaps the first thing the reader notices in Auster's and Wang's printed edition of *SMOKE*, which includes "auggie wren's christmas story," is that, with the exception of the cover page, all the titles are presented in lower case in the table of contents and the headings of particular sections. This lack of

upper case has roughly the same effect upon readers as an e. e. cummings' poem, which represents an attempt to undermine dominant social and logical structures through a more "democratic" typeface. In postmodernism, this resistance to conformity is identified with Lyotardian interrogation of master narratives and conventional hierarchies (Lyotard 1984, xxiv). Christianity is, of course, one of the most important master narratives in the West, so placing its most important "feast" in lower case removes some of the dominance of Christianity as the sole voice of the people and defamiliarizes the Christmas season, making it more available to people of many faiths and religions and to those who have none.

The film adapts this technique by putting the title in lower case but further defamiliarizes conventional openings of films by first listing the actors but withholding the actual title until the fifth shot of the film concluding Paul's comments on the weight of smoke. The film continues this technique in the terminal black-and-white sequence depicting the relationship of Auggie and Granny Ethel, which is shown in its entirety while the credits are slowly running. For all practical purposes the narrative is concluded when the viewer actually sees Auggie's interaction with Ethel, but this very moving episode keeps the viewer glued to the screen while also aware that, like smoke itself, the impact of this sequence is very difficult to weigh.

The structure of the short story itself reinforces this defamiliarization and democratization in its use of framing. The first-person narrator of this story, the "I," is a writer who has been told this story by Auggie Wren, a remote, shadowy figure. As the narrator remarks in the opening lines of the story:

> I heard this story from Auggie Wren. Since Auggie doesn't come off too well in it, at least not as well as he'd like to, he's asked me not to use his real name. Other than that, the whole business about the lost wallet and the blind woman and the Christmas dinner is just as he told it to me. (1995a, 151)

Traditionally, the use of a narrative agent in an exterior frame throws suspicion on the interior narration. In the American tradition of narration, this suspicion has been true at least since Washington Irving: although Irving publishes *The Sketch Book* and writes a "Preface," the stories are supposedly collected by Geoffrey Crayon who found some of them among the papers of Diedrich Knickerbocker, a local Dutchman who swore to the authenticity of tales like "Rip Van Winkle" and "The Legend of Sleepy Hollow," which are told in the third-person as if authentic. This nesting makes it impossible to ascertain whether statements are true or false because there are too many perplexities and inconsistencies in the narrative to peel away the layers easily and

confidently. Auster exactly creates and sustains that tone of perplexity: it is impossible to verify Wren's story because even his name is inauthentic: all we have is Paul's report from a non-identifiable and unverifiable source and his query about the authenticity of the story.

In the film this frame technique is not articulated in the same way. Indeed, the frame is not evoked at all at the beginning, but the final part of the colored portion of the film concludes in the same manner as the story, with Paul's uncertainty about the truth of Auggie's account. The film script and the film itself, however, further complicate the question of authenticity in this fragmentary framing, for, although the person centrally involved in the episode of "the lost wallet and the blind woman and the Christmas dinner" (1995a, 151) continues to be called Auggie Wren (though that name, of course, is a pseudonym), the author/narrator in the film is specifically referred to as Paul, though now Paul Benjamin. The internal and external narrators themselves, then, become increasingly mysterious floating signifiers, whose names, and therefore identity, continue to shift. If the character involved in the incident cannot be rightly named and the narrator's name continues to change, then the very stability of the narrative is in question and leaves the reader/viewer unable at some level to resolve the question of identity or of the distinction between truth and falsehood or of reality and imagination.

The issue of an unstable narrative and identity is reinforced through the interpenetration of genres and blurring of generic boundaries. Genette would call this "architextuality," that is, the intertextual borrowing, adapting, and playing with genre. This phenomenon occurs first with the publication of the short story in the *New York Times*, a most unusual venue. Fiction generally appears in magazines, journals, and books, and factual accounts and "news" come out in newspapers. A short story appearing in a newspaper thus problematizes reader expectations, appropriate venues, and the relationship of news, truth, and fiction. This question is specifically raised by the narrator's failure to identify himself in the story. Perhaps, like a newspaper byline, the "article" assumes that the author is the main observer and/or participant. Here, however, that is merely an article of faith, which the "fiction" neither supports nor refutes. The film continues to blur generic boundaries by using devices usually reserved for print and by reversing expectations about the use of color in relation to black-and-white. The most noticeable blurring of boundaries between fiction and film occurs in the "chapter" divisions of the film, which are, with one exception, identified with principle characters. The exception is the first instance in which a frame giving the season and year appears—"Summer 1990." Otherwise, these frames with a black background and blue print (the color of smoke) are listed as (1) Paul, (2) Rashid, (3) Ruby, (4) Cyrus, and (5) Auggie. These have the effect of alerting the viewer that

the film will be divided into a series of character portraits or vignettes. To some extent this assumption is false because characters other than those designated by the subtitles enter these "chapters" or "sketches," suggesting that each is not exclusively a personal portrait but rather a dramatic division. For example, Auggie's and Ruby's relationship begins in the unit entitled "Rashid," suggesting at least a certain amount of nonlinearity and dissipated focus (like smoke itself).

Not only do these "chapter titles" suggest that a novelistic or dramatic enterprise is at work, they also disrupt the normal editing practices for American continuity editing. As with the self-conscious treatment of the Christmas festival and narrative art, this disruption works to defamiliarize both fictional and filmic narratives. For those readers with access to the film script, it also problematizes and defamiliarizes that script, for the script never uses chapter divisions. Rather, the film script indicates divisions only by location, time, and scene; for example, the advice in the opening scene is "1. Ext: Day. Elevated Subway Train." That is, a subway train filmed outside (exterior) during the day. Obviously, the film does visualize this staging advice, but it is not presented in print in the film. Postmodern boundary crossing and defamiliarization, then, continue to reinforce the uncertainty and indeterminacy of this film, not so much that viewers are likely to be uncomfortable with the result but enough that they are aware of the games being played and the rationale for them.

The genres at play, then, include the cross-over between news and fiction in the original story and between the printed novel and the filmed novel in the instance of the chapter divisions in *SMOKE* itself. Within the narrative of *SMOKE*, there is another play of genre. The presence of the gangster called the Creeper, his stalking of Rashid, and the nighttime shots suggest that this film might well be noir, but Auggie's ongoing concern with Ruby and his supposed daughter Felicity and the gift to them of Rashid's money suggest that the film might be a family melodrama. In this instance, genre is thrust forward in the film, but ultimately pulled back, proving to be of little consequence in the unfolding of the narrative and adding to the instability of narration and meaning in the film.

Narrative instability and interpenetration of genres in *SMOKE* are bolstered by music and other sounds. Though this is a film about Christmas, it has no Christmas music. Instead, it uses an interesting combination of street noise and electronic and ethnic music. When the film opens, the first sound is that of a muffled drumming, which turns into the sound of the New York commuter train. Of interest here is Paul Massood's observation that "in classical narrative cinema the train was generally given the role of integration and linkage, of stabilization, especially in terms of American

national identity" (2005, 200), so the viewer might expect urban harmony. The train's reverberations giving way to the noises of the city suggests the various real and metaphorical rhythms of the city—the sounds of traffic (also mentioned in the short story), the music in bars and cafes, and the silences in conversation. Traffic is a frequent part of the film's sound, heard in the street, Auggie's cigar store, and Paul's apartment. These are the background and interfering noises of modern urban culture, but they are also the rich stuff out of which multiple meanings can be constructed. This noise, which includes radio music, televised sports events, transmission static, and even information about the first Gulf War is frequently replaced by, or interspersed with, soft, melodic, minimalist, Japanese or new-age electronic percussive music that resembles a piano or xylophone. For instance, Paul Benjamin's walking before nearly being hit by a truck is punctuated by quiet, melodic, repetitive electronic xylophone music. Indeed, Paul in his contemplative moods is often identified with this soft, jazzy new age sound, just as Rashid is by African American soul music. The film includes little background noise or music of any kind when two people are deeply engaged in conversation. Street noise, new age music, and strategic silences pervade much of SMOKE, but African American soul and blues music increases in the second half and completely takes over the final black-and-white portion concerning Auggie and Ethel, especially emphasizing positive race relations. This African American soul music is complemented by other ethnic music, suggesting the multiethnicity of New York City and, therefore, the United States: when Paul and Rashid talk in the Greek cafe immediately following his near accident, a Greek or Middle-Eastern melody is played, and when Paul and Rashid meet Auggie in a bar, Hispanic music plays, though when Auggie tells his story to Paul in a kosher restaurant, no music is played. Taken together the music and background sound suggest some uncertainty as they move almost randomly from silences to harmonic new age sounds to various ethnic music. While pleasant, it suggests a fluidity to this environment, and the prevalence of ethnic cafes and food, including Chinese, adds to that fluidity and multiethnicity.

Although "auggie wren's christmas story" is Paul Auster's own postmodern, multicultural Christmas present to the New York Times' readership, his and Wayne Wang's present to a film audience is equally poignant. Both texts use postmodern indeterminacy in representing human relationships, morality, and art even as they depict with considerable warmth the generosity and benevolence of the main characters. The film liberally borrows from the story but invents yet another narrative concerning Auggie's ex-fiancée Ruby and purported daughter Felicity in addition to that of Rashid and his father Cyrus. The kernels of retained narrative and the incremental

narrative in the film intensify the moral ambiguity, multiculturalism, and self-conscious reflection on festivals and art. The predominant use of color and the incremental black-and-white of Auggie's collection of pictures and the film's conclusion further beg questions about conventional assumptions of film production as well as, in the context of racial relations, assumptions about the expectations and reality of multiculturalism. The film uses many different means to explore these issues—to surprise and delight readers and viewers in rethinking human relationships, the subject of ethics, the possible intervention of the divine into the human domain, and the representation of such subjects in drawing, print, and film. This treatment creates an interesting story, script, and film, indicating that postmodern literature can be transformed readily into film, enhanced by postmodern film practices, and critiqued through postmodern concepts. It also suggests that very short published narratives can become important parts, and even seeds for, much larger, freeplay adaptations.

In conclusion, then, Auster and Wang's taking a single short story and embedding it in a larger, more complex narrative is an effective form of adaptation and citation that works well in raising questions about many aspects of American cultural experience. These include the meaning and celebration of Christmas, the value of smoking and art, and many different forms of relationships—familial, intercultural, and interracial. Ultimately, the postmodern concept of indeterminacy helps to link the story and the film and to understand the complexity of large urban environments like Brooklyn and New York City.

Beyond Auster's short story: *Do the Right Thing* and *SMOKE*

While *SMOKE* remains true to the spirit of the postmodern indeterminacy of Auster's short story, the film also engages in an ongoing citation of, and dialogue with, *Do the Right Thing*, expressing a playful and positive but serious alternative to the negative conclusions of Lee's film.

SMOKE's intertextual dialogue with *Do the Right Thing* begins in the opening shots when one of the three OTB men sitting in the Auggie's cigar store begins to comment on the New York Mets. The only African American of the three, Tommy reminds his white friends of the New York Mets' win in 1986 and their decision in 1990 to get rid of Mookie Wilson: "Look who they got rid of. Mitchell. Backman. McDowell. Dykstra. Aquillera. Mookie. Mookie

Wilson, for Chrissakes" (Auster 1995c, 20). In a film with little about sports or betting other than the opening scene, the citation of, and emphasis on, the uncommon name "Mookie" by a black man in Brooklyn is sufficient in itself to establish the film's connection to *Do the Right Thing*. Moreover, the Brooklyn setting of this opening scene quickly alerts the viewer to a self-reflexive intertextual dialogue with *Do the Right Thing*, the need to be on the lookout for meaningful parallels and important differences between the two films, and the possible reasons for them.[27]

The setting of *SMOKE* in Brooklyn does not follow *Do the Right Thing*'s "highly selective" design and "warped vision" (Pouzoulet 1997, 33, 35) of an almost entirely black street and monolithic community, but rather focuses on an entire interracial neighborhood where new immigrants have joined the Jewish and Italian American enclaves as well as the African American and Hispanic communities. Lee himself had remarked that Brooklyn was not just black—it was "Black American, Puerto Rican, West Indian, Korean and Italian American. Unlike Woody Allen's portraits of New York" (1989b, 28), but that is not the dominant impression conveyed by *Do the Right Thing*, which is mainly black except for the white and Asian interlopers—entrepreneurs, police, and or occasional resident that clearly are not perceived as belonging. By contrast, *SMOKE*'s Brooklyn is diverse and multicultural, containing Allen's European Americans, Jewish Americans, and Chinese Americans as well. In incorporating this ethnic and racial mixture, *SMOKE* indicates that the central issue for this city is not a vicious play of power between blacks and whites but the necessity for, and value of, peaceful multicultural coexistence.

Consequently, in contrast to the opening shots of *Do the Right Thing*, showing a hostile assertion of black power over white ("Fight the Powers That Be"), *SMOKE* presents a leisurely paced view of a commuter train coming into Brooklyn, then of a relaxed, integrated neighborhood, followed by the saving of the central character, the white Paul Benjamin, by the young black teenager, Rashid Cole, who pulls him out of the way of a careening truck—a parallel to Da Mayor's saving the little boy Eddie from a rapidly moving car in *Do the Right Thing*—but here forming a signature statement of positive race relations. *SMOKE*, then, as signaled by the commuter train, has a sense of connections to other parts of New York City and physical and social mobility that open up possibilities rather than precluding them.

[27]The setting of Brooklyn not only establishes a parallel with *Do the Right Thing* but also reminds the viewer that both Spike Lee and Paul Auster called Brooklyn their home at that time, though Lee has since moved to the Upper Eastside in Manhattan while he continues to maintain his studio and shop in Brooklyn.

As with *Do the Right Thing*, the time is summer, but this is not the hottest day of the summer that can incite racial violence. In a closely related sense, *SMOKE* has none of the scenes that Lee recounts as necessary to establish a very hot, claustrophobic environment: "people in cold showers; sticking their faces into sinks, sticking their heads into refrigerators, standing in front of air conditioners, women refusing to cook, men downing packs of ice-cold brew" (1989b, 50–51). Indeed, *SMOKE* depicts people leisurely going about their daily activities on a pleasant summer day, walking down tree-lined, leafy, busy urban streets filled with cars and pedestrians, or congregating in a cigar shop.

In parallel with *Do the Right Thing*, *SMOKE* has a central black character who is young and very much aware of his black identity, knowing that his saving of Paul Benjamin and growing friendship with him can be considered an aberration to his African American community but is willing to risk it. His self-invented name, Rashid, is also very African American, and pulls the viewer back to *Do the Right Thing*, where the central dramatic situation involves Radio Raheem, for the most part a thoughtless ghetto-blaster-owning black youth who confronts Sal in the Pizzeria, an act that results in a riot and Raheem's killing at the hands of the police. The rhetorical links between the obviously African American names Raheem and Rashid and the profound difference in attitude between these two young men again calls attention to the radically different philosophies of these inner-city, interracial dramas.

This community, like that in *Do the Right Thing*, is highlighted by other characters and photographs. The members of the community first introduced consist of the manager of the cigar store, Auggie Wren, speaking casually and gently to the OTB (Off-Track Betting) men—the black Tommy and the white Jerry and Dennis. Auggie has hired the good-natured but "mentally retarded" (Auster 1995c, 21) Jimmy Rose (paralleling the role of Smiley in *Do the Right Thing*) to sweep the sidewalk and occasionally help with the store. He hires the young 16-year-old black, Rashid Cole, as well, so this shop is about as diverse and multicultural as it can be. Whether the OTB men work is not clear, but, as with the Corner men in *Do the Right Thing*, they get along and enjoy chatting with each other; they also like chatting with an outsider like Paul Benjamin, a local writer, who comes into the shop for his cigars. The film also introduces a wide variety of African Americans and Asian Americans— Rashid's Aunt Em, father Cyrus Cole, stepmother Doreen, half-brother Junior, and his date the Chinese American April Lee. Moreover Auggie's girlfriend is the Puerto Rican Violet Sanchez. Admittedly, Augie's ex-wife and possible daughter Felicity are white, but they are the most down-and-out of the characters, so the stereotypical white-black racial and economic hierarchy is

more or less reversed. In short, this community is diverse with easy ethnic and racial relationships and a few nods in the direction of correcting racial stereotypes.

Pictures on the wall of the Brooklyn Cigar Store mirror those of Sal's Pizzeria, but those in *SMOKE* pertain only to famous smokers, including Groucho Marx, George Burns, Clint Eastwood, Edward G. Robinson, Orson Welles, Charles Laughton, Leslie Caron, Ernie Kovacs, and Frankenstein's Monster. Though there are no blacks in this group, it is an ethnic- and gender-diverse group. That this group is identified at the opening of the film suggests a parallel with *Do the Right Thing*, here implying communal harmony rather than dissent.

While community and work are particularly centered on the Brooklyn Cigar Store, the action takes place in many Brooklyn locales, showing close-ups of a bookstore, auto garage, and several restaurants and a bar, representing the diversity of shops and ethnic ownership in this borough. As in *Do the Right Thing*, the primary business in focus is not locally owned—the owner Vinnie lives on Long Island, but it is managed by a local, Auggie Wren, who never leaves this part of Brooklyn. None of the racially mixed group is concerned about Vinnie's absentee ownership or of worker exploitation, and, indeed, Auggie cannot imagine working anyplace else. Another shop in this area is the bookstore where April Lee, a PhD student, is a clerk. It is not clear whether this store is locally owned, but its presence suggests the value of reading for the community. *SMOKE* also shows African American ownership in the case of Cyrus Cole's struggling garage business. Altogether, urban employment is not broken down so simply into middle-class white owners and lower-class black unemployed and underemployed as in *So the Right Thing*. Indeed, this complex social matrix presents Roger Goodwin and the Creeper as black criminals, but Ruby's white 18-year-old daughter is unemployed and on crack, and a young white teenager steals magazines from the cigar store. Ownership, unemployment, and crime are not restricted to a single race, and income and economic stress rise above racial barriers.

Language and literacy are as important to *SMOKE* as they are in *Do the Right Thing*, but here reading is a very important part of the community, and the sound of conversation is muted. Paul Benjamin talks about Sir Walter Raleigh when in the cigar store with the OTB men, and he himself is the writer of novels, which the young black youth, Rashid, and the bookshop clerk, April, have read. The cigar store also sells magazines of various sorts, and Auggie reads the newspaper. This is a society not restricted to oral literacy, but one where language is used in a variety of contexts—printed materials, conversations, and television. Conversations in *SMOKE* are, for the most part,

agreeable, pleasant, and uncompromisingly polite, beginning with Auggie and the three OTB men talking about baseball, all in "received pronunciation" underscoring a sense of sportsman-like analysis, community, education, and racial harmony.[28] Consequently, the opening scenes of racial diversification present perceptions of family, community, and racial relations completely divergent from Do the Right Thing—the one concerning a dysfunctional white family working in the pizzeria of a black neighborhood and a racially charged society, the other of a local hangout where the racially mixed group, though not related to one another, has the hallmarks of a functional family without the fear of racial strife and city violence.

Another way in which SMOKE engages Do the Right Thing in the politics of inner-city community life and racial discourse is through urban sounds and music—an interesting combination of street noise, electronic music, and ethnic music, as mentioned earlier. While this music is quiet, smooth, intricate, and eminently listenable, it is also political—as Johnson has argued of Do the Right Thing. However, unlike Do the Right Thing's use of loud and assertive music to express the need for release, by any means necessary, from the economic, cultural and racial oppression felt in Bed-Stuy, SMOKE points to a new honest assimilation and multicultural acceptance that provides a positive vision of racial harmony not only for New York City but the United States in general.

SMOKE cuts away sharply from the narrative of "auggie wren's christmas story" and engages the politics of Do the Right Thing when it specifically refers to the pictures of Martin Luther King and John F. Kennedy on Granny Ethel's walls in the black and white portion of the film (see Figure 4.3).

These figures imply Civil Rights solidarity under the benevolent gaze of American law and government, rather than as violent resistance against a fascist police force. The fact that the film refers to King and Kennedy but not Malcolm X suggests that this latter figure has no place in the benign intercultural context of SMOKE's Brooklyn. As James C. McKelly remarks of the iconic meaning of these figures:

In the bilaterally configured semiotics of political discourse, the figure "King" has come to signify the ethics of reform: justice, integrationism, passive resistance, patience, forgiveness, constructive engagement, and an altruistic faith in democracy and in the basic goodness of the individuals

[28]Unlike Do the Right Thing, which generally announces who is black but almost never who is explicitly white, the stage directions of SMOKE clearly indicate that Tommy is black and the others white.

FIGURE 4.3 *Auggie, Granny Ethel, and the Civil Rights Pictures in* SMOKE

who compose the dominant majority. By contrast, the figure "X" has come to signify the ethics of revolution: power, separatism, proactive resistance, decisiveness, responsibility, autonomy, and a realistic awareness of the systemic failures of democratic capitalism and the complicity, whether intentional or de facto, of the individuals who comprise America's capitalist society. (1998, 216)

In *SMOKE* the figure of King also has some relevance to the sharing of material wealth which differs from *Do the Right Thing*. By going beyond one short block in Brooklyn, *SMOKE* refutes the assertions of *Do the Right Thing* that blacks have no economic opportunities and cannot sit down to the rich table of America by showing that the blacks of Brooklyn are not generally oppressed and that economic capital is not the central issue in achieving racial harmony. In fact, Rashid must himself "do the right thing" with money: he compromises himself and puts others at risk by taking a bag of money dropped by fleeing robbers, and so must begin the process of passing that money on to others who need it more than he—first his boss Auggie who loses his investment because of Rashid's mistake at work and then Auggie's ex-wife Ruby who desperately needs the money to help her daughter.

SMOKE is also concerned about accurate ways to see social reality, especially symbolized by Auggie and the symbolical value of his eyes. In addition, his ex-wife Ruby has lost an eye and so cannot see so well. Auggie, too, uses his camera to take thousands of pictures just outside his place of

business over several years, visually demonstrating the variety of life and complex social matrix of Brooklyn. Indeed, the film never "sees" one race or ethnic group as exclusively privileged or underprivileged. For example, Rashid and his family—Aunt Em, Cyrus, and Doreen—have entered the middle class, while some of the whites like Auggie's ex-wife Ruby and her daughter Felicity are part of the underclass of Brooklyn. Poverty is not a matter of black and white. Similarly, violations of the law are not restricted to one race.

If *SMOKE sees* that economic necessity and related crime are not the exclusive property and purview of the blacks, it also gives visual evidence of interracial brotherhood. This brotherhood may be part of the Christmas fantasy of hope in the film, but the great emphasis on sharing meals in a variety of locations and ethnic restaurants—the "tables of brotherhood" that the multicultural and multiethnic characters visit together—brings the viewer back to King's message. Paul Benjamin first buys Rashid Cole a meal at a Greek diner, and the two then share food in Paul's apartment and later visit a Chinese restaurant with April Lee for Rashid's birthday before going to a blue-collar bar to listen to Tom Waits' blues; sometime after this, they visit the same bar to meet Auggie, and the three of them picnic together at Rashid's father's table after Rashid reveals his identity as Thomas Cole; Paul and Auggie bring takeout food from a local Chinese restaurant (Auster 1995c, 31, 49, 97, 99, 42) when they look at his pictures, and they go to a Jewish delicatessen when Auggie tells Paul his Christmas story; finally, Auggie shares the consummate Christmas Day meal with Granny Ethel at the Boerum Hill housing projects, bringing chicken from a grocery store. This message of brotherhood suggests a moveable table with places for everyone.

This last sequence of *SMOKE*, filmed in black and white whereas the rest of the film is in color, gives the feel of a documentary rather than fiction but also symbolically suggests positive black and white racial relationships but with an ironic postmodern twist—the white Auggie pretends to be Granny Ethel's black grandson, a relationship not unlike Rashid's earlier playful suggestion that he is Paul Benjamin's father.

This play with race, family, and intergenerational friendship begs a consideration of the importance of Civil Rights leaders in late twentieth-century race relations. And it pleads for a moderate and redemptive view of a new multicultural and intercultural America, in which all races have a chance of working and playing together in a harmonious relationship. Ultimately, then, if *Do the Right Thing* complicates, and some would say destroys, the sense of brotherhood through the symbolic burning of the restaurant, *SMOKE* evokes the sense of brotherhood through the many shared conversations and meals. *SMOKE*, then, uses many of the techniques and characteristics of *Do the*

Right Thing to alert the reader that there is a more inclusive, multiethnic and interracial response to the questions raised in *Do the Right Thing*.

In creating a vibrant intercultural and interracial community in Brooklyn, *SMOKE*, then, sets up an intertextual dialogue with the philosophical positions of Martin Luther King and Malcolm X from *Do the Right Thing*, ultimately affirming improvements in racial harmony and economic opportunity rather than insisting on the existence of systemic racial prejudice, economic disparities, or the necessity for Malcolm X's black nationalism.

Together, *SMOKE* and *Smoke Signals* confirm that freeplay adaptations are stimulating, thought-provoking, challenging, and even uplifting. For Auster to take a six-page story and make it a fragment of *SMOKE* and also play off *Do the Right Thing* to make a positive statement about racial relations in Brooklyn or for Alexie to take several stories and extract certain characters, events, and ideas and to make them into the coherent adaptation of *Smoke Signals* presenting a different social point from the fiction fully exemplify the benefits of citation as an operative mode for film adaptation. Neither Auster nor Alexie has suggested that the short stories or novels have supremacy over their film script adaptations, and the resulting postmodern treatments have contributed to the developments in adaptation as well as a better understanding of interracial relations as well, fulfilling the values implicit in ethnocriticism.

5

Palimpsests and bricolage: Playful and serious citation in *Broken Flowers* and *Snow White*'s offspring

When Jay Cocks and Martin Scorsese rhetorically linked *The Age of Innocence* and *Gangs of New York*, they created sophisticated intertextual rhetorical doublings that provided a serious commentary on ethnic and racial relations in America, past and present. Likewise, when F. Scott Fitzgerald appropriated the vocabulary, setting, scenes, and structure of Edith Wharton's *The Age of Innocence* to write *The Great Gatsby*, it was to interrogate changing values and cultures in America, as did the various adaptations arising from these novels. Similarly, when Sherman Alexie used bits of short stories and a novel to develop the script of *Smoke Signals*, when Spike Lee included the pictures, rhetoric, and ideological perspectives of Martin Luther King and Malcolm X in *Do the Right Thing*, and when Paul Auster and Wayne Wang used Auster's short story and Lee's *Do the Right Thing* as foundational documents for *SMOKE*, they all engaged in supplementation through citation in order to comment further on ethnic and racial relations across the United States.

To some critics, however—even those who show a commitment to, and understanding of, the phenomenon of adaptation—supplementation, citation, and trace push the limits of acceptability because a holistic adaptation from fiction and drama to film has traditionally been seen as reproducing the greatest number and the best qualities of the textual parent. As noted throughout this book, though, intertextuality does not necessarily have anything "to do with influence, sources, or even the stabilized model favoured in historical work of 'text' and 'context'...but remains, ultimately, distinct from it" (Allen 2000, 69). In keeping with this perspective, supplementation and citation remove

the impetus to locate an inside or original and allow for a critique of the myth of filiation:

> The intertextual in which every text is held, it itself being the text-between of another text, is not to be confused with some origin of the text: to try to find the "sources," the "influences" of a work, is to fall in with the myth of filiation; the citations which go to make up a text are anonymous, untraceable, and yet *already read*: they are quotations without inverted commas. (Barthes 1977b, 160)

Consequently, intertextual citation may enter via the conduit of a particular text but is just as likely to arise from cultural coding in general.

Citation is as much a recognition of, and tribute to, a source as it is a new version, but Gérard Genette's study of palimpsests is critical here, especially in his view that a new hypertext alters, expands, and extends the old one, the hypotext. As Gerald Prince argues in his "Foreword" to Gérard Genette's *Palimpsests*, "any text is a hypertext, grafting itself onto a hypotext, an earlier text that it imitates or transforms; any writing is rewriting; and literature is always in the second degree" (Prince 1982, ix). Prince makes the process and results seem reasonably stable, but palimpsest is an overwriting that rewrites and plays with one or more originals in a destabilizing manner to inaugurate new import.

Historically, in Ancient Greece and Rome, writers inscribed texts on wax-coated tablets, parchment, or papyrus by scraping off the original writing and then adding their own. And in the Middle Ages and Renaissance, painters covered up an older painting with a new one. However, it was always possible to make out traces of previous texts by looking carefully at the medium and consequently to have a sense of the transformation. A palimpsest refers to one overwriting, a double palimpsest to two separate inscriptions, and a hyper-palimpsest to several separate inscriptions on one surface. Dialogic palimpsests refer to at least two that are in conversation in a new work. In the instance of the Novgorod Codex, up to a hundred separate texts have been inscribed on the original tablet. Palimpsest in contemporary postmodern theory has thus come to stand for a current text that hides or obscures other texts or one that contains the muted inscriptions of antecedents in order to engage this dialogue.

Palimpsest and citation are closely linked, then, in referring to, exploring, exposing, and supplementing various filiated sources. This process of citing fragments is also akin to what Jacques Derrida (after Lévi-Strauss) in "Structure, Sign, and Play in the Discourse of the Human Sciences" calls *bricolage* and the creator the *bricoleur*. *Bricolage* is "the necessity of borrowing one's concepts

from the text of a heritage which is more or less coherent or ruined" (Derrida 1993, 231) or, as Prince notes very simply, "of making something new with something old" (1982, x). The *bricoleur*

> is someone who uses "the means at hand," that is, the instruments he finds at his disposition around him, those which are already there, which had not been especially conceived with an eye to the operation for which they are to be used and to which one tries by trial and error to adapt them, not hesitating to change them whenever it appears necessary, or to try several of them at once, even if their form and their origin are heterogeneous—and so forth. (Derrida 1993, 231)

Within bricolage, textual references may be mere allusions to characters, situations, ideas, and styles, and these fleeting allusions or citations provide keys to the new artistic production. In this way citation, palimpsest, and bricolage supplement predecessors and force new meaning onto culture and texts.

Yet another theory of intertextuality assists in understanding the value of citation in the adaptative process. This is Mikhail Bakhtin's dialogism. As Allen notes of Bakhtin's concept, "All utterances are *dialogic*, their meaning and logic dependent upon what has previously been said and on how they will be received by others." He adds, "all language responds to previous utterances and to pre-existent patterns of meaning and evaluation, but also promotes and seeks to promote further responses" (2000, 19). Each response then will be heteroglossic, containing within it our own voices as well as the voices of others. In short, textuality is by definition dialogic and polyphonic, and critical to this process is the view that when texts enter into dialogue with each other, new constructs and meanings emerge.

This chapter will begin by exploring citation, palimpsest, bricolage, and dialogism in Jim Jarmusch's *Broken Flowers*, which is playful in investigating the limitations of meaning in interrogating attitudes, opinions, and sensibilities in culture. *Broken Flowers* is a film that openly repudiates the myth of filiation through the image of a man who does not want to discover that he has fathered a son. The film hints at a number of serious issues—the loneliness of single, retired men; missed family opportunities through not marrying and not acknowledging children; discovering something about identity on a road trip; and more. But the main theme of the film is located in a single citation—a reference to Nabokov's *Lolita*—that evokes the problematic of ever-elusive quests for filiation and meaning in life and texts. This is playful use of citation located in an ever-expanding palimpsest, but not without related serious points about the impossibility of ever knowing anything for certain, and the impossibility of discovering filiation in life or in art.

While Derrida's bricolage and Genette's double palimpsest handily signify the process of "tinkering" with precursor texts to produce a new one with different meanings, there is still considerable room for more extensive postmodern adaptative and citational play. Robert Stam speaks of "the ongoing whirl of intertextual reference and transformation, of texts generating other texts in an endless process of recycling, transformation, and transmutation, with no clear point of return" (2000, 66). This is an exciting looping process of fiction and other textual sources begetting films, films begetting films, films begetting other kinds of texts in popular culture, and so on ad infinitum.

Within the postmodern context, these palimpsests might not be in the same medium or genre at all. A significant case in point is the Snow White phenomenon, in which the various Snow White oral stories were codified by the Grimm brothers, then redone by numerous others in film and print, especially Walt Disney's animated musical *Snow White* (1937). This animated film stands among the top-drawing and top-income–producing films of all time, but is hardly discussed as an adaptation, presumably because it does not use live actors and, therefore, falls off the compass of adaptation commentary.

Corrigan, who writes about the many different combinations of film and literature and has a chapter devoted specifically to those between 1915 and 1940, does not even mention that Walt Disney's film draws from the Grimm Brothers and several other European folk tales. Unafraid to draw from a variety of adaptive forms including musicals and videogames, Linda Hutcheon in *Theory of Adaptation* is one who does take up the issue of animation as a form of adaptation, but, oddly, makes no reference to *Snow White*. Thomas Leitch and Paul Wells are important exceptions here, and, while not going into detail per se about *Snow White* as an adaptation, they talk about Walt Disney as an auteur (Leitch 2007, 236–256) and adapter (Wells 2009, 98), and both they and Hutcheon are among those who talk at length about the growing interest in comics, graphic novels, and animation.

Animation has been much further toward the bottom of adaptation hierarchies because it was thought to have little "truth value" and because it was coupled with illustrated books and commonly targeted at children (Wells 2009, 98). This may account for Deborah Cartmell's observation that, "given the number of adaptations of children's literature to screen, the area has attracted very little critical attention" (2007, 168).

Disney's *Snow White*, however, has a significant claim to fame, becoming what Jean-François Lyotard in *The Postmodern Condition* calls a master- or meta-narrative (1984, xxiv), trumping other contenders and spawning a host of copies in popular culture. It has not wholly supplanted the original Grimms' "Snow White" but has mass appeal to children of all ages across the world and has defined romance and femininity for generations.

Because Disney's *Snow White* is romantic, postmodern writers and film-makers set out to use, but also transform and critique, its images. One such example is Donald Barthelme's hip postmodern novel *Snow White* (1965) set in mid-Manhattan in the late twentieth century. In this cynical narrative, Snow White is the sexual partner of seven young men (the dwarfs) who wash skyscraper windows, cook baby food, and manufacture plastic buffalo humps, though she longs for a Prince to share her creative aspirations and rescue her from commerce and boredom. Manhattan is certainly not the beautiful meadows that Disney depicts, nor is Snow White either innocent or a princess, but the story itself raises issues about the dominance of narratives and the commodification of culture both represented by Disney.

The postmodern transformation of Snow White has not stopped with Barthelme and has recently given way to two TV series—NBC's *Grimm* (2011-) and ABC's *Once Upon a Time* (2011)—and, over the past fifteen years, at least five more films: Michael Cohn's made-for-TV *Snow White: A Tale of Terror* (1997), Caroline Thompson's Hallmark made-for-TV *Snow White: The Fairest of Them All* (2001), Kevin Lima's *Enchanted* (2007), Tarsem Singh's *Mirror Mirror* (2012), and Rupert Sanders's *Snow White and the Huntsman* (2012). These films blur the boundaries among older Snow White signifiers to come up with new signifieds that simultaneously use and transform older forms. The narrative of Snow White has thus become the Novgorod Codex of hyper-palimpsests—many narratives nearly obscuring the remains of the so-called original/s but always reading traces of them.

Palimpsest, play, and the myth of filiation in *Broken Flowers*: Clues, signs, and referential mania

Do the Right Thing effectively probes contemporary race relations in New York City through the writings and photographs of Civil Rights leaders, and *SMOKE* expands this interrogation through systematic citation of the visual, linguistic, and structural grammar of *Do the Right Thing*, thereby entering into a dialogue with it, King, Malcolm X, and President Kennedy. This important dialogue over race relations confirms that citation can have serious goals and sobering consequences while also being entertaining.

Palimpsests, too, may function in a variety of ways, as indicated by Jim Jarmusch's French/American film *Broken Flowers* (2005), which deliberately evokes Nabokov's novel *Lolita*, two film adaptations (Kubrick's and Lyne's) based on it, and possibly the French singer Alizee's "Moi Lolita." To these could

be added the citation of Nabokov's screenplay of the film as well as films with Lolita-like characters and plots. Behind these palimpsests lies another of Nabokov's narratives, "Signs and Symbols," written about the same time as *Lolita* and challenging the production of meaning. These citations, creating a multiple palimpsest, simultaneously push the audience toward and guard against constructing meaning.

Citation in *Broken Flowers*, however, is not restricted to particular novels, stories, or films but also to the self-conscious consideration of theme and genre. Included in the referencing of *Lolita* is the road film genre through Don Johnston's flying and driving to various locations to look up his old girlfriends. Still, that is not the only genre at play in this film: the other is the detective film referenced by the clues offered in the investigation of the circumstances and effects of the pink letter sent to Don. The sleuth in this detective narrative is partly Don Johnston (Bill Murray) himself but more centrally his neighbor Winston (Jeffrey Wright) and most importantly the film audience itself.

Indeed, these two genres go hand in hand in the film, and, when one is frustrated and truncated, so is the other. In assessing Hollywood genres, Thomas Schatz notes:

Like the classic Westerner, the hardboiled detective is a cultural middle-man. His individual talents and street-wise savvy enable him to survive within a sordid, crime infested city, but his moral sensibilities and deep-rooted idealism align him with the forces of social order and the promise of a utopian urban community. (1981, 123)

Schatz's comments put the detective at the center of the detective genre and link him to the hero of the Western as well—who is often also linked to the road hero—but his moral qualities do not necessarily mesh with those of Don, so the fulfillment of the generic requirements is at once called into question even as they are put into motion.

That Jarmusch as writer and director of the film is self-conscious in the use of these and other palimpsests is indicated by his 2004 "nothing is original" statement from his "Golden Rules" made at the same time he was directing *Broken Flowers*:

Nothing is original. Steal from anywhere that resonates with inspiration or fuels your imagination. Devour old films, new films, music, books, paintings, photographs, poems, dreams, random conversations, architecture, bridges, street signs, trees, clouds, bodies of water, light and shadows. Select only things to steal from that speak directly to your soul. If you do this, your work (and theft) will be authentic. Authenticity is invaluable; originality is

nonexistent. And don't bother concealing your thievery—celebrate it if you feel like it. In any case, always remember what Jean-Luc Godard said: "It's not where you take things from—it's where you take them to." (2004, np)

Jarmusch's citation of Godard is intriguing for he is known as "one of the most provocatively irreverent practitioners of adaptation" (Stam 2005b, 279), who often "argued that a dependence on literary sources was an uncreative and retrograde way to make films" (Corrigan 1999, 49). It comes as little surprise, then, that this playful road and detective narrative of *Broken Flowers* concerns the cobbling together of a number of different citations. Discovering these palimpsests within *Broken Flowers* affirms the performativity of the citations and palimpsests. As Barthes himself notes:

> The fact is… that *writing* can no longer designate an operation of recording notation, representation, "depiction" (as the Classics would say); rather, it designates exactly what linguists, referring to Oxford philosophy, call a performative, a rare verbal form (exclusively given in the first person and in the present tense) in which the enunciation has no other content (contains no other proposition) than the act by which it is uttered—something like the *I declare* of kings or the I sing of very ancient poets. (1977a, 145–146)

This performativity is carried forward by Don Johnston's attempt to find clues as to whether he has a son (as the anonymous pink letter claims), who the mother of that hypothetical son might be, and what that might mean. Consequently, through multiple palimpsests, the film simultaneously raises and subverts questions about origin, destiny, family, and the pursuit of truth, by using citation to explore the mystery of meaning.

In referring to Jean-Luc Godard in his "Golden Rules" and in dedicating *Broken Flowers* to the French New Wave film director Jean Eustache, Jarmusch indicates that he understands the French cultural theorists who deny original meaning and favor collaborative cultural constructs. Primary among these theorists was Roland Barthes who, among other things, interrogated the "myth of filiation," a theory germane to the palimpsest and apropos to Don Johnston's search for a son, an heir, and the boy's mother in *Broken Flowers*.

In *Image, Music, Text* (1977b), Barthes argued that trying to establish meaning by reference to the past neither guarantees an understanding of life nor gives contemporary art greater credibility. Indeed, he found that the very attempt to pin down specific meaning, locate ideas in antecedent texts, or search for significance and meaning across time was not only foolish but helped to maintain and reify outmoded structures of power and textuality. As Allen argues, Barthes attacked "notions of paternity, of authority, of

filiation—fathership, ownership, giving birth, familial power" because they ultimately lead to an endorsement of continuous and unified meaning and "dominant structures of power" (2000, 71). The destruction of this myth of filiation—"the idea that meaning *comes from* and is, metaphorically at least, the *property of* the individual authorial consciousness" (Allen 2000, 74) undermines notions of subjectivity, personal authorial style, and originality, implicitly acknowledging the benefits of fragmentation, decenteredness, and the freeplay of signification. In helping to recognize that texts are palimpsests of "quotations drawn from the innumerable centres of culture" (Barthes 1977a, 146), citation helps to undo the tyranny of the past and block the quest for unified meaning. Citation, palimpsest, and bricolage[1] thus simultaneously impoverish and add supplementary value.

This is where Jim Jarmusch's *Broken Flowers* again enters the discourse. This postmodern film does not use the conventional Hollywood linear narrative in which concepts, issues, and characters are introduced, complicated, and then resolved. The plot is a fragmentary signifying chain, with one thing giving way to another without any certain goal, center, unifying purpose, or resolution. (In this way, it is an anti-grammatical, nonlinear film in the tradition of Godard and the French New Wave—which is likely yet another palimpsest in the film.) Indeed, the film gives many clues about the life of the main character Don Johnston and his relationship with women in the present and the past, including the citation of Nabokov's *Lolita* and its film adaptations, but these clues go nowhere and deliver no solution. This lack of resolution becomes a key to the decentering of this quintessentially postmodern palimpsest.

Bill Murray's trilogy of absent fathers

Jim Jarmusch's *Broken Flowers* that won the Grand Jury Prize at the 2005 Cannes International Film Festival is the story of a solipsistic, lethargic, and passive middle-aged bachelor who, upon receiving an anonymous letter on pink stationary telling him that he may have an almost-19-year-old son, is disinterested but accedes to his neighbor's request to set out on a trip to see if this is a hoax or if one of his ex-girlfriends really has given him a child. Through the dialogue and photography, this road movie subtly opens up the character of the reclusive Don Johnston and explores the issue of missing sons and

[1]The term "bricolage" was taken by Derrida and, before him, Lévi-Strauss, from the concept of the tinker who went around the countryside fixing copper pots. After the tinkering, the original copper pot may have been largely replaced by new patches.

"the aging absent dad" (Leary 2005) first depicted in *Lost in Translation* (2003) and *The Life Aquatic with Steve Zissou* (2004), forming a unique group that David Edelstein has identified as the Loneliness Trilogy (2005, 2). These three films have been written and directed by different people—Sophie Coppola, *Lost in Translation*; Wes Anderson, *The Life Aquatic*; Jim Jarmusch, *Broken Flowers*—and it is Murray himself that holds them together with his deadpan style, inherent loneliness, and preoccupation with marriage and paternity. This in itself is noteworthy that an actor holds three films together directed by different auteurs.

Marriage and paternity are not handled precisely the same way in each film, however. In *Lost in Translation*, Bob Harris (Bill Murray) has a wife busily taking care of their young children in the United States while he is making a Suntory advertisement in Tokyo. As he is experiencing a whole new world there, she works hard taking care of the children in his old world and making decisions about home renovations. In *The Life Aquatic*, Steve Zissou (Bill Murray), separated from his wife and co-producer of Jacques Costeau-like documentaries, has been informed on numerous occasions that he has a son by an old girlfriend but ignores it until Ned Plimpton (Owen Wilson) arrives on his boat following his mother's suicide. Zissou is not altogether happy about the news that Ned might be his son because he "hates fathers and didn't want to become one." In fact, either through accident or deliberate intention, Steve is responsible for Ned's death in a helicopter crash on Zissou's quest for a jaguar shark that has killed his partner. In *Broken Flowers*, Don Johnston (Bill Murray) sets out on a road trip to discover if he has a 19-year-old son, but his neighbor Winston is the driving force behind that quest and Don is visibly ambivalent about it. He has different reactions to each of his ex-girlfriends but never shows excitement over any particular one and avoids asking them directly if they have given birth to his son. By the end, however, he is preoccupied with the question of whether he has a son, but clueless about the actuality.[2]

Paternity or filiation is thus the central issue of *Broken Flowers* and the others in this "trilogy." The important thing here is that the film raises questions about the paternity of characters to rupture the filiation of ideas without trying to resolve either of them. In the words of Dennis Lim commenting on another of Jarmusch's films, *The Limits of Control*, the pleasure of the puzzle "lies in the accumulation of cryptic clues and resonances rather than in solutions" (2009, 21).

[2]As Jim Emerson tantalizingly notes in Roger Ebert's movie review column, "the young man in the jogging suit (credited as 'Kid in car') who passes Bill Murray at the end of…*Broken Flowers* is, in fact, Murray's real-life eldest son, Homer (born in 1982)" (Ebert 2005b).

Broken Flowers *and the Nabokovian search for clues*

When Don Johnston acquiesces to the pleas of his neighbor Winston to find out whether he has a son, he sets out first on a plane and then in rented cars to the various places where his former lovers live. This film thus engages the conventions of the road genre, which, as noted in Chapter 4, are usually constructed on quests to discover personal identity, though they may have no final goal. Indeed, many of them, as in the case of Kerouac's *On the Road*, are looping narratives of many separate journeys. Nabokov's novel *Lolita* and Stanley Kubrick's 1962 and Adrian Lyne's 1997 film adaptations of it are three important road narratives for this study.

Although the question of discovering whether Don's son exists is the central motivating factor in the road film, *Broken Flowers* in a typically postmodern manner self-consciously takes the question of querying filiation into a murky Nabokovian realm. Don's first encounter with a former lover is with Laura (Sharon Stone), but before she arrives home Don meets her pubescent daughter (Alexis Dziena), who immediately sets out to seduce him by giving him sly glances, making suggestive comments, and then taking off all her clothes and strutting in front of him. When this girl introduces herself to Don, she makes a point of saying that her name is Lola, that some call her Lo, but that her real name is Lolita.[3] A little later after Laura arrives, Don again focuses on the name Lolita. This emphasis on Lola, Lo, and Lolita strongly recalls the opening of Nabokov's novel (as well as Adrian Lyne's *Lolita*) when Humbert expresses his love for his nymphet:

> Lolita, light of my life, fire of my loins. My sin, my soul. Lo-lee-ta: the tip of the tongue taking a trip of three steps down the palate to tap, at three, on the teeth. Lo. Lee. Ta.
> She was Lo, plain Lo, in the morning, standing four feet ten in one sock. She was Lola in slacks. She was Dolly at school. She was Dolores on the dotted line. But in my arms she was always Lolita. (Nabokov 1955, 9)

Moreover, her pink dress, bathrobe, bikini, earrings, and various objects in *Broken Flowers* (see Figure 5.1) hearkens back to Humbert's first intimate moment with Lolita in the novel (and Kubrick's *Lolita*): "she wore that day a pretty print dress that I had seen on her once before, ample in the skirt,

[3]This Lolita also asks about Don's name, apparently thinking it is Don Johnson, the movie star of *Miami Vice* —raising yet another possibility of a palimpsest, though nothing is realized in this instance.

FIGURE 5.1 *Bill Murray and Alexis Dziena as Don Jonstone and the Pink Lolita in* Broken Flowers

tight in the bodice, short-sleeved, pink, checkered with darker pink and, to complete the color scheme, she had painted her lips and was holding in her hollowed hands a beautiful, banal, Eden-red apple" (Nabokov 1955, 57–58).[4] This pink color is taken over in *Broken Flowers* and arguably becomes the most important textual element.

Don's relationship with this Lolita is considerably different from Humbert's with his Lolita: though both older men with underage girls, Don is uncomfortable with the nymphet's sexuality and walks out of the house before her mother comes home so that he will not be compromised, while Humbert wants to use such private moments to rid himself of Lolita's mother Charlotte Haze and lead to Lolita's seduction. The use of the situation and the clues given by Lolita's name and dress ultimately raise questions about how Don, Humbert, or anyone follows clues to arrive at conclusions and compel action.

Don Johnston's road trip; the allusion to a relationship between an older man and very young girl; the names Lo, Lola, and Lolita; the use of pink—these issues and citations all point to the underlying palimpsest of Nabokov's

[4]Although Nabokov himself was asked by Stanley Kubrick to write the film script for *Lolita*, Kubrick adapted it, leaving strong traces of the written script, but changing the dialogue (Leitch 2005, 113). Since this was filmed in black and white, it is not possible to see if the color pink had any part of the production.

best-known novel and adapted films: Stanley Kubrick's 1962 *Lolita* (based on Nabokov's own film script) and Adrian Lyne's 1997 remake with Jeremy Irons. To complicate the issue of the Nabokovian palimpsest in *Broken Flowers*, in 2000 the French singer Alizée came out with her much celebrated video "Moi Lolita" that has a basis in Nabokov's novel in the depiction of an underage Lolita, her encounter with a slightly older man who gives her money, and the pink dress she wears, which is exactly as Humbert describes it in his first important encounter with Lolita. Alizée, only 16 when she released her video, became identified with Lolita, and the video, which was award-winning across Europe and is still played regularly in concert and on video, was a deciding factor in launching her career. As a result, the recognition of Lolita as a cultural symbol across Europe reinforced its prominence in the United States. With *Broken Flower's* categorization as a French-American film and with the dedication to a French film director and theorist, it nods in Alizée's direction as reinforcement of the Nabokovian palimpsest.

These are not, however, the only points of intersection among *Broken Flowers*, the various *Lolitas*, and Nabokov: the film's emphasis on "clues" and "signs" leading to a process of sleuthing, detection, and chase—the detective genre—support an active engagement with Nabokovian palimpsests in Jarmusch's film. These are not unlike the clues about Clare Quilty that Lolita notes, but which Humbert ignored at his peril. In fact, Lolita is only a symptom herself of the primary Nabokovian concern that trying to extract meaning from clues and signs is always dangerous, but not to think about them may be equally dangerous.

To explore the performativity of *Broken Flowers* based on citations of Nabokov's novel, I will look first at *Lolita*, then at one of Nabokov's short stories—"Signs and Symbols," and finally at the implications of these for *Broken Flowers*, again returning to the color pink.

When John Ray, the fictive editor of Nabokov's novel *Lolita*, introduces Humbert Humbert's "confession" about Lolita in his stilted and pompous prose, he maintains that he made few changes to Humbert's manuscript "save for the correction of obvious solecisms and a careful suppression of a few tenacious details that despite 'H. H.'s own efforts still subsisted in his text as signposts and tombstones (indicative of places or persons that taste would conceal and compassion spare)" (Nabokov 1955, 3). Presumably, Ray has made these changes to clarify and moderate a difficult and confused manuscript, but his admission of editorial tinkering neither sheds light on Humbert and his relations with Lolita nor on the character of Lolita herself for the "real" characters and situations become ever more remote and elusive: Lolita is not only told through the first-person narrative lens of her seducer,

Humbert Humbert, but through the lens of the editor as well who has altered the text in some unspecified way. Indeed, if Humbert has "taken liberties with" Lolita, then Ray also has seduced the text. Humbert's "signposts and tombstones" designed to create a particular picture of Lolita and his relationship with her have been modified or removed by Ray, almost certainly creating a revised and very different narrative, a new palimpsest on top of Humbert's problematic one.

The incorporation of Lolita into *Broken Flowers* thus evokes not just a sexy nymphet with Nabokovian names but a whole process of tinkering with scripts in which originals and authorial intentions are hidden and/or lost.[5] This filtering by first-person narrators, editors, authors, and publishers makes the problem of filiation acute and discovering the "real" underlying situation and characters impossible. Foucault refers to "this plurality of egos" as "shifters" that blot out the "author-function," the construction of writing and creation of unity, leaving the texts open to question, uncertain, and ambiguous (1977, 129–130).

Broken Flower's self-conscious referencing of Nabokov's *Lolita* and the road and detective genres thus raises questions about shifters, texts and textuality, the ambiguous deployment of language, the quest for understanding and meaning, and the impossibility of finding certainty at the heart of *Lolita* and *Broken Flowers*, but which tease the audience into eagerly following the narratives before abandoning resolution, certainty, and unity.

Trevor McNeely notes that *Lolita* is about "mere deception," in which "the concepts of purpose and value lose all meaning, and even such fundamental existential guideposts...as love, truth, morality, and beauty, become mere verbal stratagems" (1993, 135–136). In general, I agree with McNeely's view that *Lolita* concerns mere verbal stratagems, but I also think the Lolita references are purposefully playful in engaging readers and viewers in the process of detection and then asking them to realize that, while this is a characteristic and necessary ontological process, it only illuminates the futility of ever acting on them with certainty. With these signifying shifters a clarifying signified is nonexistent.

[5]With respect to editorial inscriptions on top of existing scripts, the reader gets the kind of doubly distorted perspectives in American fiction that the fictional Dietrich Knickerbocher gave to Rip Van Winkle's account in *The Sketch Book of Geoffrey Crayon, Gent.* or that the real Rufus Griswold gave to Edgar Allan Poe's life and stories in his *Memoir*. (Both authors are suggested in Nabokov's account, and Poe in particular comes up self-consciously several times in the text of *Lolita*.) Rip Van Winkle's own narrative account of what happened on the mountain was filtered through two narrators—Knickerbocher and Crayon—before being written up by the author Washington Irving and given to his publisher, who would be charged with rendering it into print.

The lesson of Lolita and Nabokov's
"Signs and Symbols"

While the novel *Lolita* is about the difficulty of interpreting the character of Lolita as well as the elusive intentions and actions of the narrator Humbert and his editor, it is also about how we mediate information, construct knowledge, and then act upon it. Many of Nabokov's writings deal with these themes and operate in similar ways, but one short story in particular, written in 1948 when he was beginning *Lolita*, offers some special insights and useful critical language in exploring *Broken Flowers*. In "Signs and Symbols"—a story that Nabokov thought quite good, first published in *The New Yorker*, and later included in the carefully selected *Nabokov's Dozen* (1958)—he writes of the futility and danger of constructing and/or reading signs in the process of interpretation.

> The story concerns the birthday of a young man who was incurably deranged in his mind. He had no desires. Man-made objects were to him either hives of evil, vibrant with a malignant activity that he alone could perceive, or gross comforts for which no use could be found in his abstract world. After eliminating a number of articles that might offend him or frighten him (anything in the gadget line for instance was taboo), his parents chose a dainty and innocent trifle: a basket with ten different fruit jellies in ten little jars. (1996, 598)

The boy's mental derangement and suspicion of malignant activity, the parents' genuine concern for him and caution about a choice of gift, the careful enumeration of ten different jellies in ten little jars, and the possibility that this, too, could be a bad choice of gift suggest that there are clues to reading human nature and texts and that the reader will need to pay close attention and follow every lead to anticipate and understand the flow of events and meaning of the narrative.

The allusion to mental derangement in "Signs and Symbols"—especially given the title—is a sure signal to the reader that something terrible might happen, and this sense of dis-ease is intensified by the narrator's telling readers that on the night of the party "the underground train lost its life current between two stations, and for a quarter of an hour one could hear nothing but the dutiful beating of one's heart and the rustling of newspapers" (1996, 598). Phrases like "lost its life current" and "dutiful beating of one's heart" seem, on the basis of interpretation in conventional narratives, to presage a terrible event, and this is reinforced by a nurse's subsequent comment that the boy had tried to commit suicide again. The narrator then proceeds to give

the reader more objects and instances that anticipate a terrible outcome—
"a swaying and dripping tree, a tiny half-dead unfledged bird…helplessly
twitching in a puddle," the father's "swollen veins, brown-spotted skin," and
"a girl with dark hair and grubby red toenails…weeping on the shoulder of an
older woman" (1996, 599).

These details are followed by a professional medical assessment of
the boy's "system of delusions" that appears to corroborate the terrible
correspondence between his mental state and the list of awful phenomena:
his is a case of what the narrator, following the psychologist, calls "referential
mania":

> In these very rare cases the patient imagines that everything happening
> around him is a veiled reference to his personality and existence. He
> excludes real people from the conspiracy—because he considers himself
> to be so much more intelligent than other men. Phenomenal nature
> shadows him wherever he goes. Clouds in the staring-sky transmit to one
> another, by means of slow signs, incredibly detailed information regarding
> him. His inmost thoughts are discussed at nightfall, in manual alphabet,
> by darkly gesticulating trees. Pebbles or stains or sun flecks form patterns
> representing in some awful way messages which he must intercept.
> Everything is a cipher and of everything he is the theme…He must be
> always on his guard and devote every minute and module of life to the
> decoding of the undulation of things. (1996, 599–600)

The boy reads nature like poetry as foreshadowing and corresponding to his
moods, but he goes well beyond that, suggesting that nature either determines
his moods and responses or is meant to be prophetic, communicating
particular signs and symbols to him. This is referential mania.

What the story goes on to show, however, is that the details that seemed
so important in setting up the story and linked to the boy's mental condition
go nowhere. The late-night telephone rings frightening the parents presage
no actual death: "While she poured [her husband] another glass of tea, he put
on his spectacles and reexamined with pleasure the luminous yellow, green,
red little jars. His clumsy moist lips spelled out their eloquent labels: apricot,
grape, beech plum, quince. He had got to crab apple, when the telephone
rang again" (Nabokov 1996, 603). And so the story ends with no death and no
resolution to the plot.

What becomes clear in "Signs and Symbols" and relevant to *Lolita* and
Broken Flowers, is that Nabokov has undermined the production of "clues," of
making phenomena into "signs," and of constructing symbolic meaning from
them—of making signifiers into signifieds. His is a series of signifiers strung
together, which deconstruct and decenter subject, text, and the process of

citation, and which ultimately displace referentiality and unity. His is a negation that goes to the heart of the hunt for meaning in the process of detection and deciphering, serving as a warning and deterrent to the reader who attempts to discover meaning and truth in fiction, including *Lolita*, especially when characters and situations are seen through a variety of narrators and editors, each with his own limited and distorted view. But even the realization of this warning itself is the result of following clues and reading signs—a kind of referential mania, so the reader is in a classic double bind, both following the logic of language and analysis and forced to recognize the limitations and utter futility of it. Humbert loses Lolita because he fails to perceive the clues of Quilty's presence, so reading signs might have helped him, but the reader understands that clues and signs may indeed lead to a dead end, so it is a double bind.

Color it pink: The interpretive lenses of Broken Flowers

This double bind inhabits *Broken Flowers* and its exploration of the construction of meaning through the citation of Nabokov's *Lolita* and its film adaptations, Alizée's song, Nabokov's short story, and the conventions of the road and detective genres. However, these citations are the tip of the iceberg: behind and underneath is Nabokov's entire process of narration.

The first thing to look at is the narrative manipulation for this film, as in *Lolita*, raises the possibility of narrative control external to the principal characters. In *Lolita*, the narrative control of Lolita herself is managed by Humbert, Ray, Nabokov, and the publisher, who determine the meaning imposed on her. In *Broken Flowers*, a somewhat elusive character, the neighbor Winston, who is addicted to mysteries, serves as a problematic agent of change and interpretive medium, much on the order of Ray. Unlike *Lolita*, he does not manipulate the narrative, but he has power over the action and guides an interpretation. When Don Johnston sets out on his road trip to discover if he has had a son by one of his former girlfriends, he does so at the prompting of Winston. Indeed, Don would not have set out on the journey had not Winston insisted that he be given the list of Don's relevant old girlfriends, looked up their addresses on the web, created an itinerary, and booked flights, car rentals, and hotel rooms even before Don agrees to the trip. Winston may simply be a good person helping his neighbor, but it is not at all clear how naïve he is, for he is the games-master, not unlike a novelist of detective stories, a Ray-like editor who sets out to create or alter a story, or a director who follows the implications to their conclusion. It is he who sees

Don's inertia, reads the letter on pink stationery that Don receives, constructs the itinerary, and warns Don: "The letter is on pink stationery. Give them pink flowers and watch their reaction."

Although an anonymous critic on *Epinions* argues that "the pink letter is relatively irrelevant" and only "works in terms of spearheading the journey," the letter and the color pink are, in Winston's estimation, hints, clues, and signs (he remarks to Don that "You need to treat this as a sign" and "solve this mystery" and he later says that he needs to "look for clues about your son—photographs, anything or hints, like pink stationery and red ink"), so that the audience looks for their deployment as much as Don does. In Winston's handling of this adventure, pink is both clue and lure, prompting the process of detection, promising a resolution to the question of paternity, and rescuing Don from his malaise. This, of course, means that Winston has engaged the viewer in Nabokovian referential mania, and the pink color becomes the signifier of the chase itself.

Viewers can hardly watch the film without succumbing to this mania, counting up instances of the use of pink attached to, and even separate from, the former girlfriends and rhyming them off within a pattern. In this process of manic detection, they fall into some four categories: (1) the letter itself, (2) the pink effects associated with the Don Johnston, including the flowers that he carries to his ex-lovers, (3) the pink objects associated with his former lovers, and (4) the use of pink apart from the letter, Don, or his girlfriends. The audience, then, becomes as much involved in this process of detection as Don and Winston seem to be.

The pink letter itself is the first possible sign observed at various times: during the introductory film credits, it is shown being typed in red print on a manual typewriter, deposited in a mailbox and making its pink way through a largely blue automated postal system, and flown to Don's town—this without any identifying marks of the sender. This gives the letter and its pinkness a special identity and seeming purpose. It is then shown being put into Don's mailbox by the postman and received by Don as his girlfriend Sherry (Julie Delpy) leaves him. Finally, Don shows it to Winston, who becomes excited about discovering its meaning. Because Sherry herself wears a pink dress as she is leaving and because she comments tellingly that "Looks like you got a love letter from one of your other girlfriends," the viewer can suspect either her or Winston's setting up the game. The letter, then, does spearhead the journey, but also raises questions about authorship, gamesmanship, lures, control, responsibility, and deceit.

Pink is associated with Don himself because, at the opening of the film, he has pink stripes on his track-suit, a painting of a pink nude on his wall, and pink roses in a small vase, but most obviously through the flowers he

carries to his former lovers: a bouquet of pink rosebuds to Laura Miller (the professional closet organizer), a bouquet of fully opened pink roses with white baby's breath for Dora (the real estate agent who had been a "flower child" in the 1960s and is played by Frances Conroy) that is doubled in a picture of pink roses on the wall, pink lilies for Carmen Markowski (the animal communicator played by Tilda Swinton), a bunch of mixed pink and white wild flowers picked for Penny (a neer-do-well living in the country with two violent men and played by Jessica Lange), and a mixed bouquet of pink lilies and chrysanthemums to put on the grave of Michelle Pepe.

Don himself seems not to pay much attention to the kind of pink flowers he brings, but, because he is intent on looking for pink clues, the viewer joins this game as well. There is ultimately little meaningful distinction in the flowers, but there is enough to make it intriguing: the roses in bud may reference Lolita; those in full flower may refer to Dora or their relationship too far in the past; the roses and lilies returned to him by Carmen's assistant may suggest their aborted romance and his error in intruding into what seems a relationship between Carmen and her assistant; the broken flowers are almost certainly those thrown at Don after Penny's current boyfriend beats him up; and chrysanthemums and lilies associated with death are appropriately put on Michelle's grave. Any attempt at pattern-making with the flowers is, however, fraught with difficulties and at best incomplete for they do not help to resolve the question of whether any one of these women is the mother of his child.

The color pink is associated with the ex-girlfriends, though again not necessarily in a way that forms a certain and predictable pattern. Sherry wears a pink dress as she leaves Don and later sends him a note on pink stationary with red writing, perhaps an indication that she set the sleuthing in motion—though the handwriting on the envelope is hard to compare and the size of the envelope is different; Laura and her daughter Lolita at various times wear a pink bathrobe, Laura has a pink purse, and Lolita has pink earrings, a pink headband, and a pink glittery mobile phone and ultimately wears a patterned bikini with pink in it; Dora has a pink business card and a picture of fully opened pink roses on her wall that double the ones Don brings; Carmen wears pink pants and her assistant in the animal clinic a patterned blouse with pink accents; and Penny has a pink motorcycle and a pink typewriter lying in the garden. On the basis of Sherry's pink letter to Don, Winston suggests that she might "have sent the first letter and made the whole thing up just to fuck with you," but neither Don nor the readers can be certain of that.

Finally, pink is independent of Don or his lovers at various stages in the film. At the beginning, the post office building, mail delivery vans, and postman who delivers the pink letter all have a pink stripe or accents, and the cast of

characters is presented in pink typescript. Later, Don passes a pink house on the way to visit his first girlfriend, Laura, and stays at a motel with a pink sign before he visits Penny. The flower shop he visits to buy a spray to put on Michelle Pepe's grave is filled with pink flowers. The boy at the end of the film, who Don suspects might be his son, has pink stripes in his shirt and a pink ribbon on his bag for "good luck" put there by his mother, but he runs away when Don raises the issue of his being the boy's father. As tellingly—or not, Winston's children are dressed in pink at the beginning of the film, many of their toys are pink, and his wife wears a printed blouse with pink in it, perhaps suggesting that he is the one who has set the whole process in motion and that he was only attempting to transfer the responsibility to Sherry. If he does this, it may be to break Don out of his lethargy and inertia—but all that is hypothetical.

And so we have it—the film is filled with pink, too much in fact, and, despite Don's and the audience's detection, its presence does not help resolve issues in the plot. As David Edelstein remarks, all the women "respond to Don's surprise visits in different ways, but every sad, awkward, and bitterly funny meeting gives Don a glimpse of someone he damaged, a life he didn't build, a love forsaken" (2005, 2). As Edelstein goes on to say, these scenes are "glimpses of unfulfilled dreams and roads not taken"; with a "comic surface and a riptide of despair," they are "small miracles of pain and longing" (2005, 2). Each one is a cul-de-sac of possibility, history, and certainty. Don does not find out what the hints, clues, and signs might tell him; he does not discover if one of his former lovers has mothered his son; he does not know if Sherry put him up to this search (as Winston suggests), or if Winston has (as the audience might suspect), or if both Winston and Sherry are together in this game (as the audience might suspect again because each one independently refers to Don as a Don Juan, despite the paucity of evidence in the film that he is); and, consequently, the viewer has no certainty about the meaning of "pinkness" or the ultimate point of the film. The sure attachment of signifiers to signifieds and sign to symbolic meaning is not possible, and that is a significant message in itself. *Broken Flowers* sends Don on the road engaged in detection that would reveal something about his life, but ultimately short-circuits the quest for knowledge and the road and detective genres, not bringing them to closure in an expected way.

Musical lyrics and the disappearance of meaning

The collapse of meaning and the failure of genre should also be viewed in conjunction with the musical lyrics at the outset and conclusion. Winston has

burned a CD for Don to play while on the road—a device put to great effect in another road film, *Elizabethtown*, and the lyrics of jazz musician Mulatu Astatqe and a group called the Ethiopiques assert:

Words disappear
Words once so clear
Only echoes
Passin' through the night
Lines on my face
Your fingers once traced
Fade in reflection
Of what was
Thoughts rearrange
Familiar, now strange
All my schemes
Drifting on the wind.

In other words, the song lyrics framing the story suggest that language inevitably disappears, that life fades without memory, and that human intention is futile. Although the words, hints, or clues recorded on pink stationary do not disappear, they might as well, for there is an absence of signs that put the past, present, and future meaningfully together either in Don's life or the genres that the film engages.[6]

Framing the narrative with lyrics that question the importance and durability of language coupled with the inclusion of a Lolita figure place the film in thematic congruity with Nabokov's *Lolita* and "Sign and Symbol." Just as the reader cannot discover the real Lolita because of the barriers posed by the inscriptions of Humbert and Ray, so Don and the viewer cannot connect the pink dots in order to discover some ultimate message within *Broken Flowers*.

This uncertainty relates to another seemingly insignificant issue within *Broken Flowers*—the use of the computer and information. At the beginning of the film, Don is said to own no computer though he made his fortune from computers, and Winston is introduced as having a computer problem which he asks his neighbor to solve: "I need your computer expertise...It's like a whole system [is] breaking down the plots of detective fiction." This statement

[6]Ironically, Astatqe's musical score is based on Horace Silver's "Song for My Father," in which the lyrics celebrate fatherhood (Kenny). Once again, clues do not lead linearly to signs and symbols or firm resolutions, but may have some kind of circular logic.

does not just indicate that Winston is devoted to detective fiction (and a clue that this film will short-circuit that genre), but that the computer, which is supposed to organize meaning, has instead collapsed it. Once Don solves Winston's problem on the computer, Winston again becomes enthusiastic about "the whole world of information."

This seemingly peripheral comment is central to an understanding of this film, which is not just about signs and symbols, signifiers and signifieds, but ultimately the processing of information. Exposing the myth of filiation and seeing the traces of palimpsests does not heighten meaning, but disperses it. The very uncertainty embedded in this process also may account for the appeal of the film. There are literally hundreds of newspaper and magazine reviews as well as blogs that note the ambiguity of meaning in this film coupled with the viewer's interest in trying to figure out the meaning of Don's road trip, search to discover if he has a son, various relationships, and expressions. Some find this boring and lament the lack of clarity, but most are intrigued by the clues in the film that lead nowhere. It is, then, a film that uses citation, multiple palimpsests, the ambiguity of meaning about the color pink, and the relationship of plot, lyrics, and genre to develop the theme of the complexity and uncertainty of language, information, and life. Despite its seeming simplicity and paucity of meaning, this film rests upon the inability to discover absolute meaning in any text.

Broken Flowers is a bricolage, a collection of signifiers without a central signified. As such, it is about the lure—and impossibility—of trying to read inscriptions, discover filiation, and produce clear meaning. It uses citation and the palimpsest technique to bring historical figures, fictional characters, genres, and language into their sphere but, through the Nabokovian citations and the postmodern play of the text, suggests that the quest for meaning and conclusions are inconclusive.

Snow White's offspring: The hyper-palimpsest

While *Broken Flowers* demonstrates multiple uses of citational palimpsest to disperse and supplement meaning and question the investigative process, Walt Disney's adaptation of a Grimm fairy tale spawns a hyper-palimpsest dialogue of adaptations and citations. Disney's animated *Snow White and the Seven Dwarfs*, first released in 1937, has had such a strong appeal that viewers of all generations and from all corners of the globe intimately know Snow White, the Prince, the Queen/Witch, and the Seven Dwarfs. They recognize all the characters and their clothes; they can picture the castle where the evil

Queen lives and Snow White serves as a scullery maid; they are familiar with the meadows where Snow White picks flowers, the forest where she flees to avoid the wrath of the Queen, and the home of the seven dwarfs where she takes refuge; they are charmed by Snow White's special relationship with the forest animals as they help her clean the house, wash the dishes, fix the beds, and go for aid when she is threatened by the wicked Queen; they are horrified by the transformation of the arrogant Queen to the old hag and her evil attempts to kill Snow White with the poisoned apple; and, of course, they cheer when the Prince kisses Snow White, rescuing her from eternal sleep in the glass casket. Moreover, they have memorized the lyrics and can sing along with each of the songs in this musical, including "One Song" by Snow White and the Prince; "Whistle While You Work" by Snow White; "Heigh-Ho" by the Dwarfs; "Someday My Prince Will Come" by Snow White; and three others. In fact, they likely have a DVD of this animated musical, toys made and sold by the Disney Corporation, or knock-offs of both made in China and sold throughout the world at bargain prices.

Disney's animation became so popular that it was taken as the paradigm for such later Disney films as *Fantasia, The Little Mermaid, Beauty and the Beast, The Lion King, Pocahontas, Aladdin,* and *Mulan,* in its animation, narrative trajectory, romantic love and happiness, optimism, a comfortable, if sometimes difficult, life, and good conquering evil. All of these may seem innocent enough, but almost from the beginning they were controversial:

> Disney adaptations have been attacked for plundering and simplifying grand historical narratives, being responsible for the impoverishment of youth, and for closing the minds of their viewers through their insistence on closure—the endings of these films, repeatedly, resolve all the ambiguities and complexities of their literary sources. (Cartmell 2007, 171)

Then, too, Disney's sentimentalism and simplification of woods and animals were thought to give children "distorted views of nature and animals" (Cohen 2008, 9).

Besides providing a template for other animations, *Snow White* was an important film for Walt Disney for other reasons: it was his first full-length film, the first successful full-length animated film in English, the first Hollywood film to use Technicolor, the first to have a sound track for sale accompanying a film (Smith 2006, 33), and its production marks the beginning of the Walt Disney studios. Arguably, *Snow White* has had the greatest cultural impact of any single film by Disney (or perhaps by any director) for, aside from being instantly and perpetually popular, it launched the Hollywood tradition of animation and brought huge revenues to Disney

over a long period of time. In 2010 alone the Disney empire earned over $38 billion (US) (Walt Disney 2011, 1), and without doubt a considerable portion of this enormous figure derived from this film and its associated consumer products. In fact, so impressive and important is *Snow White* to the Disney industry that the corporation built its headquarters in Burbank in a neo-Greek manner with dwarfs as columns instead of the caryatides of the Parthenon (see Figure 5.2):

So successful has Disney been in the Snow White enterprise that many accept the innocent Snow White, the gentle forest animals and bluebirds, and her seven small dwarfish companions as the normative paradigm. With the universality of Disney's film and various theme parks, international audiences could hardly think otherwise: this so-called third life of the tale is entirely "at home" and naturalized in various global cultures, and little thought is given to previous "second-life" written versions (Grimm, dramatic productions, etc) or first-life oral tellings.[7]

FIGURE 5.2 *Team Disney Building, Burbank*

[7]Horn remarks that "it may well be true that oral tradition and literary tradition are not completely separable; also that the sources of the Grimm Brothers were written literature, or not exclusively, oral. Moreover, it is certainly difficult to decide whether or not the tales about Snow White, collected since the Grimms, depend on them…Furthermore, *Snow White* and other tales of the Grimms live a 'third life'…: worldwide diffusion through mass media, multiple applications in advertisements, in everyday commodities, adaptations in music, art, *Witz* and in literature" (1983, 273).

Still, Disney's version has by no means been the final adaptation of that story: apart from the dozen or so print versions, [8] there are at least 34 versions across the media, including four TV series, 20 cartoons and full-length films to say nothing of a ballet, an opera, a musical, and video games.[9] Some of these adaptations have been affirmative of the Disney source, but others have been playful, cheeky, and dark. Importantly, one of the first to send up Disney's *Snow White* was the Warner Brothers' Merrie Melodies 1943 cartoon adaptation "Coal Black And De Sebben Dwarfs." In this cartoon, the Snow White character is young, sexy, and coal black; Prince Chawmin is a black hipster; the Queen is a red-hot black mama; and the dwarfs are black GIs.

Although the Queen wants to murder Coal Black because she is attractive to the Prince, her main failing is that she hoards valuable jewels as well as commodities that were rationed during World War II, including tires, sugar, coffee, and gin, emphasizing political and economic dimensions that are often suppressed in Snow White narratives. Moreover, the cartoon changes Disney's music to jazz and blues, further emphasizing the move away from Disney's very classical and very white production. Although the characters and music undergo a racial and cultural transformation, the plot outline remains much the same. If this parody of the characters, race, and values embodied in the Disney production were produced today, it would undoubtedly be called postmodern.

[8]Jack Zipes mentions the following versions: Patrick de Heriz, *Snow White* (1926); Anne Sexton, *Snow White* (1971); Merseyside, *Fairy Story Collective, Snow White* (1972); Robert Coover, *The Dead Queen* (1973); Olga Broumas, *Snow White* (1977); Roald Dahl, *Snow White and the Seven Dwarfs* (1982); Joni Crone, *No White and the Seven Big Brothers* (1985); Clodagh Corcoran, *Ms Snow White Wins Case in High Course* (1989); Gwen Strauss, *Confessions of a Witch* (1990); *The Seventh Dwarf* (1990); Tanith Lee, *Snow Drop* (1993) (Zipes 2008, 5). In addition, Robert Coover has a Snow White story in his fiction *A Child Again* (2005).

[9]The Internet Broadway Database (2012) lists some 20 feature films and shorts (though omitting *Enchanted*) from that list: *Snow White* (1902), *Snow White* (1916), *Snow White* (1933), *Snow White and the Seven Dwarfs* (1937), *Coal Black and de Sebben Dwarfs* (1943), *Snow White and the Seven Dwarfs* (1955), *Snow White and the Three Stooges* (1961), *A Snow White Christmas* (1980), *Snow White* (1987), *Happily Ever After* (1993), *Snow White* (1995), *Snow White: A Tale of Terror* (1997), *Snow White* (2001), *7 Dwarves—Men Alone in the Wood* (2004), *Sydney White* (2007), *Happily N'Ever After 2: Snow White Another Bite @ the Apple* (2009), *Blanche Neige* (2009), *Grimm's Snow White* (2012), *Mirror Mirror* (2012), and *Snow White and the Huntsman* (2012). It also mentions the plays, TV productions, ballet, opera, and video games.

By contrast, Kay E. Vandergrift (2009) lists five feature films and shorts, including *Willa: An American Snow White* (1996); the Faeroe Tale Theatre's *Snow White and the Seven Dwarfs* (1983); "Snow White" *Cartoon*, (1932); "Coal Black and de Sebben Dwarfs" Cartoon (1943); and *Snow White and the Three Stooges* (1961)(Vandergrift 1–3). She does not list the films I will discuss.

Within the postmodern context, Donald Barthelme's short novel *Snow White* (1965) stands out as a novelistic bridge from film to print and back again to film. Disney was clearly Barthelme's target in his demystification and de-legitimation of American popular culture, which he thought had been infantilized by Disney romances. Barthleme's iconoclastic book has been followed by two significant TV series—NBC's *Grimm* (2011-) and ABCs *Once Upon a Time* (2011-)—and five major postmodern film productions of the Snow White story, all of which have an iconoclastic dimension: Michael Cohn's television film *Snow White: A Tale of Terror* (1997), Caroline Thompson's Hallmark television film *Snow White: The Fairest of Them All* (2001), Kevin Lima's *Enchanted* (2007), Tarsem Singh's *Mirror Mirror* (2012), and Rupert Sanders *Snow White and the Huntsman* (2012). Each of these shows a certain amount of skepticism about the values, ideology, and expression of Disney. There is also a self-conscious playing with tradition that helps to critique the implications of the Disney romance in relation to American culture. In this chapter, I want to compare the Grimm and Disney versions of the tale, then explore Barthelme's postmodern fictive adaptation of this tale, mention the new horror/terror adaptations (including Cohn, Thompson, and Sanders), and finally investigate Lima's and Singh's postmodern film adaptations to see how these palimpsests work.

The Grimm Brothers and Disney

Although its origins lie in European culture, for most Americans and nearly everyone else in the world nowadays, Snow White is identified with Walt Disney's film and theme parks in Los Angeles, Orlando, Tokyo, Paris, Hong Kong, and soon Shanghai. Disney's production of *Snow White* has become such a cultural icon that viewers nearly forget the diverse folk tales of Snow White preceding Disney.

Disney formed his story primarily from the 1857 fairy tale "Snow White," published by Jacob and Wilhelm Grimm, who also had an earlier variant in the Ölenberg Manuscript prepared for the *Kinder- und Hausmärchen* (*Children's and Household Tales*) of 1812. This variant was published in 10 separate editions between 1825 and 1858 and republished in 1924, 1927, and 1974 (Zipes 1999, 70). In addition, there was another, quite different story called "Snow White and Rose Red." Then, too, as Katalin Horn, Alejandro Herrero-Olaizola, and others note, there were still other folk tales lying behind the Grimm versions, including: "The Death of the Seven Dwarfs," a folk legend from Switzerland; "The Crystal Casket" and Giambattista Basile's "The Young

Slave" from Italy; and the "Gold-Tree and Silver-Tree" from Scotland. Rather than being a single founding document, the Grimms' *Snow White* of 1857 is one of many nineteenth-century rewritings, though it left the strongest impression and led centrally to Disney.

The differences in Snow White narratives depend upon place, literary style, and even moral and pedagogical purposes. As Jack Zipes tells it, the Grimm brothers traveled around to various estates throughout Germany, invited "storytellers to their home and then [had] them tell the tales aloud, which the Grimms either noted down on first hearing or after a couple of hearings. Most of the storytellers during this period were educated young women from the middle class or aristocracy" who often got the tales from their domestic helpers and governesses (Zipes 1999, 69). These domestic helpers were from different regions of the country with different narrative traditions, so each tale could have many original variants, but the Grimm brothers' final choice, including "Snow White," depended on what they thought was morally good for the readers, that is the Protestant values of "industriousness, honesty, cleanliness, diligence, virtuousness—and male supremacy" (Zipes 1999, 21).

When Disney, with his own moral and social purposes, animated the Grimm brothers' 1857 edition of the story along with Winthrop Ames's Broadway play *Snow White and the Seven Dwarfs*, an adaptation of the German play *Schneevittchen* (Allan 1999, 38), he had in mind an audience of childlike adults. As he said, "We don't cater to the child but to the child in the adult—what we all imagined as kids is what we'd like to see pictured" (Allan 1999, 43).[10] However, he, too, had a moral point, endorsing a "conservative view of the family" and espousing "the homely values of the family and country" (Smoodin 1994, 10; Cartmell 2007, 172, 170).

The significant changes from Grimm to Disney are especially worth exploring because they are interesting in themselves and as critiques of the precursors. As Allan remarks:

Disney removed two attempts by the queen to kill Snow White, first with a poisoned comb and then with a bodice. He replaced the traditional repetitive narrative element with a running gag and comic repetitions, both visual and verbal; these include Doc's spoonerisms, Grumpy's misogyny and the slow tortoise joke. In Grimm the Queen dances to death in red hot shoes at the wedding; in Disney she falls off a precipice. Grimm's line "the wild beasts roared about her, but none did her any harm" is expanded into

[10]According to Allan, "at this early stage Disney was taking on the role of complete story teller, absorbing the gothic tradition from Europe via the German expressionist cinema as well as the rise in popularity of the horror film in the early days of sound." These changed with the appeal to "a distinctly younger audience in the post-war era" (1999, 51).

the scene where the animals and birds help Snow White and take her to the dwarfs' cottage. At her death in the story the "birds came too and wept for Snow White"; this is elaborated into the mourning of all nature round the coffin which is central to the film. (1999, 37–38)

In addition, Allan notes that Disney departed from Grimm by adapting certain features from Ames's play, including the music, theatre conventions (such as Snow White standing beside a wishing well), the relationship between Snow White, the Prince, and the Queen, and other specific features:

Disney used the stage convention of disguise when the Queen becomes the Witch; it is a transformation convention taken from stage to screen. His Snow White, like Cinderella, is dressed in rags and made to clean the palace—this is not Grimm. Animals and birds (in the play a bird) help her to find the dwarfs' cottage. (1999, 38–39)

Disney's other revisions included:

- The castle as a symbol of domestic control and imperial power;

- The dwarfs' forest home as a modest, utilitarian European-style cottage;

- Beautiful meadow scenes in muted colors, especially when Snow White wakes surrounded by helpful animals, to illustrate the congruence between the beneficence of nature and the innocence of the heroine;

- The storm on the craggy mountain, so that, when the wicked Queen falls into the abyss, personal evil and hostile nature are vanquished at once;

- Dwarfs smaller than Snow White and with names and Southern vernacular speech, giving them "down-home" charm and asexual and nonthreatening identity;

- Snow White as a teenager with a developing sense of right and wrong and appropriate behavior;

- The "first kiss" test to awaken Snow White, no longer requiring an inadvertent dislodging of the apple when she is carried in the casket.

These changes boil down to representations of landscape and setting, character development, speech, and modes of plot resolution, especially Snow White's "tests" and the consequences of them. These changes also

suggest a major plot change from Grimm's short tales to Disney's film, which is driven first of all by the central conflict of Snow White and the Queen and secondly by inclusion of the seven dwarfs, all of whom are given significant character development well beyond Grimm.

In the Grimm story, the stepmother Queen is not closely described but is clearly arrogant, power-driven, manipulative, and murderous, and has access to magic in transforming herself to an old hag when tracking Snow White down. By contrast, as Allan has noted, Disney's Queen "is both a thirties *femme fatale* and a genuinely disturbing figure from an older world" of magic. The Queen, he notes, is a sinister witch with power that extends from the castle into the countryside, and her depiction exudes "Europe and its traditions, its learning and its venerability" combined with "American ruthlessness and determination" and a "Hollywood mask" along the lines of Joan Crawford (1999, 54, 52). In both of these depictions, the Queen is a fierce and powerful person, but Disney's visualization is sinister, frightening, and grounded in the movie industry.

In Grimm, Snow White is a very young girl (she is first mentioned as being seven) who can fit comfortably in the seventh dwarf's bed but who is, as a little child, silly and vulnerable. She is a bit scatterbrained, unaware of her stepmother's evil character, unconcerned about serving as the dwarfs' housekeeper, and too complacent about letting old hags into the household if they have trinkets and treats on offer: she is careless, attracted to pretty things, and potentially as vain as the Queen herself.

By contrast, Disney had in mind a 14-year-old (Allan 1999, 38), similar in height with the dwarfs, and on a more equal footing. Snow White is first depicted as a scullery maid, dressed in old clothes and sweeping the castle floors, but, when she goes into the forest with the huntsman, she miraculously changes into the flowing robes and heels of a princess. Nature liberates and elevates her, and, in her yellow dress, puffy sleeves, and red hair ribbon, she becomes royal inside and out—but, as Allan remarks, very much along the lines of Mary Pickford, Janet Gaynor, and Shirley Temple in her child-adult appearance (1999, 59), so the palimpsest of the 1930s film culture envelops her as well as the Queen. Her maturity and role as a princess are indicated by her being attracted to the traveling prince, but also by her embarrassment and caution in fleeing the prince's display of affection. She is on the cusp of adulthood, ready to fall in love and marry a prince, but not foolish about it.

Disney's Snow White really is caught between innocence and experience. When in the castle she is a forced child laborer, and when she flees in the night through the dark forest to escape the Queen's murderous wrath, she obviously needs the dwarfs' protective environment, though she is much taller and requires all of their beds to spread her body across when sleeping. When

in the dwarfs' domain, she shows her know-how and experience, taking on adult responsibilities and attitudes. After thoroughly cleaning the house with the help of the forest animals, she cooks a good soup for the dwarfs and reforms their uncleanliness and bad manners. She is like the proper 1930s American wife and mother, whose first responsibility is to keep a good house and the family well fed, well mannered, and happy. In fact, her cleaning the house and getting the dwarfs to wash and brush their teeth meets all of the standard advice for wives and mothers in the 1930s: she is wifely in assuming that all men are messy and that a wife's duty is to put things in order, and she is motherly because she treats the dwarfs like children, getting them ready to go to work as if they are going to school with a good-bye kiss on the head. Again, there is a dominant ideology at work here, reflecting Disney's active support of the Motion Picture Alliance for the Preservation of American Ideals, which emphasizes family values. Still, Snow White shows spirit and exuberance when she teaches the dwarfs to dance (see Figure 5.3), demonstrating that this goes beyond a morality tale for small children.

Disney's Snow White is only given the one test of eating the apple, which she fails, but she does so because she wants to be nice to an old woman with a heart problem, not because she is scatterbrained or attracted to pretty

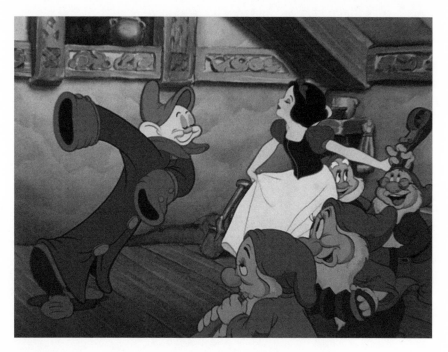

FIGURE 5.3 *Snow White dancing with the Dwarfs in* Snow White

objects, though she does not pay strict attention to the dwarfs' advice about not letting the Queen into the house. Because this apple-test is a single instance, she cannot learn from it. In this way, though young and pretty, she is not childlike and vulnerable to youthful vanity, and it would be out of character for her to fail the witch's tests so often.

An important part of Disney's adaptation is the moral framework presented for young girls. Snow White must know something about maintaining a household but must show her modesty in running into the house when the prince appears, and it is only because she is so clearly virginal that she can be saved after eating the poisoned apple: the kiss implanted on her lips must be "first love's kiss." This kiss allows her to ride away on the prince's white horse and into the happy meadows of marriage and, presumably, the running of a castle.

Disney's dwarfs, too, show more development than Grimms', who are very like the Scandinavian *nissen*, aged little men with practical common sense and helpful when they choose to be. According to Allan, their childishness is taken from Ames' play and their portrayal from the drawings of Theodor Kittelsen, John Bauer, and Arthur Rackham (1999, 58). Without names in the Grimms' version (though Ames gave them the fairly unremarkable names—Blick, Flick, Glick, Plick, Snick, Whick, and Quee—and unindividuated identities), the dwarfs are not individualized, but they are also more adult than Snow White because they warn her about not letting the duplicitous witch into the house. Their affection for Snow White grows in small increments over the days that the Queen tries to dispatch her with the tight laces in her corset, the poisoned comb in her hair, and the apple that she eats, but they do not dote on her without reservation.

Disney's dwarfs are corny, afraid of the monster in their house, stumbling over one another in their suspicions about the clean house and soup, sleeping all over the house to give Snow White the space she needs, yodeling, and speaking in Southern vernacular accents, all adding to their comic character. Given the 1930s production of the film, these vernacular accents would have been identified with the Okies who invaded California in great numbers as a result of the destruction of farming in the lower Midwest during the Great Depression. Though looking old (with the exception of the inarticulate and obviously childlike Dopey), the dwarfs act like dependent children in every way: they succumb completely to the affection of Snow White as well as her admonitions to wash their hands and keep the house tidy. They are all given individual names—Bashful, Doc, Sleepy, Sneezy, Grumpy, Happy, and Dopey—that in each case match one particular trait; they are not presented complexly and deteriorate from men who make a good living working hard in the diamond mine to children setting off to

school with the good wishes and kisses of their mother. This infantilizing of the dwarfs in Disney's version is part and parcel of a reductive romanticizing process at work in the film.

Though seemingly value neutral, the depictions of both Snow White and the dwarfs are curious in the conflicting presentations of their ages and characterization. Snow White must be child and mother at once, and the dwarfs must be childlike and old at once, so that sometimes they act in mature ways, and at other times they do not. This inconsistency accounts for part of the humor, but it problematizes the ideology of age, gender, action, and agency.

Contesting Disney: Barthelme's Snow White

Though there are increasing instances of novels being spun from films, Donald Barthelme's novel *Snow White* is a particularly interesting example of the palimpsest at work in adaptation, providing a highly unusual case of a well-regarded novel arising from an animated film. Little is known about this "ignored field" (Baetens 2007, 226–227), though most novelistic adaptations are "repackagings" of successful movies written to increase profit (Corrigan 1999, 71) and most offer an unqualified tribute to the original film. That is not what Barthelme does.

Barthelme takes elements from Disney and Grimm and invents his own, all the time making certain that his readership knows he is making a serious joke of the entire process. It is a joke because he reminds the reader that language and literature are human constructions, at least once removed from the real. It is serious because he looks at how Disney's *Snow White* in particular has become a master narrative in shaping popular culture and the modern consciousness, and how that culture simultaneously reproduces one reality and suppresses others. This he calls the "'blanketing' effect of ordinary language" (Barthelme 1967, 102).[11] In this sense, Barthelme's novel is meta-fictive, exploring and deconstructing Snow White narratives, and meta-mythical in exploring how it creates lenses and modes of perception to look at culture in general. It is also meta-textual, as Genette would say, in using, critiquing, and moving away from the parent film and, thus providing alternative perceptions (Stam 2005a, 28).

This meta-textuality is apparent in the way that Barthelme subverts the historical development of the Grimms' and Disney's Snow White narratives.

[11]For a fuller discussion of Barthelme's handling of specific cultural narratives, see Slethaug 2002a, 303–319.

The Grimm brothers set their tale mainly in the forest and placed an emphasis almost entirely on the childish Snow White and her encounters with the evil witch/Queen and dwarfs. By contrast, Disney placed an emphasis on the Queen's castle and the cottage of the dwarfs as well as the forests, and emphasized three groups of individuals and their narratives—the teen-aged Snow White, the wicked witch/Queen, and the seven dwarfs, elaborating upon their individual characteristics as well as interaction at critical points in the plot. Barthelme's novel shifts the action from rural and courtly Europe to urban New York City but maintains this multiple-character elaboration, though with the much older 22-year-old Snow White living and sleeping together with her seven men in a 1960s Manhattan commune. This text also differs considerably from Disney in minimizing the role of the witch, altogether deleting the Queen function, focusing more fully on a heroic but doomed Prince, and having the seven dwarfs not only work in the City washing buildings, making Chinese baby food, and manufacturing plastic buffalo humps but functioning as a collective narrator of the novel. Indeed, because of this collective narrator, Klinkowitz thinks of Barthelme's as an oral tale, which creates a first-order, pre-Grimm palimpsest (1991, 82).

Barthelme's is not Disney's pastoral, forested, and courtly European setting but a very real and gritty Manhattan where the dwarfs work hard for their living, not earning diamonds. By placing the story in a genuine New York City setting and giving common American names to the witch (he calls her Jane), the dwarfish companions (he calls them Clem, Bill, Hubert, Henry, Edward, Kevin, and Dan), and to the Prince (he names him Paul), Barthelme distances himself from the cuteness of Disney's production, establishes the American character of the urban culture, and calls attention to the fictive process. In choosing a French name—Hogo de Bergerac—for Jane's companion and Paul's nemesis, Barthelme suggests that Americans also label that which is foreign as evil. Snow White, however, goes by the same name that Grimm and Disney used. In this way, Barthelme calls attention to ideology at work over time in literature, film, and culture at large, including naming, and the ways in which different fictive processes unsettle that meaning.

As the central character, Snow White has some of the identifying features of the traditional tales—beauty, white skin, ebony hair, and attention to the dwarfs, but this Snow White's living together with the dwarfs reflects the values of Barthelme's 1960s culture, heavily influenced by the sexual revolution, feminism, psychoanalysis, and the Cold War. As Klinkowitz has noted, "the technique of taking a rosy-cheeked heroine straight out of Disney or the Grimms and having her speak like Gloria Steinem is a conjunction of opposites, or at least of unlikes, and as such qualifies as the art of collage, a style Barthelme has always believed to be the essence of twentieth century art" (1991, 7). This collage, pastiche, and implicitly palimpsest technique

undercuts Disney's sentimentalism, family-values ideology, and use of 1930s Hollywood personality types.

To undercut Disney's sentimentalization, the text evokes some of the darker episodes of Grimm, allowing the prototypical Snow White palimpsest to peek through in unflinching, minimalist, and nonsentimental ways. For example, Barthelme focuses on this older tradition by statements in bold type:

WHAT SNOW WHITE REMEMBERS:

THE HUNTSMAN

THE FOREST

THE STEAMING KNIFE

(Barthelme 1967, 45)

He also takes other "Grimm" memories of Snow White to highlight her psychology:

THE PSYCHOLOGY OF SNOW WHITE:

IN THE AREA OF FEARS, SHE FEARS

MIRRORS

APPLES

POISONED COMBS

(Barthelme 1967, 23)

The references to Snow White's perils and psychology link Grimm, Disney, and Barthelme, though Barthelme is unique in his self-conscious evocation of that tradition.[12] According to Katalin Horn, Snow White's dangers have been associated with "sexual phantasies, sexual problems... Oedipal difficulties between mother and daughter," the "process of individuation [and] the development of the mature personality" (1983, 275) derived from Freudian (Oedipal conflicts) and Jungian (individuation) constructs and interpretations,

[12]According to Cristina Bacchilega, those who write contemporary incarnations of the story—Barthelme, Angela Carter, and Robert Coover—simultaneously legitimate "sexual reproduction" and ratify "narrative production" (1988, 3). In keeping with this double view, Christopher Lasch finds that Barthelme's *Snow White* describes narcissistic behavior but lacks positive alternatives, while Jerome Klinkowitz and Ronald Sukenick believe that Barthelme's short little novel is about writing and language. Indeed, Robert Morace calls it a "verbal vaudeville show" (1984, 4) designed to describe "the loss of their linguistic and (thinking of Orwell's equation) political freedom, including the freedom to choose the *extraordinary* possibilities of language rather than accept the blanketed language of dwarf culture" (8). Similarly, Jonathan Culler speaks of its revelation of "the clichés that make up our culture" (1985, 11), of the verbal rubbish that litters our linguistic landscape.

which Barthelme self-consciously evokes. Indeed, Barthelme begins one chapter with an italicized statement, *"The psychology of Snow White,"* followed by the fairly mundane, "What does she hope for? 'Someday my prince will come.' By this Snow White means that she lives her own being as incomplete, pending the arrival of one who will 'complete' her" (Barthelme 1967, 76). Barthelme adds to this depiction by noting that Snow White has studied psychology in college and is fully aware of "mind, consciousness, unconscious mind, personality, the self, interpersonal relations, psychosexual norms, social games, groups, adjustment, conflict, authority, individuation, integration and mental health" (Barthelme 1967, 31). In this way Barthelme shows an awareness of Snow White's dangers and conflicts and the way critics have viewed them while undermining them with a postmodern self-referentiality.

Although Barthelme takes on Disney's portrayal of Snow White as well as feminist and psychological critics through these self-conscious references on psychology, he does not assert that *his* representation (or *any* representation, for that matter) can reveal anything that is natural, fresh, original, or innovative. His target is not only Disney but a whole system of belief in textual representation. He wastes no time in undermining his own textual representation as well as Disney's by describing Snow White's beauty spots "one above the breast, one above the belly, one above the knee, one above the ankle, one above the buttock, one on the back of the neck" as a line of six bullets on the page (Barthelme 1967, 9):

-
-
-
-
-
-

These black bullets on the white page do reference the ebony on white of the original story, but the inadequacy of print in reproducing the body suggests the lack inherent in, and utter failure of, language and textuality to describe the complexity of reality, and, by extension, the failure of Grimm and Disney to offer anything new to the modern generation. The book, then, subverts its own narrative and that of other Snow White palimpsests.

The references to Snow White's psychological and physiological profile, and allusions to Grimm and Disney make the reader acutely aware that, while

twentieth-century American culture seems original and authentic, in reality it draws from narrative myths, cultural ideology, and academic fashion, which have developed over time and are foundational palimpsests. Indeed, when Snow White longs to have two *real men*, instead of her seven dwarfish companions, her vision of real men elides into filmic and artistic versions that have replaced experienced reality: "It is possible of course that there are no more real men here on this ball of half-truths, the earth. That would be a disappointment. One would have to content oneself with the subtle falsity of color films of unhappy love affairs, made in France, with a Mozart score. That would be difficult" (Barthelme 1967, 48).

The dominion of one narrative over another is not only true of literary and filmic narratives, but all "dreck"—Barthelme's term for the inauthentic in culture. Barthelme suggests that all accounts of experience are always already second hand, filtered through representations in language, narratives, and pictures and images, among others. Thus, when Snow White longs for her prince, she cannot think of any prince but has to wonder "*Which prince?*" on the basis of what culture and textuality allow. So, she asks herself, "Will it be Prince Andrey? Prince Igor? Prince Alf? Prince Alphonso? Prince Malcolm? Prince Donalbain? Prince Fernando? Prince Siegfried?" etc. (Barthelme 1967, 83). While these princely incarnations are much more specific than Disney's or the Grimms' generic princes, each is nuanced by cultural associations drawn from national stereotypes in film and literature.

In calling attention to Snow White's musing on princely configurations, Barthelme suggests that one text always bears a reflection of others, that myth mirrors myth, that American popular culture is deeply imbricated with, and implicated in, myth, and that certain myths—or ideological perspectives— define individual lives. In short, Barthelme does not limit his explorations to a living, breathing Snow White of some psychological depth who has outgrown Disney's sentimental narrative or the Grimms' gothic tale, but rather interrogates the way all narratives continue the mythification of culture.

He uses this technique to construct the witch and dwarfs as well and continue his deconstruction of Disney. One of the principal ways he contests Disney is by limiting the negative functions of the witch and abandoning her characterization as a Queen. Called Jane Villiers de l'Isle-Adam (and thereby evoking Lilith, Adam's first wife), she first appears late in the novel—a quarter through, does not dominate the action or set terrible consequences in motion, and is barely evil with power that lies in the way she can intrude into the lives of others (Quistgaard) through letters that establish her place in the universe of discourse. Moreover, she generates reader sympathy through her realization (while sitting on a porch swing) that she has lost her looks ("'I was fair once...I was the fairest of them all'" (Barthelme 1967, 46)), that she is

attracted to the much older and "thoroughly bad" Hogo de Bergerac, and that she is beset with "hopeless love" (Barthelme 1967, 46, 63). She acknowledges that she cultivates a growing malice because Hogo turns his affections from her to Snow White. Furthermore, the poisoned vodka Gibson that she gives Snow White mistakenly kills the Prince. Neither she nor the bad Hogo seems to have poisoned the drink, but rather Bill the dwarf, who is hanged. It is, however, not certain who killed Paul. In any case, Jane's role is limited, she has no overarching mythical wickedness, and her significance is superseded by the dwarfs and Paul.

In this narrative, the dwarfs dominate in almost every respect, increasing their role exponentially over other Snow White narratives. In depicting the dwarfs, Barthelme establishes a thread with Grimm and Disney only to break it through their loquacious and repetitive rhetoric and cultural self-reflections, especially those laced with psychological and political references. For example, they remember finding Snow White wandering in the forest and reflect on how her presence has changed their lives:

> Perhaps we should not be sitting here and tending the vats and washing the buildings and carrying the money to the vault once a week, like everybody else…It was worse before we found Snow White wandering in the forest. Before we found Snow White wandering in the forest we lived lives stuffed with equanimity. There was equanimity for all. We washed the buildings, tended the vats, wended our way to the county cathouse once a week (heigh-ho). Like everybody else. We were simple bourgeois…Now we do not know what to do. Snow White has added a dimension of confusion and misery to our lives. (Barthelme 1967, 87–88)

The choice of "equanimity" to describe the key characteristic of their lives metonymically displaces the typically used American "democracy" or "justice" in "There was equanimity for all," and the choice of "bourgeois" evokes Marxist musings on politics and capitalism.[13] These are educated and literate dwarfs who have strong opinions about nation but indicate their confusion.

The dwarfish critique of American nationalism plays off Disney's view of nature as romantic in noting that each of them is born in a national park but then goes well beyond the simple romantic by affirming that "the common experiences have yoked us together forever under the red, white and blue"

[13]Along with her other accomplishments, Snow White is a poet, a student of painting, and a student of Marxism, once commenting "Let a hundred flowers bloom," reminiscent ofMao and the Cultural Revolution and a subversion of Western capitalistic and political ideology (Barthelme 1967, 22).

(Barthelme 1967, 68).[14] Their birth in a *national* park is thus not linked to romanticism but *nationalism*, suggesting the subtle ways in which ideology arbitrarily links everything, whether or not it is "natural." Even the seemingly innocent "Heigh-ho" of the dwarfs' marching music can be linked to nation and nationalism for, as Hogo remarks, band music induces patriotism: it will "reduce you to tears, in the right light by speaking to you from the heart about *your* land, and what a fine land it is, and that it is your land really, and my land, this land of ours—that particular insight can chill you, rendered by a marching unit" (Barthelme 1967, 80). In some degree, this observation draws Barthelme's story back to the Grimm version, which was linked to a rise in nationalism (Zipes 1999, 23, 77), but the emphasis here, reinforced by overtones of Woody Guthrie's "This land is your land, this land is my land," is on deconstructing American cultural and political ideology in and around the Cold War.

The dwarfs are not only products of political ideology but share in Snow White's fondness for psychologizing. They suffer from absent fathers (Barthelme 1967, 24–25) and reveal deep psychological distress: "Bill can't bear to be touched...We speculate that he doesn't want to be involved in human situations any more. A withdrawal. Withdrawal is one of the four modes of dealing with anxiety...Dan does not go along with the anxiety theory. Dan speculates that Bill's reluctance to be touched is a physical manifestation of a metaphysical condition that is not anxiety" (Barthelme 1967, 10).

Although the dwarfs and Snow White are inflected with political, psychological, and cultural ideologies, the representation of the actual prince— Paul—is more straightforward with few of the negative values that Barthelme attributes to American culture. As in Disney's *Snow White*, Paul is introduced early in the narrative but by contrast is given a fully engaging and complex personality. He is aware that he is a prince, ponders whether he has some important destiny, and thinks that he probably "should go out and effect a liaison with some beauty...and save her, and ride away with her flung over the pommel of my palfrey" (Barthelme 1967, 33). But he is a poet and painter and retreats to a monastery, preferring to strive for excellence, beauty, and spiritual transcendence and to "break out of this bag that we are in" (1967, 185). Ahead

[14]Barthelme implicitly draws a comparison between the red, white, and blue of the United States with red and communism. However, he also displaces the linking of red and communism by other "red" allusions: Snow White's red lips and towel, the bishop's red mantelpiece (1967, 110); Bill's red towel used to tie up the money for the vault (Barthelme 1967, 118), Kevin's red blushes (Barthelme 1967, 136), the rose-red wine stains the dwarfs leave on a restaurant tablecloth, and the blood that falls from Hogo's thumb as he sharpens his kris to harm Paul. Finally, there is the red and yellow shower curtain (Barthelme 1967, 129). Perhaps the red and yellow shower curtain also relates to the Chinese flag.

of the curve in creating artistic narratives rather than only reproducing those of others, his sweetness, strong feeling, artistic qualities, and rationality help him see through the concealed myths and structure of culture. In Barthelme's world, such characteristics provide a strong antidote for the various myths that constrict and cloud individual consciousness. Though he is an ideal man, Snow White feels no deep love for Paul and thinks of him as only "*pure frog*" (Barthelme 1967, 175) until he drinks the poisoned vodka Gibson intended for her. Then, too late, she recognizes that he could have been a good mate, but, in this short novel, romance does not last and those who query cultural imperatives too closely are doomed.

Snow White, then, is a book that particularly engages Disney in exploring palimpsests, textuality, myth, and the very processes of myth making and the need for demystification. Though the book is rooted in popular culture, it interrogates the larger social constructs of self, political ideology, and artistic expression to suggest the intersection of narratives, cultural myths, and experienced reality.

Self-conscious postmodern film adaptations

Although Disney's *Snow White* is the master narrative of the current Snow White discourses, and, although Barthleme's novelization demythologizes it, asking hard questions about American cultural attitudes, beliefs, and discursive practices, that is not the end of the Snow White discourse, the embedding of palimpsests, or the political and cultural reasons for their uses. New versions continue to appear, including at least five films within the past 15 years that use the Snow White narrative as the foundation, all of them with live actors, though one also with animation.

Playing off Grimm, Disney, Barthelme, and other texts, the basic five films include Michael Cohn's *Snow White: A Tale of Terror* (1997), Caroline Thompson's *Snow White: The Fairest of Them All* (2001), Kevin Lima's *Enchanted* (2007), Tarsem Singh's *Mirror Mirror* (2012), and Rupert Sanders *Snow White and the Huntsman* (2012). These Snow White films carve out new narrative and filmic spaces but also depend on the audience knowing Disney's and the Grimms' paradigmatic plots, so theirs involves a double operation of remembering and refreshing. Such "retrospectatorship" may make the audience resistant to changes but also opens up new spaces of interest and understanding (Carroll 2009a, 35, 43) often through citation of other myths, fairy tales, family blockbusters, popular fantasies, videogames, and films (Elliott 2010, 195).

As noted above, the cast of characters in full-length Snow White narratives bear strong similarities, though always with a different emphasis: most have a Snow White character, a witch/Queen, dwarfs, a prince, and often an understanding but disappearing father. They collectively follow a similar plot structure: Snow White's increasing maturity and beauty threaten the witch/Queen, who wants her life, but, after encountering the dwarfs, Snow White succeeds in repelling the Queen and marrying the prince or pursuing her own agenda. Some are dark narratives of horror, terror, repression, and murder. Some pursue the romantic and sentimental, though in recent films these are mainly postmodern retellings, which are inherently tongue-in-cheek even as they follow conventional patterns. Of the five new films, Cohn's, Thompson's, and Sanders' are dark narratives of terror and horror. By contrast, Lima's and Singh's are postmodern and ironized sentimental retellings of Snow White. I will mention the first group but focus on the latter.

The contemporary Snow White terror/horror films

Although they all have a comic resolution, Cohn's version is called *Snow White: A Tale of Terror*, and Thompson and Sanders pursue the implications of that terror genre. There are, of course, strong links between terror and horror stories, and Carol Clover notes that "horror movies look like nothing so much as folktales," including themes, characters, and situation (1992, 10–11). Following that logic, these three relate more closely to the Grimm and Germanic gothic horror oral tradition than to the Disney model, although the queens in each of these owe their complex characterization and quintessential evil to Disney's representation.

Although there may be hints of the Disney's pastoral background in Cohn's, Thompson's, and Sanders' films, they center on a blighted or fallen world with unremitting disaster and prolonged winter, negotiated and represented by the Queen and encapsulated by the "Snow" of Snow White. Cohn's version starts immediately with a hazardous carriage ride through a dark, wolf-infested, snow-covered forest, resulting in the death of Snow White's mother. Although the baby Lilliane or Lilly (the Snow White character) is saved, the father, Lord Friederich Hoffman (Sam Neill), is left a lonely widower. The description of Lilly herself contributes to this ominous and threatening opening. Lilly's white skin, ebony hair, and red lips have intense, unreal, and slightly sinister qualities in opposition to Disney's idealized or Barthelme's playfully postmodern incarnations. Because Lilly (Monica Keena) wants her father's complete affection and plots to make him cherish the memory of her

own mother over the present queen, Claudia (Sigourney Weaver), her jealousy provokes the queen's incredulity and later her own jealousy. It is only then that Queen Claudia becomes a formidable antagonist, wanting a child of her own and the king's total devotion, sexually desiring the visiting Prince Peter who would be Lilly's suitor, and arranging for Lilly's murder.

This symbolic identification of Lilly and Queen Claudia has those interesting psychological dimensions discussed earlier with reference to the Grimm brothers and Disney, suggesting that the Queen was not implicitly evil and Lilly good, but their similar seeking of the King's attention has led them both to jealousy and disastrous consequences. These jealousies are an interesting innovation, displacing the moral slant of both Grimm and Disney and the tongue-in-cheek psychological send-up of Barthelme with genuine psychological conflict and terror. Cohn, however, drops the focus on Lilly's jealousy early in the film, so that Queen Claudia assumes the role of self-obsessed victimizer, rejoining the destructive queens of Grimm and Disney. This feature relates to the young female development and fantasy of the Grimms' narrative, but this particular competition for the attention of the father exceeds that.

Lilly's escaping death by fleeing into the forest and falling down a massive hole before finding her way to the miners' cave borrows from *Alice-in-Wonderland* not only in that plot detail but in the sense of discomfiture, absurdity, and estrangement, which is also a different feature from Grimm or Disney. This feeling of estrangement is intensified when Lilly meets the miners, who are not Disney's small and harmless dwarfs, but more like Barthelme's who work hard searching for precious metals, are poorly paid, aggressive and rude, psychologically complicated, and starved for sexual affection.

One, however, assists Snow White; she surrenders to him sexually; and she eventually chooses him over Prince Peter, who has been compromised by responding to the Queen's seductions. As with Barthelme, the Prince is dispatched, but this strategy does not initially help Lilly, and the Queen gives Lilly the poisoned apple, attempts to kill the King, wants to use the Prince to hunt down Lilly, tries to bring her own dead son back to life through black magic, and engages in a real fight with Lilly and her miner at the end. This is as much the Queen's story as Snow White's. It is this edginess, estrangement, explicit sexuality, and female competitiveness that give this film its character and strength. This version has a more adult, psychologically charged, and horror-filled atmosphere and tone than Grimm, Disney, or Barthelme. It shares in Barthelme's irreverence to the Disneyfication of Snow White, but not with the same self-consciousness and wittiness.

Caroline Thompson's television film *Snow White: The Fairest of Them All* initially evokes Disney by opening in early summer with a *mise-en-scène*

of beautiful red roses and white apple blossoms clustered around a rustic Bavarian-style forest cottage and Snow White's mother Jo (Vera Farminga) pricking her finger on a rose thorn and wishing for a beautiful child with skin white as apple blossoms, lips red as roses, and hair black as ebony. She gets her wish, but dies soon after, joining the parade of mothers who have died before Snow White comes of age. The mother's death forces the father, John (Tom Irwin), to cross an ice-covered landscape in search of milk for the baby. While this landscape owes little or nothing to Disney or Grimm, it shows traces of Cohn's film, released four years previous to Thompson's. After the immersion in the frozen landscape, the tale turns completely away from Snow White palimpsests, for the father, in falling to the frozen ground and crying in despair, releases a genie who grants him three wishes—milk for the baby, a wife, and a kingdom. The wife, however, is Elspeth, the genie's ugly sister made beautiful by the magic mirror. The genie, drawn from Arab culture, Islamic literature, and Scheherazade, indicates how interart discourse can also become intercultural. This introduction of another palimpsest shows the fluidity of the postmodern Snow White adaptation process.

The relationship of Snow White and Elspeth draws from Cohn's adaptation for initially the queen seems accommodating, but, as Snow White (Kristin Kreuk) grows more beautiful and willful, the vain Queen becomes increasingly jealous, haughty, and obsessive, and the King ineffectual in trying to please both Queen and daughter. Thus, the negativity of the Queen is prompted in part by Snow White's own actions. Taking something from contemporary kitsch, however, this Queen shows her growing evil and control by turning the kingdom's gnomes and one of the dwarfs into garden ornaments and imprisoning the King within mirrored walls. Otherwise, the adaptation follows earlier conventions in having the Queen convince one of the palace staff to kill Snow White, in the retainer's allowing Snow White to flee into the forest, and in her finding the dwarfs, who live in a subterranean cave—though instead of mining jewels, they manage the weather.

In pursuing Snow White, the Queen gives her two tests—the first a band of silk to tie around her waist and the second the poisoned apple, in both cases to take breath and life. The first of these tests is reminiscent of the staylace or corset from the Grimm version, and the second from both Grimm and Disney, but this reinvention of the mirror convention has roots in Disney alone (i.e., apart from Alice in *Through the Looking Glass*). Mirrors in this film are, however, on speed. Increasingly, the Queen uses mirrors to reflect her beauty, confirm her vanity, search out her enemies, entrap her husband and Prince Alfred, turn the gnomes and dwarfs into lawn ornaments, and kill anyone who opposes her. A small magic mirror is used to change the genie's

ugly sister to the Queen, alter others' visions of her, locate her perceived enemies—Snow White, the dwarfs, and Prince Alfred—and cripple or kill them. A large room full of mirrors is used to reflect her vanity, respond to her commands, and imprison the king. Here artifice and exaggeration dethrone the seriousness of the mirror in Disney, while taking its "reflection" of evil to new, but largely unthreatening heights. The mirror itself then becomes a much more important feature in contemporary Snow White narratives than does the apple or other "tests."

As with Disney and Barthelme, the seven dwarfs play a major role in this film, and following Disney, are the goofiest part, though in these postmodern days they contribute heavily to self-consciousness and artifice. Named after the days of the week, they are all live actors, six of whom are short midgets, though the seventh, Wednesday (Vincent Schiavelli), is a tall but clear incarnation of Disney's Grumpy. The short ones wear individual intense colors because, together, they are able to form a rainbow that can transport them to various locations, so magic is a potent part of the general narrative, not just the domain of the wicked Queen. Named after the days of the week, responsible for creating weather, wearing colors of the rainbow, and being turned into garden ornaments, these dwarfs are neither so charming and likeable as Disney's, so countercultural as Barthelme's, nor so edgy as Cohn's. In fact, though they evoke the customary affection for Snow White and want to help her, their real purpose is comic, vaudeville entertainment.

Because the Queen tries to seduce the Prince (Tyron Leitso) and he resists, she turns him into a bear, which also contributes to the comedy. However, the Prince is truly in love with Snow White and, in the grand finale, saves her by licking the ice on her glass casket after she eats the poisoned apple, and is then transformed again to princedom and carries Snow White away on his white horse. The transformation of the prince owes something to other fairy tales (among them, the "pure frog" of Barthelme's prince), suggesting the playful use of palimpsests. The overall plot trajectory, then, is in keeping with Grimm and Disney, but the winter setting and fraught mother-daughter relationship of the Queen and Snow White owe something to Cohn and theories of the unconscious. Beyond that, the mirrors and the gnomes as garden ornaments owe a great deal to popular culture that disrupts conventional fairy-tale categories and usages.

As a TV-drama, Thompson's *Snow White: The Fairest of Them All* is targeted toward a young audience, with a strong focus on family entertainment. Occasionally, the production becomes morally instructive by asserting that a young girl's moral and intellectual qualities are more important than beauty. When recited, such speeches seem dramatic asides to the audience, making

certain that they keep on the right interpretive track, which is little different from the Grimms' or Disney's moralizations. However, this feminist turn is important in the genre as a whole for it is no longer acceptable for princesses to be merely romantic and ornamental: they have to prove their intellect, strength, and valor in ways that suit twenty-first-century attitudes.

More complicated than Cohn's or Thompson's productions and hugely popular at the box office, Rupert Sanders' *Snow White and the Huntsman* uses some of the conventional Snow White narrative elements, but, more importantly, stages a violent armed Tolkienesque medieval battle between the forces of good (Snow White as the rightful heir to the throne of Tabor) and the forces of evil (Queen Ravenna as the sorceress leader of the Dark Army, the murderer of the King of Tabor, and the usurper of the throne) that have destroyed the rightful rule of the land and left the kingdom dark, desolate, and perpetually in the grip of winter. The epic adventure action of this film ends with Snow White wielding a sword and leading the charge against the sorcerer Queen in a posture reminiscent of Joan of Arc. Both the scale of this action as well as Snow White's gender and fighting spirit might well account for its popularity at the box office and positive comments by Roger Ebert (2012), David Edelstein (2012), and A. O. Scott (2012).

Typical of the developing terror/horror genre of Snow White narratives that reference Grimm rather than Disney, the Kingdom of Tabor reflects European background and culture (actually filmed in Wales with a computer generated castle) and its destruction set in motion through an overreaching and arrogant Queen (Charlize Theron) who kills the King (Noah Huntley), imprisons the rightful heir Snow White (Kristen Stewart), and plunges the kingdom into political and economic chaos. Initially saved by a white stallion after escaping through a tunnel into the sea, Snow White flees alone into a beautiful enchanted forest. The physical background of the action, then, references the perpetually corrupt medieval courts of fairy tales where political disagreements are solved through wars rather than diplomacy and where only the elimination of the evil ruler restores freedom and harmony to the people and plenitude to the land. The enchanted forest, however, owes more to depictions by Disney and Tolkien than the Grimm brothers or action films.

Snow White is the moral center of *Snow White and the Huntsman*, imprisoned for many years until her beauty and influence are strong enough to be truly threatening to the Queen. After her escape from the castle, the Queen employs the stereotypical Huntsman (Chris Hemsworth) to kill her. Thus, the Snow White of this narrative follows the contemporary tendency for the princess to be a young woman capable of making her own decisions and able to marshall emotional, physical, and political support against the enemy. Unlike Cohn's and Thompson's films, the conflict of this Snow White

and the Queen is not over the affection of the King but more primal conflicts of rightful rule over a corrupt one and, ultimately, of good over evil. The film is specifically celebrative of Snow White's growing intellectual, moral, and physical strength, leading Edelstein (2012 "Grim") to remark positively that the film was "strongly influenced by a lot of smart, feminist thinking."

If Snow White is the moral and activist center of the film, Queen Ravenna steals the limelight through her strong performance. Beautiful and cruel with more than a hint of a vampire, the Queen drains the life force from many victims to sustain her youthful beauty but requires the life blood of Snow White to guarantee this transformation and ensure her reign. This characterization of murderous malice is drawn mainly from Disney, but its effect goes far beyond the personal to engage the whole empire.

Although the primary contest of the film is between Snow White and Queen Ravenna, the eight dwarfs (Beith, Muir, Quert, Coll, Duir, Gort, Nion, and Gus) play a critical role that is quite different from preceding versions of Snow White. For one thing, there are eight of them consisting of fathers, sons, brothers, and friends. They are short (played by well-known actors who had their faces digitally converted onto small bodies) and represent the way that the populace in the kingdom has been morally, if not physically reduced. Previously respected gold miners, they turned to thievery and highway robbery to make a living in this world where all values have been turned upside down. As highwaymen, they capture and taunt the fleeing Snow White but soon come to recognize that she is truly the royal princess, "the one" they have been waiting for who should inherit the throne and set things right in the kingdom. When they recognize her, they announce "We'll follow you, princess. In life and in death. And we shall have our pride again," a sentiment that other citizens of Tabor soon echo. This recognition, commitment, and ability to lead the battle by the smallest of people bears a strong resemblance to Sam, Frodo, and other hobbits in the *Lord of the Rings*, adding another layer to the palimpsests at work in this film.

The Prince and the Huntsman, too, are won over to Snow White's service. The Prince (Sam Claflin) is actually William, the son of the Duke who fled the court after the death of the king, and is now ready to help resolve the wrong that has been done, and the Huntsman, who was enlisted to kill Snow White, instead trained her as a fighter in the service of justice. These two young, strong figures support and serve Snow White personally and in battle, so that she can win the kingdom back. This is wholly a new view of the "liberation" of Snow White into the role of warrior maiden leading the charge against evil.

Cohn's, and Thompson's, and Sanders' versions all illustrate that the Grimms' gothic Snow White continues to exert a powerful influence, though it

is often mixed with the horror and epic-adventure-action genres. Disney's fairy tale in the service of American family values during the Great Depression has been displaced by darker versions in which personal and social redemption is hard won by strong and independent young women over the age of 20, who no longer need the services of a Prince to make their life complete.

Kevin Lima's Enchanted *and Singh's* Mirror Mirror

As Manohla Dargis has remarked of *Enchanted*, and it holds true as well for *Mirror Mirror*: "for a satisfying stretch, the film works its magic largely by sending up, at times with a wink, at times with a hard nudge, some of the very stereotypes that have long been this company's profitable stock in trade" (2008, 1). Dargis is talking abut the tone (postmodern winks and nudges about the film's likeness to Disney), structure, and evocation of several fairy tales at once creating self-referential pastiches, though the final message is not so different from that of the Snow White horror genre—both strive to find new ways of telling old stories, and both favor more mature, strong, and independent young women unbridled by the traditional Snow White stereotypes. In both *Enchanted* and *Mirror Mirror* those stereotypes are ironized but not abandoned or refuted, allowing a qualified view of romanticism to re-enter.

It is perhaps the self-conscious, postmodern freeplay of Lima's *Enchanted* that singles it out among the rest of the canon, and, as with Barthleme's *Snow White*, calls attention to its cultural heritage and narrative devices. Despite making no reference to Snow White in the title or naming characters after those in Disney's *Snow White*, *Enchanted* rejoices in that legacy, self-consciously invoking and playfully challenging Disney's model by means of a partly animated world in which the characters resemble their live counterparts in a Manhattan urban reality (see Figure 5.4). It does so to stress the transformation of Snow White as well as the other characters.

Playing on the importance of the fairy-tale world and a belief in love, *Enchanted* opens by depicting a book of pop-up illustrations of fairy tales as an acknowledgment of the film's origins and genre and then turns to an animated pastoral setting with the youthful Giselle and cute animals in a forest cottage straight out of Disney's production of *Snow White*. Giselle sings "Dreaming of a true love's kiss," and then the action cuts to the Prince who also sings that song to himself; shortly after, the couple meet, pledge their love, and prepare for their wedding. This fast-moving affair, however, is thwarted by the Queen, Narissa, who pushes Giselle down a well into a time and energy tunnel leading to a sewer under Times Square in contemporary New York City.

FIGURE 5.4 *The resemblance of the animated and live Giselle (Amy Adams) in* Enchanted

 The reality of the city, cynicism, and thwarted love replace the animated forest and fairy-tale love, and set the stage for the characters' various transformations, though it also continues narrative patterns, characterization, and motifs that have already been established. Many of these call attention to their origins in Disney's *Snow White*: the Prince Charming named Edward falls in love with Giselle in the forest cottage; the wicked Queen Narissa/old hag wants to prevent him from marrying her; the huntsman Nathaniel is sent to poison Giselle with an apple and a potion (an apple martini) and to bring the Prince back to the fairy-tale land of Andalusia; Giselle comments that she would like to find a meadow, a hollow tree, and dwarfs who would be hospitable; Giselle attempts to hail a dwarf in Times Square, imagining him to be Grumpy; the Prince believes the TV to be a magic mirror that can help him find Giselle; the Queen appears in all sorts of liquids (aquarium, soup, and martini) that

replicate a mirror and give her access to lives in this new world; birds, rodents, and insects come to Giselle's aid in cleaning Robert's apartment; Giselle sings the "Happy working song" (reminiscent of the dwarfs' "Whistle while you work") as she cleans the apartment; Giselle cultivates her domestic talents of sewing, cooking, and cleaning, which serve as a foundation for her Andalusian Fashion shop and confirm her transformation to entrepreneur in New York City; the haughty, beautiful, and malicious Queen dies a fearsome death as she slides off the top of a skyscraper, replicating the mountain in Disney; and others as well.

However, Barthelme's *Snow White* is also invoked through the Manhattan setting, though this is the affluent Upper East Side, not the working-class neighborhood that Barthelme's Snow White and her dwarfs inhabit. Barthelme is also invoked when Giselle is offered a cocktail as a lethal potion, though *Enchanted* changes it to an apple martini rather than Barthelme's vodka Gibson. Moreover, Snow White's comment in Barthelme that her prince, Paul, was "pure frog" certainly stands behind the cartoon figure of a princess kissing a frog in the credits of *Enchanted*. Thus, Lima has taken on board parts of Disney's *Snow White* as well as Barthelme's to enrich, transform, and ironize *Enchanted*.

Parallels with other fairy tales and fantasies are also apparent throughout to play with the fairy-tale, fantasy, and mock-heroic genres, and, as the credits roll at the end of the film, this emphasis is again pronounced in the graphics accompanying the main characters' names. Among parallel stories, the film evokes (1) the mock-heroic *Don Quixote* in the references to the fantasy kingdom of Andalusia and La Mancha; (2) *Shrek* when Giselle runs from a large and ugly but humorous troll; (3) *Alice in Wonderland* when Giselle falls through the tunnel into a new world; (4) the *Wizard of Oz* when Giselle climbs out of the sewer onto the streets of Time Square and remarks that she has never been so far from home; (5) various Arthurian romances with Robert's daughter being named Morgan; (6) various incarnations of Alvin and the Chipmunks with the chipmunk who tries to save Giselle at certain points; (7) "Cinderella" when Giselle loses her shoe at the ball and it is put on Nancy by Prince Edward, who proceeds to marry her instead of Giselle; and (8) *King Kong* when the Queen plunges to her death from a New York City skyscraper. Lima wants the audience to be in no doubt about this film's genre, but the citation, repetition, and supplementation of these images and allusions mean that the various palimpsests ironize the values and assertions of those fairy tales and fantasies even as they are employed. This is a strong and playful use of postmodern pastiche to transform narrative paradigms, engage the audience in discovering supplemental palimpsests, and locate the fairy-tale values and beliefs in the heart of a cynical city.

In common with other versions, the Snow White character (Amy Adams) is placed at the center of the narrative, and it is her values and abilities that are showcased. In this film about transformation, Giselle herself is transformed, but also helps to transform others. Blonde and blue-eyed (the ebony hair and white skin are saved for Robert's fiancée Nancy, who appropriately becomes the wife of Prince Edward), she spends her early days in Andalusia dreaming of a prince and "true love's kiss," and carries that commitment to love into her new-world surroundings. In the initial animated portion, Giselle is recognizably Disney's late-teen Snow White, singing and dancing her way through fairyland and falling in love with Prince Edward, but as the film progresses to modern Manhattan, Giselle is neither a teenager nor a little girl but a mature, 20-something woman who still believes in romance and is willing to work for it. And indeed she must work for it in a city filled with bright neon lights, honking cars, and rude inhabitants, including a thief who steals her valuable crown. Ignored at first by the hardened and cynical New Yorkers, she is persistent in that commitment to love and shows that it has value in her developing relationship to the divorce lawyer Robert (Patrick Dempsey), to his daughter Morgan (Rachel Covey), and to his African American clients as well, whom she saves from a wrenching divorce. It is this love which initially attracts her to Prince Edward (James Marsden), but which then makes her discover the beauty of her steadily maturing relationship with Robert. It is also her joy and spontaneity that allow her to make decisions (cutting up curtains for a dress, using animals and vermin to clean Robert's apartment) and quickly become a local celebrity, engaging young and old in spontaneous but orchestrated dances over the bridges and through the fields of Central Park. It is this combination of attributes that gives her a *joie de vivre*, strength, and maturity quite different from the early innocent Snow Whites of Grimm and Disney or the later emotionally fraught Snow Whites of Cohn, Thompson, and Sanders. Moreover, though this film is also indebted to the postmodern self-consciousness of Barthelme's fiction, the belief in love, joy, and spontaneity are unassailed and share an important part in the theme of transformation.

Although this version of Snow White completely omits the role of dwarfs, the handling of the three important male characters reinforces Giselle's values and attributes and stresses personal and social transformation. The first is the value of love, and the Prince is smitten enough with Giselle to pursue her from Andalusia to New York City, though, in his medieval costume in Times Square, he is even more out of place than she initially was and takes longer to transform. The emotionally hardened New Yorker Robert does not believe in true love, but he is won over by her commitment to love and integrity and so is himself transformed as a lover and father. He initially rejects Giselle because of her lack of urbanity and even more by her carelessness in cutting

his expensive curtains into a dress, but he comes to value her exuberance and spontaneity as well, becoming transformed by her *joie de vivre*. Even Nathaniel (Timothy Spall) who is sent by Queen Narissa from Andalusia to get rid of Giselle is gradually won over (as is the case of the huntsman of tradition in the Snow White narratives). Although Nathaniel tries to persuade Giselle to eat the poisoned apple and drink the poisoned martini, when the Queen actually succeeds in making Giselle eat the able and become comatose, he is outraged and helps with her unmasking at the ball. These three male figures, then, all have or develop good hearts, are positively affected by Giselle's qualities, and are won over to her views.

Apart from Snow White and the male heroes, the animals of the fairy-tale kingdom (and of Disney's *Snow White*) are transformed into the New York setting, though appropriately localized and urbanized, adding to the charm and humor. If the fantasy world has fauns, bluebirds, turtles, and squirrels that first accompany Giselle (or that help wash the dishes, sweep the floors, and fix the beds in the Disney palimpsest), New York has rats, pigeons, and cockroaches helping her to wash the dishes, clean the toilets, and sweep Robert's Upper East Side Manhattan apartment. These add recognition and humor to the film, as does the computer-generated chipmunk named Pip, who is the animal emissary from the enchanted world to New York City and the protector of Giselle.

Queen Narissa (Susan Sarandon), however, fails the test of a positive transformation, though she is negatively transformed and a superb foil for the values of Giselle. Initially appearing only to be concerned about the fate of her son in Andalusia, she becomes progressively more malicious and intrusive, forcing her emissary Nathaniel to attempt to kill Giselle. This murderous instinct becomes more pronounced, and, when Nathaniel unmasks her at the ball, she is forced to abandon the pretense of maternal protection and statesmanship, becoming not just the proverbial dragon lady but a hideous dragon itself.

Humorously, then, many of the characters, most obviously Giselle and Edward, are caught between two worlds and/or sets of attitudes. Giselle must hold on to her spontaneity and belief in love, though she makes some mistakes, and Edward must surrender some of his archaic princely values to adjust to his new environment. As Giselle sings and dances across Central Park, engages old and young alike, and leads a troupe of singers and dancers, she is comfortable and happy, exuding romance and revelry. Some things in the new world, however, do not correspond so comfortably with that of the old, and she misapprehends those features. For instance, she tries to walk into a mock castle that is part of a billboard because she does not have enough cultural consciousness to recognize what it is; in cutting up the curtains in Robert's

apartment to make a romantic dress and in calling cockroaches, pigeons, and rats to help clean the toilets and vacuum the floors of the apartment, she commits unforgivable cultural mistakes. Likewise, Edward cannot translate directly into this world as a hero, and nearly harms others in his attempts to be a hero and find Giselle. Like many other fairy tales, *Enchanted* is situated on a fault line between romance and reality, belief and cynicism, and different kinds of cultural values. It is this ambiguity that puts it in the postmodern camp of simultaneous acceptance and skepticism and motivates the overall theme of transformation.

It handles the traces of the originals through a complex marriage of the rural and the urban, the European and the American, animation and live acting, and the romantic and sardonic. As Dargis notes in his film review, "the old Warner Brothers animators used to take rollicking aim at Disney on occasion, but it's something else to watch Disney send up Disney, as it were, and do it with such sneaky, breezy irreverence" (2008, 2). It is *Enchanted*, as with Disney's previous *Snow White*, that shows the entertainment value and critical insight underlying the use of multiplicitous palimpsests in dialogue.

As with *Enchanted*, Singh's *Mirror Mirror* simultaneously uses many of the elements of the Grimm brothers' "Snow White" and Disney's paradigmatic *Snow White and the Seven Dwarfs* even as it sends these up by exaggerating and overplaying them. As it does, it also follows the contemporary reinvention of Snow White as a strong and independent young woman who increasingly knows her own mind and is able to lead a revolt against the tyrannical and usurping Queen. It also follows a by-now familiar pattern of reinventing the dwarfs and their role as well as the Prince and his role.

Mirror Mirror follows both Grimm and Disney and self-consciously acknowledges this legacy in many ways, not least the naming of one dwarf Grimm who is said to go on to write a book of fairy tales. The cartoon version at the outset of the film is another firm acknowledgment of this legacy and includes the birth of Snow White, her mother's death, the tutelage and disappearance of the King, and her suppression by the corrupt Queen. It also does so in Snow White's glimpsing the prince as part of her "awakening." However, it departs from and enters into dialogue with both in the handling of the mature Snow White, the character of the dwarfs, the nature and role of the Prince and what Snow White's awakening means, the destruction of the Queen, and the reinstatement of the kingdom.

The film shows its postmodern intertextuality and dialogue with other texts in the Snow White canon as well. Interestingly, the film references Winthrop Ames' early play *Snow White and the Seven Dwarfs* (1912) in its depiction of a little bird being a comfort and emissary to the young Snow White (rather than Disney's cohort of forest animals), but to some degree it references

Barthelme's *Snow White* and to a considerable degree Lima's *Enchanted* in the depiction of a mature, independent, and self-confident young Snow White over the age of 18 and even with the opening cartoon of the tale (reminiscent of *Enchanted*'s pop-up illustration). In indicating that Prince Alcott is from Valencia, the film also seems to nod in the direction of *Enchanted* where the prince is from Andalusia, another legendary part of Spain. It also seems to reference *Snow White and the Huntsman*, though produced at the same time, in its depiction of Snow White as a warrior princess who can do battle against the Queen and her beast in the forest. This beast in the forest, however, is a dragon, the shape that the wicked Queen assumes in the final battle of *Enchanted*.

Mirror Mirror also references texts outside the Snow White canon to enrich the film and suggest the cross-cultural freeplay of postmodernism and citational palimpsests. Part of the intertextuality concerns other fairy tales. Snow White's dressing in the swan costume when she intrudes into the Queen's ball and sees the Prince is likely drawn from H. C. Andersen's "The Ugly Duckling" or even Tchaikovsky's *Swan Lake*, with implications of maturing beauty as well as the struggle to find and keep love. The Prince's own dress as a rabbit evokes the March Hare or so-called Mad Hatter of *Alice in Wonderland*, a perennial favorite of Snow White adaptations, but also that of Brer Rabbit for the Queen notes that the rabbit is known for "cunning and trickery" to outwit his enemies. The sequel of *Alice in Wonderland, Through the Looking Glass*, is also referenced in the elaborate court game of chess that the Queen oversees when Snow White first begins to develop an independent spirit. The Queen's calling her beast "Precious" also references Golum in *The Hobbit* and the *Lord of the Rings*. Snow White's learning how to fight and be a thief with the dwarves and returning the gold they took to the people of the city strongly suggests an overlay of the various Robin Hood stories. Her ability to fight the puppet tin man that the Queen sends to destroy her and the dwarfs has its basis in the *Wizard of Oz* and suggests her growth in emotion and insight into strategy. Most obviously, these include the Bollywood tradition as well for, at the very end of the film with credits rolling, the cast (except the fallen Queen) break into orchestrated dancing to Bollywood rhythms and singing "I believe, I believe, I believe in love." This becomes Singh's way of noting the spirit of self-conscious romance at the heart of both his film and the Bollywood tradition, and it also indicates a new international cross-over between Hollywood and Bollywood so noticeable in other film adaptations like Gurinder Chadha's *Bride and Prejudice* (2004).

The liberal borrowing of *Mirror Mirror* results in an interesting plot development and postmodern pastiche. Consisting entirely of live actors, this film opens with a fleeting glimpse of the Queen (Julia Roberts) looking into

her egg-shaped magic mirror and then her voice-over giving the background of Snow White up to her 18th birthday and the Queen's conclusion that "Snow would have to fall," directly linking the snow that continually blankets her kingdom and the intended death of Snow White (Lilly Collins). This scene becomes a bookend for the end of the film in which the Queen once again resumes her narrative role, only to discover that it is she who must fall. This highly stylized and ironized bookending not only provides a nice frame for a summary of the action but also hints at the self-conscious postmodern artifice that will dominate this film.

The egg-shaped mirror that is at the center of these bookends thus assumes not just a decorative or even magical but strategic element for the plot and meaning. First, it is established as an element of wonder and control, especially when the Queen is able to merge with it and emerge from its thick viscosity in a warm, tropical center, safe from the winter she brings to her kingdom. At the end of the narrative when the Queen has to submit to Snow White, the mirror explodes, dashing all of the Queen's hope for beauty and empire, allowing spring to return, and further ironizing the introduction. Second, the mirror proves tricky because, while the Queen gets her wishes, they come with sneaky stipulations. For example, when she gives Prince Alcott a love potion, it turns out to be for puppy love, meaning that the Prince acts exactly like a puppy in his love for her. As a title, then, *Mirror Mirror* is not just the evocation and reminder of the well-known "Mirror, mirror on the wall," but a self-conscious suggestion of a postmodern doubleness in which a second part repeats, supplements, and subverts the first.

This simultaneous evocation and subversion is apparent in the opening account of Snow White's childhood and the remainder of the narrative in which she develops and conquers the Queen. The opening account presents a cartoon version of the conventional narrative pattern in which Snow White's mother died and the father, the King, lavished attention on his daughter, groomed his daughter to be a leader, and governed a kingdom where everyone laughed and danced. Perceiving a lack in his abilities to teach his daughter, he married the most beautiful and intelligent woman in the land (by the Queen's own sardonic account) and then disappeared in a forest. The Queen views this as her triumph for, following this disappearance, she sequestered the eight-year-old Snow White, ruled absolutely, ran the kingdom through suppression of liberty and punitive taxation, but also bankrupted it through her extravagant lifestyle and numerous balls. She also kept her subjects in check through their fear of a formidable beast in the forest. Moreover, her illegitimate presence put a wintery pall on the landscape.

After a 10-year hiatus in which Snow White matures into a beautiful young woman capable of thinking out problems and making up her own mind but also mindful of the Queen's power, the narrative, now with live actors instead

of cartoon figures, turns to Snow White's insubordination, escape from the castle, and ultimate destruction of the Queen. In this second part of the narrative, ironizing the first, Snow White disobeys the Queen by attending a ball in honor of a visiting Prince (Armie Hammer) whom the Queen contrives to marry. Furious with her for disobeying her so publicly, the Queen instructs the huntsman to take Snow White to the forest and kill her, but he privately releases her into the forest where she is rescued by the dwarfs. This is a fairly conventional founding narrative which Rotten Tomatoes says lacks depth and originality.

Once the foundation is established, however, *Mirror Mirror* exerts its own creativity and magic. This is largely, as might be expected from previous incarnations, through the interaction of Snow White, the dwarfs, and the Prince, but now with postmodern language and twists.

The depiction of Snow White as a strong young woman owes something to Barthelme, *Enchanted*, and, though produced at the same time, *Snow White and the Huntsman*, suggesting an unacknowledged complicity between the two films. Unlike Disney, Snow is not first shown as a scullery maid in the castle but rather, from the outset, dressed as a princess though under house arrest and confined to her room. In that time—until the eve of her 18th birthday when she first intrudes into the Queen's courtly games and ball to honor the visiting prince, she is submissive to the Queen, needing but never receiving her affection. After her birthday and the figurative laying on of hands by a castle servant and receiving of her father's dagger, she becomes increasingly strong, self-reliant, and savvy. After venturing out into the forest and city and showing her noncompliance to the Queen, she is expelled from the court and taken to the forest to be killed, but in fact begins her tutelage under the dwarfs, who, as in the contemporaneous *Snow White and the Huntsman*, teach her how to steal and defend herself. Although she shows some characteristics of the traditional Snow White depiction in staying with the dwarfs and cooking for them, she is more their friend and apprentice than mother and guide. This mature Snow White bears a close resemblance to Audrey Hepburn with her white skin and ebony hair (though the Queen snidely calls it raven), engaging the Hollywood of the 1950s and 1960s rather than Disney's 1930s, suggesting her ability to be part of the world without being corrupted by it, and perhaps even referencing Barthelme in that maturity and period look.

Snow's relationship with the Prince is part of this ability to be part of the world but not corrupted by it. When she first rescues him in the forest where he has been hung upside down on a tree by the dwarfs, she finds him in a vulnerable situation and is drawn to him, though slightly embarrassed by and reserved about it. This attraction and embarrassment continue at the Queen's ball and later when she duels with him in the forest as he comes to do battle with the dwarf bandits. In this case, however, she calls him a jerk when he

calls her a traitor for siding with them. The embarrassment is then replaced with love and anger after he has taken the potion, has been put under the spell of the Queen, and acts foolishly until Snow White gives him her "first kiss" to break that spell. In this way, she and the Prince reverse their traditional roles, for she is more emotionally strong, knowing, adaptable, and able to lead in their relationship and the kingdom.

The Prince himself, Alcott of Valencia, is an interesting figure who is as handsome (reminiscent of Pat Boone, also of the 1950s) as Snow White is beautiful and worthy of her love, but also someone who must be retrained from his false assumptions and bad habits. To some extent, this is indicated when he is under the spell of puppy love and acts foolishly, showing love to the wrong woman and not acting rationally or traditionally manly. He also has to be retrained from his social expectations: he refuses to fight the dwarfs at one point because they are "short and funny"; he later rushes inappropriately to wage battle against the dwarfs because he thinks that they are bad highway men and that "justice must be provided"; and he refuses to fight against Snow because she is a woman and therefore his physical inferior. Even his needing love's first kiss to break the Queen's spell suggests that it is he, ironically, who inherits the gender and cultural restrictions of both the Grimm brothers' and Disney's Snow White and needs to have those dropped before he is worthy and mature enough to marry Snow. When he is mature enough to apologize to Snow and the dwarves for his foolish assumptions and to say to Snow's father that "the princess is more than capable of handling things on her own," then he can marry.

The dwarfs of *Mirror Mirror* vacillate between the small dwarfs of Grimm and Disney and the large dwarfs of Barthelme, creating an interesting uncertainty about them. Although in reality very short (played by famous actors who are dwarfs) and assertive that you should "never trust anyone over four feet," they appear huge because they spring around on stilts. In this way the Prince and the Queen's court are confused about their identity. With names that individuate them but also place them in the fairy-tale tradition (Grimm, Butcher, Wolf, Napoleon, Half Pint, Grub, and Chuckles), they have once been part of the fabric of the kingdom with honorable trades but have been banned by the Queen and ostracized by others for not looking normal. Snow redeems their reputation when she takes the gold they stole from the Queen and returns it to the people who had been coerced into surrendering it as taxes. The dwarfs then become firm advocates of Snow and supporters of populist causes. Their role, then, is firmly to support contemporary views of diversity and multiculturalism, and they alone are singled out at the end of the film to have their futures indicated, accompanied by sepia-tinted pictures: "Butcher became a flyweight champ"; "Napoleon brought hair to new heights"; "Wolf

returned to his pack"; "Grub ate lunch"; "Chuckles joined the Royal Circus"; "Grimm wrote a book of fairy tales"; and "Half Pint found love."

The Queen, who leads the movie audience to believe that this is her story and not Snow's, plays a very special role in *Mirror Mirror*. First, she is beautiful and wishes to preserve that beauty forever, regardless of what it takes. Next, she is the traditional mistress of black magic through her engagement with the mirror. Finally, she rules the kingdom with the cruelty and ruthlessness shown from Grimm and Disney to Lima and Sanders. Still, she has fetching qualities that mitigate some of the cruelty, and Singh calls her "insecure" rather than cruel. There are times that she does give evidence of this, as when she comments that she is not so much "wrinkled" as "crinkled," but this is not a full descriptor of who she is, and she is, as this quote indicates, also witty and funny. She also can be genuinely excited about something as when she comments on her forthcoming marriage to the Prince, which is her fifth: "No matter how many times I do it, I still get excited on my wedding day." She clearly enjoys opulence and splendor, living in baroque-style surroundings and enjoying fashionable, regal clothing. This Queen, then, has a complexity and entertainment value that exceed the queens of many other Snow White texts.

Altogether, then, Singh's *Mirror Mirror* and Lima's *Enchanted* use and take liberties with the Snow White tradition in a more playful manner than Cohn's *Snow White: A Tale of Terror*, Thompson's *Snow White*, or Sander's *Snow White and the Huntsman* that stay more within the terror, horror, and epic-action modes. Nevertheless, all send up the romanticism of Disney and show the play of intertextuality and hyper-palimpsests as they draw from previous Snow White narratives as well as a wide variety of other fairy tales and fantasies.

6

Conclusion

For too many years in the historical development of film, critics tied a film to a specific individual literary source, limiting ideas about the diversity and intertextuality of films as well as the kind of criticism that was written. Bluestone's 1957 landmark book loosened this hold, opening the way for the expression of newer ideas and more innovative ways of critiquing films. Nevertheless, the compulsion to connect adaptation and source continued in various ways so that as late as 2007 Thomas Leitch argued that

> Adaptation studies will rest on a firmer foundation when its practitioners direct their attention away from films that present themselves as based on a single identifiable literary source—preferably a canonical work of fiction like *Pride and Prejudice or A Christmas Carol*—and toward the process of adaptation. Instead of distinguishing sharply between original texts and intertexts, future students of adaptation will need to focus less on texts and more on textualizing (the process by which some intertexts become sanctified as texts while others do not) and textuality (the institutional characteristics that mark some texts, but not others, as texts). (2007, 302)

He advocated that the postmodern emphasis upon textuality be expanded and that intertextuality be sufficiently deployed in the process of critiquing films so that the single-minded attention to faithfulness to a particular text is displaced in favor of more creative, multifaceted cultural approaches.

This emphasis upon textuality and intertextuality instead of literal adaptation has advantages and disadvantages. Its advantage lies in the recognition that few if any texts are adaptations on a one-to-one basis, and that critics can now explore the infinite variety of sources, influences, and texts at play and discover the fluid constructions of meaning arising from that. Its disadvantage is the accompanying recognition that criticism and meaning are much less certain than they were when only one text was considered as a source for adaptation. Now critics must see to what extent the various signs, symbols, and clues

can lead to new and more complicated meanings. Although Nabokov's short story "Signs and Symbols" explicitly warns against constructing meaning from clues in texts and life, interpretation is the function of critics who explore textual links of any kind. What is at stake in this process is that various theories and methodologies can help the reader assess these manifold intertextual relationships and see the open-endedness of this process. This study, then, has used the complex and fluid postmodern textual analytic to assist in highlighting and interpreting adaptations, supplementations, and citations, some of which are intrinsically postmodern in themselves.

Textual fluidity and the play of intertextuality are part of the postmodern methodology and critical toolkit used to assess texts of all sorts in this book and help in understanding the wide-ranging kinds of adaptation and citation that contemporary film production has to offer. This is a rich toolkit, including notions of substitution, supplementation, and surplus; intertextual doubling; indeterminacy, undecidability, and hybridity; and bricolage and palimpsest. Using this toolkit helps to locate texts within their network of relationships, see hybridity at work, and acknowledge the freeplay of meaning across a broad spectrum. This study, then, has used this postmodern methodology to help understand films like *SMOKE, Smoke Signals, Broken Flowers, Enchanted, Mirror Mirror*, and *The Great Gatsby* that have not been previously analyzed in detail at the same time that it offers new perspectives on films like *Age of Innocence* and *Gangs of New York* that have been critiqued in other ways and contexts.

Another part of the toolkit is the use of genres. As Thomas Schatz observes, "a genre approach provides the most effective means for understanding, analyzing, and appreciating the Hollywood cinema" (1981, vii), though many films resist classification. However, the use of genre criticism can be especially useful in films such as *Smoke Signals* and *SMOKE*. In the first instance, Chris Eyre's film becomes a postmodern Western and road film, playing off some of the conventions and understandings of the Lone Ranger and Tonto tradition and journey to the West, but altering them to reify the recent generations of Native Americans depicted here. Similarly, Auster and Wang's production plays with genre conventions to subvert the notion that film and social narratives must fit into some predetermined box. Their film specifically steps outside the box that *Do the Right Thing* creates in order to emphasize greater possibilities of effective urban social relations. This is also true of *Enchanted* and *Mirror Mirror* as they play with the generic conventions of fairy tales, sending up themselves and their predecessors at the same time as they create fun and entertainment for the audience. Especially in postmodern films, it helps to know the operative generic conventions, but the audience needs to see the play of these as well. This study has not been

organized around genre but has explored that when genre becomes a factor in the postmodern construction and impetus.

To explore these phenomena, this study has focused on films from a wide range of studios, demonstrating that the process of adaptation and citation is not restricted to any one kind of studio but broadly carried out. Three of the adaptations in this study were made by large-scale commercial studios and included Scorsese's *Age of Innocence* (Columbia Pictures), Lima's *Enchanted* (the Walt Disney Studios), and Cohn's *Snow White: A Tale of Terror* (PolyGram Filmed Entertainment of Universal Pictures, now under NBC) that were costly to produce but brought in substantial movie and television revenue. Six of these films were from independent studios and included Scorsese's *Gangs of New York* (Intermedia Films), Altman's *Short Cuts* (Lionsgate Films), Guare's *Six Degrees of Separation* (New Regency Studios), Wang's *SMOKE* (Bob and Harvey Weinstein), Thompson's *Snow White: The Fairest of Them All* (Hallmark Entertainment), and *Mirror Mirror* (Relativity Media). These generally cost less to produce but in most cases also brought in less revenue than those of the large commercial studios. The remaining four contemporary films were produced by small, avant-garde studios that included Spike Lee's *Do the Right Thing* (Forty Acres & A Mule Filmworks), Chris Eyre's *Smoke Signals* (ShadowCatcher Entertainment), Jim Jarmusch's *Broken Flowers* (Five Roses Studio and Bac Film), and Rupert Sanders *Snow White and the Huntsman* (Roth Films Production). Disney's animated *Snow White and the Seven Dwarfs* is in a class of its own because it was a highly speculative production that was outside the studio system in 1937 but helped to launch Disney's own production studio in 1939. His independent studio was also outside the studio system but now is one of the major commercial studios, producing the likes of Lima's *Enchanted* and helping to increase the popularity of animated adaptations (among other things) across the social and international spectrum. Roth Films Productions is also in a class by itself for it has only been recently founded but has focused on fairy tales and fantasies.

While the large commercial studios may have more money to fund such films as Scorsese's *Age of Innocence* and Lima's *Enchanted*, the independent studios often take on more culturally diverse adaptations with a slower pace, more dialogue and less action, and more political engagement. Luhrmann's *The Great Gatsby* may be the exception in many ways: it was a big-budget film produced in Australia by four independent studios—Village Roadshow Pictures, Bazmark Productions, A&E Television, and Red Wagon Entertainment, with the assistance of the Australian government; it has a fast pace and chaotic action; it has relatively little political involvement except for showing the attractiveness and sham of the high life; and it has taken on one of America's most popular narratives in print and on the screen. It seems,

however, the avant-garde studios produce films that are the most "dark, disturbing, intelligent, provocative, and quirky" (Hawkins 2005, 77), films such as Lee's *Do the Right Thing*, Eyre's *Smoke Signals*, and Jarmusch's *Broken Flowers*. Even Sander's *Snow White and the Huntsman* has a dark side to it in using the horror and epic action modes. There is, however, no absolute rule to the production of adaptations and citations by studios because all sorts are involved in this.

Because so many studios are located in the United States, it comes as no surprise that many films focus on America, so in using a postmodern analytic, this study has focused on those relevant to nineteenth-, twentieth-, and twenty-first-century American culture, though not all use American directors, actors, or film locations. Out of this come a few prominent themes. One important theme common to over half of the films in this study concerns ethnic and race relations. Martin Scorsese's *Age of Innocence* and *Gangs of New York* help to assess the fault lines of Anglo and Irish tribalism in the mid-nineteenth century with its implications for tribalism in the recent twentieth century. Although Spike Lee, Chris Eyre, and Wayne Wang might not refer to tribalism per se, *Do the Right Thing*, *SMOKE*, and *Smoke Signals* do critique ethnicity and race relations in America from African American, Native American, Asian American, and Euro-American perspectives, showing how the blight of racism has cut across culture and geography historically and how, according to some, this continues unabated, but, according to others, the situation may be improving. Even *Mirror Mirror* picks up this theme of tribalism in the exclusion of the dwarfs from the kingdom and their turning to thievery and banditry to make a living because they can no longer pursue their regular jobs. Then, too, although race relations is not the real point of John Guare's *Six Degrees of Separation*, it, too, raises questions about access to privileged white spaces within society.

A theme that dominates many of the films, but particularly *The Great Gatsby* and the Snow White palimpsest, is the American Dream. As Jim Cullen points out in *Popular Culture in American History*, there are many American Dreams, but those dreams are often centered on individual achievement and success:

> There is no *one* American Dream; rather, there are many American Dreams. Religious freedom, a college education, homeownership…The possibility of a poor girl from a small town becoming transformed into a Hollywood princess on the silver screen seems to embody our notion of an individualistic democracy far more than, say, an equal distribution of economic resources. (2001, 204)

Cullen also notes that "the individualist cast of American democracy in particular gives it a strongly hierarchical spin, as in the case of a remote

superstar adored by millions" (2001, 6). Paul Poitier's plan to reinvent himself and become part of the households of the rich and famous in New York City in *Six Degrees of Separation* is one manifestation of this desire, but so is Amsterdam Vallon's wish to have his gang accepted into the social fabric of the city in *Gangs of New York*, or Gatsby's wish to make enough money to secure a relationship with Daisy. Likewise, Mookie's friends in the Bed-Sty neighborhood of Brooklyn would like the opportunity to work and feel connected, and their burning of Sal's pizza parlor in *Do the Right Thing* arises from their frustration in being considered racially and economically inferior right in their own neighborhood and not having the ability to pursue that American Dream.

Hollywood has always been called a dream factory, but some dreams are more important at particular times. Disney got to the heart of one dream in *Snow White and the Seven Dwarfs*—the spectacular rise from adversity—for a couple of reasons. First, it is Snow White's ability to rise from her role as the cleaning drudge in the castle to that of a beautiful princess marrying Prince Charming. Second, in the midst of the Great Depression when this film was produced and released, the role of the seven dwarfs who toiled daily in the mines and were richly rewarded for it was the dream of escaping poverty and finding meaningful employment with a suitable income. Films that played off Disney had their own angle on dreams, however, so this palimpsest has been used to explore many other, even parodic treatments of dreams and their corresponding nightmares. Thus, Cohn's *Snow White: A Tale of Terror*, Sanders' *Snow White and the Huntsman*, and Singh's *Mirror Mirror* reflect the dark and dangerous side of life that many fairy tales incorporated, often because the better dreams could not be realized.

Related to this idea of achieving a dream is the emphasis in American adaptations, supplementations, and citations on discovering and maintaining values, of which family and social relationships are among the most important. *The Age of Innocence* depicts a time when the role of family was paramount in American society, and *The Great Gatsby* reflects upon the loss of that value in the 1920s. In *Six Degrees of Separation*, the Kittredges place a strong value on family, though their own is dysfunctional.*Short Cuts* highlights the interlocking family and social connections within the network of Los Angeles working men's communities as well as the difficulty of achieving those in a meaningful way and the likelihood of their sometimes-cataclysmic breakdown.*SMOKE* also highlights the value of those relationships straight across the multicultural spectrum in New York City (even though Felicity is estranged from Ruby and Auggie), and *Gangs of New York* and *Do the Right Thing* demonstrate the cross-generational consequences when those are not observed and are even deliberately violated. Given this strong emphasis on the family, it is indeed ironic that so many of these families are dysfunctional and that family values

are more likely to be found in groups outside the family than within it, as is the case in Auggie's smoke shop. The Snow White narratives are somewhat exceptional here because in every case Snow White's parents die and she is raised by a cruel stepmother. However, her relationship with the dwarfs creates a community that stands in lieu of the family, but even that can be fraught with conflict as Barthelme's *Snow White* suggests.

The search for values may be a collective endeavor, but in such a pluralist society as the United States, there are many different perspectives on values. Lee's *Do the Right Thing* suggests that values are created according to race and class and are not shared equally, and Scorsese's *Age of Innocence* and *Gangs of New York* pursue that logic as well. Jim Jarmusch's playful, laid-back *Broken Flowers*, however, demonstrates that human beings are in a double-bind, driven to search for values and meaning but having to admit that locating them is impossible.

Together these adaptations and citations explore basic questions that vex American society at the end of the twentieth and beginning of the twenty-first century. Depending on the perspective of the intertexts, ongoing changes in the cultural milieu, as well as attitudes and statements of directors and/or authors, these assessments will differ significantly. This, of course, raises the question of the role of the author, script writer, adapter, and film script itself.

In this postmodern period of the "death of the author," few defend a search for authorial or auteurial intentions, and deliberate statements from the authors and directors about their perspectives are quite rightly questioned and cannot be thought "author-itative." Nonetheless, the critiquing of films is a democratic business, and all points of view have some relevance in helping to understand and explain what is going on and why. Paul Auster's and Wayne Wang's *SMOKE* is a case in point. The incorporation of the original short story does not come until the final moments of the film and then only with music but no dialogue. The dialogue must all be surmised by the black-and-white photography and the expressions of the Auggie and Granny Ethel. It does help to have access to the original short story to know, for example, that the setting is the Boerum Hills housing project and that the pictures on the wall of Granny Ethel's apartment are those of Civil Rights leaders J. F. Kennedy and Martin Luther King, but not of Malcolm X. This information saves the audience from having to guess at some things. Indeed, the use of film scripts in relation to films often helps in this manner. Granted, it is the actual setting, shots, and dialogue of the film that have primacy, but being able to read the scripts can help to point out and situate the problems if not always to resolve them. In some cases, it is also a way to clarify the speaker's language when it is difficult to hear.

One thing this study has not engaged in is what kind of differences might emerge from a comparison of other nation's adaptations, supplementations, and citations. Is there a difference, for instance, in an English adaptation of the Grimm brothers' "Snow White" and the American *Mirror Mirror*? What might a postmodern study of adaptation and citation based upon national cultures demonstrate about techniques, themes, and values? And how is globalization affecting the heart of films, not just the final Bollywood sequence of *Mirror Mirror*? That is not the point of this study, but it might lead to interesting comparisons.

Adaptation, supplementarity, and citation, then, come in many forms and serve many purposes, sometimes realistic, sometimes animated; sometimes political, sometimes avowedly not; sometimes mono-cultural and sometimes multi- and cross-cultural; and sometimes with respect and sometimes transgressive. As a result, film adaptation is clearly not a single thing and certainly not a genre in itself. In the days when adaptations were linked exclusively to one source and were judged to be best when they were "full" and faithful to single sources, then it might have been possible to see adaptation as a separate category. Then, plot structures consonant between the "copy" and the original, similar characterization, common themes and images, and proximate speech and description might have been ways to identify and critique this category.

That, however, was never really the case. As Disney's *Snow White and the Seven Dwarfs* exemplifies so well, there were always a number of sources at play, with textuality tied to cultural and generic conventions of given periods. Adaptations and citations have always already participated in the full play of intertextuality and the resultant indeterminacy of meaning, though a postmodern critique has only become possible with the methodology offered by Bakhtin, Barthes, Derrida, Foucault, and others.

Works cited

Africa Policy Information Center. 1997. *Talking about 'Tribe': Moving from Stereotypes to Analysis*. Washington, DC: Background Paper. Available at: http://www.africaaction.org/bp/ethnic.htm.

Alexie, Sherman. 1993a. *The Lone Ranger and Tonto Fistfight in Heaven*. New York: The Atlantic Monthly Press.

———. 1993b. "Reservation Mathematics." In *First Indian on the Moon*. Brooklyn, NY: Hanging Loose Press. 43–44.

———. 1995. *Reservation Blues*. New York: Warner Books.

———. 1998. *Smoke Signals: A Screenplay*. New York: Miramax (Hyperion) Books.

Allan, Robin. 1999. *Walt Disney and Europe*. London: John Libbey & Company.

Allen, Graham. 2000. *Intertexuality*. London: Routledge.

Altman, Robert. 1993. "Introduction: Collaborating with Carver." In Raymond Carver, *Short Cuts: Selected Stories*. New York: Vintage Books (Random House).

Altman, Robert and Frank Barhydt. 1993. *Short Cuts: The Screenplay*. Santa Barbara, CA: Capra Press.

Andrew, Dudley. 1980. "The Well-Worn Muse: Adaptation in Film History and Theory." In *Narrative Strategies: Original Essays in Film and Prose Fiction*. Eds. Syndy. M. Conger and Janice R. Welsch. Macomb: West Illinois University Press. 9–17.

———. 1984. *Concepts in Film Theory*. New York: Oxford University Press.

———. 2000. "Adaptation." In *Film Adaptation*. Ed. James Naremore. London: The Athlone Press. 28–37.

Anonymous. 2006. "Read Review of Broken Flowers." *Epinions*. Available at: http://www.epinions.com/content_196610330244 [accessed January 26, 2006].

Aragay, Míreía. Ed. 2005. *Books in Motion: Adaptation, Intertextuality, Authorship*. Amsterdam: Rodopi.

Arnold, Matthew. 1869. "Preface." In *Culture and Anarchy: An Essay in Political and Social Criticism*. London: Smith, Elder.

Asbury, Herbert. 1998. *The Gangs of New York: The Gangs of New York: An Informal History of the Underworld*. New York: Thunder's Mouth Press (based on the Alfred A. Knopf edition, 1928).

Auster, Paul. 1995a. "Auggie Wren's Christmas Story." In Paul Auster and Wayne Wang, *SMOKE and BLUE IN THE FACE: TWO FILMS*. New York: Hyperion (Miramax Books). 151–156.

———. 1995b. "The Making of *Smoke*: Interview with Annette Insdorf." In Paul Auster and Wayne Wang, *SMOKE and BLUE IN THE FACE: TWO FILMS*. New York: Hyperion (Miramax Books). 3–16.

———. 1995c. *SMOKE and BLUE IN THE FACE: TWO FILMS*. New York: Hyperion (Miramax Books).

Axelrod, Mark. 1996. "Once Upon a Time in Hollywood; Or, the Commodification of Form in the Adaptation of Fictional Texts to the Hollywood Cinema." *Literature/Film Quarterly*. 24.2: 201–208.

Bacchilega, Cristina. 1988. "Cracking the Mirror: Three Re-Visions of 'Snow White.'" *Boundary 2*. 15.3/16.1: 1–25.

Baetens, Jan. 2007. "From Screen to Text: Novelization, the Hidden Continent." In *The Cambridge Companion to Literature on Screen*. Eds. Deborah Cartmell and Imelda Whelehan. Cambridge: Cambridge University Press. 226–238.

Bakhtin, Mikhail M. 1981. *The Dialogic Imagination*. Ed. Michael Holquist. Trans. Caryl Emerson and Michael Holquist. Austin: University of Texas Press.

Barber, Benjamin R. 1996. *Jihad vs. McWorld*. New York: Ballantine Books.

Barry, Dan. 2003. "About New York; He Conned the Society Crowd but Died Alone." *New York Times*. July 19. Available at: http://www.nytimes.com/2003/07/19/nyregion/about-new-york-he-conned-the-society-crowd-but-died-alone.html?pagewanted=1&pagewanted=print [accessed May 26, 2009].

Barth, John. 1989. "Thinking Man's Minimalist: Honoring Barthelme." *The New York Times Book Review*. September 3, 1989.

Barthelme, Donald. 1967. *Snow White*. New York: Scribner Paperback Fiction (Simon & Schuster).

———. 1999. *Not-Knowing: The Essays and Interviews of Donald Barthelme*. Ed. Kim Herzinger. New York: Vintage.

Barthes, Roland. 1977a. "The Death of the Author." In *Image-Music-Text*. Trans. Stephen Heath. New York: Hill and Wang. 142–148.

———. 1977b. "From Work to Text." In *Image-Music-Text*. Trans. Stephen Heath. New York: Hill and Wang. 155–164.

———. 2012. "Romans in the Movies." In Roland Barthes, *Mythologies*. New York: Hill and Wang. 19–21.

Baudrillard, Jean. 1993. "The Precession of Simulacra." In *A Post Modern Reader*. Eds. Joseph Natoli and Linda Hutcheon. Albany: SUNY Press. 342–375.

Bauer, Dale M. 1994. *Edith Wharton's Brave New Politics*. Madison: University of Wisconsin Press.

Bazin, André. 1971a. "Theater and Cinema—Part One." In *What Is Cinema*. Trans. Hugh Gray. Berkeley: University of California Press. 76–94.

———. 1971b. "Theater and Cinema—Part Two." In *What Is Cinema*. Trans. Hugh Gray. Berkeley: University of California Press. 95–125.

———. 2000. "Adaptation, or the Cinema as Digest." In *Film Adaptation*. Ed. James Naremore. London: The Athlone Press. 19–37.

Benjamin, Walter. 1997. "The Translator's Task." Trans. Steven Rendall. *TTR: Traduction, Terminologie, Redaction*. 10.2: 151–165.

Bewley, Marius. 1985. "Scott Fitzgerald and the Collapse of the American Dream." In *F. Scott Fitzgerald*. Ed. Harold Bloom. New York: Chelsea House Publishers. 23–47.

Bigsby, C. W. E. 1992. *Modern American Drama: 1945–1990*. Cambridge: University of Cambridge Press.

Bloom, Harold I. 1973. *The Anxiety of Influence: A Theory of Poetry*. New York: Oxford University Press.

———. Ed. 1993. *Lolita*. New York: Chelsea House Publishers.

Bluestone, George. 1999. "'The Limits of the Novel and the Limits of the Film." In *Film and Literature: An Introduction and Reader*. Ed. Timothy Corrigan. Upper Saddle River, NJ: Prentice Hall. 197–213.

Bordwell, David. 1985. *The Classical Hollywood Cinema*. London: Routledge and Kegan Paul.

Borges, Jorge Luis. 1998. "Foreword." In Herbert Asbury, *The Gangs of New York: An Informal History of the Underworld*. New York: Thunder's Mouth Press (based on the Alfred A. Knopf edition, 1928).

Brady, Patrick. 1994. "Chaos and Emergence Theory Applied to the Humanities." In *Chaos in the Humanities*. Ed. Patrick Brady. Knoxville, TN: New Paradigm Press. 5–17.

———. Ed. 1994. *Chaos in the Humanities: A Synthesis Book*. Knoxville, TN: New Paradigm Press.

Breitman, George. Ed. 1965. *Malcolm X Speaks: Selected Speeches and Statements Edited with Prefatory Notes*. New York: Grove Press.

Briggs, John and F. David Peat. 1989. *Turbulent Mirror: An Illustrated Guide to Chaos Theory and the Science of Wholeness*. New York: Harper and Row.

Brinkley, Alan. 2004. *The Unfinished Nation: A Concise History of the American People*. 4th ed. Boston, MA: McGraw Hill.

Broken Flowers. 2005. Film. Director, Jim Jarmusch.

Brooker, Peter. 2007. "Postmodern Adaptation: Pastiche, Intertextuality and Re-functioning." In *The Cambridge Companion to Literature on Screen*. Eds. Deborah Cartmell and Imelda Whelehan. Cambridge: Cambridge University Press. 107–120.

Cahir, Linda Costanzo. 2006. *Literature into Film: Theory and Practical Approaches*. London: McFarland.

Canby, Vincent. 1989. Film Review: "Spike Lee Tackles Racism in 'Do the Right Thing.'" *New York Times*. June 30.

———. 1993. Film Review: "*Short Cuts*; Altman's Tumultuous Panorama." *New York Times*. October 1.

Carle, Frances (Asbury). 2014. "Gangs of New York." 1–11. Available at: http://www.herbertasbury.com/gangsofnewyork/ [accessed January, 2014].

Carroll, Rachel. Ed. 2009a. *Adaptation in Contemporary Culture: Textual Infidelities*. London: Continuum.

———. 2009b. "Affecting Fidelity: Adaptation, Fidelity and Affect in Todd Haynes's *Far From Heaven*." In *Adaptation in Contemporary Culture: Textual Infidelities*. Ed. Rachel Carroll. London: Continuum. 34–45.

Cartmell, Deborah. 2007a. "Adapting Children's Literature." In *The Cambridge Companion to Literature on Screen*. Eds. Deborah Cartmell and Imelda Whelehan. Cambridge: Cambridge University Press. 167–180.

———. 2007b. "Introduction—Literature on Screen: A Synoptic View." In *The Cambridge Companion to Literature on Screen*. Eds. Deborah Cartmell and Imelda Whelehan. Cambridge: Cambridge University Press. 1–12.

Cartmell, Deborah, Timothy Corrigan, and Imelda Whelehan. 2008. "Introduction to *Adaptation*." *Adaptation*. 1.1: 1–4.

Cartmell, Deborah and Imelda Whelehan. Eds. 2007. *The Cambridge Companion to Literature on Screen*. Cambridge: Cambridge University Press.

Carver, Raymond. 1993. *Short Cuts: Selected Stories*. New York: Vintage Books.

Chance, Helena. 2012. "Interior and Garden Design." In *Edith Wharton in Context*. Ed. Laura Rattray. Cambridge: Cambridge University Press. 199–208.

Chatman, Seymour. 1978. *Story and Discourse: Narrative Structure in Fiction and Film*. Ithaca, NY: Cornell University Press.

Clover, Carol J. 1992. *Men, Women and Chainsaws: Gender in the Modern Horror Film*. Princeton, NJ: Princeton University Press.

Clum, John M. 1992. *Acting Gay: Male Homosexuality in Modern Drama*. New York: Columbia University Press.

Cocks, Jay, Steven Zaillian, and Kenneth Lonergan. 1993. Screenplay of *Gangs of New York*. 3rd draft. Available at: http://sfy.iv.ru/sfy.html?script=gangs_of_new_york_ds [accessed July, 2009].

Cohen, Patricia. 2008. "An Environmental Movement (Possibly) Raised on Disney Cartoons." *International Herald Tribune*. Friday, April 25: 9.

Collard, Christophe. 2010. "Adaptive Collaboration, Collaborative Adaptation: Filming the Mamet Canon." *Adaptation*. 3.2: 82–98.

Coltelli, Laura. Ed. 1990. *Winged Words: American Indian Writers Speak*. Lincoln: University of Nebraska Press.

Comolli, Jean-Louis. 1978. "Historical Fiction: A Body Too Much." *Screen*. 19.2: 41–54.

Con Davis, Robert and Ronald Schleifer. 1991. *Criticism & Culture: The Role of Critique in Modern Literary Theory*. London: Longman Group UK.

Conger, Syndy M. and Janice R. Welsch. Eds. 1980. *Narrative Strategies: Original Essays in Film and Prose Fiction*. Macomb: West Illinois UPress.

Cooper, Barry Michael. 1989. "Foreword." *Do the Right Thing*. In Spike Lee with Lisa Jones, *Do the Right Thing*. New York: Fireside—Simon & Schuster. 13–17.

Corkin, Stanley. 2000. "Cowboys and Free Markets: Post-World War II Westerns and the US Hegemony." *Cinema Journal*. 39.3 (Spring): 66–91.

Corrigan, Timothy. Ed. 1999. *Film and Literature: An Introduction and Reader*. Upper Saddle River, NJ: Prentice Hall.

———. 2007. "Literature on Screen, a History." In *The Cambridge Companion to Literature on Screen*. Eds. Deborah Cartmell and Imelda Whelehan. Cambridge: Cambridge University Press. 29–43.

Cowley, Malcolm. 1953. "The Romance of Money." In *Introduction to Three Novels of F. Scott Fitzgerald*. Ed. Malcolm Cowley. New York: Charles Scriber's Sons.

Cullen, Jim. Ed. 1981. *The Pursuit of Signs: Semiotics, Literature, Deconstruction*. Ithaca, NY: Cornell University Press.

———. 2001. *Popular Culture in American History*. Malden, MA: Blackwell Publishing.

Culler, Jonathan. 1985. "Junk and Rubbish: A Semiotic Approach." *Diacritics: A Review of Contemporary Criticism*. 15.3: 2–13.

Curnutt, Kirk. 2007. *The Cambridge Introduction to F. Scott Fitzgerald*. Cambridge: Cambridge University Press.

Cutchins, Dennis. 2010. "Why Adaptations Matter to Your Literature Students." In *The Pedagogy of Adaptation*. Eds. Dennis Cutchins, Laurence Raw, and James M. Welsh. Lanham, MD: The Scarecrow Press. 87–95.

Cutchins, Dennis, Laurence Raw, and James M. Welsh. Eds. 2010. *The Pedagogy of Adaptation*. Lanham MD: The Scarecrow Press.

Dargis, Manohla. 2008. Film Review of *Enchanted*: "Someday My Prince Will. Uh, Make That a Manhattan Lawyer." 1–3. Available at: http://movies.nytimes. com/2007/11/21/movies/21ench.html?pagewanted=print [accessed March 21, 2008].

Davidson, Phebe. Ed. 1997. *Film and Literature—Points of Intersection*. Lewiston: The Edwin Mellen Press.

Davis, Nicholas K. 2005. *Broken Flowers*. *Nick's Flick Picks*. Available at: http:// www.nicksflickpicks.com/movarchs.html [accessed January 26, 2006].

Derrida, Jacques. 1978a. "Force and Signification." In *Writing and Difference*. Trans. Alan Bass. London: Routledge. 1–35.

———. 1978b. "Freud and the Scene of Writing." In *Writing and Difference*. Trans. Alan Bass. London: Routledge. 246–291.

———. 1978c. *Writing and Difference*. Trans. Alan Bass. London: Routledge.

———. 1993. "Structure, Sign, and Play in the Discourse of the Human Sciences." In *A Postmodern Reader*. Eds. Joseph Natoli and Linda Hutcheon. Albany: State University of New York Press. 223–242.

Do the Right Thing. 1989. Film. Director Spike Lee.

Dorris, Michael. 1994. *Paper Trail*. New York: Harper Collins.

Dyer, Richard. 1989. Film Review: "*Do the Right Thing*." *Chicago Sun-Times*. June 30.

———. 1993. Film Review: "*Short Cuts*." *Chicago Sun-Times*. October 22. Available at: http://rogerebert.suntimes.com/apps/pbcs.dll/ article?AID=/19931022/REVIEWS/310220301/1023 [accessed July, 2009].

———. 1997. *White*. London: Routledge.

Ebert, Roger. 2005a. Film Review: "*Broken Flowers*: A Don Juan stuck in idle." *Chicago Sun-Times*. August 5. Available at: http://rogerebert.suntimes.com/ apps/pbcs.dll/article?AID=/20050804/REVIEWS/50722001/1023&template=pri ntart [accessed July, 2009].

———. 2005b. Film Review: "Searching for Murray's Lost Son." *Chicago Sun-Times*. August 16. Available at: http://rogerebert.suntimes.com/apps/pbcs.dll/ article?AID=/20050816/SCANNERS/50815002 [accessed July, 2009].

———. 2012. Film Review: "*Snow White and the Huntsman*." *Chicago Sun-Times*. May 30, 2012: 13. Available at: http://rogerebert.suntimes.com/apps/pbcs.dll/ article?AID=/20120530/REVIEWS/120539992 [accessed September 02, 2012].

Eby, Lloyd. 1993. "Two Takes on Cinema: Scorsese and Altman." *Film*. 8 (December): 128.

———. 2005. "So Far Away: In *Broken Flowers*, Jim Jarmusch and Bill Murray Deadpan for Gold." *Slate*. August 4. 1–2. Available at: http://www.slate.com/ id/2124025/ [accessed January 19, 2007].

Edelstein, David. 2012. Edelstein, David. "Grim and Grimmer." *New York Magazine*. Available at: http://nymag.com/movies/reviews/snow-white-and-the-huntsman-2012–6/ [accessed September 02, 2012].

Eliot, T. S. 1989. "Tradition and the Individual Talent." In *Contemporary Literary Criticism: Literary and Cultural Studies*. Eds. Robert Con Davis and Ronald Schleifer. 2nd ed. New York: Longman. 26–31.

———. 2003. *Rethinking the Novel/Film Debate*. Cambridge: Cambridge University Press.

Elliott, Kamilla. 2010. "Adaptation as Compendium: Tim Burton's *Alice in Wonderland*." *Adaptation*. 3.2: 193–201.

Emerson, Jim. 1989. "Wake Up." Film review of *Do the Right Thing*. 1–4. Available at: http://www.cinepad.com/reviews/doright.htm.

Engelhardt, Tom. 1972. "Ambush at Kamikaze Pass." *Radical America*. (July/August): 480–498.

Evans, Anne-Marie. 2012. "Wharton's Writings on the Screen." In *Edith Wharton in Context*. Ed. Laura Rattray. Cambridge: Cambridge University Press. 167–176.

Fisher, Bob. 2005. "Broken Flowers: Fred Elmes Takes Us Behind the Scenes." Excerpted from Kodak review of *Broken Flowers*. Available at: http://motion.kodak.com/US/en/motion/About/Cannes/Features/cannes_broken_flowers.htm [accessed January 23, 2006].

Fitzgerald, F. Scott. 1925. *The Great Gatsby*. New York: Charles Scribner's Sons.

———. 1931. *The Crack-Up*. Ed. Edmund Wilson. New York: Charles Scribner's Sons.

Foucault, Michel. 1970. *The Order of Things: An Archaeology of the Human Sciences*. New York: Vintage Books—Random House.

———. 1972. *The Archaeology of Knowledge*. Trans. A. M. Sheridan Smith. London: Routledge (reprint 1989).

———. 1977a. "What is an Author." In *Language, Counter-Memory, Practice: Selected Essays and Interviews*. Ed. Donald F. Bouchard. Trans. Donald F. Bouchard and Sherry Simon. Ithaca, NY: Cornell University Press. 113–138.

Gabbard, Krin. 2000. "Kansas City Dreamin': Altman's Jazz History Lesson." In *Music and Cinema*. Ed. James Buhler, Caryl Flinn, and David Newmeyer. Hanover, NH: Wesleyan University Press. 143–160.

Gallagher, Tess. 1993. "Foreword." In *Short Cuts: The Screenplay*. Eds. Robert Altman and Frank Barhydt. Santa Barbara, CA: Capra Press. 7–14.

Genette, Gérard. 1997. *Palimpsests: Literature in the Second Degree*. Lincoln: University of Nebraska Press (original Editions du Seuil, 1982).

Geraghty, Christine. 2008. *Now a Major Motion Picture: Film Adaptations of Literature and Drama*. Lanham, MD: Rowman & Littlefield Publishers.

Gilbert, Sandra M. and Susan Gubar. 1979. *The Madwoman in the Attic*. New Haven, CT: Yale University Press.

Gilman, Richard. 1992. "Barthelme's Fairy Tale." In *Critical Essays on Donald Barthelme*. Ed. Richard F. Patterson. New York: G. K. Hall.

Giroux, Henry A. 1999. *The Mouse That Roared: Disney and the End of Innocence*. New York: Rowman & Littlefield Publishers.

Gitlin, Todd. 1988. "Hip Deep in Post-modernism." *The New York Times Book Review*. November 6: 35.

Gleick, James. 1987. *Chaos: Making a New Science*. New York: Penguin Books.

Gordon, Lois. 1981. *Donald Barthleme*. Boston, MA: Twayne.

Gotham Gazette NYC Book Club. 2002. Interview with Tyler Anbinder and Jay Cocks, "Is Gangs of New York Historically Accurate?" December 23. Available at: http://www.gothamgazette.com/article/feature-commentary/20021223/202/162.

Grant, William. 1997. "Reflecting the Times: *Do the Right Thing* Revisited." In *Spike Lee's Do the Right Thing*. Ed. Mark A. Reid. Cambridge: Cambridge University Press. 16–30.

Grimm, Jacob and Wilhelm Grimm. 1992a. *The Complete Fairy Tales of the Brothers Grimm*. Trans. and Intro. Jack Zipes. New York: Bantam Books.

———. 1992b. "Snow White." In *The Complete Fairy Tales of the Brothers Grimm*. Trans. and Intro. Jack Zipes. New York: Bantam Books. 196–204.

Grossberg, Josh. 2001. "Scorsese's 'Gangs' in Waiting." 8 October. Available at: http://www.eonline.com/News/Items/0,1,8934,00.html.

Guare, John. 1992. *Six Degrees of Separation*. New York: Dramatists Play Service.

Haberer, Adolphe. 2007. "Intertextuality in Theory and Practice." *Literatūra*. 49.5: 54–67.

Haken, Hermann. 1978. *Synergetics: An Introduction*. Berlin: Springer-Verlag.

Halliwell, Martin. 2007. "Modernism and Adaptation." In *The Cambridge Companion to Literature on Screen*. Eds. Deborah Cartmell and Imelda Whelehan. Cambridge: Cambridge University Press. 90–106.

Hassan, Ihab. 1986. "Pluralism in Postmodern Perspective." *Critical Inquiry*. 12. (Spring): 503–520.

Hawkins, Joan. 2005. "Dark, Disturbing, Intelligent, Provocative, and Quirky: Avant-Garde Cinema of the 1980s and 1990s." In *Contemporary American Independent Film: From the Margins to the Mainstream*. Eds. Christine Holmlund and Justin Wyatt. New York: Routledge. 77–91.

Hayles, N. Katherine. Ed. 1991a. *Chaos and Order: Complex Dynamics in Literature and Science*. Chicago: University of Chicago Press.

———. 1991b. "Introduction." In Katherine N. Hales, *Chaos and Order: Complex Dynamics in Literature and Science*. Chicago: University of Chicago Press.

Herrero-Olaizola, Alejandro. 1988. "Revamping the Popular in *Snow White* and *Pubis angelical*: The Residual Fictions of Donald Barthelme and Manuel Puig." *Journal of Popular Culture*. 32.3: 1–16.

Hollinger, David A. 1995. *Postethnic America: Beyond Multiculturalism*. New York: BasicBooks (HarperCollins Publishers).

Holmlund, Christine and Justin Wyatt. Eds. 2005. *Contemporary American Independent Film: From the Margins to the Mainstream*. New York: Routledge.

hooks, bell. 1993. "Postmodern Blackness." In *A Postmodern Reader*. Ed. Joseph Natoli and Linda Hutcheon. Albany: State University of New York Press. 510–518.

Horn, Katalin. 1983. "'The Hair is Black as Ebony...'. The Function of *Märchen* in Donald Barthelme's *Snow White*." *Orbis Litterarum*. 38: 271–279.

Hsu, Hsuan L. 2006. "Racial Privacy, the LA Ensemble Film, and Paul Haggis's *Crash*." *Film Criticism*. 31.1/2 (Fall/Winter): 132–156.

Huntington, Samuel P. 1993. "The Clash of Civilizations?" *Foreign Affairs*. 72.3 (Summer): 22–49.

Hutcheon, Linda. 1988. *A Poetics of Postmodernism: History, Theory, Fiction*. New York: Routledge.

———. 2006. *A Theory of Adaptation*. New York: Routledge.

Ignatiev, Noel. 1995. *How the Irish Became White*. New York: Routledge.

Insdorf, Annette. 1995. Interview with Paul Auster: "The Making of *Smoke*." In Paul Auster and Wayne Wang, *SMOKE and BLUE IN THE FACE: TWO FILMS*. New York: Hyperion (Miramax Books). 3–16.

The Internet Broadway Database. 2012. Available at: http://en.wikipedia.org/wiki/Snow_White_and_the_Seven_Dwarfs_(1912_play) [accessed September 01, 2012].

Jabbur, Adam. 2012. "Social Transitions." In *Edith Wharton in Context*. Ed. Laura Rattray. Cambridge: Cambridge University Press. 262–271.

Jameson, Fredric. 1972. *The Prison-House of Language: A Critical Account of Structuralism and Russian Formalism*. Princeton, NJ: Princeton University Press.

———. 1993. "Excerpts from *Postmodernism, Or the Cultural Logic of Late Capitalism*." In *A Postmodern Reader*. Ed. Joseph Natoli and Linda Hutcheon. Albany: State University of New York Press. 312–332.

Jarmusch, Jim. 2004. "Jim Jarmusch's Golden Rules." *Movie Maker: The Art and Business of Making Movies*. January 22. Available at: http://www.moviemaker.com/directing/article/jim_jarmusch_2972/ [accessed July 13, 2011].

Jencks, Charles. 1993. *The Architecture of the Jumping Universe*. New York: St. Martin's Press.

Johnson, Victoria E. 1997. "Polyphony and Cultural Expression: Interpreting Musical Traditions in *Do the Right Thing*." In *Spike Lee's Do the Right Thing*. Ed. Mark A. Reid. Cambridge: Cambridge University Press. 50–72.

Joslin, Katherine. 1991. *Edith Wharton*. London: Macmillan.

Kaplan, Mike and John Dorr. 1993. *Luck, Trust And Ketchup—Robert Altman In Carver Country—The Evolution Of Short Cuts*. DVD 2.

Kellner, Douglas. 1997. "Aesthetics, Ethics, and Politics in the Films of Spike Lee." In *Spike Lee's Do the Right Thing*. Ed. Mark A. Reid. Cambridge: Cambridge University Press. 73–106.

Kenny, Glenn. 2005. Review of *Broken Flowers*. *Premier. com*. August 4. Available at: http://www.premiere.com/moviereviews/2230/broken-flowers.html?track=LS [accessed April, 2006].

Killoran, Helen. 1990. "An Unnoticed Source for *The Great Gatsby*: The Influence of Edith Wharton's *The Glimpses of the Moon*." *Canadian Review of American Studies/Revue Canadienne d'Etudes Americaines*. 21.2: 223–224.

Kilpatrick, Jacquelyn. 1999. *Celluloid Indians: Native Americans and Film*. Lincoln: University of Nebraska Press.

King, Martin Luther Jr. 1986a. "Give Us the Ballot—We Will Transform the South." In *A Testament of Hope: The Essential Writings and Speeches of Martin Luther King, Jr*. Ed. James Melvin Washington. San Francisco, CA: HarperSanFrancisco. 197–200.

———. 1986b. "I Have a Dream." In *A Testament of Hope: The Essential Writings and Speeches of Martin Luther King, Jr*. Ed. James Melvin Washington. San Francisco, CA: HarperSanFrancisco. 217–220.

Klinkowitz, Jerome. 1984. *The Self-Apparent Word: Fiction as Language/Language as Fiction*. Carbondale: Southern Illinois University Press.

———. 1991. *Donald Barthelme: An Exhibition*. Durham, NC: Duke University Press.

Kristeva, Julia. 1980. "The Bounded Text." In *Desire in Language: a Semiotic Approach to Literature and Art*. Eds. Thomas Gora, Alice Jardine, and Leon S. Roudiez. New York: Columbia University Press. 36–63.

———. 1986. "Word, Dialogue and Novel." In *The Kristeva Reader*. Ed. Toril Moi. Trans. Alice Jardine, Thomas Gora, and Leon S. Roudiez. New York: Columbia University Press. 34–61.

Krupat, Arnold. 1992. *Ethnocriticism: Ethnography, History, Literature*. Berkeley: University of California Press.

Kunz, Heidi M. 2012. "Contemporary Reviews, 1877–1938." In *Edith Wharton in Context*. Ed. Laura Rattray. Cambridge: Cambridge University Press. 73–82.

Laderman, David. 2002. *Driving Visions: Exploring the Road Movie*. Austin: University of Texas Press.

Lasch, Christopher. 1979. *The Culture of Narcissism: American Life in an Age of Diminishing Expectations*. New York: Warner Books.

Lazarus, Emma. 2004. "Jewish Women's Archive." 11 February. Available at: http://www.jwa.org/exhibits/wov/lazarus.

Leary, M. 2005. Review of *Broken Flowers*. *Image Facts*. December 31. Available at: http://imagefacts.blogspot.com/2005/12/broken-flowers-jarmusch-2005. html [accessed January 19, 2007].

Lee, Spike with Lisa Jones. 1989. *Do the Right Thing: A Spike Lee Joint*. New York: Fireside—Simon & Schuster.

Lee, Spike. 1989a. *Do the Right Thing: A Spike Lee Joint*. 2nd draft, March 1, 1988. With Lisa Jones. *Do the Right Thing*. New York: Fireside—Simon & Schuster. 119–265.

———. 1989b. "The Journal." In *Do the Right Thing: A Spike Lee Joint*. With Lisa Jones. New York: Fireside—Simon & Schuster, 23–104.

———. 1989c. "Production Notes." In *Do the Right Thing: A Spike Lee Joint*. With Lisa Jones. New York: Fireside—Simon & Schuster. 105–118.

Lefevre, André. 1982. "Literary Theory and Translated Literature." *Dispositio*. 7.19–21: 3–22.

Leitch, Thomas. 2005. "The Adapter as Auteur: Hitchcock, Kubrick, Disney." In *Books in Motion: Adaptation, Intertextuality, Authorship*. Ed. Míreía Aragay. Amsterdam: Rodopi. 107–124.

———. 2007. *Film Adaptation and Its Discontents: From* Gone with the Wind *to* The Passion of the Christ. Baltimore, MD: The Johns Hopkins University Press.

———. 2008. "Review Article: Adaptation Studies at a Crossroads." *Adaptation*. 1.1: 63–77.

———. 2010. "How to Teach Film Adaptations, and Why." In *The Pedagogy of Adaptation*. Eds. Dennis Cutchins, Laurence Raw, and James M. Welsh. Lanham: The Scarecrow Press. 1–20.

Lewis, R. W. B, and Nancy Lewis. Eds. 1988. *The Letters of Edith Wharton*. New York: Charles Scribner's Sons.

Lim, Cua Bliss. 2005. "Serial Time: Bluebeard in Stepford." In *Literature and Film: A Guide to the Theory and Practice of Film Adaptation*. Eds. Robert Stam and Alessandra Raengo. Malden, MA: Blackwell Publishing. 163–190.

Lim, Dennis. 2009. "Jim Jarmusch's Explorations of Wanderlust." *International Herald Tribune*. April 25–26, 2009: 17, 21.

Lolita. Film. 1962. Director, Stanley Kubrick.

———. 1997. Director, Adrian Lyne.

Long, Robert Emmet. 1984. "*The Great Gatsby*—The Intricate Art." In *Critical Essays on F. Scott Fitzgerald's The Great Gatsby*. Ed. Scott Donaldson. Boston, MA: G. K. Hall. 105–111.

Lyotard, Jean-François. 1984. *The Postmodern Condition: A Report on Knowledge*. Trans. Geoff Bennington and Brian Massumi. Minneapolis: University of Minnesota Press.

Malcolm X. 1965. "The Ballot or the Bullet." In *Malcolm X Speaks: Selected Speeches and Statements Edited with Prefatory Notes*. Ed. George Breitman. New York: Grove Press. 23–44.

———. 1999. (With the assistance of Alex Haley). *The Autobiography of Malcolm X*. New York: Ballantine Books.

Marcus, Millicent. 1993. *Filmmaking by the Book: Italian Cinema and Literary Adaptation*. Baltimore, MD: The Johns Hopkins Press.

Marcuse, Peter. 2002. "The Layered City." In *The Urban Lifeworld*. Eds. Peter Madsen and Richard Pluntz. London: Routledge. 94–114.

Maslin, Janet. 1993. "Six Degrees of Separation; John Guare's 'Six Degrees,' on Art and Life Stories, Real and Fake": Film review of *Six Degrees of Separation*. *The New York Times*. December 8, 1993: 1–2. Available at: http://movies.nytimes.com/movie/review?_r=1&res=9F0CE3DE1531F93BA35751C1A9659 58260&pagewanted=print [accessed July, 2009].

Massood, Paula J. 2005. "*Boyz N the Hood* Chronotopes: Spike Lee, Richard Price, and the Changing Authorship of *Clockers*." In *Literature and Film: A Guide to the Theory and Practice of Film Adaptation*. Eds. Robert Stam and Alessandra Raengo. Malden, MA: Blackwell Publishing. 191–207.

McFarlane, Brian. 1996. *Novel to Film: An Introduction to the Theory of Adaptation*. Oxford: Clarendon Press.

———. 2007. "Reading Film and Literature." In *The Cambridge Companion to Literature on Screen*. Eds. Deborah Cartmell and Imelda Whelehan. Cambridge: Cambridge University Press. 15–28.

McKelly, James C. 1998. "The Double Truth, Ruth: 'Do the Right Thing' and the Culture of Ambiguity." *African American Review*. 32.2 (Summer): 215–227.

McNeely, Trevor. 1993. "'Lo' and Behold: Solving the *Lolita* Riddle." In *Lolita*. Ed. Harold Bloom. New York: Chelsea House Publishers: 134–148.

Meyers, Jeffrey. 1994. *Scott Fitzgerald: A Biography*. New York: HarperCollins Publishers.

Mizener, Arthur. 1959. *The Far Side of Paradise: A Biography of F. Scott Fitzgerald*. New York: Vintage Books.

Montgomery, Maureen E. 2012. "Leisured Lives." In *Edith Wharton in Context*. Ed. Laura Rattray. Cambridge: Cambridge University Press. 234–242.

Morace, Robert A. 1984. "Donald Barthelme's *Snow White*: The Novel, the Critics, the Culture." *Critique: Studies in Contemporary Fiction*. 26.1: 1–10.

Nabokov, Vladimir. 1955. *Lolita*. Afterword, Craig Raine. London: Penguin Books.

———. 1958. *Nabokov's Dozen*. Garden City, NY: Doubleday & Company.

———. 1974. *Lolita: a Screenplay*. New York: McGraw-Hill Book.

———. 1996. "Signs and Symbols." *Stories*. Ed. Dmitri Nabokov. London: Weidenfeld and Nicolson. 598–603.

Naremore, James. 2000a. "Introduction." In *Film Adaptation*. Ed. James Naremore. London: The Athlone Press. 1–16.

———. Ed. 2000b. *Film Adaptation*. London: The Athlone Press.

Naremore, James and Linda Hutcheon. Eds. 1993. *A Postmodern Reader*. Albany: State University of New York Press.

The National Archives. 2009. Available at: www.archives.gov/publications/prologue/spring.

Natoli, Joseph. 1997. *A Primer to Postmodernity*. Malden, MA: Blackwell Publishers.

O'Brien, James and Ned Borden. 1997. "From Picaro to Saint: the Evolution of *Forrest Gump* from Novel to Film: A Hollywood Pattern." In *Film and Literature—Points of Intersection*. Ed. Phebe Davidson. Lewiston, NY: The Edwin Mellen Press. 113–122.

O'Hagan, Andrew. 2013. "F Scott Fitzgerald: Uncovering the Man Behind *The Great Gatsby*." *Esquire*. May 16. Available at: http://www.esquire.co.uk/culture/film-tv/3891/the-great-gatsby/ [accessed September 11, 2013].

Owens, Louis. 1998. *Mixedblood Messages: Literature, Film, Family, Place*. Norman: University of Oklahoma Press.

Patterson, Richard F. Ed. 1992. *Critical Essays on Donald Barthelme*. New York: G. K. Hall.

Paulson, William R. 1988. *The Noise of Culture: Literary Texts in a World of Information*. Ithaca, NY: Cornell University Press.

Perosa, Sergio. 1965. *The Art of F. Scott Fitzgerald*. Ann Arbor: University of Michigan Press.

Piper, Henry Dan. 1962. "The Untrimmed Christmas Tree: The Religious Background of *The Great Gatsby*." In *The Great Gatsby: a Study*. Ed. Frederick J. Hoffman. New York: Charles Scribner's Sons. 321–334.

Pizer, John. 1990. "The Disenchantment of Snow White: Robert Walser, Donald Barthelme and the Modern/Postmodern Anti-Fairy Tale." *Canadian Review of Comparative Literature*. 17.3–4: 330–347.

Pouzoulet, Catherine. 1997. "The Cinema of Spike Lee: Images of a Mosaic City." In *Spike Lee's Do the Right Thing*. Ed. Mark A. Reid. Cambridge: Cambridge University Press. 31–49.

Prigogine, Ilya and Isabelle Stengers. 1984. *Order Out of Chaos: Man's New Dialogue with Nature*. New York: Bantam Books.

Prince, Gerald. 1997. "Foreword." In *Palimpsests: Literature in the Second Degree*. Ed. Gérard Genette. Lincoln: University of Nebraska Press. ix–xi.

Quinn, Laura Dluzynski. 1996. "Notes" to Edith Wharton. *The Age of Innocence*. Ed. and Intro. By Cynthia Griffin Wolff and Notes by Laura Dluzynski Quinn. New York: Penguin Books, 1996.

Ray, Robert B. 1985. *A Certain Tendency of the Hollywood Cinema, 1930–1980*. Princeton, NJ: Princeton University Press.

———. 2000. "The Field of 'Literature and Film.'" In *Film Adaptation*. Ed. James Naremore. London: The Athlone Press. 38–53.

———. 2008. *The ABCs of Classic Hollywood*. New York: Oxford University Press.

Reid, Mark A. 1997a. "Introduction: The Films of Shelton J. Lee." In *Spike Lee's Do the Right Thing*. Ed. Mark A. Reid. Cambridge: Cambridge University Press. 1–15.

———. Ed. 1997b. *Spike Lee's Do the Right Thing*. Cambridge: Cambridge University Press.

Rich, Frank. 1990a. "The Schisms of the City, Comically and Tragically": Review of John Guare's *Six Degrees of Separation*. *The New York Times*.

June 15: 1–2. Available at: http://theater2.nytimes.com/mem/theater/ treview.html?html_title=&tols_title=SIX%20DEGREES%20OF%20 SEPARATION%20(PLAY)&pdate=19900615&byline=By%20FRANK%20 RICH&id=1077011431454 [accessed July, 2009].

———. 1990b. "STAGE VIEW; A Guidebook to the Soul Of a City in Confusion": Review of John Guare's *Six Degrees of Separation*. *The New York Times*. July 1: 1–3. Available at: http://www.nytimes.com/1990/07/01/theater/stage-view-a-guidebook-to-the-soul-of-a-city-in-confusion.html?sec=&spon=&pagewanted= 2&pagewanted=print [accessed July, 2009].

Richardson, Robert. 1969. *Literature and Film*. Bloomington: Indiana University Press.

Román, David. 1993. "*Fierce Love* and Fierce Response: Intervening in the Cultural Politics of Race, Sexuality, and AIDS." In *Critical Essays: Gay and Lesbian Writers of Color*. Ed. Emmanuel S. Nelson. New York: Harrington Park Press. 195–219.

Roulston, Robert. 1984. "Something Borrowed, Something New: A Discussion of Literary Influences on *The Great Gatsby*." In *Critical Essays on F. Scott Fitzgerald's The Great Gatsby*. Ed. Scott Donaldson. Boston, MA: G. K. Hall. 54–66.

Schatz, Thomas. 1981. *Hollywood Genres: Formulas, Filmmaking, and the Studio System*. New York: McGraw-Hill.

Schickel, Richard. 1968. *The Disney Version*. New York: Avon Books.

Scott, A. O. 2012. "Movie Review: The Darker Side of the Story 'Snow White and the Huntsman,' With Kristen Stewart." *The New York Times*. Available at: http://movies.nytimes.com/2012/06/01/movies/snow-white-and-the-huntsman-with-kristen-stewart.html?ref=movies [accessed September 02, 2012].

Seger, Linda. 1992. *The Art of Adaptation: Turning Fact and Fiction into Film*. New York: Henry Holt. (An Owl Book).

Seldes, Gilbert. 1926. "New York Chronicle." *The New Criterion* (London). IV. (June): 170–171.

———. 1984. "Spring Flight." In *Critical Essays on F. Scott Fitzgerald's The Great Gatsby*. Ed. Scott Donaldson. Boston, MA: G. K. Hall.

Self, Robert T. 2002. *Robert Altman's Subliminal Reality*. Minneapolis: University of Minnesota Press.

Silvey, Vivien. 2009. "Not Just Ensemble Films: Six Degrees, Webs, Multiplexity and the Rise of Network Narratives." *Forum: University of Edinburgh Postgraduate Journal of Culture and the Arts*. 8. (Spring): 1–15. Available at: http://forum.llc.ed.ac.uk/issue8/silvey.pdf [accessed July, 2009].

Sinclair, Gail D. 2012. "The 1920s." In *Edith Wharton in Context*. Ed. Laura Rattray. Cambridge: Cambridge University Press. 302–311.

Slethaug, Gordon E. 1993. "Theories of Play/freeplay." In *Encyclopedia of Contemporary Literary Theory: Approaches, Scholars, Terms*. Ed. Irena R. Makaryk. Toronto: University of Toronto Press. 145–149.

———. 2000. *Beautiful Chaos: Chaos Theory and Metachaotics in Recent American Fiction*. Albany: State University of New York Press.

———. 2002a. "'The "Blanketing" Effect of Ordinary Language': Donald Barthelme's *Snow White* and American Myths." *Journal of American Studies* (South Korea). 34.2 (Winter): 303–319.

————. 2002b. "Chaotics and Many Degrees of Freedom in John Guare's *Six Degrees of Separation.*" *American Drama.* Winter: 73–93.

————. 2008. "Class, Ethnicity, Race, and Economic Opportunity: The Idea of Order in Scorsese's *Gangs of New York* and Spike Lee's *Do the Right Thing.*" *Journal of American Studies* (South Korea). 40.1: 149–183.

————. 2009. "Spike Lee, Martin Luther King, Malcolm X: The Politics of Domination and Difference." In *I Sing the Body Politic: History as Prophecy in Contemporary American Literature.* Ed. Peter Swirski. Montreal: McGill-Queen's University Press: 113–148.

————. 2012a. "Mapping the Trope: A Historical and Cultural Journey." In *Hit the Road, Jack: The Road in American Culture.* Eds. Gordon E. Slethaug and Stacilee Ford. Montreal: McGill-Queens University Press. 13–38.

————. 2012b. "Postmodern Masculinities in Recent Buddy and Solo Road Films." In *Hit the Road, Jack: The Road in American Culture.* Eds. Gordon E. Slethaug and Stacilee Ford. Montreal: McGill-Queens University Press. 166–197.

Smith, Dave. 2006. *Disney A to Z: The Official Encyclopedia.* 3rd ed. New York: Disney Enterprises.

Smoodin, Eric. 1994. "Introduction: How to Read Walt Disney." In *Disney Discourse: Producing the Magic Kingdom.* Ed. Eric Smoodin. New York: Routledge. 1–20.

Snow White and the Huntsman. Rotten Tomatoes. Available at: http://www.rottentomatoes.com/m/snow_white_and_the_huntsman/ [accessed September 02, 2012].

Sobchack, Vivian C. 2005. "*The Grapes of Wrath*: Thematic Emphasis through Visual Style." In *Literature and Film: A Guide to the Theory and Practice of Film Adaptation.* Eds. Robert Stam and Alessandra Raengo. Malden, MA: Blackwell Publishing. 111–125.

Sollers, Werner. 1986. *Beyond Ethnicity: Consent and Descent in American Culture.* New York: Oxford University Press.

Staiger, Janet. 1989. "Securing the Fictional Narrative as a Tale of the Historical Real." *South Atlantic Quarterly.* 88.2 (Spring): 393–413.

Stam, Robert. 2000. "Beyond Fidelity: The Dialogics of Adaptation." In *Film Adaptation.* Ed. James Naremore. London: The Athlone Press. 54–76.

————. 2005a. "Introduction: The Theory and Practice of Adaptation." In *Literature and Film: A Guide to the Theory and Practice of Film Adaptation.* Eds. Robert Stam and Alessandra Raengo. Malden, MA: Blackwell Publishing. 1–52.

————. 2005b. *Literature through Film: Realism, Magic, and the Art of Adaptation.* Malden, MA: Blackwell Publishing.

Stam, Robert and Alessandra Raengo. 2005. *Literature and Film: A Guide to the Theory and Practice of Film Adaptation.* Malden, MA: Blackwell Publishing.

Stone, Alan A. 1995. "Spike Lee: Looking Back." *Boston Review: A Political and Literary Forum.* December 1994/January: 1–13. Available at: http://bostonreview.net/BR19.6/spike.html.

Strickland, Rennard. 1997. *Tonto's Revenge: Reflections on American Indian Culture and Policy.* Albuquerque: University of New Mexico Press.

Sturrock, John. Ed. 1979. *Structuralism and Since: From Lévi-Strauss to Derrida.* Oxford: Oxford University Press.

Sukenick, Ronald. 1982. "The New Tradition." *Partisan Review.* 39. (Fall): 580–588.

Tibbetts, John C. 2010. "Foreword—Desperately Seeking Sources: The Missing Title Page." In *The Pedagogy of Adaptation*. Eds. Dennis Cutchins, Laurence Raw, and James M. Welsh. Lanham: The Scarecrow Press.

Vandergrift, Kay E. 2009. "Snow White Media." 1–5. Available at: http://www.scils.rutgers.edu/~kvander/swfilms.html [accessed March 28, 2009].

Vizenor, Gerald. 1990. "Gerald Vizenor." Interview. *Winged Words: American Indian Writers Speak*. Ed. Laura Coltelli. Lincoln: University of Nebraska Press. 155–182.

———. Ed. 1993. *Narrative Chance: Postmodern Discourse on Native American Indian Literatures*. Norman: University of Oklahoma Press.

———. 1998. *Fugitive Poses: Native American Indian Scenes of Absence and Presence*. Lincoln: University of Nebraska Press.

von Bertalanffy, Ludwig. 1968. *General System Theory: Foundation, Development, Applications*. New York: George Braziller.

Wagner, Geoffrey. 1975. *The Novel and the Cinema*. Rutherford, NJ: Fairleigh Dickinson University Press.

Wagner-Martin, Linda and Charles Molesworth. 1986. *Donald Barthelme Instructor Guide*. University of Missouri. Available at: http://college.hmco.eom/englisli/heath/syllabuild/iguide/barthelm.htm.

Waldrop, M. Mitchell. 1992. *Complexity: The Emerging Science at the Edge of Order and Chaos*. New York: Simon & Schuster—Touchstone Book.

Walt Disney Company. 2010. "Report: Fourth Quarter Earnings." November 11. Available at: http://corporate.disney.go.com/investors/quarterly_earnings/2010_q4.pdf [accessed July 14, 2011].

Wang, Wayne. 1995. "Preface." In *SMOKE and BLUE IN THE FACE: TWO FILMS*. Ed. Paul Auster. New York: Hyperion (Miramax Books). vii–viii.

Washington, James Melvin. Ed. 1986. *A Testament of Hope: The Essential Writings and Speeches of Martin Luther King, Jr.* San Francisco, CA: HarperSanFrancisco.

Way, Brian. 1986. "The Great Gatsby." In *F. Scott Fitgerald's The Great Gatsby*. Ed. Harold Bloom. New York: Chelsea House Publishers. 87–108.

Wells, Paul. 2007. "Classic Literature and Animation: All Adaptations Are Equal, But Some Are More Equal Than Others." In *The Cambridge Companion to Literature on Screen*. Eds. Deborah Cartmell and Imelda Whelehan. Cambridge: Cambridge University Press. 199–211.

———. 2009. "'Stop Writing or Write Like a Rat': Becoming Animal in Animated Literary Adaptations." In *Adaptation in Contemporary Culture: Textual Infidelities*. Ed. Rachel Carroll. London: Continuum. 96–107.

Welty, Eudora. 1979."Words into Fiction." In Eudora Welty, *The Eye of the Story: Selected Essays and Reviews*. New York: Random House (Vintage). 134–145.

Wharton, Edith. 1996. *The Age of Innocence*. Ed. and Intro. By Cynthia Griffin Wolff and Notes by Laura Dluzynski Quinn. New York: Penguin Books.

Wilmington, Michael. 2007. Review of *Broken Flowers*. *The Chicago Tribune*. August 23. Available at: http://metromix.chicagotribune.com/movies/mmx-050805-movies-review-flowers,0,4848829.story?coll=mmx-movies_top_heds [accessed July, 2009].

Witchel, Alex. 1990. "The Life of Fakery and Delusion In John Guare's 'Six Degrees.'" *The New York Times.* June 21. 1–3. Available at: http://www. nytimes.com/1990/06/21/theater/the-life-of-fakery-and-delusion-in-john-guare-s-six-degrees.html?pagewanted=all [accessed May 26, 2009].

Zeidner, Lisa. 1990. "The Way of Don B." University of Houston. Available at: http://www.eskimo.com/~iessamyn/barth/nytbr.html [accessed July, 2009].

Zipes, Jack. 1999. *When Dreams Came True: Classical Fairy Tales and Their Tradition.* New York: Routledge.

———. 2008. "Snow White Assignments Page." 1–11. Available at: http://www. scils.rutgers.edu/~kvander/swteach7.html [accessed March 28, 2008].

Index